THE PENTAX WAY

THE ASAHI PENTAX WAY

The Asahi Pentax
Photographer's Companion

H. KEPPLER

Sixth Edition

FOCAL PRESS - LONDON - NEW YORK

ISBN 0 240 50638 3

First edition April 1966
First edition (U.S.A.) April 1966
Second edition February 1967
Reprinted July 1967
Reprinted October 1967
Reprinted March 1968

Second edition (U.S.A.) March 1968

Third edition January 1969
Third edition (U.S.A.) January 1969
Reprinted June 1969
Reprinted August 1969

Fourth edition January 1970
Reprinted October 1970
Reprinted February 1971

Fifth edition November 1971
Fifth edition (U.S.A.) February 1972
Reprinted April 1972
Sixth edition September 1972
Seventh Edition 1973

German Edition:

DAS ASAHI PENTAX BUCH
Verlag Die Schönen Bücher Dr. Wolf Strache.

Spanish Edition:

MANUAL PENTAX ASAHI
Ediciones Omega, S.A., Barcelona.

Italian Edition:
IL LIBRO ASAHI PENTAX
Fotografare, Roma.

Printed and bound in Great Britain by
A. Wheaton & Co.,
Exeter 1973

CONTENTS

PRACTICAL HINTS 317

THE PENTAX MOTOR DRIVE SYSTEM 326

FACTS AND FIGURES 339

INDEX 360

THE SLR PRINCIPLE

The 35 mm. eye level single-lens reflex principle is undoubtedly one of the most convenient, logical and exciting developments in the history of 35 mm. photography. You, the user, can view your subject right through the camera's own lens. You can see what the film sees. Your camera preserves on film what you were seeing up to the instant of exposure—whether a landscape using the normal lens or a far distant nebulae with your camera attached to a telescope. There, right before your eye, is the picture area. You can note what is sharp, what is not sharp and what will actually be included in the final negative or transparency. And no matter how you use your camera, no matter what lens or accessory is placed on it, you will continue to see as your camera sees with no barrier between you and the subject.

Why is the 35 mm. eye level single-lens reflex so often considered superior to other camera systems? Let's take a brief look at the others.

Simple Focusing Methods

The simplest camera need be no more than a box with a lens in front and a flat plane at the rear to hold the film. If you point this simple camera at a bright subject—a candle flame—the simple lens will project an image of the candle flame on to the back of the box. The image will be upside down. You can make the image sharper or fuzzier by moving the magnifying lens forward or backward to focus the image more precisely or less precisely on the flat sheet. This is the simplest and crudest type of focusing system. You can easily see its failings. If you put film inside the box and make the box light tight, you can't possibly see whether the image is sharp or not since you can no longer see the film plane. And even if you could, you would expose your film during focusing if you let light through the lens before the exact instant you were ready to take the picture.

The simplest solution to this focusing problem is to mount the lens on a small movable platform and mark various points on the platform where a sharp image can be obtained. You will quickly learn that if you point the lens at a distant object, you get a sharper picture with the lens close to the film plane. As you focus on closer subjects you must move the lens further away from the film plane. If you actually measure the distance between subject and film plane when the lens sharply focuses the subject, you can mark that point on your scale. Whenever the subject is that precise distance away, the lens can be set at that mark and you get a sharp picture.

Continue to make markings showing when the lens is positioned for a subject 3 ft. away, 5 ft. away, 10 ft. away up to about 50 ft. away. You will probably find a point at which everything beyond 50 ft. looks sharp. This is called the infinity focus point.

Your marked platform is actually a focusing scale. If you could measure the distance of each subject from the camera every time with a tape measure and then set the lens to the scale properly, you would get sharp pictures and you would have no focusing problems. However, you would seldom find the time to take out the tape measure. You might then resort to judging the approximate distances by eye and setting the focusing scale by guess. This would tax your ability to estimate distances and is certainly not precise. However, there are many cameras using just this system for focusing.

Focusing Screens

Even the earliest camera designers realized that actual measurements or guesses were inconvenient or inaccurate. The earliest solution to the problem was the use of the ground glass back. By placing a piece of glass with a roughly ground surface behind the lens, a camera user could actually see the image projected by the lens. The lens could then be focused accurately until the subject was sharp on the ground glass. The ground glass could then be removed and the film put into the exact same plane. This is precisely how view cameras used in studios by professional photographers work today. The deficiencies are obvious. The camera and subject must remain still while you focus, replace the ground glass with film and then make the exposure. You also have the same upside down image with which to contend.

2

Early Single-Lens Reflexes

A very logical solution to this problem was developed from the mediaeval camera obscura, later models of which were the first instruments to use the single-lens reflex principle. Light passed through a lens and was reflected upwards to a ground glass. Artists and draughtsmen placed tracing paper over the ground glass and traced the image formed by the lens. A real image could thus be made into an accurate drawing.

Once suitable photographic materials had been discovered camera designers soon realised that a piece of film could be placed behind the mirror at a distance from the lens equivalent to that from the lens to the ground glass via the mirror. If the mirror were hinged at the back, it could be lifted out of the way after focusing on the ground glass and the light rays could hit the film, making a picture. And that's just how single-lens reflexes work today, big and small.

The first big single-lens reflexes were comparatively simple to use because you could view the image easily on the large 4×5 in., 9×12 cm., or 5×7 in. focusing screen. But as manufacturers made more compact reflexes, using smaller film sizes, it became more and more difficult to see the smaller and smaller images on the ground glass. Most photographers felt that the $2\frac{1}{4} \times 2\frac{1}{4}$ in. screen was about the smallest glass that could be used. Even then, a magnifier had to be positioned over the screen for critical accuracy in focusing.

A few brave designers did try a single-lens reflex principle in a 35 mm. camera, but they met problems that seemed impossible to overcome. Even with a powerful magnifier, focusing was difficult on the tiny ground glass. In addition, the 35 mm. picture was horizontal. Suppose you wanted to make a vertical picture? In order to use the ground glass you would have to hold the camera vertically and view the image from the side. And the image would be upside down at that! Even so, the logic of being able to see the image as the lens saw it, made the tiny 35 mm. single-lens reflexes quite attractive.

Nevertheless, the single-lens reflex's original focusing and viewing problems prevented it from advancing into 35 mm. cameras to any great extent until the 1950's. In 1950, the first real advance occurred. From Zeiss Ikon of Dresden came the Contax S—a 35 mm. single-lens reflex with a five-sided

3

prism on top of the ground glass. You could hold the camera at eye level and see an unreversed, right side up, magnified focusing and viewing image. The camera did have a major drawback. After you pressed the shutter release, the mirror flew upwards blacking out the view completely until film was wound for the next picture.

The Asahi Design

In 1954 the modern 35 mm. single-lens reflex was born. Asahi Optical Co. Ltd., of Tokyo, introduced the first eye level single-lens reflex with rapid-return mirror. For the first time, you could view, focus and shoot almost without interruption. When you pressed the shutter release, the mirror immediately began to swing upwards. When it reached full swing, the shutter travelled. After the shutter was again fully closed, the mirror returned to the downward position—all in a fraction of a second. Because of the human eye's ability to retain an image for a short time after it has disappeared, the brief period of viewing blackout while the mirror swung up and down was barely noticeable at average shutter speeds. It is this original Asahi design which is used today in all advanced single-lens reflex cameras.

While this brief history of popular camera design may give you some idea of just how important a part the Asahi company played in evolving the single-lens reflex design, let's see just what other features make the single-lens reflex the leading 35 mm. camera today.

First let's take a good look at that viewing system. The whole finder area of the Asahi (Honeywell) Pentax is extremely bright. That's because the very efficient optical system includes a fresnel lens. The fresnel lens is a flat plastic sheet with very fine concentric lines. It is placed under the focusing screen to take the place of a very bulky glass condenser that once was used in single-lens reflexes to brighten the images to the very corners. Single-lens reflexes without a fresnel lens have fairly bright images in the finder centre but the image darkens towards the edges and corners of the finder.

In the centre of the Asahi (Honeywell) Pentax finder is a microgrid, one of the great improvements the Asahi company brought to ground glass focusing. In most single-lens reflexes of the past it was very difficult to judge just when

FINDER SYSTEM

Here are the essential parts of the camera's interior.

1. Five-sided prism.
2. Magnifying eyepiece.
3. Condensing lens.
4. Focusing screen.
5. Focal-plane shutter.
6. Rapid return mirror.

Focusing screen consists of central microprism grid, surrounding fine focusing collar, outer Fresnel circular lines to brighten the image to corners.

When microprism screen is not focused, image appears to be unsharp and "fractured" into tiny particles (left). When lens is properly focused, image snaps into clear visibility (right).

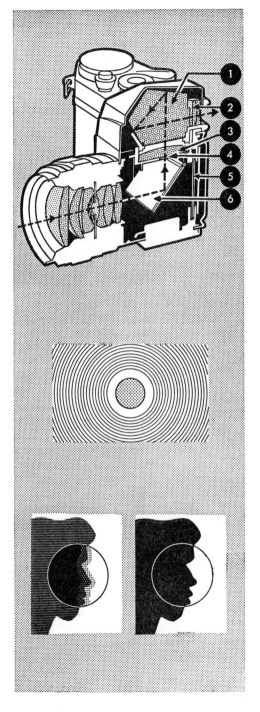

you had reached the point of exact sharp focus. The micro-grid changed all that. The grid is composed of many tiny optical pyramids. When the image is not in focus, the pyramids "fracture the image" into tiny jagged pieces which seem to shimmer. At the point of exact focus, the image snaps into sharpness and the shimmering stops—another Asahi first.

However for some subjects you might want to have just a plain ground glass for focusing. Well, you have this too—a very fine ground glass collar right around the microgrid. You can focus with grid or collar. Both give immediate accuracy of focus.

Asahi have provided many other thoughtful features in the viewfinder. If you wear glasses, note that you can still see the entire picture area. This is unusual in a single-lens reflex. In many, the wearing of glasses forces the camera user to keep his eye fairly far from the finder eyepiece. The finder edges or corners or both cannot be seen.

Takumar Lenses

Now let's turn to a very important part of any camera—the lens. Takumar lenses have been designed for high optical quality. They are well finished, too, in handsome black satin with large, legible contrasting white or coloured numerals. Try the focusing ring. You'll find that it works with incredible smoothness. And check how closely you can focus with the normal 50 or 55 mm. lens—down to 18 in.

The very finest rangefinder cameras cannot approach this flexibility. Why? Because their finder systems are located on top of the camera body. At such close distances the finders see above the subject. This is known as parallax error. With the single-lens reflex you're looking right through the lens, so you see what you get.

All Takumar lenses have anti-reflection coatings to minimize internal reflections and flare, but Asahi have now developed a superior coating for many of their lenses. This is a super multi-coating using a very special, precise, many-layered coating of high efficiency anti-reflection agents which allows the lens to transmit about 25 per cent more light than a conventional coated lens. The coating also reduces flare and unwanted internal reflections and produces unusually hard front and rear surfaces, less susceptible to scratching. The lenses are identified with the words "Super-Multi-Coated-Takumar" on the front ring.

6

SHUTTER
AND APERTURE

The focal plane shutter of the Pentax consists of two travelling cloth curtains with an open slit between them. The width of the slit determines the shutter speed. A speed such as 1/500 sec. has a narrow slit, 1/60 a medium slit, while 1/15 sec. has a large slit.

The size of the lens aperture is varied with a multi-blade metal iris. A large aperture such as ƒ2.8 shows the iris almost completely open, medium aperture ƒ8 shows the iris partially closed while ƒ16 requires a small iris opening. These two controls vary your exposure. You can achieve the same exposure using a large aperture and fast shutter speed or a small aperture and slow shutter speed. Here, the three shutter speed and lens apertures 1/500 at ƒ2.8, 1/60 at ƒ8 and 1/15 at ƒ16 all deliver the same correct exposure. The choice depends on whether you need a fast speed to stop action, a small aperture for the most depth-of-field or a compromise between them.

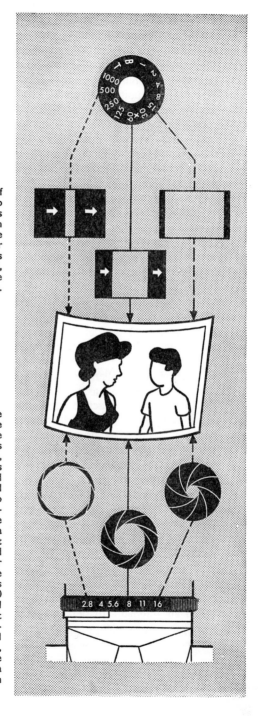

One of the most important features of the Asahi (Honeywell) Pentax is the interchangeable lens mount. If you grasp the lens firmly and twist counterclockwise 2¾ turns, you can unthread and remove the lens. This feature allows you to place bellows units or extension tubes between the lens and camera body for very close photography. More important for some photographers is the possibility of interchangeable lenses. You can replace the normal lens with lenses of varying uses—telephoto lenses, portrait lenses, wide angle lenses, zoom lenses, fish-eye lenses. You can obtain them as and when you want them. Each threads on to the camera securely and is ready to work immediately.

That's one of the big advantages of the threaded lens mount, incidentally. Unlike bayonet lens mounts which are used on many other single-lens reflexes, the Pentax thread mount never loosens and never has to be re-adjusted. And no lens can ever fall out just because the lock is fastened improperly.

Shutter Design

Since lenses are so quickly interchanged, you might well wonder why the shutter doesn't interfere. It can't because it is a very efficient focal plane shutter. This consists of two cloth curtains on rollers, which pass just in front of the film itself, far behind the lens.

When the shutter action begins, these two curtains travel horizontally over the film leaving just a tiny slit opening between them. They usually travel at the same speed. By setting different shutter speeds on the shutter speed dial, you are actually varying the width of the slit. During fast shutter speeds, the slit is very narrow. At slow speeds, the slit is quite wide, letting in more light. When you wind film with the rapid wind lever, the two curtains, this time carefully closed, return to their starting positions. This focal plane shutter is precisely the type used by most high quality 35 mm. cameras.

Automatic Diaphragm

Each Super Takumar lens has a very remarkable feature called an automatic diaphragm. As you probably know, before you take a picture you must not only set the proper shutter speed but also the correct lens opening. Quite often

HOW
THE PENTAX WORKS

When you are viewing and focusing, light enters fully opened lens iris diaphragm, is reflected upwards by mirror to focusing screen where condensing lens brightens image and pentaprism above it reverses the image so that it is correct right to left. Light then passes through magnifying eyepiece to your eye.

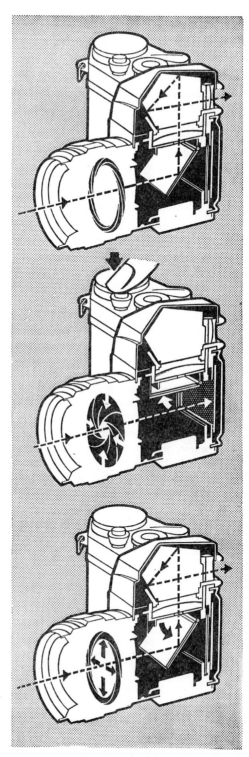

When you press shutter release to take a picture, the iris diaphragm of the lens closes to the aperture you have predetermined, the mirror swings upwards allowing the light from the lens to strike the film which is exposed through the travelling focal plane shutter.

At the end of the exposure, the lens iris diaphragm reopens instantly, the mirror swings down again in place, the shutter closes and you can again see the viewing and focusing image through the finder. At speeds of 1/30 sec. or greater, these actions take place so swiftly that you will notice only a brief blink through the finder.

the lens opening will be smaller than the full $f1.4$, $f1.8$ or $f2$ aperture of your lens. On older single-lens reflexes it was necessary to close the lens opening down by hand to the preselected opening before you took the picture. Not with the Takumar lenses. After you select the lens aperture, the lens remains wide open. When you press the shutter release, the lens automatically closes down to the proper aperture. After exposure, the lens reopens fully to maximum aperture. You always view your subject with the brightest, largest lens opening.

Sometimes, however, you will want to see just what happens when your lens is closed down to taking aperture. This is no problem. Each Super Takumar lens has a preview lever. By pushing the lever downwards you can close the lens to your preselected opening and see just what and how the lens will view the scene when the shutter release is pressed. By sliding the lever back again to the original position, the lens again reopens fully for the most efficient focusing.

The Super-Multi-Coated-Takumars also have preview levers. However they are deliberately inoperable when used on the Pentax ES model because you could possibly produce an erroneous exposure if you used them. They lock in the "Auto" position when on the camera but operate normally on other Pentax models. To preview the scene with a Pentax ES, just push upwards on the switch located on the camera body. The lens will then stop down to shooting aperture but will reopen again when you push downwards on the switch. Of course, you can use the body switch on all Pentax cameras with built in metering systems for previewing.

As you can see by now, when you buy an Asahi (Honeywell) Pentax you are not simply buying another camera. You are purchasing a very carefully evolved, highly crafted, extremely efficient example of perhaps the most logical and flexible camera design on earth—the 35 mm. single-lens reflex.

OLDER PENTAX MODELS

Not everyone can be privileged to own the newest of the Pentax cameras. While these are certainly the most advanced and best models made by Asahi, the older models owned by thousands of photographers around the world are daily performing excellent service. These earlier Pentax models also can often be purchased as used equipment. This chapter is devoted to describing such Pentax models.

The Asahi Optical Co. Ltd., was founded in 1919. Today it is one of the world's leaders in camera and optical design. Asahi entered the photo field in 1923 when it commenced the manufacture of motion picture projector lenses. The first camera lenses were produced by Asahi in 1931.

However, Asahi's substantial growth in the photo industry began in 1951 when the Asahiflex 35 mm. single-lens reflex cameras were introduced. These were the first Japanese-made 35 mm. single-lens reflexes. Three years later Asahi announced a real break through in reflex camera design—the instant-return mirror, which ended image blackout. Immediately after the shutter closed following exposure, the mirror swung downwards again into viewing position rather than remaining upwards blocking the view. Instead of a blackout after the release of the shutter, there was only a blink during the actual exposure after which the user could again view the subject through the finder.

Asahi Optical Co.'s main factory is located in Mashiko, Japan, which is north of Tokyo. It has another major factory in Itabashi, Tokyo. While some optical blanks and raw glass are purchased from outside sources, all grinding, polishing, assembly and lens design are done by Asahi engineers, technicians and workmen in the Asahi plants.

Older Models

Now to the camera models. The following are the models no longer in production.

Asahiflex I (Introduced 1951): This 35 mm. single-lens reflex had a waist-level-only viewfinder plus separate but non-focusing sports finder. The standard interchangeable lens

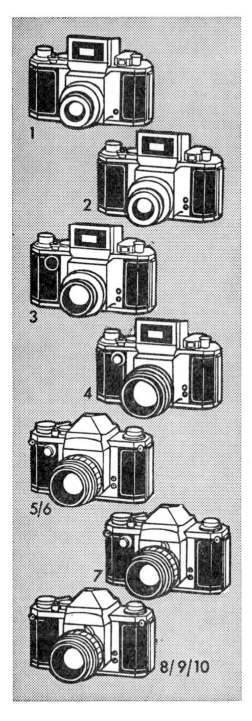

PENTAX PEDIGREE

1. **Asahiflex** (1951), known as Tower in U.S.: Waist-level finder, 50mm. lens. X-sync. only.

2. **Asahiflex IA** (1953): Same as above but with X and F. sync. and simplified shutter.

3. **Asahiflex IIB** (1954), known as Tower 23 in U.S.: Slowest shutter speed 1/25 sec. World's first instant-return mirror.

4. **Asahiflex IIA** (1955), known as Tower 22 in U.S. Separate slow shutter speeds to $\frac{1}{2}$ sec. on front shutter speed dial.

5. **Original Pentax** (1957), known as Tower 26 in U.S.: New eye-level pentaprism reflex body, rapid wind lever, folding rewind crank, larger universal Pentax thread mount, speeds from 1 to 1/500 sec.

6. **Pentax S** (1957): Same as Pentax above but with nearer arithmetical progression of shutter speeds. 55mm. $f1\cdot8$ Takumar introduced.

7. **Pentax K** (1958): Top shutter speed of 1/1000 sec. semi-automatic diaphragm mechanism coupled to new 55mm., $f1\cdot8$ Auto-Takumar lens, microprism finder.

8. **Pentax S1** (1961): Essentially same as S1a but with 55mm., $f2\cdot2$ Auto-Takumar.

9. **Pentax S2** (1961), known as H2 in U.S.: Same as S1 but with 55mm., $f2$ Auto-Takumar.

10. **Pentax Super S2** (Japanese market only): Similar to S3 (see 11 over) but with 55mm., $f2$ Super Takumar.

PENTAX PEDIGREE

11. Pentax S3 (1961), known as H3 in U.S.: Auto-manual control for automatic diaphragm mechanism, top shutter speed 1/1000 sec. 55mm., *f*1·8 Auto-Takumar.

12. Pentax SV, H3v. Similar to S3 but with self-zeroing exposure counter, self-timer, improved microprism, 55mm. *f*1·8 or *f*2 Super Takumar.

13. Pentax S1a, known as H1a in U.S. Top speed of 1/500 sec. Otherwise same as Pentax SV, H3v. 55mm., *f*2 Super Takumar.

14. Pentax Spotmatic (current): New body and mechanism, faster operating shutter, improved instant return mirror, repositioned self-timer, pull-up knob backlatch, behind-the-lens exposure system, new 50mm., *f*1.4 Super Takumar lens.

15. Pentax SL (current): Essentially same as Spotmatic but without metering system.

16. Pentax SP500 (current): Same as Spotmatic but with top 1/500 sec. speed, no self-timer.

17. Pentax Spotmatic II (current): Same as Spotmatic but with hot flash sync shoe atop prism and 50mm f/1.4 or 55mm f/1.8 Super Multi-Coated Takumar lens.

18. Pentax Spotmatic IIA (current, available in U.S. and Mexico only): Same as Spotmatic II but with built-in Strobo-Eye for use with all Honeywell Remote/ Auto Strobonar electronic flash units.

19. Pentax ES (current): Fully automatic exposure with electronically controlled shutter 1 to 1/1000 sec., manual speeds 1/60 to 1/1000 sec., 50mm *f*1·4 Super-Multi-Coated Takumar, full aperture exposure measurement through lens, hot flash shoe atop prism, no self-timer.

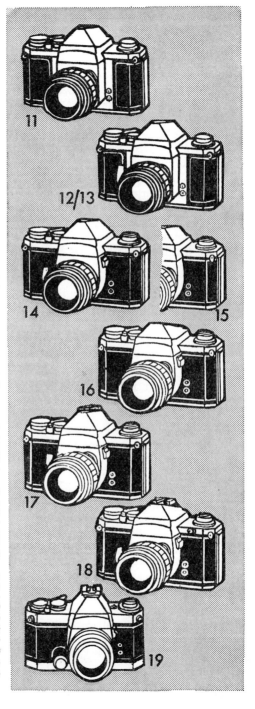

in Asahi (not the present Pentax) thread was the 50 mm. *f*3.5 Takumar with preset diaphragm. The focal plane shutter offered speeds from 1/20 to 1/500 sec. plus T and B. The shutter was synchronized for both X and F flash. Film advance and shutter wind was by a single knob. Lenses from this camera can be used on present-day Pentax cameras with a special insert adapter. But the current Takumar lenses cannot be used on the Asahiflex I body.

Asahiflex IIB (Introduced 1954): Essentially the same as the original Asahiflex I but the lowest shutter speed was 1/25 sec. instead of 1/20 sec. World's first instant-return mirror incorporated. Standard lens was 50 mm. *f*3.5 or 58 mm. *f*2.4 Takumar in Asahiflex thread with preset diaphragm. These lenses can be fitted to current cameras with special insert adapter, but the current Takumar lenses cannot be fitted to Asahiflex IIB body. Camera with 50 mm. *f*3.5 lens was also sold in the U.S. as Tower 23.

Asahiflex IIA (Introduced in 1955): Similar to Asahiflex IIB but with additional slow shutter speeds of 1/2, 1/5, 1/10 sec. Lenses same as IIB. Sold in U.S. also under name Tower 22 (with 50 mm. *f*2.4 Takumar lens).

Asahi Pentax (Introduced 1957): Completely new body design with permanently mounted eye level prism, rapid wind lever, folding rapid rewind crank, focal plane shutter with speeds from 1 to 1/500 sec., separate slow speed dial on front of camera, X and F sync., choice of 58 mm. *f*2, 55 mm. *f*2.2 or 58 mm. *f*2.4 Takumar lenses with preset diaphragm. Finder image life size with 58 mm. lens. New, larger Pentax thread mount compatible with Praktica and Contax D cameras and lenses. Also sold in U.S. as Tower 26 (with 58 mm. *f*2.4 Takumar lens).

Asahi Pentax S (Introduced 1957): Essentially same as Asahi Pentax but with nearer arithmetical progression of shutter speeds—1, 1/2, 1/4, 1/8, 1/15, 1/30, 1/60, 1/125, 1/250, 1/500 sec. instead of older 1, 1/2, 1/5, 1/10, 1/25 sec. etc. progression. Lenses available were 55 mm. *f*2.2 or *f*1.8 Takumar.

Asahi Pentax K (Introduced 1958): Essentially same as Pentax S, but had top speed of 1/1000 sec., internally coupled semi-automatic diaphragm which closed to the preselected aperture automatically when the shutter release was pressed and reopened afterwards manually with a cocking

OLDER PENTAXES

Pentax, Pentax S: Older Pentax has slow speeds from 1 to 1/25 sec. on front shutter speed dial, fast speeds 1/25 to 1/500 sec. on main speed dial on top of camera. Pentax S has speeds from 1 to 1/30 sec. on front dial, 1/30 to 1/500 on main dial. Lens has preset diaphragm.

Pentax K: Slower speeds from 1 to 1/30 sec. on front speed dial, fast speeds from 1/30 to 1/1000 sec. on main speed dial on top of camera. Lens has semi-automatic diaphragm.

Pentax H2: All speeds 1 to 1/500 sec. on single dial on top of camera. Lens has semi-automatic diaphragms.

lever. Camera had first central microprism focusing grid. Standard lens was 55 mm. f1.8 Auto-Takumar. However, all previous Asahiflex lenses could be fitted to this model with an adapter.

Asahi Pentax H2 (Introduced 1959): Similar to Asahi Pentax K but has top speed of 1/500 sec. with all speeds on single top, non-rotating (during exposure) dial, shutter cock indicator, 55 mm. f2 Auto-Takumar lens. Also sold under names of Asahi Pentax S2, Asahiflex H2, Heiland Pentax H2 (in U.S.).

Asahi Pentax S3 (Introduced 1961): Essentially same as Pentax H2 but has fully automatic diaphragm requiring no recocking to full aperture after exposure, top shutter speed of 1/1000 sec., standard lens 55 mm. f1.8 Auto-Takumar with fully automatic diaphragm. Sold in U.S. as Honeywell Pentax H3.

Asahi Pentax S2 (Introduced 1961): Modified version of model H2 with top speed of 1/1000 sec. While lens remained semi-automatic 55 mm. f2 Auto-Takumar, some S2 bodies had fully automatic diaphragm mechanisms in camera body similar to S3.

Asahi Pentax S1 (Introduced May 1961): Essentially same as S2 but with 55 mm. f2.2 Auto-Takumar, semi-automatic diaphragm. Some S1 camera bodies had fully automatic diaphragm mechanisms in camera bodies similar to S3.

Asahi Pentax SV, Honeywell Pentax H3v in U.S. (Introduced 1962): Similar to S3 or H3, but with automatic resetting film exposure counter, self-timer cocking wheel surrounding rewind knob, improved microprism, 55 mm. f1.8 or 55 mm. f2 Super Takumar lens.

Asahi Pentax S1a, Honeywell Pentax H1a in U.S. Similar to SV or H3v but has marked top speed of 1/500 instead of 1/1000 sec., 55 mm. f2 Super Takumar lens.

Current Models

We now come to the current Asahi Pentax models:

Asahi Pentax Spotmatic or SP, Honeywell Pentax Spotmatic in U.S. Although outward appearance and trim resemble older Pentaxes, this model is actually a completely new camera with faster-operating shutter mechanism, improved instant return mirror, additional body castings, heavier metal cover plates, simplified lens mount interior with

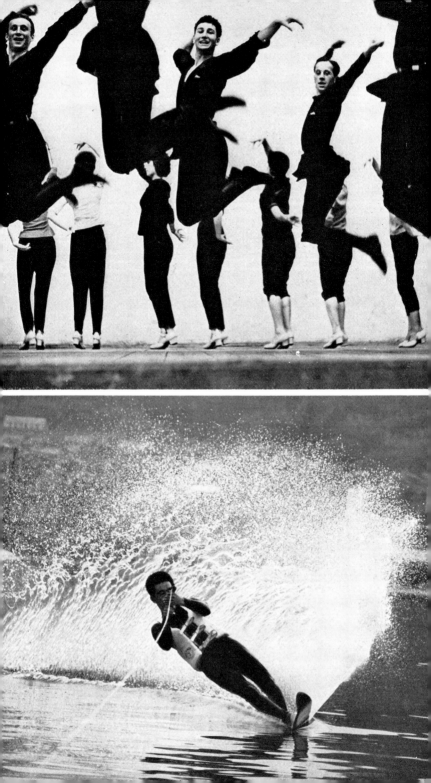

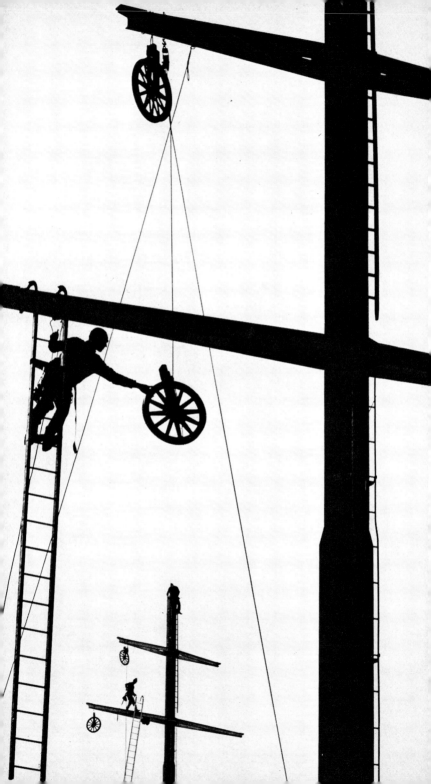

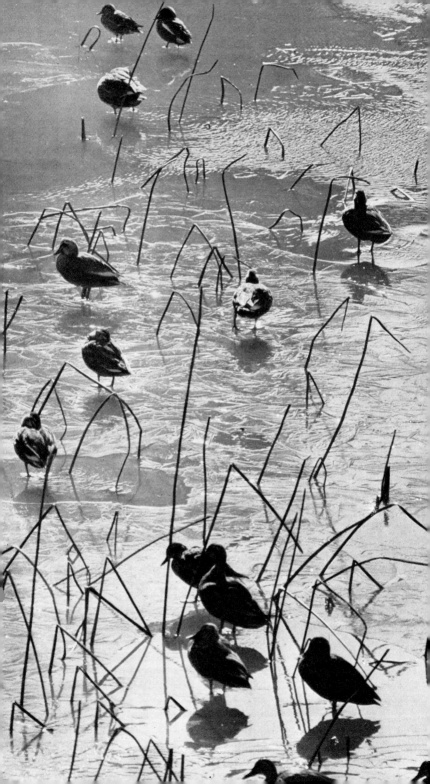

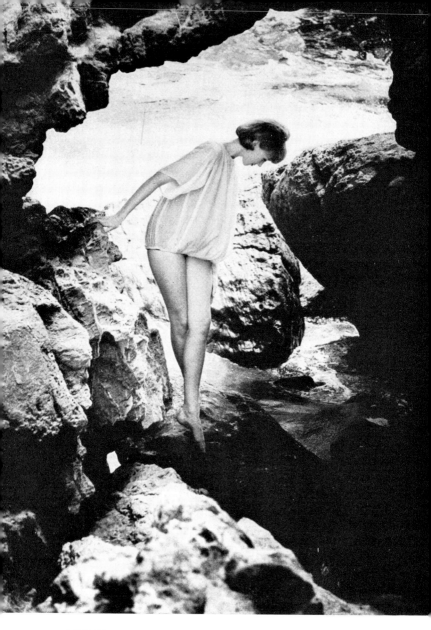

ACTION

Page 17 (top). You can often stop action without a very fast shutter speed. Here Leonid Bergoltsev needed but 1/60 sec. at *f*/2.8 to catch these Georgian dancers at the height of their leap.

Page 17 (bottom). The photographer used 1/1000 sec. to halt all action in the picture of a water skier. With a high contrast subject you may have to bias your exposure in favour of the light or dark area in the scene.

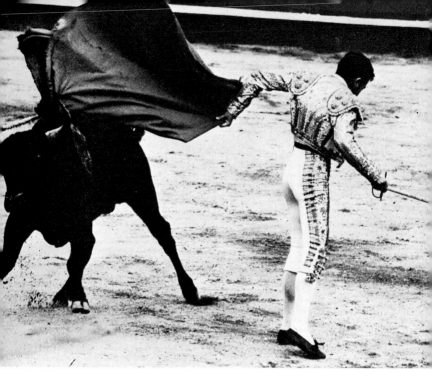

TWO LENS MONTAGE

Page 18. Starkly dramatic double print of man on ladder by Swiss photographer Kurt Lembachner is actually composed of two negatives montaged. The photographer shot scene with man and ladder using a 55 mm. $f/1.8$ and reshot with a 105 mm. $f/2.8$, then combined negatives on a single enlarging paper.

TELEPHOTO EXPOSURE

Page 19. Judging exposure with a long (500 mm.) lens can be difficult. Here the photographer exposed for a middle grey tone, thus the birds are in partial silhouette.

EXPOSING FOR FLESH TONES

Page 20. Richard Lukes here exposed for the most important area of the picture, the flesh tone, avoiding the influence of the bright background or dark shadowy rocks with his exposure of 1/125 sec. $f/5.6$.

Page 21. K. Niiyama avoided bright reflections from the water in the pool, and ensured correct tones with an exposure of $f/8$ at 1/250 sec.

LONG LENS ACTION

(Above). A 200 mm. $f/4$ Super-Takumar on Xharder Gaston's Pentax Spotmatic provided the ideal length for a tight cropping of a classic matador pass during a bullfight. The Belgian photographer shot at 1/250 sec. and $f/16$ on Kodak Tri-X Pan film.

CITY SCENIC

Page 23. An overall exposure reading produced a good negative of New York skyscrapers with 300 mm. $f/4$, Takumar.

EXPOSURE DILEMMA

Page 24. Should M. Yura use a fast shutter speed with his Pentax to stop action or a small aperture for depth of field? Luckily a compromise of 1/250 sec. at $f/11$ was possible.

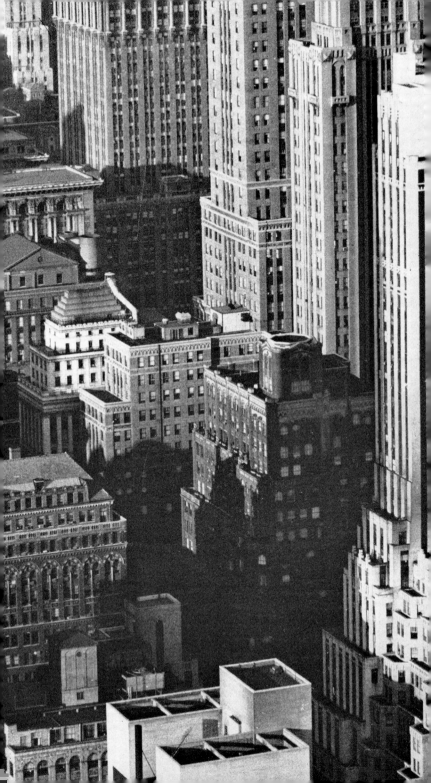

PENTAX FEATURES

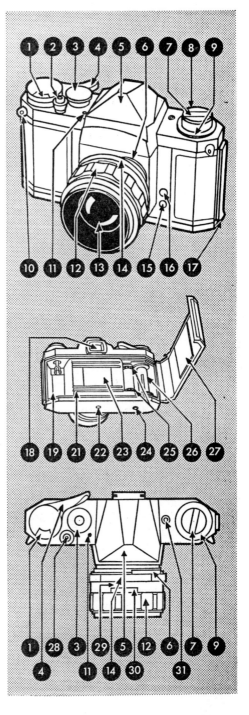

Here are the features and controls of the SIa and HIa Pentax cameras. Controls on Spotmatic camera are similar. See page **63** for special Spotmatic, Spotmatic II, SP500 and SL features. See page **65** for Pentax ES features.

1. Film counter.
2. Shutter release.
3. Shutter speed dial.
4. Rapid wind lever.
5. Prism housing.
6. Preview lever.
7. Folding rewind crank.
8. Rewind knob.
9. Film indicator.
10. Neck strap lug.
11. Shutter cock indicator.
12. Focusing mount.
13. Lens.
14. Diaphragm ring.
15. X flash terminal.
16. FP flash terminal.
17. Back lock.
18. Finder eyepiece.
19. Film chamber.
21. Film track.
22. Tripod bush or socket.
23. Focal plane shutter.
24. Rewind button.
25. Film sprocket drive.
26. Take-up spool.
27. Film pressure plate.
28. Shutter release.
29. Depth-of-field scale.
30. Focusing scale.
31. Film Transport indicator.

anti-reflection ribbing, larger instant return mirror, pull-up catch for swing open back, repositioned self-timer mechanism, larger shutter dial, larger rewind crank and many other improvements. However, most important is the incorporation of a behind-the-lens exposure meter system reading the illumination from the focusing screen. Standard lens is 50 mm. f1.4 Super Takumar.

Asahi Pentax SL. This is basically a Spotmatic without the metering system.

Asahi Pentax Spotmatic II. This model is very similar to the Spotmatic but is equipped with the new 50 mm. f1.4 or 55 mm. f1.8 Super-Multi-Coated-Takumar featuring a new multi-layered anti-reflection coating which increases light transmisson, reduces flare and internal reflections far beyond the ability of standard coatings. The camera also has built-on hot shoe atop the prism housing for cordless flash operation. The regular flash terminals can also be used. The contact on the hot shoe is always switched off except when a flash unit is slipped into the shoe, thus preventing any accidental shock. There's a ring switch underneath the rewind knob which allows you to switch the hot shoe from FP to X sync or vice-versa. Additionally, the ASA speed settings of the meter have been increased from a top of 1600 to 3200, the self-timer lever is easier to cock, there's a loaded film type indicator under the rewind knob and the takeup spool has been redesigned with sure grip slots.

Honeywell Pentax Spotmatic IIa. Available in U.S. and Mexico only, this model is same as Spotmatic II but has built-in Strobo-Eye electronic flash sensor for use with all Remote Auto-Strobonars made by Honeywell.

Asahi Pentax SP500. This camera is based on the regular Spotmatic which it closely resembles. However, it has no 1/1000 sec shutter speed and lacks a self-timer.

Asahi Pentax Spotmatic II Motor Drive. The motor drive camera is based on the Spotmatic and the system includes a wide variety of accessories. A full description is given on page 326 *et seq*.

Asahi Pentax ES. Completely new, fully automatic exposure camera with electronically controlled shutter. It offers automatic exposure through almost all Pentax Takumar lenses, past and present. It is so different we have devoted a full chapter to this camera on page 63 et seq.

PENTAX ACCESSORIES

The most important accessories are fully described and their operation explained in the appropriate chapters, but there are a few other extremely useful items of which you should know.

Right-Angle Finder

Although the Pentax does not have an interchangeable view-finder—because the designers feel that a fixed, fully-enclosed prism has closer tolerances and is more dust-proof—there is often a need for viewing at waist level. This is provided by a Right-Angle Finder which slides into grooves behind the pentaprism eyepiece and provides all the advantages of a waist level finder plus a few others. Not only does it produce a brilliant magnified image of the entire focusing screen for horizontal shots, it can also be swivelled around for waist level, vertical photographs. This can't be done with an ordinary waist level finger. The eyepiece of the finder is adjustable.

The Right-Angle Finder is especially useful for viewing subjects where it is inconvenient or even impossible to get behind the camera for ordinary eye level prism viewing. If you have the camera on a copying stand or are taking pictures on or near the ground, the finder is very convenient. It is also handy for candid photography. Since the finder operates at 90°, you can face in one direction but take pictures in another.

Focusing Magnifier

A somewhat similar accessory is the Clip-on Magnifier which also slides into the grooves behind the prism eyepiece. The Clip-on Magnifier, however, is a straight tube which must be used from the rear. It enlarges the already magnified finder image for critical focusing.

Copying Unit

For a light portable copying unit, there's the Copipod, con-sisting of four calibrated telescoping legs plus a lensboard

with adapter rings for 46 or 59 mm. lenses. It's contained in a flat leather carrying case. With the four legs fully telescoped, the Copipod allows the normal 55 mm. Takumar lens to focus at its closest 18 in. distance.

The Copipod is excellent for copy work when you are in a hurry. It's splendid for copying manuscripts or book pages (in a library, for instance). Don't use the Copipod with direct overhead light. If the light is overhead a shadow of the camera and Copipod will be thrown directly on the subject underneath.

Accessory Clip

The Accessory Clip slides into the grooves on either side of the viewfinder. It provides a shoe for various accessories such as small flash or electronic flash guns.

Leica Adapters

The Leica Adapter A fits Pentax bodies and permits Leica threaded lenses to be used on the Pentax. However, because of the great back focus distance of the Pentax (distance between camera body lens mount and film plane) Leica thread lenses will not focus to infinity and can only be used for limited close-up work.

The Leica Adapter B permits Takumar lenses to be fitted to equipment having female Leica threads. Takumar lenses can then be mounted on such equipment as enlargers with Leica-thread lens mounts.

Film Cassette

The Asahi Film Magazine provides the Pentax owner who wishes to load his own bulk film with a precision all-metal film cassette. It comes apart quickly for loading and yet snaps together positively to prevent accidental opening when loaded with film. The Pentax film cassette can also be used in other 35 mm. cameras.

Prescription Eyepiece

The Clip-on Prescription Eyepiece offers eyeglass wearers an eyeglass-correction holder mounted in a soft rubber eyecup. Any qualified optician can grind and place most eyeglass prescriptions in the eyeglass holder. However, even non-

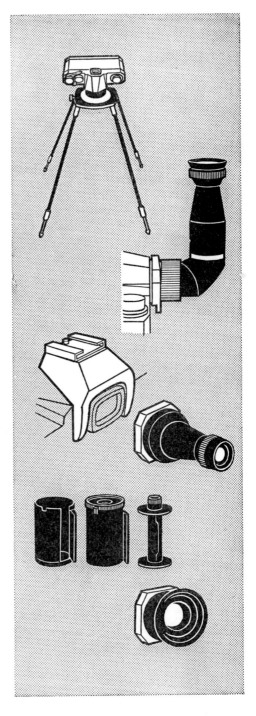

Copipod is portable copying stand with calibrated, telescoping legs and adapter rings for all normal focal length Pentax lenses. It can be dis-assembled and fitted into small pouch-type case.

Right angle finder allows Pentax to be used at low angles, for close-ups, on copy stands or other positions where it's inconvenient to view and focus directly through the prism finder.

Accessory clip provides shoe for mounting flashgun.

Magnifier offers 2X magnification for critical focusing.

Film magazine allows bulk film to be loaded into the Pentax without danger of scratching.

Prescription eyepiece provides holder for specially ground corrective lens. It also has a rubber eyecup to prevent extraneous light from entering eyepiece.

eyeglass wearers may find the all-rubber eyecup handy for eliminating stray light from the viewfinder.

Cable Release

The Cable Release is 10 in. long and has a special locking collar to allow time exposures.

Lens Cover

Rear Lens Covers are available to protect the rear of Takumar lenses when they are not attached to the camera. These simply thread directly on to the back of each lens.

Caps for the camera body thread into the front lens mount of the camera. Whenever the camera body is carried or stored without lens, the cap should be used to prevent dust, dirt or moisture from entering the camera body.

Self-timer

A self-timer is available for the earlier model cameras which did not have a built-in unit. The self-timer threads into the cable release socket of all models.

Mirror Adapter

A 90° mirror adapter screws into the front part of the 200 mm. $f3.5$ Takumar, the 200 mm. $f4$ Super-Takumar and the 300 mm. $f6.3$ Tele-Takumar. It contains a 45° reflex mirror which enables the user to "shoot round corners". The front of the adapter has a dummy lens. The viewing screen image when using this adapter is upright but reversed left to right. Maximum aperture is reduced to $f5.6$ and a slight increase in exposure is necessary.

Stereo Adapter

The Asahi Pentax Stereo Adapter set consists of the Stereo Adapter and Stereo Viewer. The Stereo Adapter fits the front frame of the Super-Takumar 55 mm lens for taking stereo colour pictures (reversal colour/colour slides). The Stereo Viewer is for viewing the stereo colour slides.

When using the Stereo Adapter with the Spotmatic, there is no problem in determining exposures as the Spotmatic reads the exact amount of light coming through the Stereo Adapter and the taking lens. When using this adapter with a non-TTL camera, open up the diaphragm by a half stop to give optimum exposure.

OPERATING THE PENTAX

Although the writers of instruction manuals which accompany cameras have the best of intentions, the writings and suggestions often leave much to be desired. While these booklets do form the useful function of getting a camera owner off on the right foot by showing him the controls and explaining how to operate them, they often do not give the hints and tips that only much use with a camera can reveal. If our suggestions here differ somewhat from those in the instructional booklets or the advice given by your camera dealer, please accept our apologies. We will attempt to draw on our years of experience in practical shooting with the Pentax and also the experience of many professional photographers who have been using it. Sometimes our ideas and the ideas of the instruction book won't coincide. In that case, you be the judge.

Holding the Camera

Let's start from scratch. How do you hold the camera? This might seem a very academic question. However, if you do hold the camera the way you see it held in the instruction booklets, you'll find that you must change hands continuously as you focus and then shoot. It is best to find one position which gives you a firm, shake-free grip that need not be changed while the camera is at eye level.

Unfortunately, users' physiognomies are different. The ideal shooting position for one user may not suit the next. The size of your hand, your nose, whether you are right or left eyed, right or left handed has much to do with camera holding.

Let's assume you have now read the instructions that came with your camera, you have tried all the controls, enjoyed yourself by trying to focus on everything in sight—in short given your camera a full dry run. Now you are ready to learn how best to use it. Here are a few camera holding

positions you should try. Adapt and alter whichever seems to suit you best.

This is a position that seems to work well with small-boned, right-handed, right eyed people, but it may still work for you if you don't quite fit into such a specialized category:

Place the camera on the palm of your left hand with thumb and forefinger grasping the knurled focusing ring. Grasp the right side of the camera with your right hand, keeping your thumb on the tip of the rapid wind lever and your right forefinger on the shutter release button. Draw your arms in towards your body and raise the camera to eye level. Use your left arm as the camera support and your right hand as the directional arm which points the camera. Focus with your left thumb and forefinger and press the shutter release with your right forefinger. If you are right eyed you should be able to focus, wind and release the shutter without shifting your hands. Find this awkward? Then try an alternative hold:

Instead of resting the camera in your left hand, grasp it firmly with your right directional hand, making this the support hand as well. Now grip the focusing ring between left thumb and forefinger but allow the camera body to leave your left palm. You can focus, advance and shoot now without changing finger position.

Here's a third alternative: Keep the grip on the camera with your right hand but turn your left wrist around so you are now grasping the focusing mount with your left thumb and forefinger but from above the lens instead of below. Again try operating all shooting controls without changing your grip.

One of these positions should do the trick for you. If you are left-eyed, you will have to move the camera slightly from your face when winding film and shutter in order to clear your nose.

Why are the three positions of holding the camera listed in the order given? Because the first is the most stable—with one hand acting solely as camera support; the second the next stable with the working hand holding the camera but the left hand offering two-point support from below. The last position, gripping the lens from above with the left thumb and forefinger obviously offers less stable support.

With any position, however, try to press the camera to

HOLDING THE PENTAX

While there are count-less ways that the Pentax can be held, here are several tried and true methods. Adopt or adapt the one best for you.

Cradle Pentax on palm of left hand with thumb and forefinger operating focus-ing mount. Use right hand to direct camera, release shutter.

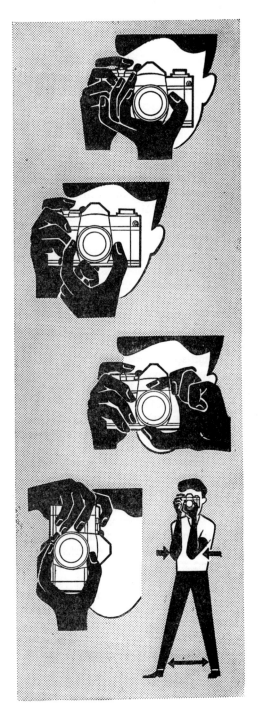

Hold camera with right hand. Grab focusing mount between thumb and forefinger.

If neither of the first two methods suits you, try holding camera in right hand, grasping focusing mount between thumb and forefinger of left hand at right angles to the camera.

For verticals, cradle end of Pentax in palm of left hand, grasp focusing mount between thumb and fore-finger. Use right hand to direct and steady Pentax, release shutter.

Far right is good solid stance for steady picture taking. Place feet com-fortable distance apart, draw elbows into body for maximum support.

your forehead for additional support. Of course if you wear glasses this is not possible.

While one of the three positions will probably suit you for shooting horizontal pictures, you'll also want to take vertical pictures. The best position evolved by professional photographers is to cradle the left side of the camera in the palm of the left hand. Grasp the focusing ring with the thumb and forefinger of the left hand. Now bring the right hand over the right side of the camera so that the thumb hits the end of the rapid wind lever and the forefinger is over the shutter release. Again, this will allow you to focus, view, shoot and advance film without changing your finger position.

Focusing

Now let's try focusing with your new position. You will find that you cannot possibly turn the focusing ring the full 270° from nearest focusing to infinity without moving your focusing thumb and forefinger several times as you twist the focusing ring. However, you will find that most subjects do stay within certain focusing zones—portraits from 18 in. to six or so ft., middle distance scenes from 6 to 25 or 35 ft. and scenics or landscapes between 35 ft. and infinity. Therefore once you have the general range of your subject material you will be able to take one grip on the lens mount and not be forced to alter it as your subject moves back and forth.

Now let's try focusing on some objects outdoors or in your own room. Don't pick out a book jacket or a picture on the wall. These are easy to focus and are on a single plane. If you intend to use your camera mostly for copying work, this will do nicely, but if you intend to photograph three-dimensional objects by all means try to find a willing one, animate or inanimate. Of course, a human being is ideal.

Although you will probably want to use your camera under all lighting conditions, first practice under fairly good light. Practice and experience will inevitably allow you to focus with almost equal facility under more trying lighting conditions.

Unless you happen to hit on the exact focusing distance, the scene in your finder will look rather blurred, indicating that it is out of focus. Take a picture in this manner and you'll get almost the same blur as you see—almost because if you use a smaller lens aperture than maximum aperture for

shooting you will achieve slightly better sharpness even for out-of-focus images. We'll see just how this works and how we can put it to use later when we investigate depth of field (see page 230).

Now as you move the focusing ring back and forth, you'll note that the image seems fuzzier when you twist the ring in one direction and sharper as you move it in the other direction. Keep moving it towards the sharpest image. Some years ago there was much controversy over whether it was best to move the focusing ring swiftly or slowly. It was difficult to decide on the exact point of sharpest focus. With the microprism focusing aid this is no longer a problem. You can move the focusing ring as slowly and precisely as you wish. When the image you are focusing upon is in correct focus, you will see it "snap" into absolute sharpness. When the image is out of focus it will seem to shimmer and appear blurred and broken up into small pieces. When it stops shimmering and becomes one single needle-sharp object you have pinpoint sharp focus.

What should you focus on? We'll discuss this later when we examine how to photograph various types of subjects. Right now, just focus on whatever is the most important element in your picture. In a portrait, focus on the eyes. In a landscape, focus on the principal point of interest.

Releasing the Shutter

Now that your camera is pointed at the subject and you have achieved sharp focus, let's release the shutter. Releasing a shutter properly is akin to firing a pistol or rifle on a firing range. It must be so gentle and so easy that the camera is not jarred at all. If someone is watching you shoot, he should not be able to see any indication that you are actually taking the picture. Only your slightly arched right index (or middle finger if you find it easier) should move. And it should move so slowly and smoothly that it's undetectable.

Although there has been much talk in the past about whether it's best to hold your breath when shooting or whether you should take a deep breath and then let out some of it, most such talk is academic. As more and more pictures are taken of subjects in action, and more and more depends on the instant when the subject is ready, it becomes evident that the photographer rarely has the advantage of

dictating the exact shooting moment. Therefore he must be ready at all times, breath and all. Many professional photographers allow themselves to breathe easily—perhaps more slowly than usual so that their chests won't cause the arms supporting the camera to move any more than necessary. At the moment of exposure they merely freeze their breath control, whether inhaling or exhaling, while the shutter release is pressed. After shooting, they resume regular breathing.

How should you stand to take a picture? With your feet spread out a comfortable distance to give yourself a good solid support. Remember you may want to swivel your body to follow a subject, point your camera up or down, lean slightly one way or the other. Adopt a stance which will allow you to do all these things without changing foot positions. After a while, this will come to you naturally.

Now squeeze off a few pictures, changing subjects several times. From here on, proficiency in focus and ability to hold a camera steady depend on practice. You now know all there is to it mechanically. If you think that steadiness and precise focus are not important at all times remember that most unsharp pictures taken at all speeds and lens openings are generally the result of camera unsteadiness and improper focus, not subject movement.

Setting the Controls

Let's get acquainted with the other external controls, the shutter speed dial and aperture ring. In order to set these, you must bring your camera down from eye level so you can see the speed dial and aperture ring on the lens. Of course with the Spotmatic models or SP500 you can adjust controls while looking through the finder. With the Pentax ES, the camera is fully automatic and you need only set the aperture control. The metering system will set the speed.

With other Pentaxes you will want to set controls in the fastest and most convenient way possible. Here's how many professionals do it. If you bring the camera down from your eye still grasped in right and left hand, move your left thumb and forefinger from the focusing ring closer to the body where you can grip the aperture control ring. Then move the right thumb and forefinger so they are gripping the shutter speed dial. You can now set the two controls almost simultaneously. However, you can hold the whole

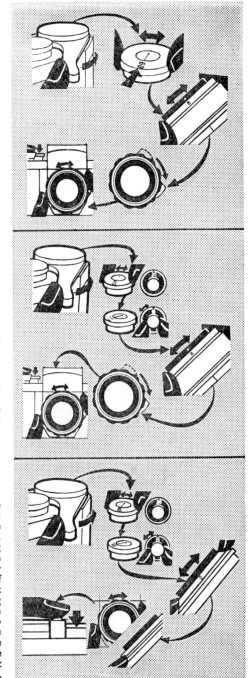

When shooting with the Pentax H2, advance film and wind shutter with single stroke of rapid wind lever. Set shutter speed dial, select shooting aperture by turning click stop aperture ring. Pull down cocking lever to open lens to full focusing aperture. Focus Pentax H2 and shoot.

When shooting with the Pentax K, advance film and wind shutter with single stroke of rapid wind lever. Set shutter speed using fast speed dial on top of camera or slow speed dial on front of camera. When using slow speeds, top dial must be set to 30. Select shooting aperture by turning click stop aperture ring. Pull down cocking lever to open lens to full focusing aperture. Focus Pentax K and shoot.

When shooting with the Pentax S, advance film and wind shutter with single stroke of rapid wind lever. Set shutter speed using fast shutter speed dial on top of camera or slow speed dial on front of camera (with top dial set at 30). Select shooting aperture by pushing in and turning click stop aperture ring. Open lens fully with rear aperture ring. Focus lens. Close down aperture to preset stop. Press shutter release.

camera in one hand and set all controls with the other but this does slow up camera operation. Caution: it's best to set the aperture ring from underneath so that you don't move the preview lever by error.

Aperture setting is easier than on lenses of different makes. All Takumar lenses have diaphragm scales turning in the same direction. Note that you can set Takumar lens apertures not only on the marked settings but also on the in-between dots which indicate half full f-number settings. This allows the Takumar lenses to be set with far greater exposure accuracy than lenses with only full f-stop markings. You'll also note that all settings are click-stopped—that is they have small click detents which prevent the settings from changing after you've set them. This also is true for the shutter speed settings. The shutter speed dial can also be continuously turned in any direction to move to the proper shutter speed setting. With many other cameras, you must either always move the shutter speed dial in one direction or you may find that you cannot turn the shutter speed dial continuously.

Carrying the Camera

We've been discussing camera holding with the bare camera. While the camera is certainly easier to hold with no case, most users will want to shoot pictures with the case on so that the camera will receive maximum protection. There are two distinct types of camera case. Both allow the owner to use the camera without removing it from the case. Both are furnished with sturdy neckstraps. The strap for the soft ever-ready case fastens to the split rings attached to the eyelets of the camera. You can remove the case for film loading without taking off the neckstrap. The neckstrap remains on permanently.

The advantage of a permanent strap is obvious. Whenever the camera is in use, with case or without case, you can have the strap around your neck to protect the camera from slipping from your grasp. This is a design Asahi pioneered. The hard leather case has a strap attached to the case itself.

This most common case furnishes the best protection for your camera. It consists of a camera body holder with tripod anchor screw and a front and top flap which can be unsnapped and lowered for picture taking. On some cases, the front flap can be snapped off completely for convenience. On

PENTAX CARRYING CASES

Collapsible soft case allows neckstrap to be fastened to camera body lugs. Removable front and top piece can be crushed and stuffed handily into a pocket.

Hard leather case furnishes more protection, has its own neckstrap attached to sides of case. Bulkier front and top piece is usually removable but is not collapsible.

Hard leather cases and some soft leather cases are fastened to camera by tripod anchor screw on bottom of case body. Some soft leather cases however have snap strap over top of camera between prism housing and rewind knob.

If desired, most front and top pieces of cases can be removed by turning them so that they disengage from slotted swivel snap.

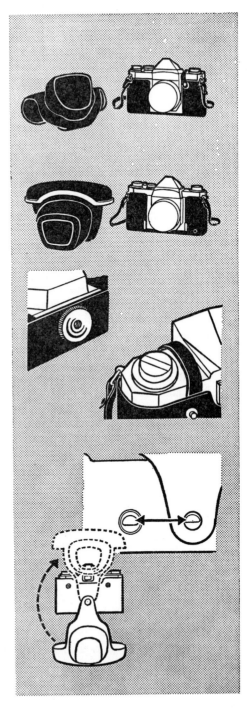

others the front flap swivels around when lowered but is non-removable. With the non-removable front flap, be careful when shooting not to allow the flap to obscure the lens partially. Although you may not notice it through the view-finder, a tiny edge of the case front covering the lens can cause a blur over part of the negative image.

In attaching the camera to the case make sure the tripod screw is attached securely.

However, the case most favoured by professionals and advanced amateurs is the soft leather carrying case. The case is in much the same style as the hard leather but the soft leather is pliable. The front and top cover can be removed and stuffed into a pocket easily. The leather is thinner and thus the camera in the case is less bulky. Instead of a tripod screw, some older Pentax models are held in the case by a short strap and snap fastener across the top of the camera housing. This works quite well.

Some neckstraps are adjustable and some are not. If you have an adjustable strap, it's advisable to keep it fairly short so that the camera will rest on your chest when you're not shooting, not on your stomach. This length is also best for carrying the camera over your shoulder since your arm and elbow will serve as protection for it. When you turn there is less danger of the camera swinging out with considerable force and being damaged by hitting something. The shortened strap also allows you to use the strap for additional support when shooting. You should be able to wrap the strap around your arm and wrist until it pulls tight and helps hold the camera at eye level.

Loading the Camera

Now let's see how to load the camera with film. There are many ways that this can be done. Here is the technique we've found most efficient and foolproof. Open the back of the camera. This can be done on older models by pulling down on the sliding latch on the left side of the camera. On the more recent Pentax cameras, simply pull upwards on the rewind knob.

Then pull upwards on the rewind handle so that the film cassette can be dropped in the empty film chamber with the film end (the leader) lying across the film channel left to right. Now hold the camera so that the end with the empty

TELE PORTRAITS

Page 41. A long lens is good for portraiture provided you employ a fast shutter speed to minimize camera shake. M. Kondo used a fast film and 1/500 sec. at $f/4.5$ with his 300 mm. $f/4$ Takumar.

Page 42. With this equipment M. Kondo took another portrait.

INDOOR STUDY

Page 43. Bounce light on a backdrop was used by Glavco Cortini.

PEARL DIVER

Page 44. Compare her torso and foot to see the distortion used by K. Toshida for this effective shot.

FROZEN TEAR

Page 45. In order to use 1/500 sec. speed Ong Kim Leong used maximum aperture $f1.8$, and focused precisely on the tear itself.

MAKING BACKGROUND COUNT

Page 46. Backgrounds are often best out of focus, but this straw hut was essential to Vic Franzoni's study of mother and child.

LONG LENS FOR ANIMALS

Page 47. A long lens is helpful in bringing animals close when you cannot approach them yourself. K. Suzuki used a 200 mm. Takumar.

QUICK CANDID

Above. The automatic diaphragm is ideal for grabbed shots. Joseph C. Collins used his 55 mm. Super Takumar with 1/125 sec. at $f/11$.

film chamber is pressed toward your body, the prism housing is at the left and the open back cover is away from you. Draw sufficient film from the 35 mm. cassette so that you can easily slip the end of the leader into one of the slits in the take-up spool. Push the leader end in as far as it will go.

Now advance the film by alternately winding with the wind lever and releasing the shutter until the take-up spool tightens the film leader across the sprocket wheel. Make sure the sprocket teeth engage the sprocket holes. With the thumb of your right hand turn the take-up spool by its milled edge until the film is tightly wound on the spool. Close the camera back.

Before advancing film to the first exposure take this little precaution used by almost every professional photographer: once the back is closed, take up the slack in the film cassette by rewinding the film until it is tight. Use the folding rewind crank to do this. You can then use the rewind knob as an indicator that the film is properly threaded in the camera and is actually advancing. Every time you wind the film and shutter using the wind lever, the rewind knob should also turn. If it does not, film is not travelling inside the camera body. This means that the film leader has probably slipped out of the take-up spool slot.

Now you're ready to advance film for the first picture. Except on early models, you need not set the frame counter. When you close the camera you will see that the frame counter on top of the wind knob registers at two dots before zero. Advance the film by winding the lever and releasing the shutter three times—until you reach the first vertical line after the zero marking. You are then ready to take the first exposure.

With earlier models having no automatic frame counter, loading is exactly the same. However, when you close the camera back and take up the slack with the rewind crank, advance the film using the wind lever and shutter release three times. Then turn the frame counter with your fingers to the No. 1 marking. From this point on, both auto resetting and manual frame counters will register each exposure automatically as the camera is wound.

You can always tell when the shutter is wound and ready for an exposure. There's a small indicator hole adjacent to the shutter speed dial. When the indicator inside is red, the

camera is ready for shooting. When the indicator is blank you must wind film and shutter before taking a picture.

Unloading

After the last exposure—12, 20 or 36, depending on the length of the film you're using—you must rewind the film into its cassette. Do not open the camera until the film is rewound or the light will get at it and ruin your pictures.

Many people find that they can actually make one or even two additional exposures on a roll of film provided they have loaded the camera carefully. It is quite all right to try this provided you are careful when winding the film. After the last officially indicated exposure (12, 20 or 36) wind the film and shutter with the wind lever very gently and carefully. Stop instantly if you feel any additional tension on the wind lever. Tension indicates that you have reached the end of the roll. Don't force the lever further or you may cause the film to detach itself from the cassette spool. If this happens you will have to unload the camera in complete darkness or ruin your entire film. However if you're careful you should be able to squeeze out at least one additional exposure on nearly every roll of film.

To rewind the film, press in the small button on the bottom of the camera, unfold the rewind crank and turn it in the direction of the arrow on top of the rewind knob. It's advisable not to rewind too swiftly or you may generate some static electricity on the film which could cause static markings. However, you should still be able to rewind a 36-exposure roll within about a 20-second period.

There has been much discussion as to whether the film should be wound back into the cassette completely or whether the leader end should stick out as it did before shooting. Most professionals prefer to wind the film into the cartridge completely so that the film cannot be mistaken for an unused film. You can rewind it either way quite easily. While rewinding, put your ear close to the camera. Listen carefully. You will hear a pronounced click and feel less tension on the rewind crank as the film leader is at last pulled free from the take-up spool.

If you want the end of the leader to stick out, remove the film immediately at this point by re-opening the back of the camera, pulling upwards on the rewind knob and turning

LOADING THE PENTAX

Pull down latch on left side of camera with your finger. Back will swing open.

Pull up on rewind knob and insert film cartridge into chamber. Return rewind knob to original position after inserting cartridge.

Thread film leader into take-up spool slot. Push end in as far as possible.

By operating rapid wind lever and releasing shutter, wind on film until full width of film lies over sprocket wheels and sprocket holes on both edges engage sprocket wheel teeth.

Close back. Push latch back to original position, if necessary.

With wind lever and shutter release, advance film until frame counter on wind lever hub registers first indicator line after 0.

On older Pentaxes without auto resetting frame counter, close camera and advance film three frames. Then turn frame counter dial to first line after 0 with finger.

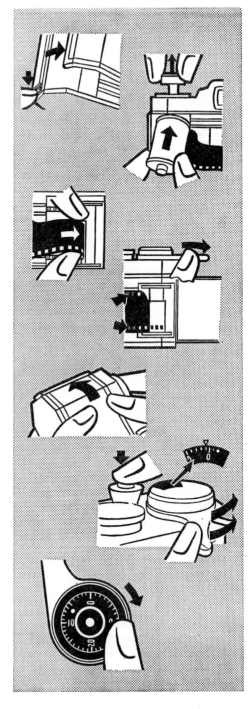

the camera so that the film will drop into your hand (which is easier than keeping the camera right side open and trying to pick the cartridge out with your fingers). If you want to wind the film all the way back into the cassette, just continue rewinding after the leader has pulled loose from the take-up spool. When there is virtually no more tension on the rewind crank as it revolves, the film has been completely withdrawn into the cartridge. Open camera back and remove film.

Pentax Data II

Asahi makes a specialized data recording Pentax camera with a watch built into the detachable back. Not only the time and date but also written data can thus be recorded on negative or transparency in the upper left hand corner of the picture. Here's how you operate its special feature:

Before loading, open camera back, pull down light shield in lower right hand corner to block picture image from data area. Remove watch from battery housing cover by turning handle counterclockwise. Watch should be stem wound (it lasts for 24 hours). Pull it out to set time and pull it further to set date. Centre-of-dial has white surface to write day, year or other data with lead pencil (which can later be erased). Replace watch, load film and close camera. Plug connecting cord from data housing into either camera body sync. socket. When you make two blind pictures to get frame counter to 1, pilot light atop housing indicates that circuit and battery are all right. Pilot light goes on during each exposure.

Use ASA ring atop housing to set film speed. Employ white scale for black and white film, orange for colour. ASA range is 50 to 400 for black and white; 100 to 800 for colour. You can check condition of Ever Ready 544 6 v silver battery alone by pushing battery check button on left side of housing. If there's no light, replace as indicated under battery housing cover on bottom of recorder housing.

There's a special out power connector cord and battery box for use in temperatures under $-5°$ C. Keep battery warm by placing box in your shirt pocket. A special soft leather ever ready case is available to accommodate the Data II camera with recording unit in place, but the camera back is removable and can be replaced with standard camera back or 250-exposure back for Pentax Motor Drive.

When not using the data recording feature, remember to push light shield behind focal plane shutter upwards, out of way.

OPERATING THE SPOTMATICS, SP500 AND SL PENTAXES

The original Spotmatic which is 3/16 in. taller and but 3 oz. heavier than previous Pentax cameras remains the foundation of the line. It was joined by the Pentax SL which uses the same body construction and operational methods but lacks the metering system. This camera was designed for those who still prefer a separate meter or who own more than one Pentax and feel it is sufficient (if not convenient) to have but one behind-the-lens meter camera.

The SP500 is precisely the same as the Pentax Spotmatic except that it has no top 1/1000 sec. speed and has no self-timer—an economy camera at a slightly lower price. The Spotmatic II is virtually the same camera too but it has a hot sync shoe atop the prism housing and was the first Pentax equipped with the Super Multi-Coated Takumar lens as standard equipment. With its introduction many people began calling the original Spotmatic the Spotmatic I to distinguish it from the Spotmatic II. In the United States Honeywell introduced a slightly different version of the Spotmatic II called the IIa which has a special electronic flash sensing device which we'll discuss later.

However for the purposes of camera handling, all Spotmatic cameras and the SP500 have metering systems which operate in the same manner while the SL model's controls, except for the meter, are the same too. For simplification we'll refer to all as Spotmatics in this chapter.

Hidden within the Spotmatic (but not the SL) body, at either side of the finder eyepiece are two small highly sensitive cadmium sulphide cells which accurately measure the light transmitted through the prism from the surface of the Pentax focusing screen. These cells are connected to a mercury-battery-powered electrical circuit. By setting the proper shutter speed and aperture combination to centre a needle within the Pentax finder, the proper exposure can be obtained for any subject to be photographed—with normal lens, accessory lenses, scientific instruments, bellows, micro-

53

scope or telescope. Here is how you operate the Spotmatic cameras (SL owners can follow the same steps except for instructions concerning the metering system):

Loading the Camera

Film is loaded precisely as previously described for older models with a single exception. To open the camera back of the Spotmatic, you need not pull out a side hinge. Instead, just pull up smartly on the rewind knob and the back will automatically swing open.

Opening the back also resets the frame counter to –2. When the rewind knob is pushed down again, you can close the back and advance film by alternately winding film and shutter and releasing the shutter until the first line after the zero appears in the frame counter (within the hub of the wind lever). This line indicates that you are ready for your first exposure. The frame counter will now continue to indicate the number of frames used and will change numbers every time film and shutter are wound.

To make sure that the camera is properly loaded and that the film is travelling through the camera correctly, tighten up the slack film using the folding rewind crank and turning it in the direction of the green R. Every time you advance film with the windcrank, the rewind crank should also turn, indicating that the film cartridge is paying out film.

Incidentally, take advantage of the film reminder dial around the rewind crank. Set it to "empty", "panchromatic", "colour daylight" (with the small sun) or "colour tungsten" (with the small bulb). The Spotmatic II reminder dial is slightly different from that on the Spotmatic I. Instead it has 20 and 36 exposure indicators in green (for tungsten type colour), white (black and white film), orange (for daylight type colour) and EMP for empty.

Checking the Battery

First, make sure the camera's mercury battery which powers the metering system is installed and working. Turn the camera over and look at its bottom plate. You'll see a small circular cover with a fairly wide slit. Use the edge of a coin in the slit to turn the cover in the direction of "open". If there is no battery underneath look for it in a small envelope packed with the instructions of the camera or in a separate small pocket in the top of the carrying case.

SPOTMATIC, SP500 AND SL FEATURES

Here are the controls for the Pentax Spotmatic, SP500 and SL cameras.

1. Film counter.
2. Shutter release.
3. ASA film speed window. (Spotmatic only.)
4. Rapid wind lever.
5. Hot sync shoe (Spotmatic 11, 11a only).
6. Preview lever.
7. CdS meter switch (Spotmatic only).
8. Focusing scale.
9. Rewind knob and crank.
10. Shutter speed dial
11. Self-timer lever.
12. Rewind button.
13. Tripod bush or socket.
14. Lens.
15. Focusing mount.
16. Battery cover (Spotmatic only).
17. Flash terminals.

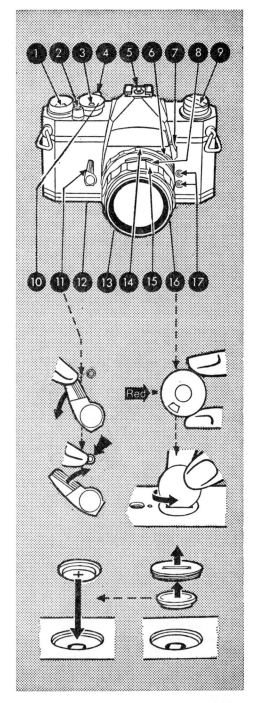

To operate self timer push self timer lever counter clockwise. To start self timer push button shown.

To check the Spotmatic's battery life, turn shutter speed until its tiny index window shows red. Turn on meter switch and view through finder.

If Spotmatic needle drops rapidly, battery is all right. If not, replace battery. Remove bottom cover by twisting coin in cover slot. Take out old battery. When inserting new battery, make sure that the plus side (+) is down towards camera.

Insert the battery with the small + downwards, away from the cover. Refasten the cover securely. The battery under normal circumstances will last up to two years, but it is advisable to check it occasionally.

Mercury batteries, unlike the standard alkaline cells used in flash and flashlights do not become weak slowly. They maintain power almost to the end of their life and then die quickly. To check battery set the shutter speed dial at B and the film speed indicator at 100. Press upwards on the SW switch to turn on the meter circuit. If the battery is all right, the needle should fall rapidly towards the − (minus sign). If the needle is anywhere near the centre, the battery should be replaced. For replacement use a Mallory RM400R or equivalent. To be safe keep an extra battery in the compartment inside the top of the camera case.

Next, set the ASA film speed index in the small window within the shutter speed dial. Just lift up the outer rim of the speed dial and turn this outer rim until the proper ASA index for the film being used appears opposite the red marker in the window. Then let the ring snap back to its original position.

Using the Meter

The Spotmatic or SP500 exposure meter measures the brightness of the entire ground glass. Therefore it should not be used until you have focused your subject accurately on the ground glass. To turn on the meter, press upwards on the small lever marked SW at the left hand side of the camera. The metering circuit is now "on" and the lens diaphragm closed down to whatever aperture you have set.

The metering system can be operated in either of two ways. You can set the aperture you wish and then turn the shutter speed dial to reach proper exposure or, in reverse, set the shutter speed you desire and then change aperture to reach proper exposure.

No matter which method you use, the general technique is the same. Look through the finder. At the right of the picture area you will see a small vertical cut out section with a + at the top and a − at the bottom. A needle can be seen travelling within this area. Rotate either shutter speed dial or aperture ring until the needle is exactly centred between the lips of the small opening. If the needle swings upwards towards the

POSTMATIC METER SYSTEM

Here are the electrical and optical parts of the Pentax Spotmatic exposure system.

1. Ground glass.
2. Variable resistor.
3. Ground glass mask.
4. Pentaprism.
5. CdS cells.
6. Eyepiece.
7. Semi-fixed resistor.
8. Lens.
9. Diaphragm blades.
10. Rapid-return mirror.
11. Fresnel lens.
12. Galvanometer.
13. Switch.
14. Mercury battery.

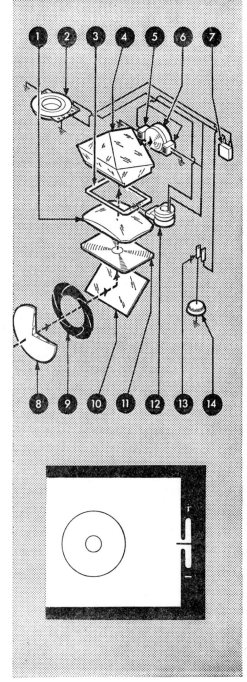

When shutter speed and aperture have been set correctly for the proper exposure, the meter needle is centred exactly in the dot within the viewfinder.

+ it indicates that you will be overexposed. If the needle swings downwards towards the –, the picture will not get sufficient exposure.

There are limits beyond which the meter needle cannot be made to centre properly. If you look carefully at the small triangular indicator of the shutter speed dial, you will see that it changes colour as you turn the dial itself. When the indicator is black, the meter is operational. When the indicator turns red, the meter is not operating within its limits. Check the extent of these limits in the Facts and Figures section in the back of this book for full particulars as to what settings can be used and which ones cannot. You will see from the table that if you have an ASA 100 film you can use any shutter speed from 1 sec. to 1/1000 sec. in combination with any aperture that will centre the needle properly. The total range of the aperture settings possible depends on the lens being used. Note however that there is an area of exposure from ASA 400 to 3200, from B to 1/4 sec. which cannot be used even though the shutter speed indicator may not turn red.

Notice as you change the aperture setting to centre the meter needle that the view through the finder dims. This is caused by the actual lessening of transmitted light. After obtaining proper exposure by centring the needle you can either immediately take the picture (if you are sure of your focus) or push down the SW switch on the side of the camera. By pushing the switch down, you automatically turn off the exposure meter circuit and again cause the lens aperture to reopen fully for maximum focusing brightness and shallowest viewing depth of field. You can then refocus and shoot knowing that the camera is properly set for the right exposure.

If you decide not to reopen the lens but instead to shoot the picture while the meter circuit is still on, you need not worry about turning off the meter circuit afterwards. When you press the shutter release, the circuit will automatically cut itself off, the SW switch will return to "off" position and the lens will reopen to full aperture after exposure. To check exposure for your next picture you will have to press the SW switch upwards again.

The SW switch should not be kept on unless you are actually making a meter reading, Leaving the switch in the

OPERATING
THE SPOTMATIC
AND SL

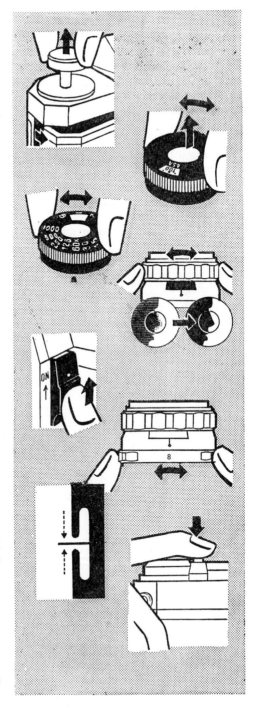

To open camera back for loading, pull upwards sharply on the rapid rewind knob.

To set film ASA index for the Spotmatic's meter system, pull upwards on outer ring of shutter speed dial, turn until proper ASA index appears in cutout window, then let ring fall back into place.

Set shutter speed by turning shutter speed dial in either direction.

Turn focusing mount until image becomes sharp on microprism grid and surrounding fine focusing collar.

Turn on Spotmatic's meter circuit by pushing upwards on meter switch.

While looking through viewfinder, turn aperture setting ring until meter needle within finder is centred.

Press shutter release to take picture.

"on" position causes loss of mercury battery life. You can tell whether the Spotmatic I's meter is on by looking at the SW switch. If a small red dot indicator is showing on the switch, the meter circuit is in operation. If there is no red dot, the meter is off. Of course you can also tell by looking through the finder to see whether the needle moves from the zero point when you aim the camera at a bright light source.

On some early models the meter needle remained in the central position when the meter was switched off. On current models the meter needle position is towards the minus mark when the meter is switched off.

Special Subjects

While the two cadmium sulphide cells reading the focusing screen will generally give you an accurate exposure meter measurement for both your colour and black-and-white work, some reasonable thought must be given to special picture-taking situations in which an overall integrated exposure may not be best.

When some specific part of a subject within the picture frame is of prime importance, and this area is of a brightness different from that of the rest of the picture area, a special exposure reading technique must be used. Instead of taking a reading from camera position, approach closer to your subject so that only the area of importance is visible through the finder. Make a proper exposure reading by centring the needle while viewing the subject from this close-up position. Then return to your regular camera position and make your picture using the same exposure you obtain when close-up.

Quite often it will not be possible for you to approach close to your subject. In such cases, you can make a substitute reading from a subject closer at hand which is in the same light as the subject. For facial tones, the palm of your hand makes a good substitute. Just be certain that it is in the same type of lighting as the real subject.

Because the Spotmatic meter reads through the lens, you can use this ability to advantage to make a precise close-up reading from a distance if you have a longer than normal focal length lens. Instead of approaching closer to your important subject area, change to a longer lens which just frames the important area. Now take a meter reading and

set your camera accordingly. Then change back to the shorter focal length lens.

The behind-the-lens meter reading system works equally well for any lens or accessory to which the camera is attached. For instance, the metering system will instantly tell you the right shutter speed for any bellows extension and close-up lens, for a microscope or telescope. As you change the aperture of your accessory, the meter will also change its reading. Then you can recentre the needle to the correct exposure by turning the shutter speed dial.

When shooting small objects at close distances or when you use the Spotmatic cameras for astro-photography, some additional thought must be given to altering the exposure. The main subject may be only a small part of the whole picture area and may differ in brightness. If it is darker than the rest of the picture you must give more exposure than the meter recommends. If it is lighter, you give less. The amount by which you open up or stop down your lens must depend on individual circumstances. Sometimes it may be possible to take a close-up reading from a substitute object similar in tone but even that can never give a completely reliable reading. It is advisable to make two or three exposures around the estimated correct one.

There is one danger which you should avoid for most accurate exposure readings. The two meter cells face forward to read the light coming through the lens via the mirror and the pentaprism. But a certain amount of additional illumination can also enter the finder system through the eyepiece. This is particularly true if the major illumination for the picture is exceedingly strong and is right behind the photographer. Quite often this light is brighter than the subject itself.

If the photographer does not keep his eye as close as possible to the eyepiece, thereby excluding extraneous light, an inflated meter reading can result. This does represent somewhat of a problem for eyeglass wearers who cannot get their eye right up to the finder window. Moreover, eyeglasses themselves may pick up additional light and transmit it through the finder. Eyeglass wearers may eliminate this if it becomes a serious problem by using the Pentax clip-on prescription eyepiece. This consists of a rubber eyecup and a small lens adapter. The eyepiece can be slipped over the

finder window. For best results, however, eyeglass wearers should have their eyeglass prescriptions ground to fit the small adapter ring of the clip-on eyepiece. Opticians can accommodate eyeglass wearers in this manner if the clip-on eyepiece is brought to them. You can then have your exact prescription mounted in the eyepiece. Whenever it isn't needed, of course, the eyepiece and eyecup can be slipped off the camera instantly.

The Honeywell Spotmatic IIa

As mentioned before, the Spotmatic IIa is identical in all features to the Spotmatic II except that it has a Honeywell Strobo-Eye remote sensor for automatic electronic flash built right into the side of the camera. The sensor automatically measures the light reflected from the flash and turns off the flash when the required amount of illumination has been reached. Unlike other automatic flash systems it can be used for on or off camera flash or bounce flash. Here's how you operate it: Connect a standard PC flash sync cord to the Remote Honeywell Auto/Strobonar and to the cameras's X sync terminal or flash sync shoe (with the control set for X sync). After pulling up the rewind knob, set the inner dial around it to the film's ASA index (ASA 25 to 400). For any automatic flash unit you have a choice of three possible apertures with any given film. Turn the outer dial until the ASA index is opposite the range indexes and note the aperture recommended. The triangle index mark indicates the largest aperture of the range, the circle, the middle aperture while the square represents the smallest aperture. The smaller the aperture used the shorter your maximum automatic exposure range. You can check the range with the dial on the back of your electronic flash unit. When in doubt you can test flash the unit. A green light will go on if you are in proper range. Although the ASA film speed dial only goes up to 400, you can use faster films. If the film is double speed (ASA 800), set the dial to 400 but use apertures one f-stop smaller than is indicated. For an ASA 1600 film, you would use apertures two f-stops smaller than indicated. This new Strobo-Eye system has been designed to work for present and all future Honeywell Strobo-Eye-capable flash units.

OPERATING THE PENTAX ES

It is quite true that there have been fully automatic single lens reflexes before the Pentax ES—in fact, quite a few. However, the Pentax ES is a far more advanced camera than any of these. While other camera makers have employed all sorts of complicated gearing and levers to provide automatic exposure, the Pentax ES is the first electronically controlled SLR camera in which the exposure is fully determined by a through lens meter which sets the correct shutter speed by means of highly accurate, shockproof, integrated circuitry.

The integrated circuits for automatic exposure control enable the whole electronic shutter system to withstand difficult temperature variations from −20° to +50°C, and make it more reliable. Moreover, unlike other automatic single lens reflexes, the Pentax ES does not depend on a single set of specially-made lenses for automatic exposure. Literally any lens or lens accessory that you fit to the camera from a high magnification microscope to a super long telescope can produce the same accurate, fully automatic exposure as the camera's regular lens equipment. The meter system has no mechanical exposure limits. It can operate at any ASA index from 20 to 1600 and deliver proper exposures automatically at all apertures and shutter speeds, provided there is sufficient light for at least an 8-second exposure.

Basically, the camera body resembles the Spotmatic II, with all controls in approximately the same place and operation in the same manner. The ES has the same screw thread mount. But before we do anything else we have to insert the 6-volt silver oxide cell in the battery housing. Unlike the Spotmatics or the SP500, which have battery housings on the bottom, the Pentax ES battery housing is on the left front of the camera (as you hold it facing you), close to the lens mount. Unscrew the cover of the battery housing and insert the battery. Make certain you get it in properly, with the minus terminal pointing inward.

How the Pentax ES works

Now hold the Pentax ES to your eye. If you've used other Pentaxes, you'll immediately notice the main difference in the viewfinder. At the right edge of the finder, running vertically, is a shutter speed scale from 1 to 1/1000 sec., plus a black meter needle. Although you will actually be setting your aperture on the lens first, the scale will always keep you informed as to what shutter speed the meter is setting. To see how it operates, first set the proper ASA film speed of the film you will use in the small white cutout window surrounding the rewind knob. By lifting up on the outer rim collar of the rewind knob mount you can then turn the collar in either direction until the proper ASA film speed appears in the window. Then allow the rim to drop back in place. Next, turn the shutter speed dial until the red arrow marked "Automatic" is opposite the indicator mark next to the dial on the top of the camera.

Now point the camera at a fairly bright subject and depress the shutter release ever so slightly. The meter needle will descend on the scale and indicate the shutter speed which will be set for the lens opening you are using. Owners of Pentax Spotmatics or SP500 cameras will notice another important difference of the Pentax ES. Unlike the Spotmatics or the SP500, the Pentax allows you to view, focus and use your meter at full lens aperture—the brightest image possible.

If you want a slower or faster shutter speed, turn the lens aperture ring to a larger or smaller aperture and you'll notice that the meter needle will change position appropriately on the shutter speed scale in the viewfinder. However, the meter needle will respond much faster if you take your finger off the shutter release momentarily while changing aperture and then press the release again.

You may wonder why the meter needle within the viewfinder sometimes rests between marked shutter speeds. The speeds which are being set by the electronically controlled shutter are infinitely variable, from 1/1000 sec. to 1 sec. (and actually beyond, to 8 sec., although these longer speeds aren't marked on the scale). The selection system is not simply setting fixed speeds of 1, 1/2, 1/4, 1/8, 1/15, 1/30 and so on; it is giving you the precise speeds. If the combination of lighting on the subject, the ASA film speed and the aperture you set requires 1/23rd of a second, that is what you get.

PENTAX ES FEATURES

Here are the controls for the Pentax ES camera.

1. Film counter.
2. Shutter release.
3. Shutter speed dial.
4. Rapid wind lever.
5. Accessory shoe.
6. X-sync contact point.
7. Preview lever of lens.
8. Battery check button.
9. ASA film speed window.
10. Battery compartment.
11. Aperture setting ring.
12. Focusing ring.
13. Flash terminals.
14. Stop-down lever.
15. Exposure factor control dial.
16. Rewind crank.
17. Rewind knob.
18. Viewfinder eyepiece.
19. Focal plane shutter.
20. Sprocket wheel.
21. Takeup spool.
22. Pressure plate.
23. Tripod socket.
24. Film plane rails.
25. Rewind button.

Here's what you see in the view-finder: Centrally, there is a microprism focusing circle surrounded by a fine focusing collar. You may however also use the outer areas for focusing if needed. At the right is your shutter speed indicator scale with pointer which will show you what shutter speed the automatic exposure system will select for any aperture you set on the lens.

To actuate the automatic exposure system, push down slightly on the shutter release button. The shutter speed indicator scale pointer will then swing downwards to show you the speed to be set.

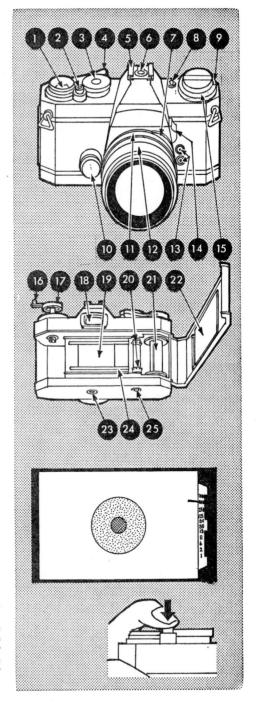

Overriding the automatic system

For general photography, you will set the click-stopped exposure factor control dial around the rewind knob at the red 1X setting. However, there are three alternate settings. To the right of the red 1X you will see a white 1/2X marking which you can use for such subjects as distant landscapes and scenics where standard exposure may result in overexposure. The 1/2X indicates that the camera will automatically cut the exposure in half when you take the picture. To the left of the 1X mark are the 2X and 4X settings, which actually cause the camera to double or quadruple the regular exposure. These are handy in moderate and heavy backlight situations, where there is much light from behind the subject pointing toward the lens. By using the 2X setting in moderate backlight and the 4X in heavy backlight, you can increase automatic exposure sufficiently to get detail in your less well illuminated, backlit subjects. Since this dial is continuously variable, you can actually set exposure corrections between the markings for more precise exposure control.

Never use an aperture so large that the meter needle swings upward beyond 1/1000 sec. or downward below 1/30 sec. If the needle swings upward beyond 1/1000 sec., try a smaller aperture and get the needle down to 1/1000 sec. or below. If you don't, you will have an overexposed picture. If the needle swings below 1/30 sec. you will get proper exposure, but 1/30 sec. is generally considered the slowest shutter speed at which you should hand hold a camera unless you are a practised expert. For slow speeds use a tripod by all means or other firm support if you wish sharp photos.

Battery check

In the centre of the shutter speed scale, within the viewfinder, you'll note a small cutout segment adjacent to the 1/30 sec. marking. This is the battery check indicator. If the silver oxide battery is alive and well, the meter needle will deflect to this cutout or go beyond when the battery checker button is pressed. This button is located atop the camera body, near the rewind knob rim. However, I find the cutout also useful for a quick check to see if I have a sufficiently fast speed to hand hold the Pentax ES. If the needle is at the cutout I know I must take my chances or find a support of some kind for the longer exposure.

EXPOSURE CONTROLS FOR THE PENTAX ES CAMERA

To set the ASA film speed, lift up the outer rim collar of the rewind knob, turn it in either direction until the proper ASA speed appears in the small cutout window, and then allow the rim to drop back into place.

To set the film reminder dial, move the small metal two-pronged pointer until it brackets a black and white square when you are using black and white film, a sun symbol for daylight-type colour film, a lamp symbol for indoor-type colour film or the "emp" marking indicating that there is no film in the camera at all.

For automatic operating make sure the shutter speed dial "automatic" pointer is set directly opposite the red arrow-head on the camera.

To use manual shutter speeds or B (bulb) turn the shutter speed dial until the shutter speed you wish to set is opposite the red arrowhead on the camera.

When using most Super-Multi-Coated Takumar lenses, the stop down lever should remain in the down position.

If you wish to see your depth of field before taking a picture or you want to use non-SMCT lenses, push upwards on the stop-down lever.

For standard automatic exposure operation, the exposure factor control dial should be set at 1X.

For special lighting situations where you need more or less exposure than the metering system would normally provide, grasp the outer ring of the control dial and turn it to 1/2X, 2X or 4X or in between, depending on the effect you wish to create.

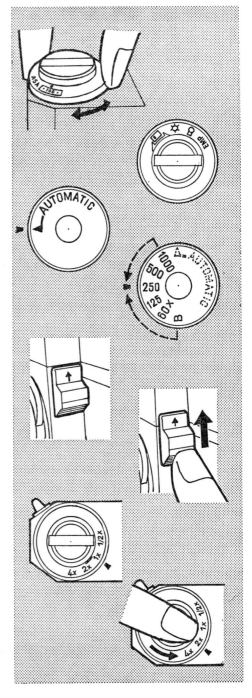

Manual shutter speed settings

Besides the automatic exposure operation already mentioned, users do have an alternative shutter speed control. The camera may be taken off automatic exposure completely and operated with regular set manual speeds. Speed settings from 1/60 to 1/1000, plus B for extra long exposures, are located on the shutter speed dial. To use any of these, simply turn the shutter speed dial to the shutter speed you wish. While on manual speed control the metering system is inoperative and the meter needle in the viewfinder will not indicate shutter speeds.

Lenses and aperture controls

The Pentax ES camera is equipped with a 50 mm. ƒ1.4 Super-Multi-Coated Takumar lens having an easy-to-grip rubberized focusing ring. Besides the advanges of the Super-Multi-Coating, these lenses are mechanically slightly different from the other Takumars. At the back of each lens are two clearly visible additional items—a small lever which changes position as you change apertures and a small fixed square lug. These are the new governing mechanisms which allow you to make exposure readings with the Pentax ES at full aperture. All Super-Multi-Coated Takumars except the 85 mm. ƒ1.9 and the 85 to 210 mm. zoom lens have these mechanisms. With all other Pentax lenses (and other lens accessories, such as lenses on extension tubes or bellows, microscopes, telescopes and lenses of makes other than Asahi) you can still get fully-automatic exposure control, but you must make your exposure readings at shooting aperture rather than at full, brightest aperture. Incidentally, you can also make readings at shooting aperture with the Super-Multi-Coated lenses as well, if you don't want to make readings at full aperture. Here's how you operate the camera automatically at shooting aperture.

On the right side of the camera as you hold it towards you, you will see a black stop down lever switch.

When taking a shooting-aperture reading with a Super-Multi-Coated Takumar or using any other lens or lens system, push this switch upward. Doing so will close down any Super Takumar, Multi-Coated or not, to the aperture set on the lens aperture scale. Now, when you press the shutter release slightly, the meter needle will show you the proper speed for that aperture. When you press the release all the way, the

FEATURES OF THE PENTAX ES CAMERA

The Pentax has an X-only sync contact, ideal for small cordless electronic flash units, built into the accessory shoe.

At the side of the lens mount on the camera body are two standard push-on PC flash terminals for flash units having sync cords. Use X for electronic flash and FP for focal-plane shutter bulbs.

Make sure the 6-volt silver oxide cell is inserted properly with the minus terminal pointing inwards.

To check the efficiency of the battery, press downward on the battery check button atop the camera while looking through the viewfinder. The pointer on the shutter speed scale at right should swing downwards to the central cut-out or a little further. If it doesn't, your battery needs replacing.

Here is a graph indicating battery efficiency at various centigrade temperatures. If you do intend to use the camera for extended periods in low temperatures, it's advisable to purchase a remote battery cord and battery box which will allow you to keep the battery warm in your pocket.

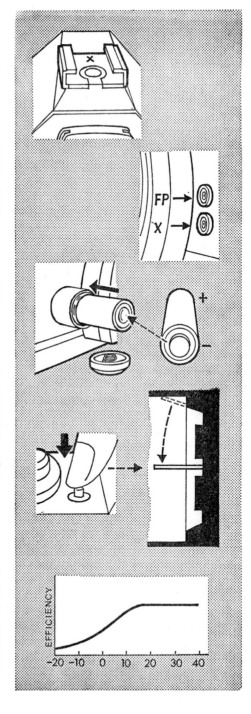

meter system will set this shutter speed for you automatically.

Care must be taken after using the stop down switch to return it to the down position if you wish to resume regular full aperture metering because, unlike the meter switch on the Pentax Spotmatics and the SP500, the level will not automatically return to the down position following exposure. It will remain in the shooting-aperture position until you push the switch down. When changing lenses or fitting extension tubes or bellows, you must have this switch in the down position, or the accessory will not couple correctly.

Incidentally, if you release the shutter at "Automatic", with a lens cap on, or without lens, or with extension tubes, bellows, microscopes, telescopes or with other non-open-aperture metering lenses, the reflex mirror will remain up if you have not moved the stop-down lever *up*. To reposition the mirror to its normal position, just turn the shutter dial off "Automatic" or move the stop-down lever up.

By the way, if your battery should perchance fail while you are out shooting (a very unlikely event if you change batteries every year, or after every 10,000 exposures), you can still operate your camera by using the manual speeds, since the manual speeds do not depend on the battery at all.

Each Pentax ES comes with an accessory eyepiece cap which slides down over the finder eyepiece to prevent any light from entering the meter when you use the camera away from your eye. Remember to put it in place before taking a picture under these conditions.

Other operational differences

There are a few minor additional differences between the Pentax ES and the Spotmatic II. While both have hot shoe sync connections atop the prism housings, allowing cordless electronic flash units to be used, the Spotmatic II can be used for FP bulbs as well by changing the sync, using the ring around the rapid wind lever. The Pentax ES has X sync only in the hot shoe and has a red X engraved on the shoe plate to indicate this. However, standard FP and X PC terminals are located on the right front of the camera body for cord sync connection.

Loading, focusing, and operating the controls of the Pentax ES are precisely the same as for other Pentax models.

TAKUMAR LENSES AND
SUPER-MULTI-COATING

The quality of Asahi's Takumar lenses has always been among the finest in the world. However in 1971 Asahi introduced a major advance in optical design and manufacturing. This is the now famous Super-Multi-Coating. Here's what it's about.

Although we normally think of a glass lens surface as transmitting all the light that hits its surface, that's not what happens. A certain amount of the light instead is reflected backwards again and isn't transmitted at all. Most optical glass today, if left untreated, reflects about 7 per cent. However it isn't just the light loss that affects the final picture. Since most lenses today consist of many elements—7 in the case of a 50 mm. $f1.4$ and as many as 14 in a zoom lens—the total amount of reflection from all surfaces when added together is considerable. A 7-element lens might transmit only 41.8 per cent of the light while the zoom might only transmit 17.5 per cent. In addition the reflected light bouncing around inside the lens itself often reaches the film in the form of ghost images and a general loss of brightness and contrast of the main image.

Most lens makers now use single layer anti-reflection coatings on all optical glass to air surfaces to cut down the reflection. With such coatings a dramatic improvement can be noticed. Surface reflection is cut to 1.7 per cent and the 7-element lens can transmit 81.4 per cent of the light while the 14-element zoom transmits 66.3 per cent. However in many situations, particularly in back-lighted scenes or brightly illuminated areas, distinct reflections are still caused on the film and loss of contrast and colour can be noted caused by what is commonly called "flare".

Asahi's exclusive Super-Multi-Coating combats this by the use of seven ultra-thin anti-reflection layers using several kinds of rare elements. Reflection from a surface is cut to 0.2 per cent. A 7-element lens transmits an amazing 97.6 per cent of all light while the 14-element zoom lens shows an incredible

brightness increase of over 50 per cent more than a single layer coating, bringing transmission up to 95.3 per cent. Ghost images virtually disappear, contrast increases immensely, colours are richer. In addition, Super-Multi-Coating allows maximum light transmission for all wavelengths of light while cutting off ultraviolet rays like a UV filter. A Super-Multi-Coated Takumar requires no lenshood and no UV filter. All Asahi lenses now being made have this great optical advance. Every lens so coated is marked "Super-Multi-Coated Takumar". Occasionally you will see it abbreviated as "SMCT" or "SMC" Takumar which stands for the same thing.

While Asahi's SMCT lenses are obviously preferable there are many older Takumar lenses around, all single layer coated, which are able to perform as well as or better than lenses made by other manufacturers. What is surprising however, is that Asahi has been able to offer the new SMCT at so little increase in cost over the single layer coated lenses.

The "Normal" Lens

Takumar lenses can be divided into five groups according to use: normal (with which the camera is originally furnished), wide angle, telephoto or long focus, special purpose and zoom. There are Takumar lenses of many different types which fit into all of these categories. Let's start out with an examination of the so-called normal Takumar lens. The word "normal" refers to the lens' focal length—the distance between a point in the lens and the film when the lens is focused on infinity. A normal focal length lens on any camera is considered to be a lens whose focal length closely approximates the diagonal of the picture area produced on the film. With 35 mm. cameras, this actually works out to be about 43 mm., generally considered a little too short to produce the best angle of coverage and most pleasing perspective. Consequently, makers of 35 mm. cameras have varied their "normal" focal lengths between 50 and 58 mm. With early single lens reflexes the longer 58 mm. length was in general use. However, in recent years there seems to be a trend to slightly shorter focal lengths which produce a greater angle of view. Current Pentax models use both 50 and 55 mm. focal length lenses. As explained, the 55 mm. lens does produce a life-size viewing

FORM AND SHAPE

Above. Noting the interesting contrast yet similarity between the figure and guitar, Pell Holmstrom combined them neatly with a 28 mm. *f*/3.5 Auto Takumar lens. Aperture with electronic flash was *f*/16.

SKATERS

Page 74. Bright light in foreground enabled M. Matsui to make an exposure of 1/60 sec. at *f*/5.6 using a 55 mm. *f*/1.8 lens.

BEATLE WATCHERS

Page 75. No biologists these youngsters, but fans of Beatle music. Corrie Meyer-Kattenburg used a 105 mm. *f*/2.8 Takumar at 1/125 sec. *f*/2.8 (*top picture*), then moved in for a closer look with a 55 mm. *f*/1.8 lens (*bottom picture*) but closed down to *f*/5.6.

BLACK AND WHITE

Page 76. To wash out the background, S. Yamazaki used intense bounce light on seamless backdrop, and exposed for the figure at *f*/8, 1/30 sec. with a 55 mm. *f*/1.8 Super Takumar.

BLACK AGAINST WHITE

Page 77. Antonio Cassera of Italy contrasted a high key nude study with a shaggy black dog using a Pentax SP with 55 mm. *f*/1.8 lens at *f*/8 at 1/60 sec.

NATURAL PORTRAIT

Page 78. With little light available, S. Miyano chose the slowest speed he could hand-hold safely—1/30 sec.—which allowed *f*/4 aperture, just enough to register both face, hands and sculpture in adequate focus. He used the 55 mm. *f*/2 Super Takumar on his Pentax K.

DECISIVE MOMENT

Page 79. Is maximum aperture and minimum hand-held shutter speed practical? Leo Qvennerstedt proves it is in this exciting available light picture of the birth of a baby made at 1/30 sec. $f/1.8$ with a 55 mm. $f/1.8$ Auto Takumar lens. Here picture interest transcends any lack of sharpness.

CLOSE PORTRAIT

(*Above*). Swirling haired natural close portrait was actually made at 1/60 sec. at $f/8$ by Kjetil Moen of Norway using a Pentax SV and the ideal portrait lens, an 85 mm. $f/1.9$.

image through the finder. The 50 mm. image is slightly smaller.

Normal lenses don't just vary slightly in focal length. They also differ in maximum aperture. The Asahi company has, in years past, produced normal lenses with apertures of $f3.5$, $f2.4$ and $f2.2$. However, present lenses are faster, allowing more light through—$f2$, $f1.8$ and $f1.4$. There is a full f-stop of actual speed between the $f1.4$ and $f2$ lenses. The $f1.8$ is roughly $1/2$ stop between $f1.4$ and $f2$. For all practical purposes the optical ability is the same with any of them at similar apertures. In terms of choice, the 50 mm. $f1.4$ Takumar produces a brighter viewing image than the $f1.8$ or $f2$. Since it does have a larger aperture, it has a shallower depth of field and therefore offers a snappier-to-focus image with less depth of field. Most important, of course, is the ability of the lens to gather more light for picture taking. The $f1.4$ can produce a better exposed negative under very poor lighting conditions (where maximum aperture is needed) than can the other two lenses.

The present normal focal length lenses available on cameras are:

55 mm. $f2$ SMC TAKUMAR: 6 elements, $f16$ minimum aperture, minimum focusing distance 1.5 ft., angle of view 43°, weight 7.6 oz., fully automatic diaphragm.

55 mm. $f1.8$ SMC TAKUMAR: specifications as above but maximum aperture is $f1.8$ instead of $f2$.

50 m.m. $f1.4$ SMC TAKUMAR: 7 elements, $f16$ minimum aperture, minimum focusing distance 1.5 ft., angle of view 46°, fully automatic diaphragm. Important! This lens can be used only on the Spotmatic, SL or models S1a (H1a), or SV (H3v) with red or orange "R" markings on the rewind knob. The 50 mm. $f1.4$ can be severely damaged if used on earlier Green "R" Pentaxes. Earlier models had 8 elements.

The normal (50–55 mm. Takumar) focal length lens is the best compromise yet worked out for most picture taking needs. Physically it's small. Optically, it is very well corrected. In practical terms it can handle almost any picture taking situation with good flexibility, be it scenic or close-up. It can focus closer than two feet without any additional accessories. Many have found that the lens fills every need and have never investigated the other lenses available. They should. The experience of at least trying other lenses is

81

very enjoyable, even if you don't (or can't) purchase every single one of them.

Wide-Angle Lenses

Selecting the first additional lens is always difficult. Should it be a wide-angle, long-focus (or tele) lens? This depends much upon the type of pictures you plan to take. If you specialize in general scenes, group shots, interiors and other pictures where you don't wish to approach too close to a subject but want to get more into the picture than the normal lens gives you, the wide-angle lens is certainly the one you should consider first. Why did we specify "where you don't wish to approach too close to a subject?" Because of a very interesting optical phenomenon—apparent perspective distortion —which is more pronounced with wide-angle lenses than with others as we'll see a little later.

If you decide upon a wide-angle lens just how wide a lens should you choose? It might seem logical to get the widest possible. While this certainly would cover a greater subject area than a less wide lens, there are definite disadvantages to the very wide lenses and reasons why a moderate wide-angle lens is a better choice.

As the angle covered by the lens becomes wider and more subject matter appears on the negative area, the images themselves become smaller on the negative or transparency. If a greater angle of view is to be accommodated it can only be done if all the objects within the negative area are smaller in size. And the wider the lens the smaller the objects.

While subjects are becoming smaller, other optical events are happening. Wide-angle lenses make depths appear far greater. In other words, a tree behind a man will appear smaller and at a greater distance when shot with a wide-angle lens than when shot with a normal or longer lens. You can illustrate this easily by photographing a person in front of a tree with a normal lens. Now replace the lens with a wide-angle lens. Move into the person until his body is the same size on the viewing screen as it was with the normal lens. Take another picture. The tree in this picture will appear much more distant and smaller although the body remains the same size. Many lens buyers who wish to photograph distant scenics do purchase very wide-angle lenses to get more into

82

DIAPHRAGM MECHANISMS

Fully Automatic: Super Takumar and SMCT lenses allow you to (1) select the aperture you wish; (2) focus at full aperture for maximum brightness. When you press the shutter release the lens will automatically close to your pre-selected aperture (3) and then reopen automatically to full aperture after the exposure is made.

Semi-automatic: All Auto Takumar lenses allow you to (1) select the aperture you wish. You then must use the cocking lever (2) to open the lens diaphragm fully for maximum brightness in focusing. You can then focus at full aperture (3). When you press the shutter release, the diaphragm will automatically close to your pre-selected aperture and remain closed (4).

Preset: Most Takumar lenses allow you to (1) select the aperture you wish. You can then focus at full aperture for maximum brightness (2). When you are ready to take a picture, you turn the preset ring until it stops, which will close the lens down to your selected aperture (3). You can then take the picture (4). The diaphragm will remain closed until you reopen it manually.

Manual: Some Takumar lenses have no preset mechanism. Instead you focus at full aperture for maximum brightness (1). You then manually close the lens down to the aperture you wish (2) and press the shutter release (3). The diaphragm will remain closed until you reopen it manually.

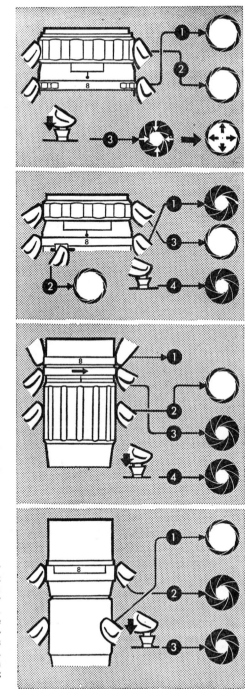

their scenics only to find that the distant mountains have now become so small they are almost invisible.

We are not attempting to discourage you from buying and using a wide-angle lens, but buy it for the right reasons. A wide-angle lens helps most in showing more middle distant objects—groups and interiors as we mentioned.

Perhaps the best all-round focal length for general wide-angle use is the 35 mm. It covers an angle of 63° as compared with the 55 mm. normal lens' 43°. The next question, of course, is "How fast a wide angle lens do you need?" Wide angle 35 mm. Takumars come in two speeds.

Inverted Telephoto Wide-Angle

The most common wide-angle is the 35 mm. f3.5, SMC Takumar, but there is also a newer f2 which is almost a full two f-stops faster than the f3.5. However, the f2 is also far larger in physical size. Why the great size when rangefinder-camera 35 mm. f2 lenses are so small? Because of the limitations imposed on wide-angle lenses by the construction of single-lens reflex cameras. With rangefinder cameras, standard lens designs can be used which allow wide-angle lens to be mounted the proper close distance from the film plane. On a 35 mm. lens for instance the lens would be approximately 35 mm. away from the film.

In a reflex camera, there's an interior swinging mirror to reflect the lens's image to the prism finder. The rear element of the wide-angle lens fitted to a single-lens reflex must remain far enough away from the film plane to allow this mirror to swing out of the way during exposure. Therefore the 35 mm. wide-angle lens cannot be as close as 35 mm. from the film plane.

However, the designers of the Takumar lenses have used a clever optical way around this problem. They use a special lens formula called an inverted telephoto, in which the back focus (distance from rear of lens to film plane) is far greater than the true focal length. Such lenses require large front elements. The greater the maximum aperture the larger must be the front element.

While the additional speed of the f2 may be extremely valuable to many photographers for use in low light, the large aperture also has an additional advantage. Wide-angle lenses are undeniably harder to focus than longer lenses. The

WHICH LENS?

By changing lens focal lengths and subject distances you can change the comparative size of objects within a picture. By changing focal lengths you only change image size.

Sign in close foreground and building in background appear like this when shot with 35mm wide angle lens.

With 50mm lens and increased camera to subject distance to keep sign at same size, building size increases and depth decreases.

Photographer now changes to a 200mm lens and again backs away from sign until it appears equal size to that above. Building in background looms far larger and distance to building appears far shorter

From same distance as 200mm picture above, photographer switches to a 50mm lens. Immediately all subject material becomes smaller. But note that size relationship between sign and building are the same.

Shifting lenses again, this time to a 35mm, at the same distance as above, the image becomes smaller but there still is no change in relative sign-building size.

With 135mm lens, background appears to interfere with head.

By shifting to shorter 35mm lens and decreasing subject distance to maintain same size as main figure, background shrinks and appears further off where it is less distracting.

short focal lengths have far greater depth of field at any given aperture and subject distance than the longer lenses. As a result it can be more difficult to find the exact plane of sharpest focus when focusing a wide-angle lens. However, the wider the maximum aperture, the shallower is the depth of field. If you view through the 35 mm. $f2$ Takumar you will quickly see that it is a faster and easier focusing lens than the $f3.5$. The subject "snaps" in and out of focus far more precisely than with the $f3.5$ lens.

Undoubtedly, the much higher cost of the 35 mm. $f2$ Takumar will be a criterion as to which lens you may buy. For ease of focusing and versatility the $f2$ is preferable.

Though the 35 mm. can be considered the "standard" wide-angle lens, a slightly wider angle for those who want it is provided by the 28 mm. $f3.5$ Super Takumar, while the 24 mm. $f3.5$ should prove useful for all photographs needing an even wider angle—for small room interiors, for example.

The current wide-angle lenses are:

35 mm. $f3.5$ SMC TAKUMAR, 5 elements, $f16$ minimum aperture, minimum focusing distance 1.5 ft., 63° angle of view, weight 5.4 oz., fully automatic diaphragm.

35 mm. $f2$ SMC TAKUMAR, 8 elements, $f16$ minimum aperture, minimum focusing distance 1.25 ft., 62° angle of view, weight 8.6 oz., fully automatic diaphragm.

28 mm. $f3.5$ SMC TAKUMAR, 7 elements, $f16$ minimum aperture, minimum focusing distance 1.3 ft., 75° angle of view, weight 9.2 oz., fully automatic diaphragm.

24 mm. $f3.5$ SMC TAKUMAR, 9 elements, $f16$ minimum aperture, minimum focusing distance 0.8 ft., 84° angle of view, weight 8.6 oz, fully automatic diaphragm.

20 mm. $f4.5$ SMC TAKUMAR, 11 elements, $f16$ minimum aperture, minimum focusing distance 7.8 inches, 94° angle of view, weight 8.1 oz., fully automatic diaphragm.

We'll discuss the wider fish-eye lenses later.

Long-focus Lenses

While the choice of a general purpose wide-angle lens was easily narrowed down to two different 35 mm. lenses, the choice of a slightly longer than normal lens can be a more perplexing problem.

Why do you need a longer than normal focal length lens? Many may think that the longer lens is simply used for

bringing distant objects closer. Actually this is only one of many important uses for longer than normal lenses. For instance, slightly longer than normal lenses—from 85 to 135 mm.—are often used for portraiture. Because these focal lengths are longer than normal, you can actually go further from your subject and yet produce the same size image on the negative. By shooting from a slightly greater distance, you can avoid apparent perspective distortion which makes near objects appear over large as compared with far objects.

In portraiture this is extremely important. For instance if you shoot a portrait of a person looking into the camera from less than 3 feet, there is a good chance that the person's nose, which is closest to the camera, will appear far too large in comparison with the face. Ears may appear too tiny.

While this state of perspective may be quite true in reality if you do approach that close to a person and look at them, your own ability to see in three dimensions renders the view, large nose and all, in proper perspective. A camera which reproduces a view on a flat plane cannot do this.

To correct the apparent distortion so that the face becomes more acceptable, we use a longer lens and stand further away from the subject. We now have a portrait with quite an acceptable nose.

Longer lenses take care of other apparent perspective distortions—the hand with cigarette which appears too large through a normal or wide-angle lens will return to apparent proper perspective with a longer lens used further away. The foot crossed but pointed toward the camera will also appear more normal from the more distant viewpoint with a slightly longer lens.

Of course, what we are really requiring the longer lens to do is to compress depth for us—push in the nose which appears too large until it is rendered more acceptable. And the distant viewpoint that the long lens makes possible produces such compression with all subject matter in depth— just the opposite effect to that of the wide-angle lens which seems to stretch depth. With a longer lens, a street photographed down its length will appear shorter. Cars on the street will appear close together. This is known as fore-shortening distortion.

While the words "foreshortening distortion" do sound rather ominous, they really aren't. Foreshortening often aids

picture taking. Mountains which seem too small and distant to your eye appear larger and more dramatic in the picture. Subjects in middle distance seem larger and closer. The picture elements seem more compact. The photograph gives the impression of being more tightly composed.

How much foreshortening distortion is good and how much is too much? This is a matter of personal choice, and unless you have a good number of different focal lengths at your command, you will have to accept whatever foreshortening your own longer-than-normal focal length produces.

This, of course, brings us back to the problem of selecting a first longer-than-normal focal length lens.

Many camera owners do make an initial mistake of attempting to get the longest lens possible on their first purchase. While such lenses can be very impressive and they do have the ability of bringing distant scenes closer—with some difficulties as we shall see—the medium telephoto or long focal length lens is far more versatile for general photography.

Telephoto Lenses

While the differences between a telephoto and long focal length lens should mean little to the photographer in terms of practical use, you may still wonder what the difference is. The difference is optical. "Long focal length" indicates that the distance between the middle of the last lens element and the film is approximately equal to the focal length of the lens. Therefore a 135 mm. long focus lens will extend 135 mm. from the rear lens element to the film plane.

By today's physical lens standards, that's a rather lengthy lens barrel. Most lens makers, Asahi included, have successfully reduced the size of long focal length lenses to $\frac{1}{2}$ or, in some instances, even $\frac{1}{3}$ their former length by employing telephoto optical designs. A telephoto lens consists of a lens element group at the front which converge the light rays strongly, plus a lens element group at the back which lessens the convergence. By employing these positive and negative lens groups, the back focus (or actual distance from last lens element to film plane) can be shortened considerably while maintaining the same focal length. A tele lens design is bound to be more complicated and therefore more expensive to manufacture.

Because the medium telephoto lens is so important in photography today Asahi offers 6 Takumars in 5 focal lengths between 85 and 150 mm. Each focal length offers a fully automatic diaphragm lens which closes to the pre-selected aperture when you press the shutter release and then reopens after the shutter action. One focal length also offers a more moderately priced Takumar lens with preset diaphragm which you must close down manually to the proper aperture before you shoot, then reopen again manually. The primary choice is one of focal length.

The 135 mm. focal length deserves prime mention. It is classically the general purpose moderate tele for single lens reflexes and best fills the need for a lens which brings objects quite close—reaching out and pulling in the very distant objects with more convenience than longer lenses. The 120 mm. $f2.8$ SMC Takumar bridges the gap between 105 and 135 mm. with a very compact close focusing optic, making it an ideal compromise lens with high speed.

The 135 mm. length is also excellent for portraiture since it does minimize apparent perspective distortion. It's limitation, however, is one of minimum camera-to-subject distance. Quite often its not possible in the confines of a home to get into the picture all the elements because of the necessary great lens-to-subject distance.

The newer 150 mm. SMC Takumar is a close rival of the 135 mm. Giving a slightly larger image it is nevertheless lighter in weight and just as easy to handle.

The 120, 135 and 150 mm. Takumars are:

120 mm. $f2.8$ SMC TAKUMAR, 5 elements, $f22$ minimum aperture, minimum focusing distance 4 ft., 20° angle of view, weight 12 oz.

135 mm. $f2.5$ SMC TAKUMAR, 5 elements, $f22$ minimum aperture, minimum focusing distance 5 ft., 18° angle of view, weight 15.5 oz.

135 mm. $f3.5$ SMC TAKUMAR, 4 elements, $f22$ minimum aperture, minimum focusing distance 5 ft., 18° angle of view, weight 12 oz.

150 mm. $f4$ SMC TAKUMAR, 5 elements, $f22$ minimum aperture, minimum focusing distance 6 ft., 16.5° angle of view, weight 11.3 oz.

For some photographers the maximum aperture of $f3.5$ and the minimum focusing distance of 5 ft. may seem a

handicap. Quite often a larger maximum aperture is wanted for shooting pictures with existing low light indoors. Often apertures of $f2$ or larger are needed. The 85 mm. $f1.9$ or $f1.8$ SMC Takumars are for just such purposes. Their slightly longer than normal focal length minimizes apparent perspective distortion of close subjects, allows you to remain a respectable distance from your subject while still filling your picture frame well and gives you an extremely large maximum aperture. With the very short minimum focusing distances there are few lenses to equal them for available light photography.

The 85 mm. $f1.9$ SMC TAKUMAR has 5 elements, $f16$ minimum aperture, 2.75 ft. minimum focusing distance, 28° angle of view, weight 12.3 oz., automatic diaphragm.

The newer 85 mm. $f1.8$ SMC TAKUMAR has 5 elements, $f16$ minimum aperture, 2.75 ft. minimum focusing distance, weight 12.3 oz. and the same diaphragm and angle of view. Unlike the $f1.9$ however it has full mechanical coupling to allow automatic exposure at full aperture with the Pentax ES camera.

In recent years, the in-between, 100 to 105 mm. focal length and aperture have become quite popular. The 105 mm $f2.8$ is appreciably smaller in actual length ($2\frac{3}{4}$ in. against 4 in.) yet it retains much of the 135 mm. lens' abilities to pull in medium distant and distant objects while combining this with slightly more than one half f-stop additional speed. Many users who previously just couldn't decide between 85 mm. and 135 mm. are enthusiastic about the 105 mm.

The 105 mm. Takumar lens is:

105 mm. $f2.8$ SMC TAKUMAR, 5 elements, $f22$ minimum aperture, minimum focusing distance 4 ft., 23° angle of view, weight 10.2 oz., fully automatic diaphragm.

The Really Long Lenses

Lenses from 35 mm. to 135 mm. focal lengths have always been considered the standard range for most camera owners. But the ease with which the Asahi Pentax can be fitted with longer lenses plus the constant cutting of weight and bulk of all lenses has made it no longer necessary to use tripods at all times even with the longer lenses. It's not unusual today for an amateur to shoot sports from his seat in the stands while hand-holding a 300 mm. lens, or to use a 200 mm. lens to photograph children jumping off a diving board.

Prices of such long lenses, once astronomic and almost beyond the scope of the average amateur photographer, have dropped to a point where they are not prohibitive—although, of course, good tele or long focal length lenses such as the Takumars are still not inexpensive.

Why a longer than 135 mm. lens? For just such subjects as the two we've described. The long lens allows you to photograph objects which you cannot approach closer. The long hand-held and tripod mounted lenses for 35 mm. cameras have revolutionized bird photography. Until recently most ornithological photographers used large plate or sheet film cameras and huge lenses. Now they can do virtually the same sort of work with an Asahi Pentax and a long hand-held lens.

The problem, as always in selecting focal lengths is just how long a lens should you contemplate. The answer depends on your own personal needs.

Asahi has aided the outdoor photographer willing to sacrifice great maximum aperture in return for a considerable decrease in lens size and weight. There are alternative versions of the lens in the 200 and 300 mm. focal lengths while even the 400 mm. lens may be hand-held.

Looking through a 200 mm. or longer lens in a Pentax is an experience. It's your first real glimpse of the telescope qualities of a long lens. You can capture on film objects and detail not readily visible to your naked eye.

Surprisingly enough the 200 mm. lens, besides being a splendid lens for bringing middle distance images extremely close, is a remarkably flexible lens for distant scenes. As stated before, many photographers become quite disappointed when using normal or wide-angle lenses whenever they try to shoot widespread landscapes. All parts of the landscape become so small and insignificant that little of the grandeur of the original scene remains.

With a 200 mm. lens, you can select interesting parts of a large scene, magnify them with the 200 mm. lens and then photograph them with more clarity and detail than you were able to see.

The lens also remains a fine outdoor candid portrait lens. Few subjects believe the photographer can be so far away and still take crisp closeups. This is particularly true with the 200 mm. *f*4 SMC Takumar which weighs only 19 oz. and

is more compact than many shorter focal length lenses produced by other manufacturers.

Because the 200 mm. *f*4 SMC Takumar and the 150 mm. *f*4 SMC Takumar are light and small, they have no tripod socket. If you do wish to use them on a tripod, you can attach the tripod to the socket on the camera body itself. Most such lenses are too heavy to allow this and must have their own tripod socket. There is no danger, however, with these lenses.

200 mm. *f*4 SMC TAKUMAR, 5 elements, *f*22 minimum aperture, minimum focusing distance 8.2 ft., 12.5° angle of view, weight 19.3 oz., fully automatic diaphragm.

Probably one of the most convenient lens lengths for sports and animal photography is the 300 mm. It's manageable hand-held or it can be used on a tripod. The 300 mm. *f*4 for the Pentax has the added advantage of being remarkably fast for such a long lens and so will allow you to shoot tele shots even under rather poor lighting conditions.

Details of the 300 mm. Takumar lens:

300 mm. *f*4 SMC TAKUMAR, 5 elements, *f*22 minimum aperture, minimum focusing distance 18 ft., 8° angle of view, weight 33 oz., fully automatic diaphragm.

Before we hit the tripod-only long lenses, there is one more Takumar specially designed so that it, too, like the 200 mm. *f*4 and 300 mm. *f*4 Takumars, can be hand-held, if and when desired. For some time, the Asahi company has been aware that there is a demand for a slightly longer than 300 mm. lens which can be used for distant action shots, for bird photography and other subjects which the 300 mm. lens just cannot reach.

Until recently such longer than 300 mm. lenses were usually giant affairs requiring very sturdy tripods. However, the 400 mm. *f*5.6 SMC Takumar is the exception. While furnishing a surprisingly large maximum aperture, it is still sufficiently small and light for non-tripod use. The tripod socket ring which allows the camera to be used for either horizontal or vertical pictures, can be removed when the lens is used hand-held.

The 400 mm. *f*5.6 SMC TAKUMAR has 5 lens elements, *f*45 minimum aperture, minimum focusing distance 24.6 ft., 6° angle of view, weight 2 lb. 11 oz., preset diaphragm.

There are two extremely long focus lenses at the big end of the Takumar lens scale. Both are designed for tripod-only

THE ADVANTAGES OF SUPER-MULTI-COATING

In present day optical glass, if left uncoated (A), about 7% of the light is reflected back from each side of a glass surface and does not reach the film. This reflection can be reduced by 75 per cent by applying a thin magnesium fluoride coating on the lens surface (B). This technique, used by most lens makers since World War II, can reduce reflection to 1.7% of the total light hitting the surface. With Super-Multi-Coating however (C), the amount of reflection is reduced to only 1/35 of that of an uncoated element. Total reflection is therefore cut to as low as 0.2% of the light.

Super-Multi-Coating improves light transmission and flare elimination in zoom lenses tremendously. Here we see a 14-element zoom lens. Without any lens coating (A), only 17.5% of the light would finally reach the film. With regular single coating of magnesium fluoride (B) about 66.3% of the light reaches the film. Asahi, using Super-Multi-Coating is able to transmit up to 95.3% of the light to the film or 50% more brightness than a standard single coating.

Now let's see how Super-Multi-Coating improves a standard normal focal length lens of 7 elements. With no coating (A), only 41.8% of the light reaches the film. With magnesium fluoride coating (B), 81.4% of the light gets to the film. Super-Multi-Coating (C) allows 97.6% of the light to reach the film.

operation since they are far too bulky and heavy to be hand-held. Such very long lenses have specialized applications such as photographing rocket firings from a safe distance, astro-photography, extremely long distance photography (when weather conditions warrant it) special sports events.

The 500 mm. $f4.5$ SMC TAKUMAR is quite fast in maximum aperture for its length. It therefore provides a bright focusing image. It has a smooth double helical focusing mount like shorter Takumar lenses plus a built-in lens hood. For quick sighting it has an open metal pointer sight. This fast, easily-handled lens is prized by news and sports photographers. The large tripod socket ring can be loosened and the entire lens and camera rotated for either horizontal or vertical pictures.

The 500 mm. $f4.5$ SMC TAKUMAR has 4 lens elements, $f45$ minimum aperture, minimum focusing distance 32.8 ft., $5°$ angle of view, weight 7 lb. 2 oz., manual diaphragm.

The 1000 mm. $f8$ SMC TAKUMAR is double the focal length of the 500 mm. yet it still has a very focusable maximum aperture of $f8$. Because of the vast size and weight of this lens, a special tripod is furnished with it as well as wooden cases for both tripod and lens.

It might seem strange that a tripod should accompany the lens. However, with such extreme focal lengths the slightest tremor of the camera and lens—even if a very high shutter speed is used—will cause a loss of sharpness. The tripod furnished holds the lens in perfect balance with camera attached and provides the extreme rigidity needed. The tripod provides full camera movement, both vertically and horizontally and allows the lens plus camera to be turned 90° for horizontal and vertical pictures.

The focusing mechanism is quite different from that of the 500 mm. Takumar—two rack and pinion wheels which move the entire camera body back and forth.

The 1000 mm. $f8$ SMC TAKUMAR, has 5 elements, $f45$ minimum aperture, minimum focusing distance 98 ft., $2.5°$ angle of view, weight 10 lb.; with metal tripod 17 lb. 12 oz.

The Zoom Lens

We now come to an extremely interesting type of lens—the zoom. Anyone who has watched sports coverage on television has seen the advantage of the zoom lens. From a fixed

camera-to-subject distance, a zoom lens seems to allow you to travel towards the subject area—or away from it if you start close. The zoom is actually a continuously variable focal length lens covering an infinite number of possible focal lengths between a minimum zoom and maximum zoom focal length.

In order to qualify as a true zoom, the lens must maintain focus throughout the zoom. That means if a zoom lens is once focused upon a subject, you can zoom to any focal length without the necessity of refocusing. This is important since there are so-called zoom lenses which are not really zoom lenses at all. They must be refocused at all different focal lengths. These are really multiple focal length lenses, not zooms.

While the zoom concept is not new, the successful application to the high standards of still photography is. Zoom lenses have many more lens elements than do ordinary lenses. Some of these move within the lens during the zoom thereby changing the focal length. To compensate for this lens element shift other elements must also move to maintain optimum sharpness. Until lens coating became practical for all lenses, such zoom lens designs were known but were not usuable. The internal reflection from so many glass surfaces plus the light loss made the theoretical designs impossible in practical terms. The optical glass available was also inadequate for the high refraction indexes needed.

Even with the advent of coating and the use of high-refractive-index glass, most zoom lenses left much to be desired. Definition if good at one focal length was poor at others. Lens faults such as pincushion distortion (where straight lines at the edge of the picture area bow in) or barrel distortion (where lines bow out) were considered normal for zoom lenses. There was also lens flare showing as loss of contrast and distinct image separation with bright objects. Many zoom lenses suffer somewhat from such faults even today—but not the 85 to 210 mm. SMC Zoom Takumar $f4.5$.

This lens at any focal length and aperture equals the performance of most single focal length lenses.

The Zoom Takumar has been specifically designed to take the place of all moderate aperture focal lengths between 85 and 210 mm. The combination ring is particularly helpful to

the fast working photographer. With the one broad well-knurled ring he can both zoom and focus.

While additional advantages of a zoom lens become evident the more you use it, we should mention a particular advantage for the precise photographer. With any subject you have the ability to frame swiftly the picture composition as precisely and tightly as you want without taking a single step. What might take minutes now takes seconds. Pictures cannot be lost while you attempt to get closer for a tighter cropping or try to back away for a wider angle shot. The Zoom Takumar itself takes care of this for you—all from the single subject distance.

Should you really substitute a zoom lens for all the various focal length lenses its range covers? We think this is only possible provided you don't need a larger aperture than $f4.5$ at any time nor need to focus closer than the zoom's closest focusing distance. If you do, you will inevitably find the single focal length Takumars still necessary. The zoom then should be reserved for situations where fast acting subjects make normal lens interchanging impossible.

The lens, which has a fully automatic diaphragm, is provided with a special close-up attachment which changes the focusing limits to $6\frac{1}{4}$ ft. to 11.5 ft. for close-ups.

The 85–210 mm. SMC TAKUMAR ZOOM $f4.5$, has 11 lens elements, $f22$ minimum aperture, minimum focusing distance 11.5 ft., 28° 30′ to 11° 30′ variable angle of view, weight 1 lb. 9 oz., fully automatic diaphragm. (Note: When this lens is used on the Pentax ES camera, exposure must be made at shooting aperture using the "MAN" switch.)

Special-purpose Lenses

The 17 mm. $f4$ SMC Takumar at first glance would seem simply to be wider than usual wide-angle lenses. However, it is more than that. Unlike ultra-wide-angle lenses for other single lens reflexes which require a special not-through-the-lens finder, you can attach this extremely compact lens to your camera and view right through the lens. However, it does have peculiarities. Unlike general purpose lenses, it has pronounced barrel distortion at the picture edges—that is the centre of straight lines bow out like a barrel while the ends of the lines curve inwards. The closer you get to the picture edges the more pronounced becomes this bowing.

WOODLAND SCENIC

(*Above*). Bright sunlight filtering through the trees gives this photo of two children in the woods an almost fairy tale appearance. A Pentax SP with 50 mm. *f*/1.4 lens was used by Pedro Luis Raoto of Argentina at 1/125 sec., *f*/22.

FISHERMEN'S FESTIVAL

Page 98. The excitement of a watery carnival was caught by J. Matsunaga using a 55 mm. *f*/2 Super Takumar at 1/125 sec. *f*/8.

WIDE ANGLE BALLOON

Page 99. Balloon, although close to earth was captured in its entirety with 28 mm. *f*/3.5 lens set at *f*/6.3, 1/250 sec. by George Harvan of the U.S. using a Pentax SP.

SPORTS AND GYMNASTICS

Pages 100–1. Even 1/500 sec. shutter speed used by S. Suyama failed to halt all action, but A. Shimazaki used a motionless instant with 1/60 sec.

BANDSMAN

Page 102. Traditional street band drummer in Italy was photographed by Adamo Zilio with Pentax SP, 50 mm. *f*/1.4 lens, 1/60 sec. at *f*/11.

SPEED AND DEPTH

Page 103. Only a very fast film could allow G. Konig to shoot at 1/1000 sec., to freeze the action yet maintain *f*/11 for good depth.

ACTION STOPPED AND NOT

Page 104. (*Top*). Using 1/30 sec. K. Sasaki made action-like blurs of karate boxers. (*Bottom*). To arrest action Kondo shot at 1/250 sec.

The 17 mm. SMC TAKUMAR focuses as close as 8 in. (0.2m) and has three built-in filters (UV, yellow and orange), changeable by rotating a filter selector ring.

Besides being able to cover an amazing angle for ultra-wide angle pictures, the barrel distortion can produce interesting effects in the hands of the creative photographer. Since you can see right through the lens using the Pentax finder, you can produce just the effects you wish by careful choice of viewpoint and subject matter.

The 17 mm. $f4$ SMC TAKUMAR has 11 elements (plus three filters), $f22$ minimum aperture, minimum focusing distance 8 in., 180° angle of view, weight 8 oz., fully automatic diaphragm.

The normal focal length macro lens, specially computed for high resolution and mounted in a focusing mount allows focusing to a life size 1:1 image ratio. Such lenses have become popular among single lens reflex users. By limiting the maximum aperture to a moderate size, very high correction for optical faults can be made. In addition, an extremely flat field can be maintained which means that flat subjects can be copied at close range with excellent, even sharpness from centre to corners.

Such macro lenses need not be used only for specialized work. In their universal focusing mounts they can focus from the extreme close-up position right to infinity.

The 50 mm. SMC $f4$ Macro-Takumar is suitable for high resolution normal photography and specialized close-up and copying work as well—all without any special accessories or adapters. In addition, the Macro-Takumar can be used as an enlarging lens.

The 50 mm. $f4$ SMC Macro-Takumar ranges from $\frac{1}{2}$ life size to infinity and has an automatic diaphragm.

Photographers desiring the highest standards of definition and colour correction at the expense of a larger maximum aperture may wish to consider the Macro-Takumar as their primary standard lens. Certainly for copying work, nature close-ups or scientific applications, it is ideal.

The 50 mm. $f4$ SMC MACRO-TAKUMAR has 4 elements, $f22$ minimum aperture, minimum focusing distance 9 in., 47° angle of view, weight 8.6 oz., fully automatic diaphragm.

Besides the Macro-Takumar there is another method of

105

operating the Pentax which allows you to focus continually from infinity to close-up—an equipment which produces an even greater close focusing image size than does the Macro-Takumar. The 100 mm. $f4$ Bellows SMC Takumar is specially designed in a short mount to fit on the Pentax Auto-Bellows or Bellows Unit I. With the bellows compressed, the lens can focus on infinity. With the bellows at maximum extension, you can achieve 1.62 magnification of the subject with the Auto-Bellows or 1.4 with the Bellows Unit I. However, it isn't simply the additional magnification that makes the Bellows-Takumar important. The Bellows-Takumar is twice the focal length of the Macro-Takumar. You can achieve the same image size with the Bellows-Takumar as with the Macro-Takumar, but at a greater camera-to-subject distance. In photographing small live animals this is a great advantage of course. In addition you do get less apparent perspective distortion with three dimensional objects with the Bellows-Takumar since you can remain further away from your subject.

Since the Bellows-Takumar has no scales except an aperture ring, the magnification and exposure factor scales have been engraved on the chrome bellows track of the Bellows Unit I and on the removable scale of the Auto-Bellows. The Bellows-Takumar itself is specially designed, like the Macro-Takumar, to produce extremely high definition with a very flat field, meaning that you can achieve good sharpness from picture centre to picture corner.

The 100 mm. $f4$ BELLOWS SMC TAKUMAR, has 5 lens elements, $f22$ minimum aperture, closest focusing distance at maximum bellows extension 22.17 in., 24.5° angle of view, weight 5 oz., preset diaphragm.

Note: While older Takumar, Super-Takumar and Auto-Takumar lenses could be used on a variety of non-Pentax cameras, most of the new Super-Multi-Coated Takumar lenses cannot. You will notice a small lug protrusion at the back of each lens which keys the proper maximum aperture into the Pentax ES camera. This lug will not clear the rapid return mirror on many non-Pentax cameras and can cause damage to both lens and camera body. The only Super-Multi-Coated Takumar lenses that can safely be used with most screw thread mount non-Pentax cameras are the 85 mm. $f1.9$ Super-Multi-Coated Takumar and the 85–210 mm. $f4.5$

Super-Multi-Coated Takumar. These two lenses, if used on the Pentax ES, must be used at shooting aperture rather than full aperture for automatic exposure operation.

Be careful when mounting any of the new SMC Takumar lenses (except the 85 mm. ƒ1.9 and zoom) to the bellows units. They will work quite well with the Bellows Unit I or Auto Bellows but should not be used on the older Bellows II because it is possible that they may not be able to be removed from the bellows after attachment. When in doubt as to which older bellows units may be used, consult your local photo dealer or Pentax representative.

The older non-Super-Multi-Coated Takumar lenses can be used on the new bellows units with no difficulty.

BLACK-AND-WHITE FILMS

The problem of choosing and using the right black-and-white films correctly is extremely important in 35 mm. photography. With the tiny $1 \times 1\frac{1}{2}$ in. negative format there is little room for error in film choice. Unfortunately for the novice there seems to be a virtually endless choice of films by many manufacturers.

Film Speed

It's most easy to divide the available films into types by their film speeds. Basically films with a low film speed are considered to be slow and need more exposure than films with a higher film speed. The standard indications of film speed now in use are those approved by the American Standards Association (ASA) and the German Deutsche Industrie Norm (DIN).

ASA film speeds are directly proportional to the sensitivity of the film. A film having an index of 100 needs for correct exposure just half the amount of light that is necessary for a film with an ASA rating of 50. These ratings are supplied by the film manufacturers who have tested their films for speed using a very precise technique as outlined by the American Standards Association.

With DIN scales, each increase of three numerals represents an arithmetic doubling of film speed. Thus a film with a 21 DIN rating is twice as fast as a film with an 18 DIN rating. The scale is logarithmic. Since the ASA scale is now in most common use, we will use it only here. However, a conversion scale is printed in the back of this book for those with films or exposure meters in other film speed settings.

We'll divide all films into four groups according to speed.

GROUP 1: VERY SLOW (finest grain) ASA 16–ASA 25.

GROUP 2: GENERAL PURPOSE (medium slow, very fine grain) ASA 32–ASA 64.

GROUP 3: GENERAL PURPOSE (medium fast, finest grain) ASA 80–ASA 200.

GROUP 4: HIGH SPEED (least fine grain) above ASA 200.

You can usually classify films by examining the boxes in which the film is packed. Many manufacturers list the speeds on the container. Others include it in the instruction booklet. Practically each major film maker produces one film in each group, except perhaps Group 1. Which brand within a group is best must remain a matter of personal choice although we suggest that at least at first you choose major brands. Now let's see how the groups differ and which films should be used for what purposes.

Choosing the Right Film

Which group is the best for all-round shooting? We'd suggest Group 3 as first choice. These provide amazing combinations of speed, exposure, latitude, lack of graininess and ability to produce crisp photographs. It's quite often almost impossible to tell pictures made with these films from photographs made with films in Group 2 *provided the Group 3 films are developed properly.* Group 3 films can easily handle outdoor scenes yet give you sufficient speed to cope with many difficult low-lighting conditions.

The choice of the next most important group depends very much on the type of pictures you take. If you want to be able to make natural-light photographs under poor conditions and yet come up with some very good negatives, Group 4 is your best bet. There is quite a variance in film speed within the group. For best results with acceptable sharpness and graininess we suggest you use films with speeds no higher than 500 ASA. Films with higher ratings should be reserved for subject material which is just impossible to handle with slower film. With the super-fast fast films print quality will undoubtedly suffer. With proper care, however, the moderate fast films from ASA 200 to 500 can yield surprisingly good results.

The very careful workman desirous of all the quality that the 35 mm. film size can provide will undoubtedly be drawn to Group 2. These films are obviously meant to be used in bright light. Results when used carefully and processed

properly can be amazing and almost impossible to tell from much larger sized films than 35 mm. These films can exploit the fine qualities of the Takumar lenses to the fullest degree.

Group 1 films do permit fantastically fine negatives capable of incredibly great enlargements of over 20×. However, unless such gigantic enlargements are contemplated (such as photomurals) the extreme loss of speed in Group 1 (as compared to Group 2) would preclude their use.

You'll actually find that the greatest differences in quality characteristics are not between Group 1 and Group 2, or Group 2 and Group 3, but between Group 3 and Group 4. Fast films are special purpose films and should not be used for general purposes. Undoubtedly, however, as films and developers improve, the differences between film groups will become less.

Film choice cannot be separated really from exposure and processing. These two considerations can make or break the quality of your black-and-white negative just as much as the actual choice of film.

Exposure Latitude

What can an average black-and-white film capture in terms of the subject? Although black-and-white films do vary according to Speed Group (and films also vary from one manufacturer to another) most modern black-and-white films can reproduce a subject with a brightness range of about 7 *f*-numbers. So if your meter reads an exposure of 1/300 at *f*2 in the shadows, and 1/300 at *f*16 in the highlight areas, all the detail between these two extremes can be registered on the film. While a straight enlargement or print cannot possibly reproduce all this detail, a good print maker can preserve nearly all of it by careful print manipulation. This is quite an amazing range and should serve as a great comfort to those photographers who are not quite sure of their ability to decide upon the correct exposure.

However, don't let this very great film latitude delude you into thinking that any exposure between the two extremes will ensure a good negative. Proper exposure always yields the best negative. The further you depart from correct exposure the poorer your negative becomes. Both underexposure (not allowing enough light to strike the film) and over-

WHICH B & W FILM?

Choose your film to fit the subject whenever you can. The faster ASA speed films do show graininess to a greater extent than the slower films. As speed increases, resolution and contrast decrease.

Use film in this group for fine copying work, subjects to be made into giant enlargements or murals.

Use film in this group for bright outdoor scenes, landscapes and intricate detail where sharpness and resolution are essential in the final print.

Use film in this group for shooting action where you need a fairly fast shutter speed to halt movement.

Use film in this group under poor lighting conditions where it would be impossible to take a picture without it.

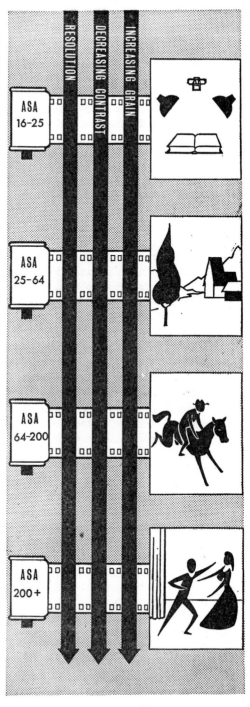

exposure (too much light hitting the film) will cause trouble even though you may get printable negatives.

When you overexpose, your negative becomes quite dense. An overexposure of your principal subject material of but one *f*-stop can actually cause an increase in graininess which may be visible on your print. More overexposure also dulls sharpness and causes loss of detail.

Making an error in the opposite direction is also costly. At one time it was thought that a slightly underexposed, thin negative yielded the best print. It doesn't. Thin or underexposed negatives must be printed on a very contrasty paper. Contrasty paper tends to emphasize the graininess. For best prints with least graininess it's advisable to produce negatives easily printable on normal Nos. 2 or 3 grades of printing or enlarging papers.

Are there any special tricks in the use of exposure meters when shooting black-and-white pictures? Very few. Since the use of meters does vary so, it's advisable to follow the instructions which are provided by the meter manufacturer quite carefully.

All Pentax meters—built into cameras, clip-on and hand-held have very complete instructions. However, precise instructions on their use are included in pages 166–182.

Developers—Special and Otherwise

A word of warning. You will quite often hear of photographers "pushing" film speeds in order to use films in poor lighting conditions. They set their meters not to the official ASA film speed ratings but instead, to much higher, inflated readings. These photographers then attempt to compensate for this underexposure by using special developers. Often much of the supposed gain in film speed is illusory. Since black-and-white films do have so very much latitude, a certain amount of underexposure is possible, particularly in low lighting conditions. Negatives exposed in this matter can yield good prints. However, careful tests of "pushed" film processed in the so-called speed developers indicate that no more than about $1\frac{1}{2}$ *f*-stops of true speed can be gained even with the best of them.

What developer should you use with black-and-white films? Certainly your first choice should be the developer recommended by the manufacturer of the film. Quite often

the name of the recommended developer will appear in the instruction sheet which is packed in the film. If you wish to experiment with other developers after you have become familiar with the film manufacturer's product, well and good. But in making fair evaluation tests always run a dual test with two rolls of film. Shoot both rolls under similar conditions. Then develop one roll in the new developer and one roll in the manufacturer's developer. Then compare the negatives and prints made from them.

Aside from choice of film, proper exposure and processing, what other considerations will improve black-and-white picture quality? Let's take a better look at this elusive quality we call sharpness.

What is Sharpness?

Sharpness is not a very exact term. Do we mean lack of graininess, crisp outlines of the subject? More detail? Perhaps some of all of it. What, for instance is graininess?

Actually the small sandpaperish texture we see in a "grainy" print is not the effect of individual silver grains at all. It is rather the effect of the clumping together of these grains. The individual grains are much too small to see with the naked eye. The individual grains and the grain clumps are much smaller in fine-grained, slow films, than in high-speed, fast films. At one time it was thought that the size of the grain clumps and only the size of the grain clumps governed the sharpness of the picture. Today many more factors appear involved.

Sensitometrists have found that it isn't so much the size of the grain clumps which is the most important factor in determining picture sharpness—it is rather the sharpness of the grain clumps. That is, if grain clumps have soft, indistinguished edges, the picture tends to lack crispness no matter how fine the grain. Even when graininess is greater the picture will *appear* sharper if the grain clumps have sharply delineated edges. The ability of a film to delineate these grain clumps sharply is termed the acutance of a film. When a film is said to have high acutance, the technician is merely indicating the film's ability to produce a sharp picture, not necessarily the film's graininess characteristics. Actually specific tests have been worked out which allow technicians to measure the acutance of a film.

What does the difference between graininess and acutance mean in practical terms? Simply that at average viewing distance some of the more modern, faster films which have very good edge sharpness characteristics may appear to be sharper and crisper than some of the fine grained films. Of course if you go right up to the enlargement and examine the print for resolution of fine detail you will find that the slower fine grained film reproduced the detail to a greater extent than the faster films. However, at ordinary viewing distances the film with more graininess but more acutance may look sharper.

Perhaps sand forms a good analogy. Sand grains with smooth round surfaces, well worn by time and water, are certainly fine grained. But does it look as crisp as coarser grained sand with rough edges? A mosaic at a proper distance may appear far sharper and crisper than a painting even though every line in the painting is as crisp and the painting is as detailed as the human hand can make it.

Producing the Print

We'll discuss printing and enlarging only briefly since it's really a whole field in itself.

Unless you actually do your own developing and printing and enlarging, you will not know what fabulous pictures can be made with your Pentax camera. Unfortunately, all too often owners of first-class cameras simply drop their exposed film off at a photo store and let the photo store processors develop and make snapshot-sized enlargements of each picture. These prints, often made by production line machinery, are inexpensive comparatively, but give you no more than a tiny inkling of what is really contained in the negative. Many amateur photographers have come to accept these pictures as the most they could expect from their fine 35 mm. cameras. Those who do their own processing and enlarging at home do know what can be done in black-and-white—the wonderful huge enlargements that can be made with all the fine detail.

If you simply cannot in any way find it possible to do your own processing and printing, by all means try a first class professional laboratory, if and when you have a picture you really prize. While such a lab cannot possibly interpret the printing of the picture as you could

yourself, you will get a result far superior to the small snapshot. Perhaps a few glimpses of what your negative really holds will inspire you into taking up developing and printing.

COLOUR FILMS

More and more 35 mm. camera owners today are discovering the delights of colour photography. While only a few years ago, photographers were primarily interested in black-and-white pictures, today the swing is toward colour.

The addition of colour even to a rather drab subject certainly heightens the interest in the picture. And while it's pleasant to be able to take out one's wallet and show small colour photographs of friends or family, there is probably no greater thrill than to project a bright colour transparency on to a good sized screen for an appreciative audience.

Colour Negative Film

In 35 mm. photography there are two main types of colour film. If you are primarily interested in having colour prints, a negative colour film is the preferable material to use. Used properly and developed either by you or a commercial processor, the colour negative looks something like the black-and-white negative except that the various parts of each picture frame are oddly coloured in the complementary colour to the actual colour of the subject you photographed. When printed (and again this is something you can do at home although it's more complicated and needs more precise technique than black-and-white) the colours resume their true, original nature.

Colour prints can be made from transparencies as well as from colour negatives, but they are rather more expensive. Even prints from colour negatives cost sufficiently more than black-and-white prints to make negative colour users rather chary of having every negative printed in colour. It's advisable to have the colour negative film processed and then to have black-and-white prints made. From these you can pick out the best shots for colour printing.

Perhaps the least expensive way to see your colour negative results is to have a contact sheet or contact strip

WHAT COLOUR FILM?

Colour films are either reversal films, which produce a transparency, or negative films, which produce colour negatives. Which is best?

Reversal films produce one colour transparency of each picture. Duplicate transparencies are generally inferior to original and are costly. Colour prints are slightly more expensive than prints from negative film.

Negative colour films produce a colour negative of each picture. From this negative either black-and-white or colour print can be made at less expense than with reversal film. However, making a transparency is an additional extra charge. Transparencies from negative colour film generally do not have the quality of the original transparency from reversal film. However, negative film has more exposure latitude than transparency film, can produce surprisingly good colour prints or slides even if original shot was substantially over or under-exposed.

made in colour. This is a long contact print, same size as your 35 mm. negatives. While the quality is certainly not what you should expect if the pictures were printed individually, a contact sheet or strip is sufficient to allow you to examine your colour negatives to see which you wish to use for colour prints.

Can you get good black-and-white prints from colour negatives? Yes, you can. However, for most accurate rendition, special enlarging paper is necessary. If you're interested, ask your photo dealer about it.

Besides having the ability to produce either colour prints or black-and-white prints directly, negative colour films have another important feature. They usually have far more exposure latitude than do transparency films in that they do not form the final picture and a certain amount of correction can be carried out in printing. Some of the negative colour films actually seem to have just about the same seven-stop latitude as black-and-white films. This means that some error in exposure calculation is allowable with little loss of colour print quality. A great deal of error can be tolerated with somewhat greater loss of quality—usually heavier, muddy colours.

Most negative colour films can be used in any kind of lighting, except domestic tungsten lighting. Ideally, they are usually designed for use with clear flashbulbs or something between that light and daylight, but as we have mentioned before, a certain amount of correction can be made in printing. You can safely use daylight, electronic flash, blue or clear flashbulbs without a filter. With photoflood lighting it is advisable to use the appropriate filter and with ordinary household lighting a filter is absolutely necessary for correct colour rendering. The laboratory printing machines can just about manage the correction for photofloods but not for ordinary tungsten light. Daylight, electronic flash and blue flashbulbs give light of a similar quality and it is usually possible to mix them in the same shot. But you must never mix any of these types of illumination with photoflood or tungsten lighting. You can use them on the same roll of film, but not in the same shot.

Transparency Colour Film

The most widely used and popular 35 mm. colour films are the transparency types which, after processing, yield a

FILM LATITUDE AND GRAININESS

The best pictures are always made when you expose the picture correctly. But how far from the proper exposure can you stray and still get adequate results?

In black-and-white film, the amount of permissible error is 7 full f-stops ($3\frac{1}{2}$ on either side of correct exposure) as shown on the Pentax clip-on meter. With colour reversal film, the latitude is but two full f-stops (one on either side of correct exposure). Colour negative film has a latitude similar to black-and-white film, however.

Does a fine grain film always yield the most apparent sharpness? Not necessarily. Here fine grain film produces more fine detail in eye (above). However, less fine grain film (below) appears to produce sharper image because grain clumps have sharper edge. Films which give such apparent extra sharpness are said to have higher acutance.

THE COLOUR ILLUSTRATIONS

Page 121: Soft diffused light prevented any harsh shadows from falling on this study of a boy and his toy stuffed bear. Photographer Brendan Doyle of Ireland used a 50 mm. *f/*4 Macro Takumar lens on his Pentax S3. His exposure was 1/60 sec. at *f/*5.6. Note how simple background in almost same tonal range as subject's sweater and toy gives photo an almost pastel quality.

Page 122: A rainy day in a small French village offered Guiseppe Lonardi an excellent picture possibility of photographing two children sharing a single umbrella. Although the rather poor light prevented the photographer from using any aperture smaller than *f/*4 with his Pentax and 50 mm. *f/*1.4 lens, that aperture was sufficient for a surprisingly good amount of sharpness from foreground to background. The 1/30 sec. shutter speed was sufficient to stop almost all movement from the rear save for a tiny blur in the girl's right galosh.

Page 123: Brightly coloured patterns can be found in everyday life if you look for them. Here the photographer, peering down from an office window, found the intriguing colours in a car park across the street.

Page 124: Achieving good figure studies requires much practice in posing, in lighting and in model selection. Here a seamless red studio backdrop eliminates any distractions from the contours of the model.

Page 125: Shooting from inside out, Veli Nurminen of Finland posed the young man carefully in a doorway for a classical colour silhouette. His exposure of 1/250 sec. at *f/*5.6 with a 50 mm. *f*2 lens on his Pentax H2 was for the outdoor scene. Note how very much the bright coloured liquid in the glass held by the subject adds to the photo. The photographer focused on the figure in the doorway but the out of focus building outdoors does not detract from the picture.

Page 126: Close-up pictures of small figurines can easily be made with the Pentax in any of four ways: with close-up lenses over the camera's own lens, with a lens on an extension tube; with a lens on a bellows unit or with the 50mm *f*4 Super Macro-Takumar lens. Focal length is quite important in choosing lenses for close-ups. When shooting three-dimensional objects such as this figurine, a slightly longer than normal lens will prevent, or at least minimize, any perspective distortion that close working distance with a shorter lens might possibly cause.

Page 127: Macrophotograph of an ant can be accomplished easily with a Pentax. A full set of extension tubes or long bellows draw plus a fairly short focal length lens provide sufficient bigger than life magnification. The normal 50-55mm Super Takumar lens makes an excellent copying and close-up lens for such work.

Page 128: Harsh, direct late afternoon sun crosslit Canadian fishing and hunting guide's face, warming it slightly. Note how cross lighting picks out all the details. The 105 mm *f*2.8 Super-Takumar was stopped down to *f*8 and the shutter speed was 1/125 sec. Subject was actually sitting in stern of small boat controlling an outboard motor while photographer shot from amidships.

positive colour transparency which can be viewed with a hand illuminator or can be projected on a screen with one of the many projectors available on the market today. The cost of the film often includes the cost of the processing. After taking your pictures, you simply mail the film (in the mailing bag supplied) to the processor who returns your slides, generally mounted in cardboard or plastic for projection. If they are returned in strips, it's a simple matter to obtain suitable mounts and mount the transparencies yourself.

The cost of producing slides is much lower than the cost of obtaining colour prints from each frame of a negative colour film. And you can, of course, have prints made from the slides at a slightly higher cost than with negative colour film. There are many different transparency colour films available which cover the film speed range almost as completely as do black-and-white films. And like the black-and-white films, the slower speed colour films yield the best quality—brightest colour and least graininess—while the superfast colour films do allow pictures under poor lighting conditions but at a price—loss of brightness and increased graininess.

Besides the increased cost of making colour prints there are other drawbacks to transparency films. Your exposure with any transparency-making reversal film (a film which yields a positive image rather than a negative one) must be extremely accurate. Instead of the vast latitude of black-and-white film or even of negative colour film, most transparency colour films yield only a latitude of about one full *f*-stop over or one full *f*-stop under the proper exposure. Beyond this range, your picture will look washed out, lacking colour, if overexposed, or too dense if underexposed.

Unfortunately there is no practical norm which you can follow as to when your shots are exposed exactly right since so much depends on how you intend to view the slides. Generally the brighter the projector and the smaller the projected image, the denser and less exposed should be the colour slide. Colour slides with average colour and brightness quite often look pale and sickly when projected by the exceptionally bright and efficient modern 35 mm. projectors. You will have to establish your own exposure norm depending on your own equipment. Of course, the correct ASA

P.W.—G

film speed rating should be used until you see what results you get.

Since there is so little exposure latitude in colour transparency films, you should use exposure meter readings. In determining exposure if there is a range of brightness between highlight areas and shadow areas of more than two ƒ-numbers, it's advisable to favour the highlights and if necessary underexpose the shadows. While dark shadows lacking detail are acceptable in colour slides or prints, washed out highlights with no detail are very disturbing.

There is another important consideration you face when shooting 35 mm. colour transparencies—colour balance. Unlike colour negative film which can be altered in colour during printing, it is nearly impossible to alter transparency film colour selectively after it is exposed. Since all colour transparency films are carefully designed to render colours correctly under specific lighting conditions, any variations away from these conditions must be corrected in shooting by the use of the proper filters.

Film manufacturers have done their very best to make proper colour balance easy for 35 mm. camera owners. Many film makers have two types of colour film—one for daylight and one for artificial light.

With photoflood lamps, you should use artificial light type (or Type A film). You can use daylight film with the appropriate filter but only at the cost of appreciable loss of film speed. A special Type B film is available for use with high-powered studio lamps. Quite often you will want to use flash with your daylight film. In that case you should use electronic flash or blue-coated bulbs. If you use clear bulbs you must use a filter over the camera lens.

Until rather recently, only complicated charts were available to help you pick the right filter to match the light source to the film. However, we've included a helpful nomograph in the Facts and Figures Section at the back of this book which can quickly give you the proper filter for virtually any type of colour film and any type of illumination. We would suggest you check the types of films you intend to use most and the illuminations you will most often encounter and purchase the necessary filters immediately. When you are actually shooting, it's too late to think about the filters you need. Asahi make excellent filters, although not all you may

need. Always ask first for a filter made by the maker of your lens—Asahi.

If you are in any doubt, take your camera and lens to your photo dealer and he will see to it that you purchase the filter you need and that it threads properly into the front of your lens.

Although proper filtration is generally recommended for best colour results, you will be surprised at the colour you can get using the illumination around your own home. One of the joys of owning a fine 35 mm. camera with a fast lens is the possibility it offers to shoot colour by existing light at home and elsewhere indoors. You will, of course, need large apertures and fairly slow shutter speeds (and a fairly high-speed colour film). You won't get accurate colour rendering because no colour film is balanced for ordinary tungsten light, but Type A or B or negative colour film can give quite pleasing results.

Make careful exposure meter readings of your subject matter. Keep subjects fairly close to your light sources—a person reading by a table lamp is a good example. Try to use light from white frosted bulbs or light from lamps whose shades are fairly close to white. If you don't, the colour of the shade or bulb will overlay all the colours in your picture.

Slide Projectors

Now a word about projection equipment. There are many excellent machines on the market in nearly every price category. The simplest machines with low powered illumination are generally manually operated—you put one slide at a time through them by hand. These projectors are comparatively inexpensive but quite compact. They have the additional advantage of being simple in construction so there is little mechanically that can go wrong (aside from the projection bulb burning out once in a while).

From these machines you can pick your way upwards through semi-automatic machines that take slide trays. You can leave your slides stored right in the trays. At the top of the list are the very comprehensive fully-automatic remote control projectors that allow you to focus them at a distance. Some projectors, including those made by the U.S. importer of the Pentax, Honeywell, actually focus themselves automatically.

The choice depends on your pocketbook, need of extra

conveniences and the amount of brilliance you require. The larger you intend to project your slides, the better should be the machine.

Before leaving the subject of colour photography we must point out one unfortunate failing. As of the present time, no dyes used in colour transparencies are permanent. The colours in both types of materials are liable to fade in time. This doesn't mean that they *will* fade. It does mean that they *may* fade. Aside from keeping both prints and transparencies away from heat and light when not being viewed, there is little you can do to prevent possible fading.

Colour photography nevertheless represents perhaps the most exciting challenge that photography has to offer.

While having as many colour prints made as you wish offers no problem (except a monetary one), you may wish to have colour slide copies made. These can be made by most colour labs but you will find it an easy and less expensive matter to make them yourself at home. The Pentax equipment available is simple. You can usually make better copies yourself than you will receive if you let a regular photofinisher do the work for you. All the information you need to select the right equipment can be found in the chapter on slide copying (see page 202).

USING FILTERS

Filters are a very useful aid in black-and-white photography. They can emphasize certain colours in a picture by making them darker or de-emphasize colours by lightening them. Perhaps the most well known use for filters is to bring out clouds. Actually the filters generally used for this purpose—yellow, green, orange or red, don't really "bring out the clouds". They darken the blue sky so that the contrast between sky and clouds can be seen.

The best way to learn the proper use of filters is to understand what they do. It will then be an easy matter to put this knowledge to useful work.

Black-and-white films must translate all the colours in a scene into shades of grey—with pure white at one end of the scale and black at the other. Today's panchromatic (sensitive to all colours) films do a very remarkable job of this. However, two problems can still exist. There are some colours which the films do not render properly. Secondly when rendering colours into shades of grey, some colours which contrast with others when you can actually see the colour, are very similar in brightness and therefore are rendered as almost the same shade of grey. Filters can often help alleviate both conditions.

Except for grey neutral-density filters, whose function is simply to absorb light of all colours, filters are made in various colours. They may take the form of a sheet of coloured gelatin sandwiched between two pieces of optically pure glass or glass dyed in the mass.

What the Filter Does

The colour of the filter determines just what colours will pass through to your camera and what colours won't. Filters always transmit strongly the colour of the filter itself. A red filter transmits red, green transmits green, yellow transmits yellow, etc. While transmitting its own colour the filter

also holds back (or absorbs) other colours. A red filter holds back blue or green, a green filter holds back red and blue, a yellow filter holds back blue. The deeper the colour of the filter the more strongly it acts. As a result, all filters for black-and-white pictures lighten the tone on the print of objects of the filter colour and darken the tone of colours they hold back.

Filter Factors

Coloured filters cut down the amount of the total light striking the film, so an increase in exposure must be made to compensate. Each filter has a filter factor which determines the proper exposure compensation. Filter compensation is not necessary with Pentax cameras having through-the-lens metering systems. The meter automatically gives you the correct exposure. The following applies to Pentaxes without through-the-lens meters. Filter factors tell you specifically how much more exposure you must give. For instance, most medium yellow filters have a factor of 2. This indicates that you must double the normal exposure. Instead of using an aperture of *f*11 without a filter, you would use *f*8 with the filter. Many exposure factors are in fractions such as 1.3, 1.4, 1.5, etc. Of course it's almost impossible (and impractical) to make such minute adjustments. For practical photography just take the factor to its nearest full or half number: 1, 1.5, 2, 2.5, etc.

You needn't change aperture. You can instead alter shutter speed. With a factor of 2, cut the speed to one-half. With a filter factor of three, cut the speed to one-third or to the nearest appropriate setting. A third and perhaps the easiest way of dealing with filter factors is to alter the ASA rating of your exposure meter setting. If you are using a film with an ASA rating of 160 and you have a filter with a factor of 2, cut the ASA rating to 80. If the factor is 1.5, use an ASA setting of 125. If the factor is 3, use an ASA setting of 50.

If you find this arithmetic too difficult, turn to the Facts and Figures section at the back of the book. There you'll find tables giving the most often used filters along with the recommended filter factors and amounts of exposure increase.

Choosing Filters

What filters should you own? A look in any filter catalogue or a trip to the photo store will reveal an almost endless

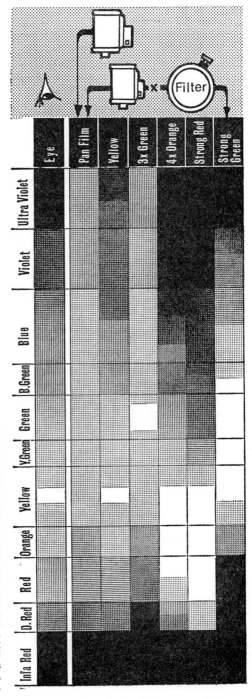

Here is the complete spectrum of colours as seen by your eye, by ordinary panchromatic film and by various filters plus the pan film. Yellow filter darkens blue and violet. Light green makes green (such as foliage) much lighter. Note dark red appears almost black. Orange filter lightens orange and yellow, red slightly, makes green slightly darker, darkens blue and ultra-violet measurably. Strong red filter makes red and orange nearly white, has almost same effect on yellow. Blue is very dark, green almost black. Strong green filter makes red appear black, darkens orange, violet and blue, lightens green and yellows.

number. It's best to start out with one or two and then add other filters when and if needed.

The basic filter for all photographers is usually the medium yellow. Its principal function is to make clouds stand out by darkening the sky slightly. But even on cloudless days it will prevent the sky portion of your picture from looking grey and washed out. It will also darken water and bluish shadows. Other objects are seldom affected at all by the medium yellow filters' action.

The second most important filter is probably the light green. Not only will it darken blue slightly but it tends to make faces slightly darker and less washed out. It lightens the green in foliage and grass.

A medium-red filter will probably be your third choice. This adds a startling dramatic quality, making blue skies almost black and also darkening foliage appreciably. It is not recommended for portraiture since it will make skin tones quite chalky. It's extremely handy at the seashore if you have whitecaps since it will darken the water measurably, making the white foam stand out.

The Asahi company provide many of the filters you will need. Each threads securely into the front of your Takumar lens. However, you may want to purchase additional filters. If so, be sure to take your camera lens to your photo dealer when the filter is fitted. Always insist on filters which thread directly into the front threads of the Takumar lens or filter adapter rings which also thread into the front of the lens.

With adapter rings, you purchase one ring and then can place non-threaded filters right into the adapter where they are held in place by a retaining ring which threads securely into the adapter ring. Under no circumstances purchase any lens accessories including filters which simply push on the front of your lens. These can easily drop off and become lost. More important, they will scratch the fine finish of your Takumar lens mount.

UV and Polarizing Filter

Two other important filters should be mentioned. The UV or Ultra-Violet haze cutting filter holds back ultra-violet light rays only, in sunless scenes, preventing, or at least limiting, haze in the picture. Unlike all other filters for black-and-white photography, the UV has no filter factor at

all and requires no additional exposure increase. Many photographers leave it over their lens permanently for lens protection. The UV filter can never harm your picture. It can only help.

The Asahi UV filter is the "ghostless" model. This is a curved filter designed to eliminate the ghost image sometimes formed in against the light shots when using the conventional plane filter.

The last filter of importance is the polarizing filter. It is one of the few filters which has important functions in both black-and-white and colour photography. It works like no other filter.

Light, when travelling, vibrates in all directions. However, in certain instances light from a blue sky or from reflections vibrates in one plane only. This light is said to be polarized. By turning the polarizing filter you can either let through all of these light polarized rays or you can block them out partially or completely. You can thus darken blue skies to any degree you wish or eliminate partially or completely unwanted reflections—as from water or glass—simply by turning the polarizing filter until the sky darkens appropriately or the reflections disappear or lessen.

Although the polarizing filter does darken skies or water and may eliminate reflections, it does not alter the tonal rendition of black-and-white pictures or the colour in colour shots. The polarizing filter will also cut through haze.

There is no set filter factor for polarizing filters. Much depends on the degree of polarization achieved. It's advisable to check the instructions accompanying the polarizing filter before attempting to use the filter. Usually, however, the increase will vary between 2× and 4×.

While it would seem advantageous to make exposure readings with the Spotmatics or Pentax ES cameras right through the lens, quite often proper exposure isn't achieved in this manner because of the peculiarities of polarized light. With the Spotmatics, make your reading without the filter, apply the correct exposure increase as per filter directions and reset your camera. With the Pentax ES, note the correct unfiltered exposure through the finder, then switch the speed dial to manual control, alter the exposure suggestion as per the filter instructions and shoot the picture on manual shutter speeds and aperture settings.

EXPOSURE

Whether you have ever used a camera or not you have probably heard about exposure. You may know that a film which is not exposed to enough light will give you an under-exposed picture while a film which is exposed to too much light will produce an overexposed picture. Obviously the ideal is perfect exposure. If there were but one single setting on a camera which produced perfect exposure, this might be simple. However, there are many possible perfect ex-posures depending on your subject, what is the most impor-tant element in your subject and just what type of a picture you wish to create.

Although proper exposure is often thought of as the product of the film's speed, shutter speed and lens aperture, another control is inextricably connected to the problem—focus. These four factors will determine at all times the effects that can be achieved with any given subject matter.

Film Speed

We'll start with film speed. Let's briefly examine what we mean by fast films, slow films and medium speed films. When using either colour or black and white, slow films gener-ally need more light to record a picture than do fast films.

In other words, if you use a slow film, you will have to allow more light into the camera with either a slower shutter speed or a larger lens opening than you would with a fast film. You probably know that a large lens opening means that you will have a very shallow zone of sharp focus and a slow shutter speed means that any movement of your subject (or of the camera) will cause a blurring of the picture. Fast films allow smaller lens openings and faster shutter speeds. You can also take pictures in poorer lighting conditions. Why not use fast films all the time? Because the faster films usu-ally have inferior quality—poorer colour rendition in the case of colour films and more graininess in the case of both

colour and black-and-white. You should not choose a film any faster than you really need.

Shutter Speed

Now let's discuss shutter speed. In most cameras with leaf shutters which open and close centrally like an iris of an eye, the concept of shutter speed is visible. When you use a fast shutter speed, you can actually see the shutter opening and closing quite swiftly. With the focal plane shutter, the action is quite different. The shutter travels at a constant speed at all settings from 1/30 sec. to 1/1000 sec. The secret is in the size of the open slit between the shutter blinds. At high speeds the slit is narrow; at low speeds the slit is much wider. A narrow slit passes little light and so produces the equivalent of high shutter speeds. A wide slit passes more light and thus produces the equivalent of a slower shutter speed. The actual full shutter action of the slit travelling from one side of the film area to the other is far longer than the higher shutter speeds set on the camera. The amount of time it takes the full slit to cover a specific point on the film plane governs the shutter speed.

When do you use fast shutter speeds and when do you use slow speeds? Fast shutter speeds stop movement. They minimize any motion of the camera and cameraman and also minimize movement of the subject. It would again seem logical to use fast shutter speeds at all times, but you can't. Fast shutter speeds allow little light to hit the film as compared to slow shutter speeds. If the amount of light hitting the film is low, you must compensate for this by allowing more light in during the short exposure. You can only do this by using a large lens opening.

Lens Apertures

So we come to the theory and use of lens apertures. You can see the difference between a large aperture and a smaller one by looking through your viewfinder. Set the lens aperture ring to a fairly small opening—$f8$ or $f11$. Now press the preview lever. The view through the finder becomes much dimmer because the lens opening has closed down. If you turn the camera around so that you can look through the front of the lens, you'll see the smaller aperture formed by the iris diaphragm blades.

When looking through the finder with the smaller aperture, the view is dim, but you do get more sharpness in depth—near and far objects before and behind the plane of focus appear sharper than when the lens is wide open. This is the proof that you do get more depth of field or a deeper zone of sharp focus (see page 157) at smaller lens openings.

You may wonder just what relationship the so-called f-stops have to the lens openings. The f-stop is a ratio obtained by dividing the focal length of the lens by the actual measured diameter of the aperture of the lens. Low f-numbers mean large apertures; high f-numbers indicate small apertures. Thus, $f8$ is a smaller aperture than $f4$. On Takumar lenses each marked f-number is twice the value in light-gathering power of the next number: $f4$ lets in twice the light of $f5.6$, for instance.

Small lens openings as we've seen, allow you more depth of field (zone of sharp focus). You get more foreground sharpness in front of the object that you focus upon and more background sharpness behind it. In addition, all lenses deliver their best performances at apertures smaller than maximum. Therefore you usually attempt to use smaller lens openings for the most sharpness. But at the same time, you are also trying to use the fastest shutter speed to get more sharpness by stopping movement. This is much like a tug-of-war game. When you increase one element, you lose some of the other. Every exposure is a compromise based on decisions you must make about the light level and how you want to treat your subject.

Exposure Aids

Many years ago there was no definitive aid to setting the shutter speeds and apertures correctly for your camera. At best you followed the small printed slip of instructions which accompanied your film. These instructions gave specific lens openings and shutter speeds for various lighting conditions (such as 1/30 sec. at $f11$ in bright sun). While this might be enough for the average snapshooter with a simple camera, it certainly was highly unsatisfactory for owners of quality cameras. Suppose you didn't want to use 1/30 sec. but wanted to use 1/500 or 1/1000 sec. to stop the action of a soccer game? Suppose the light wasn't exactly bright sun but there seemed to be a slight haze? Suppose the subject

were wearing very light clothes? The number of possible variables which would make the directions on the instruction slip questionable in terms of reliability were practically endless.

A more scientific means of determining correct camera settings was needed—a method which could offer you a wide variety of possible exposure choices depending on your shutter speed and aperture requirements.

The Asahi (Honeywell) Pentax offers three excellent modern metering systems—the fully automatic exposure Pentax ES with built-in meter making a reading right through the lens, semi-automatic Spotmatic and SP500 cameras, also with through-lens metering, and a special spot meter which allows you to make accurate exposure readings even from tiny subject areas at a distance—such as actors on a stage. All of the Pentax systems are the very latest in photographic electronics—a meter with a cadmium sulphide photo-resistor circuit.

The cadmium sulphide meter circuit is extremely ingenious. Think of an electrical circuit consisting of a battery and a resistor. Now think of the resistor as a cadmium sulphide (or as it's commonly known, CdS) type. For that is what the CdS resistor is—a small electrical resistor with a very unusual property. Its resistance varies with the amount of light falling on it. The more light hitting the resistor, the more current it allows to flow through the circuit.

Now if we have some sort of meter in the circuit we can measure the amount of current flowing. By calibrating this meter scale carefully we can use it to give an accurate indication of just how much light is hitting the CdS resistor. This gives an indication of the amount of light reflected by the subject which we want to photograph. Then we must learn just how the meter should be pointed, how the calculator dial should be set for the film that's being used and how to decide which shutter speeds and which lens apertures are applicable to our own picture-taking situations.

To learn how to set the exposure controls of a camera properly, we must first use an exposure meter, a calculator dial (which is far less accurate) or a well-developed ability to estimate exposures (very risky indeed), based on that small piece of instructional paper packed with the film. In our opinion a good exposure meter is mandatory today.

Using Exposure Meters

If you watch most people with a meter, you will see that they often stand at camera position, point the meter in the general direction of the subject and then read the meter dial to find the amount of light reflected from the scene. This is a hazardous and not always accurate method of determining exposure. Let's try to develop a better one.

First, before taking any reading, check the film box or instructions to find the film speed. This essential information will probably be given in either ASA (American Standards Association) or DIN (Deutsche Industrie Norm) ratings or both. Set your meter calculator to this rating before you do anything.

All meters except spot exposure meters are integrating meters—they give you a reading for an entire area depending on the angle of coverage of the meter. In the case of the Spotmatic camera, the reading you get is the integrated reading of the entire viewing area. For many scenes this reading will be quite adequate—most of the fully automatic exposure cameras made today use this reading only in setting the camera. However, in many instances, such a meter reading will not produce proper exposures.

While many exposure meter instruction booklets do cover the exceptions to the overall exposure situations, few instructions for built-in meters do. Let's see quickly just how you should handle each subject. (If you own a Pentax Spot Meter II please turn to the section which deals with this excellent instrument (page 178). It's handling is quite different from that of ordinary meters.)

For scenes with average tonal range in which there is no marked difference between highlight and shadow brightness, use an overall reading from camera position.

For scenes with bright highlights and deep shadows, make exposure readings for darkest and brightest subject areas and take the average between them as the proper setting.

When you want to emphasize the dark areas of a scene with bright highlights and deep shadow take readings from darkest and middle tones. Use average between them.

When you want to emphasize the highlight areas in a similar scene make readings of highlights and middle tones. Use exposure midway between.

When shooting pictures of a landscape with pronounced

METERING METHODS

Simply pointing the camera in the direction of the subject from camera position does not necessarily yield the right reading. Here are some techniques which you should use for best exposure. For average scenes a reading from the camera position is usually quite accurate. However it's advisable outdoors to point the meter or camera slightly downwards when taking the reading to exclude excessively bright sky.

When parts of the subject are in shadow and part in bright light, make a close-up reading of each area; use a mean average of the two for your exposure.

Always take a close-up reading of your principal subject if you can for best exposure. This is most important when any amount of backlight is present. Get close enough to your subject to make an accurate reading without including extraneous back-light. If you want a silhouette, however, expose for backlight only.

Often you won't be able to get close enough to your subject for a close-up reading. If you can hold the palm of your hand in the same type of light as the subject, you can read your palm and get an accurate reading of the fleshtone of your subject. For general scenes a better substitute is a neutral grey card available from many photo dealers.

Watch out for arches or other foreground shieldings which may give you an erroneous reading of your more distant subjects. If necessary, move forward to exclude unwanted foreground.

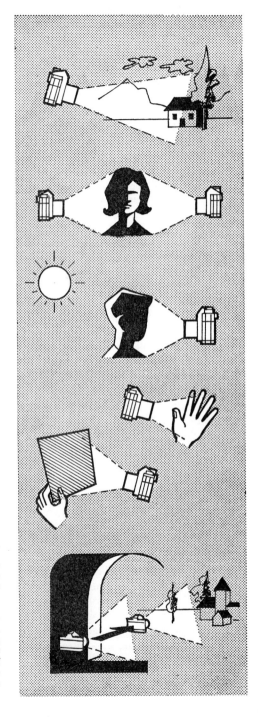

sky area, tilt meter downwards slightly to prevent bright skylight from inflating the reading.

When you are standing in a different light than the subject, try to approach closer for a more accurate reading.

With a sidelit subject take readings of highlight and shadow areas. Average them. If you wish one or the other to dominate, alter exposure accordingly by taking readings of dominating tone and middle tone, then using average.

For subject backlit, approach close and take reading blocking out extraneous light from behind the subject.

For a silhouette, point meter at light—sky, sun, etc.—beyond subject. Use this reading.

For water scenes, take reading from palm of your hand in the same light. Use this reading to avoid inflated exposure caused by reflection of light from water.

For shooting extreme close-up pictures or copying documents, take a reading from a neutral grey card (available from your photo retailer). Place card where subject would be and in same light. If you don't have a grey card, try using the palm of your hand. Make certain shadow of meter doesn't fall on the palm of your hand. Also get meter sufficiently close so it will measure your hand and your hand only.

Making special area exposure meter readings with the fully automatic exposure Pentax ES camera can be done quite easily. For most subjects, of course, the exposure automatically set with the camera on standard automatic exposure settings will suffice. However when you do wish to use a special reading such as those we've described, simply make the reading and note in the viewfinder and on the aperture scale the suggested settings. Now move back again to actual shooting position and use the exposure factor control dial or the manual shutter speeds to achieve just the exposure that you want.

Choosing the Right Setting

Once you have accurately measured the light, you will see on your meter scale or dial an embarrassing choice of riches. You don't have just one possible exposure setting, you have a whole series. If, for instance, your meter indicates 1/30 sec. at f11, you will also note from the meter that you can use 1/60 at f8, or 1/125 at f5.6 or 1/250 at f4 and so on.

All of these are exposures of equal value. As the shutter

HOW FOCAL LENGTHS COMPARE

While there are many different reasons for using various focal length lenses, one of their primary purposes is to change the size of the subject and the angle of view. Here are the important Pentax focal lengths used in turn on the same subject from a fixed camera position. From left to right, pictures were made by Takumars in the following focal lengths: 18 mm., 28 mm., 35 mm., 50 mm., 55 mm., 85 mm., 105 mm., and 135 mm. Note the unusual perspective of the 18 mm.

Above, left to right, we have 200 mm., 300 mm., 400 mm., and 500 mm.
Below is an enlargement of a picture made with 1000 mm. Compare
this with the first 18 mm. Takumar photo on the preceding page.

A LONG LOOK

(*Above*). Down the track, right at the photographer—only he is far away, behind the 1000 mm. Takumar lens. A 1/500 sec. stopped action, fast film allowed f/16 for depth of field. (*Below*). Unable to approach these elephants, Gordon Warsberg used a 500 mm. lens at f/16 with a 1/250 sec.

WIDE ANGLE SCENIC

Too many photographers simply use their wide angle lenses to take in a greater view of far distant subject material. Actually it is most important to consider the foreground and middle ground area. If it is barren, a wide angle lens will make it look more so. The Piazza San

Marco in Venice, famed for its pigeons, provided an excellent study in both width and depth for the incredible 18 mm. Takumar. Note extreme depth of field even at $f/11$ from pigeons in foreground to building in background. Curving lines of buildings is typical of the distortion produced with this lens.

149

GRAND PRIZEWINNER

Page 150 (*top*). Winner in Asahi's International Photo Contest was the famous Max Jacoby picture showing the crowd out to greet U.S. president, John F. Kennedy, on his visit to Berlin. Jacoby used a 135 mm. *f*/3.5 Super Takumar and made the exposure at 1/250 sec. *f*/9.

MULTIPLE EXPOSURE

Page 150 (*bottom*). Alix Jeffry of the United States photographed the subjects singly using a 35 mm. *f*/3.5 lens on his Pentax SP, full aperture at 1/30 sec. He then carefully combined the images in printing.

RHYTHM PATTERN

(*Above*). By reprinting negatives of two girls many times on a single piece of enlarging paper, Joesf Helmers of Belgium has produced a fascinating rhythmic pattern. Original photos were made at 1/125 sec. and *f*/11 using an 85 mm. *f*/1.9 lens on a Pentax SP camera.

AT THE ZOO

Page 152. This Penguin was on one side of barrier. Photographer K. Niiyama was on other. A 135 mm. *f*/3.5 Takumar brought them fairly close together. Exposure was *f*/11 at 1/125 sec.

speed gets faster, the lens opening gets larger. Therefore the same amount of light hits the film, no matter which pairing you choose.

Occasionally you will find that your meter does *not* give you a clear cut, marked exposure indication. For instance, the meter may suggest 1/125 half way between f4 and f5.6. But that's no problem here. You simply set your Takumar lens aperture ring midway between the two lens openings and you'll find that there is a built-in click stop setting to take care of just such in-between readings.

But which of the many varieties of exposure settings should you choose? Until recently the general rule was to use a fairly small lens opening—f11 or f16 where possible, instead of f1.8, f2.8 and to compensate for this by using a slower shutter speed.

This, of course, gave you far more sharpness in your picture from foreground to background. You can see this by examining the depth of field scale on your Takumar lens. Note how the large aperture markings on the depth of field scale—f1.8, f2, f2.8 are right close together. They delineate the near and far boundaries of the acceptable sharpness on your focusing scale opposite. But look at the markings for f11 or f16. See how much further apart they are. When you compare them with the focusing scale you see that far greater depth of field is possible with these small openings.

For many years great depth of field was thought to be most advantageous in photography. It meant the subject focused upon was sharp and so was a good deal of territory in front of and behind the subject. However, photographers have been rethinking the problem of shutter speed versus lens openings. Many now feel that the old ways were not necessarily best.

By using a small lens opening and getting a great deal of depth you do register much foreground and background sharply. Is this good? Many photographers think that the rest of the picture when delineated sharply actually detracts from the viewers' concentration on the main subject. They also point out that a picture with sharpness, foreground to background, is directly opposed to the natural way we see subjects. When our eyes focus upon a subject, objects in front of and behind this plane are out of focus. Therefore the small lens opening often distorts the picture we would see

153

with our naked eye. A larger lens opening which showed the main subject sharp but renders the rest of the scene softly is far closer to seeing reality.

Further, after much study, many professionals discovered that much unsharpness in pictures made with good equipment comes from the use of an inadequately fast shutter speed. A slow shutter speed can emphasize not only movement of the subject but also movement of the camera. And with more and more present day camera owners concentrating on moving subjects and more and more photographers disregarding the tripod except when absolutely necessary, a faster shutter speed would certainly seem advantageous. Therefore many photographers today advocate the reverse of the old school teaching. They suggest a fast shutter speed to stop action of subject and movement of camera user and a larger lens opening to throw the distracting matter around the subject out of focus.

Of course, there will always be exceptions to the rule— pictures where you will deliberately want sharpness from foreground to background or photographs where you will want a slow shutter speed to show a blurred action, indicating speed. However, only by actually trying faster shutter speeds and larger lens openings and then comparing the pictures you make in this manner with the small aperture, slow shutter speed variety, will you be able to make up your own mind about the controversy.

Previewing the Picture

The Pentax camera is admirably equipped to help you preview just what will and what will not be sharp in your pictures. Each Super Takumar lens has a preview lever shaped like a half moon near the top of the lens barrel where it can be moved with a finger of your hand. By moving the lever, you can close the lens down to whatever aperture you have set. You can then "preview" how much sharpness you are going to get in your picture by examining the picture area on the ground glass.

When SMC Takumars are used on the Pentax ES camera, the depth-of-field preview levers are inoperative. Instead, you can preview the scene by pushing upwards on the "MAN" switch. Remember to return it downwards after use.

Of course this is simply an approximation of your

real depth of field. You are only looking at a small ground glass magnified about 5×. Some areas will appear sharper on the ground glass than when they are enlarged on a print or on a projection screen. If it's essential to know exactly how much sharpness you are getting, you will find the depth of field scale on the lens more accurate and the depth of field tables at the end of this book even more so. But the depth of field preview lever can be a very practical "in the field" tool.

Not all Takumar lenses have depth of field preview levers. The Auto-Takumars and Takumars—all the way up to the 1000 mm. ƒ8 don't need any. With these lenses you can close the aperture down manually to the correct opening you intend to use. After previewing your picture, you can reopen the lens to full aperture for focusing.

This preview facility is useful because it is always best to focus when possible at full lens opening. At maximum viewing aperture your picture is at its brightest and depth of field is at its smallest. This means that as you focus, the picture will "snap" in and out of focus with much more alacrity than with smaller apertures. At first it may seem puzzling as to why this is an advantage. Wouldn't it really be better if you used a small lens opening where the image seemed in focus over a greater range? The key to the answer is in the word "seemed". Actually no matter what aperture you use, critical sharpness is only maintained in the precise plane on which you focus. The so-called depth of field is an area in depth before and behind the subject where sharpness is *considered* acceptable. Sharpness falls off slowly in front of and behind the plane of focus. At the point where we consider the picture no longer to be acceptably sharp, we place the limits of the depth of field. Therefore to pick and focus upon that important plane of critical sharpness you should always focus at maximum aperture where the plane of critical sharpness can be determined most easily.

Matching Settings to Subject

Now let's get back to those peculiarities of choosing the right shutter speed and aperture from that large series of possible shutter speeds and apertures. There is no set rule as to which set of equal exposures you use. You must choose your exposure settings to match your picture taking conditions. Often

this requires very good judgment—the type of judgment no automatically-operating camera will ever be able to do all by itself.

Obviously when you are faced with a subject in movement, you should immediately use the fastest shutter speed possible. However, there is a danger in carrying this to extremes. Is $1/1000$ sec. or $1/500$ sec. at $f1.8$ or $f2$ really a more intelligent choice than $1/250$ sec. at $f2.8$ or $f4$? The answer, of course, is no. You should reserve the very large apertures of $f1.8$ or $f2$ for those low lighting conditions where only such apertures will make picture taking possible.

The reasons: first there's the depth of field problem again. The depth of field at maximum or nearly maximum aperture is so perilously shallow that any slight error in focus or movement of the subject in depth will produce a picture without acceptable sharpness. In addition, no lenses for any modern 35 mm. cameras—not even the Takumars—deliver their very best sharpness at maximum apertures. These apertures should be thought of as a reserve—like knowing your car can do 125 miles per hour. Use only when absolutely necessary.

For average picture taking it's advisable to use lens openings smaller than $f4$ or—stretching things a bit—$f2.8$. You will find the $f5.6$ to $f8$ or $f11$ range a very good one. Now for the speed problem.

Much nonsense has been written about shutter speeds. You probably have seen or heard of many charts and tables ostensibly telling you just what shutter speeds you need to halt certain actions. The speed set depends on the type of action, the direction the subject is travelling and the distance the action is away from the camera. The error of such a table can easily be discovered by examining the problems of photographing a man running. His body may be moving at one specific speed forward which can be stopped at the speed suggested by the table. But his arms and legs must certainly be moving at a far greater speed. A locomotive may also be moving at a specific speed, stoppable by a certain shutter speed setting. But the wheels are actually revolving at a faster speed.

What we are discovering is that most objects in motion do not have a single stoppable speed but instead, a number of motions at different speeds.

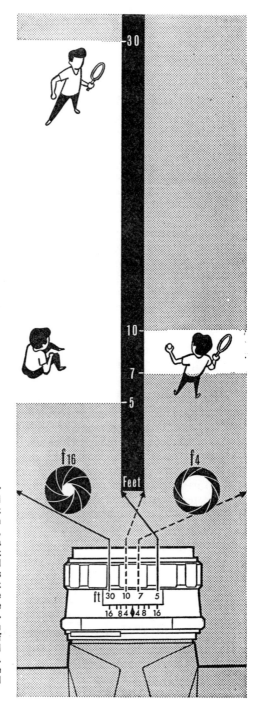

You can check your approximate depth of field at any time by glancing at the depth of field scale on your lens. If, for instance, you are focused upon a subject at about $8\frac{1}{4}$ feet away, the depth of field scale on your normal lens will look much like that below. Simply read the depth of field between the two lens aperture indicators. For instance, if you were using an aperture of f16, depth of field would extend from 5 ft. to 30 ft. However, if you were using f4, depth of field would be but 7 to 10 ft.

We can also dispense with the belief that it is possible to use a slower shutter speed when the subject is at a distance. It is true that the subject will look less blurred if you produce only a small print but if you make enlargements to give the same-sized image from the two different viewpoints, you will get precisely the same amount of blur. In colour, of course, if you project all your slides at the same magnification, the more distant viewpoint will give an apparently sharper image—but the subject will be much smaller.

On the other hand, a subject moving directly across in front of the camera will be blurred to a greater degree than a subject which is moving diagonally across or is heading straight for or away from the camera. However, you can stop movement of the subject comparatively simply by moving (panning) the camera so as to keep the subject in the same position in the viewfinder. You follow your subject as a hunter might follow a flight of ducks. Pan smoothly with the camera held steady in the hands. Move the body at the hips and fire as you pan. Don't stop panning as you release the shutter.

Shooting Action

What's the right shutter speed to use? Why the fastest you can, of course, depending on the film you have, the lighting conditions and the necessary lens opening. When shooting action, with a single subject in movement, such as a child, try to keep your aperture no larger than $f4$.

When shooting action such as football or hockey you may need a small lens opening to get enough subjects sufficiently sharp in the picture. Your choice: more sharpness because of a smaller lens opening or more stopping power because of a greater shutter speed? The higher shutter speed at the expense of sharpness in depth is probably the right choice in nearly every picture-taking situation, particularly where your shooting distance is rather long, as it may be at sports events. But don't overdo it and open the lens further than $f2.8$.

Let's turn from action to two other types of general subject material—portraits and general scenes. How should they be handled in terms of proper exposure selection?

Settings for Portraits

In portraiture it might also be assumed that the most sharp-

ness from front to rear of the subject is required. But this is not necessarily so. If you examine the depth-of-field scale on your lens or the tables in the back of this book you'll note that depth becomes far less at close focusing distance—such as portraits—than it is in medium or distant shots. Therefore in order to register a portrait head in sharp focus from nose to back of ear, for instance, it is essential to use a very small aperture—$f16$ is none too small. Unless you have a great deal of light or you are using a rather fast film, a small aperture will probably require a lengthy shutter speed. This may mean 1/30 sec. or even more—1/15, 1/8 or longer. At such slow shutter speeds, a tripod is really needed to assure sharpness. And your subject must certainly remain quite still. The combination of added paraphernalia plus the necessity of requiring your subject to freeze in a pose generally produces a very static picture unless you're working with a professional model used to posing.

Professional 35 mm. camera users who specialize in portraits have been slowly weaned away from the small aperture and now think nothing of lens openings of $f4$, $f5.6$ or $f8$ for really good technically high-quality portraits. They feel that the human eye sees a person more like a lens with a large opening than a lens with a small one. When you talk to a person, you generally look them in the eye. Other parts of their head, nose, ears, become far less important and actually are unsharp unless you shift your gaze right to them. Modern-day 35 mm. portraiture often calls for just such an approach —pinpoint focus on the eyes. You'll be surprised in a head-on portrait how very little the sharpness of nose or ears matters. It's essential that your plane of sharpness be highly detailed. The rest of the subject surprisingly takes care of itself.

A larger lens opening of course, means that you are able to use a higher shutter speed. It is no longer necessary for your subject to remain absolutely motionless. And you won't need a tripod either. With your camera and subject relaxed, you have a far better chance of a natural and more exciting portrait.

Lastly let's consider general scenes and landscapes briefly in terms of focus and exposure. Here, too, quite often you may be misled into thinking you need a small aperture when you don't. Many a landscape subject really has no close subject matter and could actually be shot at full aperture as

far as depth of field is concerned. However, since we do know that no lens produces its best results at full opening a small aperture is recommended. But there's no reason why a landscape can't be photographed at $f4$ or $f5.6$. Don't use a small aperture just because you've always heard that small apertures are employed in landscape pictures! Of course if you have a subject in the foreground or are attempting to frame your distant scene with near foliage, you should use a smaller lens opening which will register both foreground and background sharply. However, it's quite obvious that it may be most intelligent to think in terms of a large aperture and high shutter speed at all times and modify this depending on the subject matter instead of thinking the other way around—slow shutter speed and small lens opening —as most photographers have been doing almost since the advent of photography.

We've discussed what should be the largest aperture normally required—$f2.8$. How about shutter speed? What is the most advantageous range for picture taking? Many photographers feel that the $1/125$ sec. is almost the ideal compromise since it can stop a good amount of action, it does minimize camera movement and yet it's not so high that you may need a very large maximum lens opening. It's wise at all times to remain above $1/30$ sec. when hand holding a camera. At slower speeds even the photographer's breathing or the tiny movement of a subject will cause the picture to lose sharpness. It is true that many professional photographers do pride themselves on the ability to hand hold very slow shutter speeds and produce sharp pictures, but the percentage of photographers who really can do this is small and the number of successful shots that these photographers can make in this manner is also minute.

You can see now why we stressed the importance of focus in this chapter in exposure. Focus pinpoints what you and your camera are viewing while the exposure settings determine the depth behind and in front of the critical focus and also govern what can and cannot register in your picture. We'll go into this more critically in the individual chapters on black-and-white and colour film.

Using Depth of Field

There are a few tricks of the trade in focus however which

can make picture taking easier and give you more sharpness for any exposure. One is the intelligent use of depth of field. As we've seen, at any aperture there is a certain amount of acceptable sharpness in front of and behind the main subject (which we call the zone of sharp focus or the depth of field). The smaller the lens opening, the more the depth of field. The closer the subject, the less depth of field. And we have seen in the chapter on Takumar lenses that focal length also is directly connected with depth of field.

Surprisingly, even very few professional photographers use depth of field properly. Most waste it. Actually if you don't need it in one spot you can sometimes transfer it to another where you do need it. Here's how this works.

Suppose you are photographing a man standing at 15 ft. from the camera. If you focus on him the depth-of-field scale on your lens (for more exact figures, consult the depth-of-field table in the back of this book) will indicate a depth of field from about 10 ft. to 35 ft. In other words, anything between these two distances will appear in adequate focus. Let's say you have a beautiful landscape in the background. Of course the depth-of-field scale will indicate that the background won't register sharply. However by shifting the depth of field you can achieve sharpness in the background with little sacrifice to your main subject. Here's how you'd go about it in this case. Instead of keeping the main focus at 15 ft., shift the focusing ring on your lens to approximately 35 ft. (slightly over 30 ft. or under 10 metres will do nicely). Now look at the depth-of-field scale on your lens. It will show that everything between the original 15 ft. setting and infinity will be adequately sharp. You then have both main subject and landscape background in adequate sharpness within the depth of field. All you've really lost is the depth of field you had in front of the subject which you were not using. Always keep in mind that you can shift your main critical point of focus to either end of the aperture markings on the depth-of-field scale—if you need extra sharpness beyond the normal depth of field—provided you won't mind losing sharpness at the other scale end. You will, of course, lose some slight sharpness of the main subject if you do this. As explained before, only one plane in the picture—that on which the camera is actually focused—will be critically sharp. If you do intend to shift depth of field,

then you must accept a loss of critical main subject sharpness in return for a gain in overall picture sharpness. With a little practice using your depth-of-field scale on the lens you'll be able to make adjustments, if and when necessary, quickly and correctly.

There is still another possible shifting of the depth of field which can be used. This involves the so-called hyperfocal distance. If you are taking a picture of a landscape, you may find yourself focusing at infinity or nearly so. By consulting your depth-of-field scale on the lens you can quickly establish the nearest point of your depth of field for any lens aperture. But what is your far point? Theoretically it extends beyond the infinity marking. This, of course, is useless depth. Photographically there's nothing beyond infinity. You are possibly wasting valuable sharpness in your depth of field. You can shift the infinity marking of your lens from the centre focus mark to the depth-of-field scale aperture you intend to use. You thereby gain much more depth of field in the foreground (see diagram opposite).

If you originally were focused on infinity, you can shift your focus to the far point of depth of field at the aperture you're using. Then everything from half this distance to infinity will be in focus. This distance at which you set your lens to get such depth is called the hyperfocal distance. Let's take an example. If you are using $f11$ and have your lens focused at infinity, your near point of focus on the depth-of-field scale would be roughly about 30 ft. Now if you line up that 30 ft. marking with the centre line of the focusing scale, you will see that the infinity marking is still within the depth of field (on the left-hand side of the $f11$ aperture marking on the lens' depth-of-field scale). But look what you've gained on the right-hand side. Your nearest point of sharpness is about 15 feet. By shifting the focusing scale and using the hyperfocal distance you've increased the depth of field from 30 ft. to infinity to 15 ft. to infinity.

While this aspect of depth of field may be slightly difficult to grasp at first, some work with the depth-of-field scale on practical problems should make it quite clear. When there doesn't seem to be enough depth of field or sufficient zone of sharp focus, don't give up. If you can't use a smaller lens opening try shifting the zone as you want it. (You can often gain far more sharpness by shifting the focus and thus the

PROPER USE
OF DEPTH OF FIELD

Here are two examples illustrating how you can shift your depth of field so it does more work for you.

A. Here you have focused upon a main subject at 15 ft. The depth of field in front of subject is wasted because there is no useful subject material. However, the landscape behind is out of focus, outside the depth of field.

B. By changing your focus setting so that the 15 ft. distance is at the near depth of field mark instead of at centre point, you have now shifted your depth of field so that it extends from your main subject backwards to infinity, thus producing an adequately sharp background.

C. Here's another case of misused depth of field. You have focused your camera at infinity for a landscape. But much of your depth of field is lost beyond the infinity point.

D. By shifting the infinity setting on the focusing mount until it coincides with the near depth of field mark on your lens aperture scale, you have also shifted your depth of field into a more useful position. Depth now extends from 15 ft. to infinity.

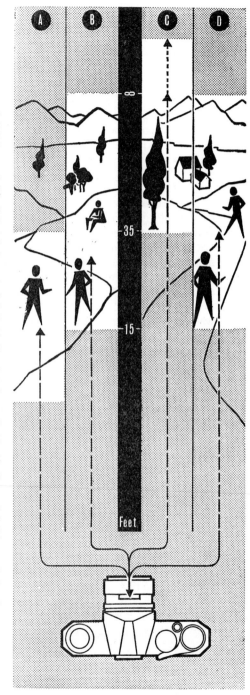

depth of field than you can by attempting to use a slightly smaller lens aperture. And you don't have to sacrifice shutter speed at all.)

Brightness and Contrast

Before we leave the subject of general exposure, there are a few considerations that you should keep in mind when choosing exposure and when operating a meter.

Correct exposure is always easier to determine for flatly lit subjects. You need not worry about highlight detail or shadow detail. Slight errors in judgment are not necessarily fatal. However, as brightness range in the picture increases (the difference in measurable illumination between the darkest part of a picture area and the brightest) troubles in determining exposure begin.

Unfortunately no film is capable of registering the brightness range that you can see with the human eye. As you scan a brilliantly lit scene, the iris of your eye can automatically accommodate for brightness change by opening up further to show you detail in dark shadows and then closing down when you look at a brightly lit area. If you switch your view quickly and don't give the irises in your eyes time to accommodate to the new lighting condition, you will momentarily experience the same problem your camera has many times permanently, an inability to really see detail in what's in front of you. Perhaps the most usual illustration of this is in your discomfiture on entering a darkened cinema from the daylit street. If there is no attendant to light your way, it is an appreciable time before you dare go in search of a seat.

As we'll see in the two chapters on black-and-white and colour film, there are specific limitations as to the brightness range that a film can encompass. In the case of black-and-white film, the range is rather wide. Only by special print manipulation can you get on to printing paper all the highlight and shadow detail that is inherent in a wide brightness range negative. However, by careful exposure you can get an amazingly detailed negative with today's films under surprisingly contrasty conditions. The trick of reproducing it is in the printing. However, when exposing for colour you will not be nearly as fortunate. Colour films, simply do not have the ability to reproduce colours correctly in a great range of brightnesses. It's necessary to make your choice as

to what part of the brightness range you wish to render most correctly and then take a close-up reading of this area if possible.

In this chapter we've given you the exposure basics for both colour and black-and-white which will allow you to handle most normal picture taking situations adequately. The problem of exposure is understandably a large and almost never-ending one. Every roll of film you expose will teach you more for future shooting.

THE PENTAX EXPOSURE
METERS

Certainly two of the most important accessories for users of the earlier Pentaxes without meters are the two separate exposure meters. The clip-on meter is designed to fit the S1, H1, H1a, S1a, S3, H3, SV and H3v cameras. It will not fit older models nor will it fit the Spotmatics, SP500 or Pentax ES or SL models. These last except the SL have their own behind-the-lens metering systems, and so do not need a separate meter.

Attaching the Clip-on Meter

The clip-on meter is an accurate, easy to use, very sensitive and highly selective instrument. To attach it to your camera, you depress the two release levers on either side of the meter eyepiece and slip the meter over the prism housing. You then release the levers and the meter locks in place. The meter couples directly to the shutter speed dial. To lock the coupling, rotate the meter shutter speed dial until the coupling pin on the bottom of the meter dial couples with the slot in the camera's shutter speed dial. It will click into place and drop slightly downward. To check the coupling, simply turn the meter shutter speed dial. The camera's shutter speed dial should rotate with it.

To use the meter you must first set the ASA index for your film on the film speed setting collar. This scale is located around the meter's coupling pin, underneath the meter shutter speed dial. The ASA indexes are clearly marked white on black. A ribbed indicator ring with white dot must be set to the correct ASA index. You will probably find it easier to set this ring if you take the meter off the camera. Hold the ribbed film speed dial firmly between your right thumb and forefinger so it doesn't turn. Make sure the white dot is upwards where you can see it. Now with your left thumb and forefinger rotate the shutter speed dial of the meter. As it rotates, you will see that the white dot will change ASA indexes with a positive click for each set-

166

CLIP-ON METER FEATURES

Here are the features of the Pentax clip-on and coupled exposure meters.

1. Shutter speed dial.
2. "Low", "High" and "Off" switch.
3. Battery check button.
4. Needle indicator.
5. F/stop scale.
6. Light window.
7. Film speed dial.
8. Film speed setting.
9. Battery hold down.
10. Mercury battery.
11. Zero adjust screw.
12. Camera attachment clips.
13. Shutter speed coupling pin.
14. Release lever.
15. Film speed index mark.

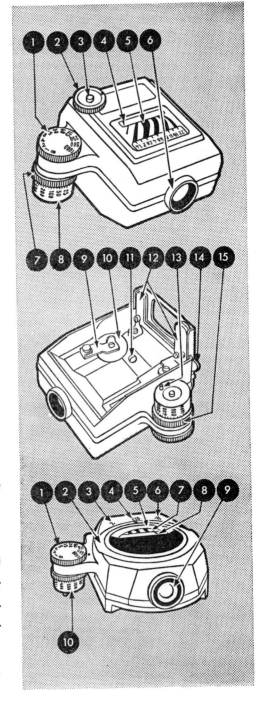

Here are the features of the earlier clip-on meter.

1. Shutter speed dial.
2. "Low", "High" and "Off" switch.
3. "Low" light position.
4. "Off" light position.
5. Aperture scale.
6. "High" light position.
7. Needle indicating scale.
8. Needle indicator.
9. Light window.
10. Film speed setting.

ting. Continue turning the shutter speed dial until the proper ASA setting is opposite the white dot. Then replace the meter on the camera as previously explained.

The meter has a three-way switch on top marked L (for low light), H (for high light) and "Off". When the meter is not in use, the switch should be set to "Off" to conserve the current of the small mercury battery which powers the meter circuit.

To turn on the meter, rotate the switch to the H position and point the meter towards the subject. If there is insufficient light to move the needle indicator on top of the meter to the first broad black stripe on the meter needle dial, turn the meter off again and rotate the switch in the other direction to L. When you change switch positions you are actually shifting both the meter cell's sensitivity response and the aperture scales from a high light reading scale to a low light reading scale. However, never set the "L" for low light setting until you have found that the "H" for high light scale is not usable. If bright light hits the meter cell while it is in the low light position, the cell can be permanently damaged or at least temporarily made unable to measure low light illumination accurately. If you do point the meter at a bright light which causes the needle to swing violently upwards to the top of the dial while in the "L" or low light position, the sensitivity of the meter will generally recover if you shut the meter off for about 5 minutes. This is a characteristic of all meter systems which use cadmium sulphide circuits.

Reading the Meter

To make a reading with the switch in either the low light or high light positions, turn the shutter speed dial of your meter to the setting you wish to use, note the position of the needle indicator on the scale and read off the recommended aperture opposite the appropriate broad black or chrome band. Set the camera's lens to this aperture and you're ready to make a picture. Of course you can work the meter in reverse as well. Turn the shutter speed dial until the aperture you intend to use and have pre-set lines up opposite the meter needle. The camera's shutter speed will then be set for that aperture.

The advantage of the clip-on meter is two-fold. First you have a compact meter which has actually become part of the

EXTENSION TUBE CAT

(*Above*). Flash, slightly above the cat (named Oscar) highlighted the furred facial textures. A No. 2 extension tube allowed R. Anthony Lovatt's 55 mm. *f*/2 Super-Takumar to focus sufficiently close for this feline portrait. Even so, the photo represents but $\frac{1}{2}$ of the original negative area. Note that with a simple flash set-up only one highlight appears in each eye, a number of such highlights are confusing and look unnatural, especially with animal subjects.

SEA HORSE

Page 170.　　Although the standard lenses of most Pentax cameras permit pictures to be made at a minimum of 18 in., it isn't sufficient for extreme close-ups. H. Inoue Fukuoka used extension tubes and electronic flash to make this close-up of a sea horse. His 55 mm. *f*/1.8 Super Takumar was closed down to *f*/16. When photographing subjects in a tank from the outside, it is advisable to place the lens right up against the glass to avoid troublesome reflections. On nearly all lenses the flange protrudes further forward than the lens surface and so there is no risk of damage to the optical surface when using this technique. Furthermore the side of the glass tank can be useful for steadying the camera where no alternative support is available.

NORMAL LENS ALONE

(*Above*). A bird in the hand is easily captured on film with the close focusing normal 55 mm. *f*/1.8 Super Takumar lens at its minimum 18 in. setting. Ennio Citta used 1/250 sec. to make certain the subject and hands would not be blurred but had to sacrifice depth of sharpness in the hand with an *f*/4 aperture, in order to base the exposure on the subject itself. A small dark subject in relatively bright surroundings needs special care with exposure. A general meter reading would be only a basis to work from, the lens would then be opened two stops or so to achieve good detail in the feathers. But care must be taken to focus accurately with such a small depth of field.

EASY WATER DROPLETS

Page 172. Freezing droplets of water is actually very simple if you have Pentax extension tubes and the necessary electronic flash unit to stop all movement. Just drop a small object into water and shoot the picture. Timing only takes practice. K. Kurata's 55 mm. *f*/2 Takumar was attached to extension tube Nos. 2 and 3. His exposure was at *f*/16.

FROSTY CLOSEUP

Page 173. Crystalized frost on a window in winter was the subject of Peter Millan's closeup made at $f/16$, $1/60$ sec. with a 55 mm. $f/1.8$ Super Takumar lens.

MACRO PHOTO

Page 174. For extreme closeups of insects, a bellows unit is very useful. Here an insect's multi-faceted eyes are caught with a 50 mm. $f/1.4$ Super-Takumar lens set at $f/22$ for maximum depth of field (which is very shallow in closeup work). The electronic flash unit was manoeuvred to obtain proper exposure so that the small aperture could be maintained.

CATERPILLARS

Page 175. Special lighting isn't always necessary or closeups of insects. N. Miyazaki photographed these larvae with his 55 mm. $f/2$ Takumar lens at $f/8$. Shutter speed was $1/30$ sec.

WINDOWLIGHT

Page 176. Sunlight through a kitchen window illuminated this day lily for James Gianelos. His wife held a piece of black paper from a box of printing paper behind the flower to serve as a backdrop. Exposure with a $f/2.8$ Super Takumar lens on extension tubes was $f/22$, 2 sec.

camera, obviating any need for a separate, dangling accessory meter. Secondly, you have eliminated one usual meter step since the meter is coupled directly to the shutter speed dial.

The meter reads an angle of view of 40° to match the angle of view of the normal lens. It accommodates all films with ASA indexes from 6 to 1600 and, of course, has all apertures found on Takumar lenses from f1.4 to f22. As these lenses have half f-stop click positions, you can also read and use meter needle positions half way between actual marked apertures.

In the "off" position, the meter needle indicator should line up with the short black line at the right of the meter needle scale. If it does not you can readjust "zero point" by turning a small zero readjust screw on the back of the meter.

Changing the Battery

The mercury battery of the clip-on meter should last about a year. Mercury batteries, unlike standard alkaline cells do not weaken slowly. They decline rapidly in power towards the end of their life and you should have a replacement available. You can check battery life in an instant. At the hub of the light level switch is a small green button. When the button is pressed, the meter needle should swing over the meter scale to a green scale marking. If it does, the battery is usable. If it does not, the battery needs to be replaced.

On the underside of the meter you will find a circular battery hold-down cover and arm. Swing the arm to the side, off the cover. Turn the meter itself right side up with your hand cupped over the meter bottom. The battery hold-down cover and the mercury battery within will fall into the palm of your hand. Replace the battery with a Mallory 625 or similar mercury battery.

For proper methods of taking exposure meter readings with the clip-on meter, see pages 142–144.

Should you wish to keep the clip-on meter attached to your camera at all times, you can purchase a special Pentax carrying case or case front which provides sufficient room for both camera and meter attached.

The Asahi Spot Meter

The second accessory meter made by Asahi ranks as one of the most accurate and useful exposure measuring instruments

P.W.—I

in the world. This is the Asahi Pentax Spot Exposure Meter Model II (called the Honeywell Pentax 1°/21° Meter in the U.S.). This meter, unlike the built-in through-the-lens meter of the Spotmatic camera or the Pentax clip-on does not attempt to produce an average reading of the entire picture area. Instead it accurately measures a spot of only 1° of arc —but from any distance from the subject.

The spot meter is particularly useful when long-focus lenses are used. With it you can make an extremely accurate reading of a distant object—an on-stage performer right from your theatre seat, a boat far out in the ocean. You need not attempt to take close-up readings by approaching close to the subject or finding an appropriate substitute nearby. It can also take readings from very small objects, such as a tiny flower a dozen feet away. Moreover, it gives you an accurate check on the relative brightness of all objects within the picture area, which can be useful if you are afraid that the brightness range of a scene may be too great for accurate colour reproduction.

The spot meter consists of a one-piece body with attached handle made out of high impact, crack-proof plastic. At the back of the housing is an eyepiece which allows you to view the scene through the lens at the front of the meter. When you hold the meter to your eye you will see a right-side-up rectangular viewing image of 21°. If the view reminds you of the view seen through a Pentax finder, it isn't surprising. The meter uses the same interior pentaprism. In the centre of the field you will see a small engraved circle. This 1° circle is the area actually measured by the spot meter.

Using the Spot Meter

The actual operation of the spot meter is relatively simple. Hold the meter to your eye by grasping the handle. Turn the adjustable eyepiece until you can see the engraved scale within the meter clearly. Don't try to look *through* the meter at a scene. Instead concentrate your eye focus *on* the scale engraving itself. Point the meter at the subject to be measured. Place the centre measuring ring directly over the most important or representative area of the subject. The meter needle within the finder will climb to a point on the meter scale. If it does not move, there is insufficient light to use the meter's high light scale. Press the large button

METER ANGLE COVERAGE

Your clip-on Pentax meter covers a 40° angle of view which is just slightly less than the angle seen by the normal lens of the camera. The Pentax Spotmatic camera behind-the-lens meter sees a 46° angle of view duplicating the exact angle of the 50 mm. lens. However, this metering angle varies with each different focal length fitted to the camera. The Pentax Spotmatic's meter always covers the same angle of view as the lens fitted. The Pentax Spot Exposure Meter covers a very narrow angle of 1° to give you pinpoint exposure accuracy of even a tiny area at a great distance.

marked "L" located in the trigger finger position on the front of the spot meter. This shifts the meter on to the low light scale. Read the needle indication on the lower scale marked L.

Under no circumstances point the meter at a bright light while pressing the "L" button. The extremely sensitive meter circuit can be permanently damaged if you do. In low light, allow the needle sufficient time to reach a true stopping position. If it continues to rise or fall slowly, wait for the needle to stop.

The calculator dial for the spot meter is located on the left side. First set the ASA or DIN film speed index in the two central curved film speed windows. To do this, push on the two metal nipples so that the inner calculator dial rotates to the proper ASA setting. Now turn the outer ring to match the light level number read by you against the white triangular pointer at the bottom of the calculator dial. You can now read all the possible f-number and shutter speed combinations on the outer rings on the top of the calculator dials. Any of the couplings will produce correct exposure. The entire dial is marked in full f-numbers and mathematical shutter speed progressions but there are in-between markings indicating $1/3$ f-numbers as well.

A spot meter must be used with much thought. If it is, it will certainly yield the best exposed pictures, particularly with colour transparency films where exposure must be extremely accurate.

The single meter reading made from one part of a subject will seldom be sufficient in actual shooting unless the single object read has a brightness the same as the rest of the picture area. To use the meter fully, take a reading of the brightest area in which you wish to hold high light detail. Then make a second reading in the shadow area in which you wish to hold detail. Use the calculator dial to find the proper exposure for each of these areas. In black-and-white photography films can generally handle any brightness range up to 7 full f-stops. In other words, should the shadow reading suggest $1/30$ at $f2$ and the high light reading come to $1/30$ at $f16$, an exposure of about $1/30$ at $f5.6$ will give you a negative adequately exposed through the whole range. Negative colour film would probably find this a little too much and it would be advisable to bias your exposure

SPOT METER III

1. Objective lens.
2. Zero adjustment screw.
3. Battery checker button.
4. Switch button for low light.
5. Adjustable eyepiece.
6. Shutter speed scale.
7. Diaphragm scale.
8. DIN scale.
9. Index for DIN scale.
10. ASA scale.
11. Index for ASA scale.
12. Light level scale.
13. Index for light level scale.
14. Battery housing cover.
15. Outer ring for matching light level.
16. Film speed setting plate.
17. Nipple for turning inner disc.
18. Scale illuminator button.

When using meter, place small central spot over area to be read. In bright light read needle on top H scale. In low light read lower L scale. Horizontal bar beneath lower scale is battery check indicator.

To replace mercury battery, unscrew battery housing cover (14) with a coin. When replacing mercury battery, make sure + side is up. To replace the dry battery, unscrew the strap retainer (19) and turn lever (18) in direction of the arrow. Housing will then open and battery can be removed. When inserting new dry battery make sure it makes correct contact with + and − terminals.

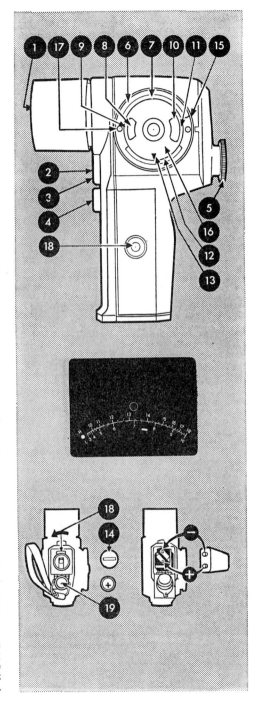

towards the end of the scale in which you wish to obtain most detail. Colour transparency film can handle the brightness range, but only at the expense of true colour rendering. Here it is advisable to bias your exposure towards the high light reading unless the shadow colours are of vital importance.

The spot meter has a usable shutter speed range from 4 minutes to 1/4000 sec. and an aperture range from $f1$ to $f128$. It can handle films from ASA 6 to ASA 6400. The cadmium sulphide cell circuit is powered by two batteries, one 1.3 volt mercury battery (Mallory RM640, Eveready E640 or equivalent) and one 9 volt dry battery (Mallory M1604, Eveready 216 or equivalent).

Checking the Battery

To check battery life, hold the meter to your eye and press the small grey button marked "B" above the "L" low light button. The meter needle should swing over to a short black horizontal line two-thirds of the way across the meter scale if the batteries are all right. If the needle does not swing fully, the batteries should be replaced.

To replace the batteries, first unscrew the wrist strap from the bottom of the meter handle. On the bottom plate of the meter you will see a small slide lever with an engraved arrow. If you push the lever in the direction of the arrow, the bottom plate of the meter will spring open. You can now remove the 9 volt battery. In replacing it with a fresh one, make certain that the plus and minus terminals line up with the proper plus and minus terminals as marked on the inside chamber of the meter. Then close the bottom plate by sliding the lever again in the direction of the arrow, closing the bottom plate.

The 1.3 volt mercury battery is housed under a small circular cover on the bottom plate of the meter. It isn't necessary to open the bottom plate to change this smaller battery. Just unscrew the slotted cover with a coin and remove the battery. When replacing with a new battery follow the directions on the inside of the cover for proper battery placement.

COPYING AND CLOSE-UPS

The closest focusing range of the 50–55 mm. Takumar lens is about 18 in., measured from the film plane of the camera. While this itself is remarkably close for a normal camera and lens with no special attachments, many will want to make pictures at even closer range.

The single-lens reflex is the ideal close-up camera. With its reflex focusing finder, you can clearly see exactly what will appear on the film whether you are making a close-up portrait or a photograph through a microscope.

Although there seems to be much mystery surrounding the making of close-ups, technique can be as straightforward or as complicated as you wish. If you have fairly ordinary close-up needs, you may need nothing more than a simple close-up lens over your regular camera lens. For great magnification with extreme sharpness, more advanced techniques are necessary. However, they are not complicated once you understand the basic mechanics.

Close-up Equipment

Let's begin with the simplest type of close-up. You have a subject—a flower, a map to be copied, a page from a book which you would like to reproduce. You focus your 50–55 mm. Super Takumar lens at the subject. But even at its closest focusing distance the image on the finder is far too small.

The easiest way to make it larger is to thread a close-up lens to the front of your normal lens. This close-up lens is a low powered magnifier which slightly shortens the focal length of your normal lens. By shortening the focal length while maintaining the same film plane to lens distance you get the effect of a closer-focusing lens. The stronger the close-up lens, the closer you can focus.

The special Pentax Close-up Lens provides a focusing range of from 11 in. (with the normal lens's focusing mount

fully extended) to 18½ in. (with the camera lens's focusing mount set at infinity). However, if you wish stronger close-up lenses they are readily available from your photo dealer. Generally speaking a +1 lens focuses from 20 in. to 38 in.; a +2, from 13 to 20 in.; a +3, from 10 to 13 in.; a +4, from 8 to 10 in.; a +5, from 6½ to 8 in.; a +6, from 6 to 6½ in.; a +8 at 5 in. and a +10 at 4 in. The focusing distances are not dependent on camera lens focal length. No matter what lens you use on your camera, subject distance with the same close-up lenses remain the same. Naturally, the area covered varies with the focal length of the lens and the image size will be greater with the lens of longer focal length.

Greater magnification can be obtained by using longer focal length camera lenses with the close-up lenses. This is not recommended, however, since longer lenses do not provide good sharpness when close-up lenses are used with them.

Close-up lenses have one great advantage over other methods of making close-up pictures. You need make no alteration in your exposure calculations when you've attached a close-up lens.

Close-up lenses do have a disadvantage. Then tend to cause a loss of definition when compared to photographs made with your camera lens alone. The amount of sharpness lost depends on a number of factors; quality of the close-up lens, strength of the close-up lens, aperture used, focal length of the lens used, quality of the camera lens over which the close-up lens is placed.

The stronger the close-up lens, the more loss of quality in your picture. If possible it's advisable not to use close-up lenses stronger than +3.

Do not use a large aperture when using close-up lenses. Instead use an aperture of ƒ8 or smaller, if possible. The larger apertures tend to produce rather unsharp pictures with close-up lenses.

The close-up lens magnifies the image through the camera's taking lens. The better the camera's taking lens, the better will be the product of the camera lens plus close-up lens combination.

Loss of sharpness when using close-up lenses is most often apparent in the corners and edges of the picture area.

For snapshots, or any type of close photography where

CLOSE-UP LENSES OR BELLOWS?

With close-up lenses, power of close-up lens (usually in diopters) determines front-of-lens-to-subject distance. Note 50 mm., 100 mm., 200 mm. lenses all must be used as same 4 in. distance with +10 close-up lens. However the longer the camera lens the more magnification through the same close-up lens. No exposure increase is necessary but there will be a decrease in sharpness with powerful close-up lenses when used on longer than normal focal length camera lenses.

By inserting extension bellows between camera body and lens, much more flexibility is available. Distances are now measured from focal plane to subject and are usually greater than with close-up lenses. Because magnification can now be altered by bellows extension and lens interchangeability, more control can be exercised over subject perspective because you can vary camera-to-subject distance. Note 50 mm. picture far left resembles 50 mm. plus close-up lens shot above. However, same size image can be produced with 100 mm. lens at greater distance (centre) with less apparent depth between dice. With 200 mm. lens (right) far greater distance can yield same size image with even more depth flattening. Sharpness of original lens is maintained but additional exposure must be given.

quality is not so much of an essential, close-up lenses can provide a simple, efficient, compact and inexpensive way to make close-up pictures.

The alternative to the close-up lens is lens extension—extending the focusing range of the camera lens by actually moving the lens physically further away from the film plane of the camera. To do this the camera lens must be removed from the camera body. Either a rigid extension tube or tubes or a variable bellows unit is then inserted between lens and camera body. The further away you move the lens from the film, the greater the magnification of the image on the film.

Macro and Micro

There are three terms you should know and be able to distinguish between in close-up photography. The simple close-up, macrophotography and photomicrography. You will hear these terms often, unfortunately misused more than not. The differences between them are relatively simple.

Close-up photography includes all pictures made at distances closer than the normal close focusing.

Macrophotography is the process of taking larger than life size pictures of a subject. That does not mean larger than life size pictures in an enlargement. It means that the actual size of the image on the film itself must be as large as or larger than the object itself.

Photomicrography begins and macrophotography ends when the image on the film is 10 times or greater than the size of the object itself.

We, therefore, have close-up photography from a lens's close focusing distance to a life size image, macrophotography from life size image to ten times life size image and photomicrography when the image is any bigger.

Magnification

In close-up photography it is not correct to talk in terms of camera-to-subject distance to indicate the size of the image on your negative or transparency. A long focal length lens will produce a larger image from the same distance than a shorter focal length lens. However, lenses of different focal lengths can produce images of the same size if the camera-to-subject distance is varied.

In close-up photography, therefore, a term having a more

common base than distance was needed. The common term used is magnification.

If the image on film is precisely the same size as the actual object we say the magnification is 1. If the image size is only half the size of the subject the magnification is .5. If the image size is only 1/10 the size of the object the magnification is .1.

When images become larger than the actual subject we obtain magnification like this: images twice as large as the subject 2, four times as large as the subject 4, etc.

These numbers once understood are simple to apply. If you are ever in doubt as to what the magnification is, you need do nothing more than put a measuring rule at the picture area and check how much of it appears in the Pentax's viewfinder, keeping in mind that the Pentax negative roughly measures $1 \times 1\frac{1}{2}$ in. or 24×36 mm. If you see a full $1\frac{1}{2}$ in. across the frame, you have a life-size $1\times$: if you see $\frac{3}{4}$ in., you have $2\times$ magnification.

These numbers are quite important since the additional exposure increase needed when using bellows extension or extension tubes for close-up and macro work are directly related to the magnifications.

Exposure Adjustment

There's a very good reason why additional exposure must be given when the lens is extended beyond its normal close focusing point. The amount of light transmission of a lens for a 35 mm. camera falls off, like all light, as the square of the distance. Ordinary f-number light transmission is based on the amount of light effectively delivered to cover the format of a 35 mm. negative. However, as a lens is moved further and further away from the film plane, it not only enlarges the image cast on the film plane but also spreads the illumination further. The 35 mm. negative area in the centre is no longer getting the same amount of transmitted light even though the lens's physical aperture remains the same. To compensate for this loss of illumination, additional exposure must be allowed. This can easily be computed from the extension distance of the lens from the film. With the Spotmatic or SP500 cameras this is no problem since the built-in meter will measure the exact light through the extension. If you own a Pentax ES camera it will automatically

give you the correct shutter speed exposure for almost any extension. However with unmetered models, the exposure increase must be taken into consideration. The Pentax bellows units are clearly marked with the magnification factors and necessary exposure increases. The extension tubes are also specifically calculated for exposure increase based on the amount of magnification.

There is an Auto Extension Tube Set, consisting of three tubes, 9.5 mm., 19 mm. and 28.5 mm. long, with coupled automatic diaphragm release pins. These overcome the inconvenience of having to stop down manually when using ordinary tubes.

The Pentax Extension Tube Set tubes may be used singly or together for greater magnification.

The three tubes are marked 1, 2 and 3 in order of increasing length. The No. 1 tube when used with the standard 55 mm. Takumar lens allows close focusing to 11.4 in.; the No. 2 tube to 9.4 in. and the No. 3 to 9 in. However, a complete series of tables giving all focusing distances, magnifications possible and necessary exposure increase or f-number increase can be found at the end of this book in the Facts and Figures section.

By glancing at the charts you will quickly see that the longer the lens used on any given tube, the less the magnification. For maximum magnification the shorter focal length lenses are preferable. For instance, with all three tubes, a 135 mm. Takumar produces .48 magnification, while a 35 mm. Takumar produces 1.18 magnification with Nos. 1 and 3 alone.

Besides the fixed length auto extension tubes there is another handy variable tube which does not have the automatic diaphragm pin. The Focusing Extension Tube provides variable extension from 16.8 mm. to 30.6 mm. (magnification from .3× to .71× with a 55 mm. lens).

We cannot give unqualified indorsement to the short focal length lenses as best for close-up results, however. The shorter lenses must be used quite close to the subject as compared to the longer lenses. This closeness can cause apparent perspective distortion in three dimensional subjects, that is, the closest parts of the subject will look over large as compared to those parts more distant from the camera. Longer lenses get around this trouble to a greater extent by allowing you

to maintain a greater camera-to-subject distance. The normal 50 to 55 mm. Takumar with which your camera is equipped makes an excellent close-up lens with tubes or extension bellows.

Increasing exposure to compensate for extra lens extension with non through lens meter Pentaxes is simple as long as you have the necessary magnification factors or exposure increase factors in table form. There are two basic ways to use these factors. You can either divide the ASA index of the film you are using by the exposure factor and read your meter directly or you can multiply the shutter speeds you intend to use by the exposure increase factor. For instance, if you were using a film with an ASA index of 100, and were using extension tubes Nos. 2 and 3 together with a 55 mm. Takumar lens, you would see that an exposure increase factor of 4.1 is recommended. It would, however, be close enough to divide the 100 index by 4 and set your meter's ASA index scale to the resulting 25. The meter would then indicate proper exposure for this combination of extension tubes. However you could instead alter the shutter speed. In other words, if your meter was set at ASA 100 and called for a shutter speed of 1/125 sec., you could multiply the speed by 4 and shoot at 1/30 sec. Both methods of using the exposure increase factor would yield proper results with the No. 2 and 3 tube combination.

While the extension tube set represents the most compact and least expensive method of extending the lens for close-up work, it does have definite limitations. The three tubes used together do have a rather limited magnification. To get greater magnification more extension would be necessary. Adding a second extension tube set is possible but rather awkward in terms of the number of tubes which must be threaded together.

The other disadvantage of extension tubes is the fixed magnification. In order to increase magnification you must change tubes or use more than one. Some magnification alteration is possible by using the lens's own focusing mount in conjunction with the extension tubes, but each tube is still limited in range flexibility.

Using the Bellows

The Pentax bellows units offer an excellent solution to the

problem. After placing the camera body at one end of the bellows and the camera lens at the other, you can increase magnification continuously by drawing the bellows out further and further. There are two models, the Bellows I and the Auto Bellows, with double cable release to operate diaphragm and shutter simultaneously. The Auto Bellows is slightly longer than the Bellows I and has a lens reversing system and improved construction. The necessary magnification and exposure factors are engraved on the chrome metal bellows guide rods. You do no more with the 50 or 55 mm. Takumar than note the position of the lens mount and read the proper increase and magnification at that point right from the rod.

While the use of extension tubes is limited because they do not produce great magnification, the bellows unit has a limit in the other direction. It has a minimum extension of 39 mm. which means that with the 55 mm. Takumar, it has a minimum magnification of .69. For less magnification with the normal lens but greater magnification than with the lens as used regularly in the camera, you must revert to one of the extension tubes.

For both bellows, however, there exists a remarkable lens, the 100 mm.. $f4$ Bellows Takumar. This lens is mounted in a special short barrel. When threaded into the bellows unit, the 100 mm. $f4$ Bellows Takumar provides continuous focusing from infinity (with the bellows almost fully compressed) to 1.4× magnification at maximum bellows extension with the Bellows I and 1.62× with the Auto Bellows.

This means that you can use the same lens and camera to take ordinary distance pictures yet quickly increase bellows extension whenever required for extreme close-ups. The 100 mm. $f4$ Bellows Takumar. There are a number of photo-excellent centre-to-corner definition for close-ups. It has a preset lens diaphragm which allows you to focus at full aperture yet close down to shooting aperture quickly. The lens is completely described in the chapter on lenses. The bellows units also have millimetre callibrations from 35 mm. to 200 mm. engraved on the chrome travel rods for this useful 100 mm. $f4$ Bellows Takumar. There are a number of photographers who use the bellows units and Bellows Takumar as their all-in-one flexible camera unit for all photography.

The operation of the Bellows Takumar itself is rather interesting. The Asahi Bellows should not be confused with

AUTO-BELLOWS FEATURES

Here are the features of the Pentax Auto-Bellows:

1. Rear board.
2. Magnetic seat for scales.
3. Bellows.
4. Clamp screw A.
5. Index for scales.
6. Lens mount.
7. Cable release socket
8. Gear rail.
9. Stopper screw.
10. Clamp knobs.
11. Tripod position shift knob.
12. Red dot.
13. Clamp screw B.
14. Extension knobs.
15. Clamp knob.

Two magnification scales are provided. One is for the 50mm lens; the other, for the 55mm lens, also has a millimetre calibration for lens extension.

The double cable release allows the lens diaphragm to be closed down first and then releases the shutter.

other types of bellows units which are often available. The Asahi Bellows are very rigid, extra sturdily made units which provide maximum close-up flexibility.

Let's start with the small, compact and simple to use Bellows I. If you only plan on taking closeups occasionally or need a unit you can actually hand hold and carry with you easily, the Bellows I should fit the bill ideally. It is composed of a male Pentax thread at the rear with a set screw, the bellows proper, the front lens mount whose position is governed by a large wheel at the left and a locking wheel on the right, and the bellows rod on which the front lens mount rides. You just unthread the lens from your camera. Loosen the set screw and fasten the revolving male Pentax thread to your camera body. Now you mount your camera lens to the front of the bellows and that's that. The bellows rod is marked on one side with the magnification factors for a 55 mm. lens and marked in millimetres of extension on the other. By observing the millimetres extension for any subject you can then look up the proper exposure factor or magnification for any lens in the directions accompanying the Bellows I or use the magnification and exposure scale on page 351 in this book.

The Auto Bellows, although larger and heavier, is a far more versatile unit which will allow you to maintain fully automatic diaphragm connections so you can view and focus at full aperture as you would with the camera lens mounted directly on the camera.

To attach it to your lens and camera, first loosen the set clamp screw at the rear of the bellows and remove the rear lens board ring. Remove the lens from your camera and screw the ring in its place. Attach the ring, now mounted on your camera body, to the back of the bellows and tighten the clamp set screw. Attach the lens to the front of the Auto Bellows. To extend the bellows, rotate the extension knobs and tighten the clamp knobs on the other side when you have the extension length you wish. Always remember to loosen these clamp knobs before changing the extension. Once you have the bellows extension you want and decide you wish to maintain this exact magnification, you can focus or refocus by moving the now fixed bellows extension and camera. To do this you move camera bellows and lens backwards or forwards in relation to the subject using the tripod positioning knob located on the undercarriage of the bellows.

Two scales are provided with the Auto Bellows, one for the 50 and one for the 55 mm. lens. They are engraved on both sides for normal lens use and for use when you reverse the lens as we'll explain. They fit atop the bellows and stay in place magnetically. For accuracy, you must set the focusing ring of your lens to infinity. Also set the preview lever of the lens to automatic position.

To take advantage of the fully automatic diaphragm, you'll need the double cable release provided with the bellows. Attach the cable with the red ring to the socket on the side of the front board of the bellows and attach the other cable to the release of the camera body itself. By pressing the release button of the double cable you can cause your lens at the end of the bellows to close down to shooting aperture and then the camera shutter to operate. To adjust the release so this will operate properly, loosen the ring at the red marked end of the cable and adjust the plunger so that the diaphragm will close down before the shutter is released. Tighten the ring after adjustment.

While operation of the bellows in normal position will be quite satisfactory for most of your picture taking situations, you will get better definition in macrophotography by reversing the lens and using it backwards on the Auto Bellows. To reverse the lens, first remove the stopper screw at the very end of the bellows tracks. Now, while holding tight to the screw atop the front board, loosen the side set screw. Push the top screw backwards, separating bellows from front board, and remove the board from the front end of the bellows. Reverse the front board and lens and attach them in reverse position to the rail rod. Fix the front end of the bellows onto the front end of the lens and tighten the top clamp set screw. Rethread the stopper screw at the end of the bellows track. When using the magnification scale rods, be sure to place them in the reverse position. Note that you can still operate the automatic diaphragm of the lens and camera using the double cable release although the tripod socket on the front board will be on the opposite side of the bellows. If you need additional magnification, more than is provided by maximum bellows extension, you can use a shorter focal length lens or add extension tubes between the front of the bellows in unreversed position and your lens in reverse position using the reverse adapter. However the double

cable release automatic diaphragm mechanism will not operate with the extension tubes in place.

For optimum results in macrophotography try using the Macro Takumar lens or Bellows Takumar. For extreme close-ups, wide angle lenses used in reverse are often quite good and helpful.

Warning: Do not use the Super-Multi-Coated Takumar lenses on the older Pentax Bellows II. There is a danger that these newer lenses will lock in place and will not be removable except by a competent repairman. Of course all Pentax lenses will fit the Bellows I and Auto Bellows with no difficulty.

Exposure for Close-ups

Close-up exposure techniques require care and good judgment. With Spotmatics, SP500 or Pentax ES the meter reading, of course, is done directly through the lens which does aid proper exposure considerably. However, equally good results can be obtained with a separate meter provided the meter reading is done properly. First, let's examine the classic method of obtaining a close-up reading from an ordinary hand-held exposure meter.

Most such meters read a fairly wide angle of coverage, generally an angle somewhat greater than the normal lens of your camera. For the most accurate reading possible, try to get the meter as close to the subject as you can without obstructing the illumination on the subject or casting a shadow on the subject yourself. This is particularly important when photographing a fairly small object in the midst of a field of a different brightness—a small insect on a white or black background, for instance. If the reading is made from a point too far away, the background will dominate the scene and give you an erroneous reading for the subject. When using the Spotmatics, SP500 or Pentax ES, make certain you are getting exposure for the subject only. With these cameras you may find it necessary to adjust even these readings when the background dominates the picture.

The best method of determining accurate close-up exposure with an ordinary hand-held, general-use meter is to make a substitute reading using an 18% neutral grey test card (available from photo dealers). This card provides a medium-grey surface which, when read by a meter produces an exposure for normal subject material. You hold the card just in front

of the subject, but in the same light as the subject and take a meter reading from the card rather than from the subject.

The best accessory meter to use for close-ups is the Pentax Spot Exposure Meter II which reads a 1° central angle. With it you can easily make accurate readings of even the tiniest subjects and exclude all unimportant background material. No grey card is necessary. The Spot Meter II is fully described on pages 178–182.

You may have the CdS clip-on meter which fastens to the top of the Asahi Pentax prism housing and engages the shutter speed dial (see page 166). Of course this meter cannot be used on the camera for measuring close-ups accurately. Instead remove the meter and use it as an ordinary hand-held meter to get the proper close-up reading and then set the camera's controls accordingly.

There is one more method of calculating proper exposure for close-ups that some Pentax owners have used success-fully: making a meter reading through the prism finder of the light coming through the Takumar lens. This is rather a primitive duplication of the method used by the Spotmatic which takes a very accurate through the lens meter reading. Before using this exposure technique on an important subject try the method out to see whether it will work for you.

Place the cell window of your CdS clip-on meter against the viewfinder of your camera. To make sure that no extraneous light is striking the CdS cell, fit the rubber correction lens adapter to the Pentax. Set the ASA index of your meter for the film you are using. Next extend the bellows or fasten the extension tube between camera and lens. Then focus on your subject until you are certain you have the right size image magnification you wish. Close down your lens aperture to shooting opening. Take the meter reading through the finder. Hold the meter as close to the eyepiece as possible and use the low light scale. Set the shutter speed dial of the meter so that the $f16$ black calibration of the meter's scale matches the meter needle reading. Now read the correct shutter speed from your meter's shutter speed dial. Set your camera to this shutter speed and you are ready to shoot the close-up picture.

You can also try this system with other meters. Take a reading through the finder as already explained. But after setting the calculator dial, read the proper shutter speed

opposite the f_1 aperture marking on the meter calculator dial.

In the author's opinion, this technique, although far from exact and absolute, can furnish you with a general area of proper exposure. Once having calculated an exposure in this manner, take some pictures with slightly less exposure and others with slightly more to make sure you do get the picture. As you experiment more with the system, you will learn just exactly how far you can really trust it.

Lighting the Close-up

Lighting small close-up objects is something of a problem. Large floods and spots are not only too big to squeeze into the tiny space between camera lens and subject, they also often produce far too much light and heat.

There are several worthwhile lighting alternatives. A 35 mm. slide projector with no slide usually makes an excellent light source. The concentrated projected light beam can be aimed with certainty. To cut down on the area illuminated, simply cut the proper cardboard mask and insert it in the slide holder. A small white cardboard, such as an index file card can be used as a backup reflector on the opposite side of the subject. The light from the projector can strike the subject directly and also be reflected by the card. The new diminutive high intensity table lamps which make use of small bulbs similar to those used in automobile headlamps make excellent close-up light sources. In addition you will find that their illumination seems to produce good colour results with both Type A and Type B tungsten colour films.

While tungsten illumination is probably the easiest to handle in terms of seeing the effect on the subject and being able to calculate exposure accurately, it does have disadvantages with living subjects. It is bright and hot. For shooting pictures of moving objects—small animals or insects, for instance, electronic flash provides undeniable advantages. Whereas most extreme close-ups are shot at relatively slow shutter speeds, the very short duration of the electronic flash itself provides the ability to stop subject action.

It is quite possible to use electronic flash extremely close to your subject. There are no rules, however, governing proper exposure. You will simply have to experiment with a roll of film to see just what exposure would be proper with the flash unit in extreme close-up position. If there seems to

be too much light you can cut down the illumination with one or more layers of white handkerchief over the flash head.

Electronic flash ring lights which fit around the outside of the lens provides very even and shadowless illumination for close-ups. Most such units come with full exposure directions for close-up use. When photographing very close, however, even these rings may produce a dark central spot in the middle of the picture area where the lens is located. In such cases the standard electronic flash head is probably preferable.

The direction of the light is particularly important in close-up photography. Front lighting is even but quite flat in character. It picks up little of the surface detail of three-dimensional objects although it is fine for non-textured two-dimensional copy work. Cross lighting at about a 45° angle is generally best for producing three-dimensional effects with highlights and shadows. Such shadows can be extremely confusing. One light should definitely predominate if the picture is to look normal. For such subjects as bas-reliefs, etchings or engravings, a rim light at almost 90° from camera position skimming the surface of the art work is effective in picking up the fine lines and reproducing them with the necessary contrast.

When copying two-dimensional surfaces such as the pages of a book, stamps, maps, etc., an opposite technique must be used to the one employed with three-dimensional objects. When shooting two-dimensional surfaces, lighting should be frontal and as even as possible. You can check evenness by measuring the light at the centre of the picture area and at the edges with a good exposure meter. There should be no more than a 25% fall off of illumination or the darkening will show up in the negative or transparency. The same light sources—projectors, high-intensity lights, electronic flash or ringlight can be used although there is no real need for the latter two. Usually a continuous light whose effect on the subject can be studied is preferable.

When photographing semi-glossy and glossy surfaces, manoeuvre the lighting so that no glare is reflected back into the camera lens. Lighting and camera must be moved so that hot spots are not visible in the camera finder. Whenever you do see them there, they will appear in the picture itself. With some difficult surfaces you may not be able to direct light

on the subject proper at all. This is often true of subjects covered by glass. In such cases, it's possible to reflect the light from large cardboard reflectors well out of camera view.

Films and Filters

In copy work, proper choice of film and filtration are extremely important. In film, use the finest grain film possible. This will probably have a rather low ASA film speed index. In copying, however, this should make little difference since it merely indicates that longer exposures will be necessary. Of course, all copying work should be done from a rigid tripod or copying stand.

Why filters? Panchromatic film, the only type now generally available in 35 mm. black-and-white does reproduce all the tones of the original photograph in the proper shades of grey. However in tungsten illumination which is most often used for copying, red tones are produced much lighter than we actually see them, while blue tones tend to darken more than we may wish. A pale blue filter can offset this tendency and help give you a proper visual balance.

In daylight, blues may tend to become too light. In such cases, a pale green or pale yellow filter will negate the excessive blue sensitivity of the film. Of course, we are assuming that you are copying a coloured subject. For reproduction of a black-and-white page only, no filtration of this type is necessary.

These filtrations suggested are known as colour correction since they simply try to bring back into proper visual balance those colours which will not reproduce on a film as you see them. However, more often a photographer is faced with just the opposite problem—how to increase colour contrasts to separate tonal values to a greater extent than normal. This works in much the same manner as we noted in the chapter on filters—that is, a filter will darken its complementary colour by absorbing it while passing light of its own colour. Suppose you wish to copy a letter which is smudged with blue ink. By using a blue filter the blue ink can be almost if not completely eliminated. If the blue ink was pale and we wished to make it appear more pronounced we could photograph it through a yellow filter.

Some other often-used copying filters are: blue filters for

USING MICROSCOPE ADAPTER

Adapter consists of main tube (*left*), stopper clamp (*right*), coupling and fastener tube (*bottom left*), and light sealing tube (*bottom right*).

Loosen knob, pull out light sealing tube, and disengage fastener tube.

Unscrew lens from camera and replace with adapter main tube.

Pull out microscope eyepiece, adapt the fastener tube with coupling ring to microscope extension tube. Insert eyepiece or light sealing tube.

Loosen coupling ring and fasten main tube bayonet to coupling ring. Turn camera body to desired position and tighten fastening knob. Lift extension tube to desired calibration. Fasten stopper clamp.

Attach the cable release. Look through camera finder, adjust lamp, subject and focus.

copying a partially faded photograph, yellow filters for copying old photos on a yellow background.

The filters that we have been discussing are, of course, for use with black-and-white photography. When using colour films, simply use the nomograph in the Facts and Figures Section in the back of this book to determine the proper filter for any lighting source and type of film.

Using the Microscope Adapter

We have been discussing close-ups and copying to magnifications of about 3×, the limit of the normal 55 mm. Takumar on the Bellows II. Of course, greater magnifications can be obtained either with shorter focal lengths lenses or with more extension—by adding extension tubes to the bellows, for instance. This is the area of macrophotography as we have previously defined it. To produce greater magnification, 10× or more, we must go into photomicrography. Here we will fit the Pentax camera body directly to a microscope by means of the Asahi Pentax Microscope Adapter, which can be used with any microscope having a tube of 25 mm. The adapter is carefully designed to prevent strain on the microscope tube itself. Unlike many microscope adapters available for various cameras, the Asahi adapter has a special device to prevent the excess weight of the camera body from causing the microscope tube to move downward, thus altering focus.

The microscope adapter consists of the following parts:

1. Main tube adapter, one end of which is threaded, to be screwed to the lens mount of the camera body. The other end is a bayonet mount.

2. Main tube bayonet adapter.

3. Coupling ring. One side is threaded to accept the fastener tube. The other side is a bayonet which engages the main tube bayonet adapter.

4. Fastener tube which fits the extension tube of the microscope.

5. Fastening knob.

6. Light sealing tube that prevents interior reflection of light inside the extension tube of the microscope when the eyepiece of the microscope is not in use.

7. Stopper which fastens to the tube of the microscope

above the barrel to prevent the weight of the camera body from altering the microscope focus setting.

Here's how you mount the microscope adapter and camera:

1. Loosen the knob (5 above) and pull out the light sealing tube (6).

2. Disengage the fastener tube (4).

3. Unscrew the lens from the camera.

4. Screw the main tube adapter (1) to the lens mount of the camera.

5. Pull out the eyepiece of the microscope.

6. Fit the fastener tube (4) with the coupling ring (3) to the microscope tube.

7. Insert the eyepiece or light sealing tube (6) into the fastener tube (4).

8. Loosen the coupling ring (3) and then fasten the bayonet (2) to the coupling ring.

9. Turn the camera body and adapter set to working position. Tighten the fastening knob (5).

10. Lift the extension tube of the microscope. Stop it at a desired height. Fasten the stopper (7).

11. Insert cable release into cable release socket to prevent camera movement during exposure.

12. Adjust lighting and position of subject while looking through camera finder.

13. Focus microscope correctly while observing focus through camera viewfinder.

14. Determine exposure and shoot picture.

Actual magnification of the image depends greatly upon the optical potential of the microscope used. However, resolving power is generally far more important than magnification. Resolving power can be expressed simply in the ability of the camera, film, microscope combination to separate two close lying microscopic objects. This is actually dependent on the aperture of the microscope objective.

Exposure through a microscope depends upon the illumination source, the microscope optics and the magnification. No hard and fast rule can be given. With the Spotmatic, a through-the-lens meter reading will certainly prove an adequate starting point for determining correct exposure. For other models, a reading through the finder lens as suggested earlier in this chapter is advisable. Only tests can assure you of correct exposure with your equipment.

SLIDE COPYING

Transparency colour films which are processed into slides for hand viewing or projection are very popular. However, such films do have what may seem at first to be a severe limitation. The very film that you expose in your camera is the one which is turned into the transparency slide. You have, in effect, a single, original, positive picture in colour. With negative films, of course, you have either a black-and-white or colour negative from which you can make any number of equally excellent prints.

While there are commercial services available that will make duplicate slides for you, the cost is high and, perhaps more important, the quality is rather low. Only a few processors can guarantee first class duplicates. It isn't surprising therefore that the word "dupe" has come to mean second rate in terms of quality. Most dupes bear only a slight resemblance to the excellence of the original picture. The dupes usually are much more contrasty, lacking the great tonal and colour gradations of the original. Colour is often washed out. Highlights and shadows don't have the detail in the original picture.

If you learn to duplicate your own slides however, you can do far better. Not only can you duplicate your original transparency in colour, contrast and sharpness, you can quickly learn to improve transparencies whose original colour didn't quite suit you. You can even recrop your transparency and enlarge portions of it. The cost of such a duplicate is no more than the cost of an original picture made on transparency film—usually less than one-fifth of the cost of a commercially made dupe which isn't one-tenth as good.

Assembling the Slide Copier
The heart of the Asahi slide copying equipment is the Auto Bellows with slide copier attachment. To set up the slide copier, remove the stopper screw at the very end of the

USING THE SLIDE COPIER

Here are the features of the Auto-Bellows/Slide Copier:

1. Retainer plate.
2. Slide slot.
3. Bellows.
4. Clamp screw C.
5. Bellows retainer plate.
6. Copier rail.
7. Clamp knob.
8. Slide copier attaching screw.

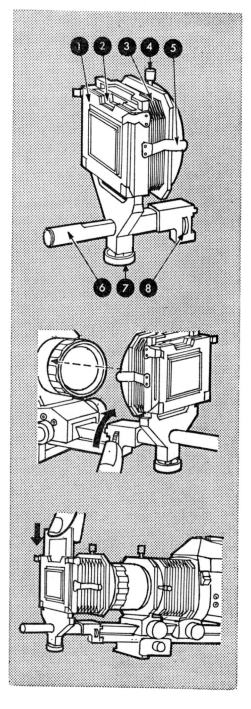

To attach the Slide Copier to the Auto-Bellows, remove the stopper screw at the end of the bellows rail and fix the slide copier attaching screw (8) into the thread for the stopper screw. Open the bellows retainer plates (5) on both sides and stretch bellows towards lens in direction of the arrow. Place the copier bellows ring over the lens rim and tighten clamp screw C (4).

When inserting a colour slide to be duplicated into the slot, the view through the camera finder should show the slide right side up and correct right to left.

bellows track and fasten the slide copier attaching screw into the thread for the stopper screw. Now extend the front plate of the bellows with lens forward on the gear rail. Open the bellows retainer plates on both sides of the slide copier attachment. Pull out the slide copier bellows and place the copier bellows ring over the front of the lens and tighten the top clamp screw on the copier. (If you're using the lens in reverse position, which is advisable when copying, put the end ring of the copier bellows into the grooved ring of the lens board and then tighten the top clamp screw.)

If you're using a 50 mm. lens, extend the Auto Bellows fully and lock it. When using a 55 mm. lens, extend it to the red dot on the gear rail instead and then lock it.

Insert the slide to be copied in the slide copier's slot. Look through the camera's viewfinder to make sure the slide is right side up and correct right to left. Note that the copier rod has a magnification scale from 1 to 1.5 for both 50 and 55 m.m. lenses. Loosen the copier's bottom knob and move the copier rod holder's red dot to the magnification you want. For same size slides, choose I. If you want to crop out some of the original slide choose a somewhat greater magnification, varying it until you get the cropping you wish. Actually this scale is for copying film strips but it is a good enough approximation for your initial adjustment with mounted slides. For vertical cropping you can shift the film holder up and down. There's a click position at the central copying point.

If you want to copy a slide or film at a specific magnification, look in the tables accompanying the slide copier or bellows for the amount of lens extension needed for that magnification. Now either extend or compress the bellows as needed using the magnification rods as a guide until you reach the proper extension. Move the slide copier back and forth on its rod until you get the correct focus through the viewfinder. Then lock it in place. Alternately however we think you will find it easier to set the slide copier itself at the wanted magnification using the slide copier rod as a guide and then move the camera body itself back and forth using the rear panel knob.

If you have a film strip that you want to copy, unhinge the strip film retainer plate from the slide copier and position the film strip between the diffusing plate and the slide copier.

You'll find that the slide copier plate has a grooved slot of the proper width to accept the strip film. Now refasten the retainer plate. It's advisable however not to attempt to slide strip film through the copier. Open the copier at the hinge and reposition the picture to prevent film scratching.

Once you have mastered the mechanics of setting the slide copier for whatever magnification or cropping of your original colour slide that you may want, you are ready to proceed to three other essentials in slide duplication:

1. Choice of illumination.
2. Choice of duplicating film.
3. Exposure.

Light Sources

The most satisfactory slide duplication is generally made using a light source similar to daylight. While daylight itself is certainly the least expensive and the most widely available light source it varies greatly in quality depending on sky, time and weather conditions. Electronic flash or floodlights balanced for daylight probably make the best illumination sources. Daylight balanced floodlights work quite well with the Spotmatic camera since the continuous light source makes it possible to determine the correct exposure for slide duplication by using the behind the lens meter. For other copying, one of the modern small, inexpensive electronic flash units probably makes the most convenient light source. However, we will cover both types of lighting in conjunction with slide duplication.

Which Film?

Daylight balanced film is the only proper choice if you intend to use daylight or a daylight-balanced light source for duplication. There are more types of daylight films available than tungsten films so the choice of daylight illumination with a daylight-balanced film would seem a logical one.

Which of the many brands and types of daylight films is best for slide duplication? High speed colour films should be eliminated immediately. While these are excellent as prime films to take photographs under difficult lighting conditions, they tend to show excessive graininess and have less colour saturation. The slower, brighter, more fine-grained films are far superior for duplicating purposes.

Still there are many different brands and types of slow colour film. How do you choose the best? Actually you cannot. While some colour films generally will give you good duplicates, the very characteristics of some—more or less contrast, softer colours, finer grain can often help you with specific problem slides.

Generally speaking, a slide duplicate tends to pick up additional contrast and lose in-between tones. Therefore for pictures of average contrast with good range of middle tones, a duplicating film of relatively low contrast but bright colour is preferable.

The same type of duplicating film is also recommended for original slides having low contrast although a duplicating film of average contrast might also do. For original pictures having very high contrast, a very low contrast film should be used. The fact that a film makes excellent colour pictures in a camera is no guarantee that it makes good duplicates. Agfacolor (Agfachrome in the U.S.) produces fine slides yet makes a very poor duplicating film. Some film manufacturing companies make film designed specifically for slide duplication. Your photo dealer can tell you what is available in this line.

Exposure

Once you have loaded your camera and have the slide to be duplicated in place, your big problem with daylight or any continuous light source such as floodlight is exposure. First position your light. With a small flood, place the reflector about three feet in front of and facing the diffuser plate of the slide copier.

Certainly the most convenient and simplest method of determining proper exposure is with a through lens metering Pentax camera: the Spotmatics, SP500 or the Pentax ES. Basically all you need do is to make a reading through the lens as you would for any closeup and shoot the picture. With the Pentax ES of course, it's only necessary to press the shutter release and the camera will automatically set the proper shutter speed for the duplicate. We have found by experience however that it's advisable to make a few additional exposures at other settings if you are not familiar with duplicating. Give double and half exposure as well as the one which your equipment suggests. With the Pentax ES

camera you can do this using the exposure factor control ring at $\frac{1}{2}\times$ and the 2× settings. In addition we've noted that with dense slides additional exposure is often required, while very light slides sometimes need only half the recommended exposure.

While a through lens meter camera is the easiest to use for duplicating with constant light sources, you can get adequate readings with separate meters. If you have a CdS hand-held meter, remove the slide from the copier, hold it up to the light you will use for duplicating, and take a reading through the slide. Replace the slide in the copier and using the magnification scales on the bellows to determine the exposure increase needed. Apply this to the exposure you made though the slide.

In all slide copying it's advisable to use the optimum lens opening, between $f4$ and $f5.6$, varying the exposure by changing shutter speeds when needed. The 50 mm. $f4$ SMC Takumar is the best lens for copying.

While we have stressed making three exposures for each slide to be duplicated, one on exposure suggested, one at less and one at more, we feel that with experience you will be able to eliminate the two additional exposures so as to conserve film. Don't expect perfect results immediately. After you have made a number of duplicates and have been able to see the results you should be able to make a very good duplicate in one or at the most two exposures.

There is another method of obtaining correct exposure when using the slide copier. If you have the clip-on or another hand-held CdS exposure meter, you can try taking a reading right through the finder eyepiece with the original slide and light source in place. When using the Pentax clip-on, place the input window of the meter against the viewfinder of the camera. With the meter placed in position, you will be able to read the light that actually exposes the film. However, its advisable to prevent extraneous light from coming into the input window of your meter and thereby giving you an inflated reading. You can shield the viewfinder window adequately if you slip the correction lens eyepiece over the finder window.

To take a reading, set the film speed calibration ring of your meter to the speed of the film you are using. Turn the switch ring of your meter to "L" since the illumination

through the viewfinder is usually dim when copying slides. Now turn the shutter speed dial of your meter so that the black calibration of ƒ16 of the meter's scale matches the needle. This black calibration of ƒ16 with your meter switched in at the "L" position corresponds to ƒ1.

Then read the shutter speed dial of your meter and use the speed matching the shutter speed index. Since you are reading the light coming in through the closed down diaphragm, extended bellows and the prism finder you don't have to take exposure increase factors into consideration.

If you have a CdS meter other than the clip-on, you can take a reading in a similar manner by holding the meter to the eyepiece while the meter scale is in the low light scale level. After setting the meter calculator, read the proper shutter speed opposite the ƒ1 aperture setting. This is the proper exposure to use.

We must warn you that the foregoing method is not an exact one. It will, however, furnish you with an approximate exposure. To be more certain that you obtain a satisfactorily exposed duplicate, make a second exposure at half the shutter speed indicated and a third exposure at twice the shutter speed indicated.

Giving specific advice on exposure to the many photographers who do not own a Spotmatic or ES camera or CdS meter is rather difficult since it is impossible to measure the illumination from the slide accurately. A series of trial exposures using an ideally exposed test slide will be necessary. Set your camera lens to ƒ5.6 and make a series of exposures from 1 sec. to 1/125 sec. When you get the results back from the processors, you should be able to pick out the properly exposed slide quickly. The data from this slide will then serve for this particular film and lighting set-up with a properly exposed transparency. If you intend to take a duplicate which is slightly larger or smaller than the test duplicate, you can easily compute the proper exposure correction. If the test was made at same size reproduction, you can make a properly exposed duplicate of 1½× by giving 1½ times the exposure. In like manner you can produce the same size duplicate if the test was at 1½× magnification by giving two-thirds of the exposure.

When you are copying slides which have more density and shadow detail than the test slide, double your exposure. If

the slide is rather light without density, halve your exposure. At all times if possible, take a few shots under and over the estimated proper exposure for insurance.

The foregoing procedure was based on maintaining an exact control of the duplication procedure. Once you have established the strength and distance of the illumination source, do not change it or your exposure calculations will be different. Measure the light to copier distance carefully, note the lamp designation and type of reflector. Make sure when duplicating slides that you reproduce the lighting situation exactly.

Using Daylight

You can probably understand by now why daylight is rather unsuitable for duplication. Not only does the strength of the illumination vary considerably day by day and hour by hour but the colour of the light and the quality also change. If you do duplicate by daylight some slides may be too blue, some too warm, depending upon the quality of the daylight when you make the duplicates.

If you intend to use daylight, it will be almost impossible to guess at exposure. The Spotmatic camera or the clip-on or similar CdS meter can, as already explained, give you a good indication of exposure. If you have another type of meter, you may proceed as follows. Using daylight as an illumination source, make a series of test exposures using a well exposed slide as the original to be copied.

Shoot a series of tests at $f5.6$ using varying shutter speeds from 1 sec. upwards to $1/125$ sec. At the same time, take a direct reading of your light source with your meter. When you receive the processed transparencies back, pick out the properly exposed transparency and determine the exposure at which it was made. The next time you duplicate slides by daylight, read the direct illumination again with your meter. If the illumination is exactly the same, you can use the same exposure as you did before. However, if the light proves to be stronger or weaker than the original illumination, you will have to alter the duplicating exposure by the same amount. If your meter indicates that there is but half the illumination, for instance, double your exposure. If the illumination is twice as much as originally, halve the exposure. Of course,

P.W.—L

you must also adjust your exposure if the slide to be duplicated is not ideally exposed itself.

What type of daylight illumination is best? Since no daylight illumination is ideal for slide duplication, it is more a question of what type of daylight is least harmful. Direct sunlight is almost always too bright. In addition, the brilliancy causes the scattering of light rays producing flare in slide duplication.

Clear north light or blue sky is quite good as an illumination source. However the scattering of ultra-violet light which causes the sky to be blue will also cause a bluish tinge in your transparency. To correct for this use the proper filter for blue sky illumination which you can find with the filter nomograph at the back of this book.

Using Electronic Flash

Perhaps the best illumination source for slide duplication is the light from a small electronic flash unit. Electronic flash is adequately balanced for daylight illumination. The quality is virtually constant. The light is easy to control. You just hold the electronic flash about a foot in front of the slide copier diffuser, and release the shutter. Since many small electronic flash units today have short connecting cords for the camera which are non-detachable, you may have to obtain an extension cord which allows you to remove the flash sufficiently from the camera. A coiled cord extending up to two or more feet is most practical.

In using electronic flash for copying, you must again establish an ideal exposure for a properly exposed transparency. Although it is possible to fix the flash at a nonchangeable distance and then change aperture to vary the exposure, it's best to shift the illumination itself to maintain the same most critical lens aperture. You can then vary exposure by establishing a series of different flash-to-copier distances between one foot and three feet.

Again you must make a series of test exposures to establish a norm for your own flash unit. Once you have found the proper illumination placement and aperture, make sure that you jot down all the data so you can duplicate the set-up again whenever you wish to dupe slides.

In duplicating well exposed slides, you will find that some slides are more difficult to duplicate than others. This is

usually caused by the varying characteristics of the slide subjects. If facial tones are of primary importance, you may find that some films used for duplication are not as ideal for facial tones as others. On the other hand, a film which does not reproduce facial tones well, may be extremely good with foliage or some other specific colour. The more experience that you have in duplication, the more films you use for the purpose, the more expert you will become on choosing the right film for each slide.

Correction During Copying

Duplicating slides which you consider excellent is but one copying possibility. Slides which are slightly off colour can not only be duplicated but can be corrected as well.

In duplicating under- or over-exposed slides, vast improvement can be made. However, it is not possible to put back detail in either washed out highlights or unrelieved shadows. You can alter the colour, the contrast and the overall density but you cannot create in the duplicate any detail that was not in the original.

When making a duplicate to correct exposure error, allow less than the "correct" exposure time for an over-exposed original and more for an under-exposed original. The amount of exposure increase or decrease of course, depends upon the error in the original slide. When possible try a number of different corrective exposures varying each slightly. To get the perfect dupe make use of the half stops on the Takumar lens.

Colour correction is a fascinating area of slide duplication. Quite often original slides will be off colour. If taken on sunless days or even on a bright day at the beach, a slide may appear bluish. Slides made early in the morning or late in the afternoon may be too warm. The same types of filters used to correct the original picture taking situations will also work nicely here. We recommend a full set of nine: CC10Y, CC20Y, CC40Y, CC10M, CC20M, CC40M, CC10C, CC20C, CC40C. The filters, incidentally, are available as gelatin squares which can be held in front of the copier diffuser plate. Gelatin squares cost only a fraction of the price of glass mounted filters. Therefore a full set of nine will be less expensive than it might appear at first.

There are no hard and fast rules as to which strength filter

will work best. Obviously, if the picture is too warm a bluish filter should be used in copying while a yellow or magenta filter will cut down on the blue in an original.

Making Black-and-White Negatives

Besides making duplicate colour slides, you can use the slide duplicator for another purpose—to make black-and-white negatives from transparencies which will allow you to make black-and-white prints directly.

Actually the making of black-and-white negatives is far simpler than the making of slide duplicates. The exposure latitude of black-and-white film is far greater so that the duplicating exposure is far less critical. In addition, the quality of the illumination is not so critical either. It matters little whether the light is balanced properly for daylight or tungsten film. As long as it's bright and even, it will serve for black-and-white film. Of course, any of the duplicating illumination set-ups we've already described will do splendidly.

Fairly slow black-and-white film having an ASA index between 25 and 50 is recommended for making black-and-white negatives. Since the final black-and-white print will have a combination of the graininess qualities of both the original colour transparency and the graininess of the black-and-white film, you won't want to use a grainier film than is absolutely necessary.

After processing the black-and-white film, you should have a perfectly exposed negative from which excellent black-and-white pictures can be made.

USING TELE LENSES

There are few thrills in owning a Pentex camera greater than when you fit a longer than normal focal length lens to your camera and for the first time, look through the view-finder. The longer the lens, the more magnification of the image you achieve and the closer appear the objects at any given distance.

While using long lenses was exciting in the days when such lenses were very heavy and needed tripod support at all times, the possibilities offered by the newer, smaller and lighter optical designs are greater still. Imagine hand-holding lenses up to 400 mm. and still getting acceptably sharp results!

As you begin to use longer and longer focal length lenses, however, various technical difficulties, unforeseen while view-ing through the finder, become evident.

Entire areas which appear to be photographable at rela-tively slow shutter speeds of 1/30 or 1/60 sec. become blurred when a singled out subject is photographed with a longer lens. Seascapes which looked sharp and crisp through the finder yield bluish, hazy transparencies. Photographs of a distant building with a long lens appear to show the straight lines of the building waving like a flag in the breeze.

Some of these inherent difficulties with tele lenses can be overcome directly; others can be avoided. A few are impos-sible of solution. In this chapter we will try to analyze the telephoto lens problems and help you solve the solvable ones.

Use a Tripod

How do you obtain the sharpest picture with a longer than normal focal length lens? The same way you do with any camera and lens—put the camera and lens on a tripod. No matter what shutter speed you use, focal length lens you employ, aperture you shot through, ability to hold a camera steady you may have, the tripod shot will always be sharpest.

However, as images are magnified by longer and longer lenses, the difference between the hand-held shot and the tripod mounted shot becomes more evident. We, therefore, urge that a tripod be used for all longer than normal focal length lenses except where the tripod proves an inconvenience or hindrance to obtaining a good picture. All efforts to obtain steadier hand-held photos with longer lenses are attempts to approach the tripod mounted shot's sharpness, but we shall not really equal it.

There are no specific rules as to what long lenses can be safely hand-held with adequately sharp results and which ones cannot. Likewise there are no specific rules as to what shutter speeds must be used with which focal lengths to obtain passable sharpness. The answers to these questions depends on your own ability to hold steady and the degree of unsharpness you might tolerate in a picture. For the average photographer a general rule of 1/30 sec. minimum shutter speed for wide-angle to normal focal length lenses, 1/60 sec. minimum for 85 mm. to 135 mm. lenses, 1/125 sec. for 200 mm. lenses and 1/250 sec. for 300 mm. or over lenses is a good starting guide. However, when shooting, if you can sacrifice depth of field and use a larger lens opening to reach a higher shutter speed, you will usually get sharper results.

When you have your camera and lens mounted on a tripod, of course, your technique can be varied considerably. You no longer need keep a fast shutter speed to minimize camera movement. You can instead, let the movement of your subject govern the speed and attempt to use a smaller lens aperture when possible for greater depth. To make maximum use of the tripod, the lens should be in perfect balance with the camera using the tripod mount itself as the fulcrum. You will find that the makers of the Takumar lenses have deliberately positioned the tripod sockets so that proper balance can be maintained on the tripod when the camera is attached to the lens.

It's also advisable when tripod mounting a long lens to use as heavy a tripod as possible. Oddly enough small 35 mm. cameras really require a heavier and sturdier tripod than do larger cameras. Larger and heavier cameras contribute their own weight to the stability and rigidity of the tripod-camera combination. Light cameras and lenses lacking such weight

must make it up by using heavier tripods. In addition when using very long lenses, 500 mm. and upwards, many photographers find it advantageous to dampen vibration by draping a blanket or similar piece of cloth over the top of the lens on the camera.

Needless to say, a cable release should be used when the camera and lens are on a tripod. If you attempt to release the shutter by hand, you may easily undo all the good of the tripod by jarring the camera and lens at the moment of exposure.

Correct Hand-holding

Your stance is extremely important in hand-holding a long lens. With a normal focal length or shorter lens, the primary support is under the camera body. With longer lenses, starting with the 85 mm. f1.8 or f1.9 SMC Takumar and going upwards, the primary support should be under the lens.

Holding a long lens and camera properly resembles closely the problems of holding a rifle for offhand shooting. The only difference between camera and rifle is that you can use several body support aids in photography that just aren't allowed in rifle shooting.

In taking up position with a long lens, don't stand square on to your target. Stand at an oblique angle as you would in shooting a rifle. The left side of your body which is closer to the subject will support the lens barrel. This should be your left hand. If you are right handed the position will seem quite natural to you. If left handed, you will have to adopt this stance anyhow since the shutter release is on the right-hand side of the camera body.

Now crook your elbow and support the lens with the entire palm of your left hand. You can use your thumb and middle or forefinger to operate the focusing ring. Bring the camera up to your eye with your right hand. Your right thumb should be on the rapid wind lever, your right middle or forefinger on the shutter release.

To give your lens maximum steadiness, draw your left elbow into your body so that the point of your elbow digs you in the side, forming a support point. Draw your right arm into your side as far as possible for additional support. Press the camera against your cheek or forehead when steadying yourself before shooting.

This basic position plus a slow, steady release of the shutter with a highly arched finger should work well with all hand-held lenses from 85 mm. up to 400 mm. Dry practice runs will pay off in sharper results later.

Focusing practice is extremely important also. The magnified image and narrow field of view offer little depth even at medium distant shots. For instance, if you were photographing a football game with a 300 mm. Takumar lens and had closed the lens down to $f11$, your depth of field at a 30-ft. distance would only be about $1\frac{1}{2}$ ft! However, if your main subject is sharply focused on the principal plane of interest (generally the face of a person in a game), the picture will be acceptable to the viewer even if other aspects of the photograph are less sharp.

Problems of Long Lenses

We have now covered the physical considerations of using longer than normal focal length lenses and now must turn to the optical problems involved. At close focusing distances of 100 or so feet, there are no more optical problems than with shorter lenses. However, long lenses are often used for photographing distant objects or scenes. Over such long distances the atmospheric conditions create problems for the photographer.

Unhappily even on the clearest day, the distance between you and a far subject is not purely empty space.

The first time you shoot a long distance shot with a telephoto lens, you'll be amazed to find that the apparently very clear atmosphere has somehow wreaked all sorts of havoc with picture sharpness and colour. Your transparencies are apt to be rather blue. The cause: ultra-violet radiation scattered by water vapour in the air. The best time for picture taking of distant objects is when the atmosphere is the driest. Unfortunately, it's during the summer when relative humidity is apt to be the highest that you'll probably want to shoot your tele pictures.

At 80% relative humidity some of the tiny dust and dirt particles always floating in the air begin to pick up moisture which then develops into tiny water droplets about a millionth of an inch thick. As white light (which contains light of all colours) passes through the air, the tiny droplets scatter the short wavelengths (blue light) very much more than the

longer wavelengths (red light). The blue of the sky is scattered and causes the bluish haze which is seen to a greater or lesser degree in all very distant landscapes. As the relative humidity approaches 100%, the size of the water droplets increases and the haze becomes stronger.

This possible haze caused by moisture is only one of the difficulties encountered. But even when the moisture content is low, the air is not perfectly uniform. When warm air is on top and cooler air is below it, the atmosphere is very steady and fine for photography—but this is seldom the case. If the day is sunny, the warmth of the sun hitting the earth causes the earth to heat thereby warming the adjacent air. The air is warmed underneath but the cooler air remains above. This results in turbulence. How does turbulence become evident? Usually as heat waves which cause distant images to shake or wave when seen through telescopes, binoculars or telephoto lenses.

Watch out for little puffy cumulus clouds. These are a sure sign that atmospheric conditions are far from stable. When such clouds are about, it's not advisable to try distant telephotography. However, a high overcast will increase your chances of seeing long distances. If you have a clear atmosphere under the clouds you have a good chance of getting acceptable telephoto pictures.

The most acceptable conditions for telephotography occur over water, over snow or over land covered with dense vegetation. Here the sun produces little heating of the surface.

If you can manage to take your tele shots at a slight angle up or down, your picture quality should improve and the distant objects should show less unsteadiness. When you shoot at an oblique angle, you are shooting from one stratum of air into another. When you shoot horizontally, you may be shooting directly into the interference between two strata of air causing irregular light refraction.

Astronomical photographers experience less difficulty than you will because most observatories are located on mountains or high hills above the most image-degrading atmospheric conditions. In addition, they don't attempt to shoot pictures horizontally. Their cameras and telescopes are shooting upwards, through the atmospheric layers.

There will be few days on which all atmospheric conditions are perfect for long distance photography. Early in

the morning on a clear day when the sun has not had time to warm up the earth is a good time to try. Directly after a thunderstorm when the air and earth are still cool is another fine time.

Although you must put up with atmospheric conditions, what can you do concerning the haze? On a very clear day, you can cut down the blue in distant shots with a UV filter for colour or black-and-white film. For black-and-white film alone, a medium yellow or light red filter will do a good job of giving you better clarity and sharpness. These two filters will also help with light haze. There is nothing you can do for heavy haze with ordinary colour or black-and-white films.

A useful film for distant black-and-white shots is infra-red film (with a suitable infra-red filter). Infra-red film and filter will allow you to get rid of some scattering of light.

If you use your long lenses on less distant scenes, you will not run into the same amount of atmospheric problems. However, it's still advisable to keep the UV filter on at all times for colour or black-and-white.

AT LONGER RANGE

While the best telephoto pictures are certainly made through long focal length lenses designed specifically for photography, it is quite possible to use ordinary telescopes and binoculars.

Most of these instruments available for home use are not designed with photographic requirements in mind. They have been made for visual observation only. Nevertheless, they can be used for photography.

Why go to the trouble? First, because high powered binoculars and telescopes produce greater magnification than even the longest lenses available for the Pentax camera. For best astronomical photography, such high magnification is necessary. In addition, many photographers already own binoculars and telescopes and it seems a pity not to make use of them, if possible.

First let's look at some distinct disadvantages of this type of photography. There is a very definite loss in overall sharpness. Binoculars and telescopes do not have the same amount of resolving ability, the same colour correction, the same lack of optical aberrations as do good telephoto lenses. Nor do they have the same amount of light gathering power. In addition, most maximum apertures are generally rather small, necessitating both fast films and fairly slow shutter speeds. Moreover, binoculars and telescopes are not physically made for attaching to cameras. Connecting them and focusing them can be somewhat of a chore.

Despite these three snags, it is still a great deal of fun to take pictures using such long range instruments.

With the Spotmatics, SP500 or Pentax ES, exposure computation isn't even needed with these long teles. All you need do is centre the meter needle with the Spotmatics or SP500 while the Pentax ES will automatically provide the proper shutter speed.

There are three basic methods of shooting pictures through telescopes with your Pentax—Afocal, Prime Lens and Negative Lens Projection.

Afocal Method

This is the simplest method. Focus the telescope by eye, set your camera lens to infinity, hold it as close as possible to eyepiece and shoot the picture. Quite acceptable snapshots can be made in this way but you'll want a more solid, more substantial coupling for best results. Many telescope manufacturing and importing firms have special brackets available. If not, a camera repairman can fabricate a good coupling.

For best results, the camera lens should be about one inch from the eyepiece. Extraneous light between lens and eyepiece should be eliminated with a lens hood or cylinder of dark paper. The normal 50–55 mm. lens is suitable but a slightly longer focal length such as the 85 mm. Super-Takumar is even better.

To calculate approximate length of the combination:

1. Measure actual length of light travel in telescope from front of main glass element (in a standard all-glass refractor telescope) or mirror (in reflecting telescope) to telescope end of eyepiece. Let's say this is 45 in.

2. Check telescope eyepiece for focal length. Usually it's engraved on the eyepiece. Let's say it's 25 mm. or 1 in.

3. Divide focal length found in step 1 by eyepiece focal length of step 2. This is total telescope magnification power. In this telescope example we would have $45 \div 1 = 45$.

4. Multiply total telescope power (of step 3) by focal length of camera lens. This is focal length of combination. Thus in our example, we would multiply 45 by 2 in. (approximate equivalent of 50–55 mm. if you use the standard lens). This gives us an effective focal length of about 90 in. or in millimetres, $90 \times 25 = 2250$ mm. A longer 85 mm. Takumar lens if used instead of the normal 50 or 55 mm. Takumar would yield a total effect of about 4000 mm.

You now have the focal length—and it's impressive. But to make a proper exposure you must have the effective working aperture. If you have a Spotmatic camera, of course, you need only read the exposure right through the telescope and the Pentax ES gives you correct exposure automatically. However, if you have another Pentax model, here's how you find the aperture:

(*a*) Divide the telescope power of step 3 above by the

SHOOTING THROUGH TELESCOPES

There are four basic methods of attaching your Pentax to a telescope. In direct objective method the camera lens and telescope eyepiece are removed and the telescope's main objective acts as an ordinary telephoto lens (*left*). Image is seen upright through the finder. In the afocal technique (*second from left*), both the telescope's eyepiece and the camera's own lens are used. The Pentax, in effect, views through the telescope and sees the primary image upside down as you would. In positive projection (*third from left*), the telescope eyepiece is used to project the primary image into the lensless camera body. The image appears upside down in the finder. In negative projection (*far right*), a negative lens element or system is used instead of the telescope's eyepiece to project a right-side-up viewing image into the lensless camera body.

Your Pentax can be adapted to shoot pictures through a monocular or half of a binocular. Actually the monocular or binocular is nothing more than a folded telescope which uses prisms to fold the long telescope length to handier dimensions. Most binoculars or monoculars can be attached to the Pentax using the afocal technique in which the camera's lens sees through the monocular or binocular's eyepiece as you would. Image seen in camera finder is right side up.

diameter of the front telescope lens or mirror. Just take a tape measure or ruler and measure the lens or mirror across the middle. Quite often you will find this step unnecessary since telescopes are usually classified by the diameter of their lenses or mirrors. For instance, a 4 in. telescope indicates that the lens or mirror is 4 in. in diameter. If we had a 4 in. telescope (a common size) we'd divide 45 (from step 3) by 4 and get a little over 11.

(b) Multiply figure from step (a) by focal length of the camera lens. This would be 11 × 2 (if a 50 mm. lens) or $f22$.

When examining the results of your tele photography with such an afocal system, one or two dark corners indicates your camera lens isn't properly centred over the eyepiece. Four dark corners indicate that the camera lens was too far from the eyepiece. Light streaks or patches will occur if there is open space between the eyepiece and the lens which isn't properly shaded from an extraneous light.

Prime Lens Method

The above method of taking pictures through a telescope is probably the simplest method but it doesn't yield the best results. You are combining three different lens systems—the main lens of the telescope, the optics of the eyepiece plus the elements of the taking lens of your camera. Perhaps the best method in terms of sharpest results is the prime lens method.

If you take the eyepiece from the telescope and remove the camera lens, you can fit the telescope main lens directly to the camera body. In other words, you use the telescope lens as a giant direct telephoto or more properly, long focal length lens. Again you will have to consult a telescope manufacturer or importer or a camera repairman for the proper fitting. Quite often a short extension tube on the camera can be joined to or slipped within the focusing tube of the telescope.

To find the total focal length of the combination, measure from the refractor lens or reflector mirror to the normal position of the telescope eyepiece. (For instance a 3 in. refractor measures about 31 in. or 775 mm.) This is the total focal length possible using the telescope as the prime lens. To find the working aperture divide the focal length found by the telescope lens diameter. In the case of a 3 in. telescope already mentioned, this would be $31 \div 3 = f10.3$.

The system has the advantage of good sharpness and fast aperture but the disadvantage of a relatively short focal length and definite vignetting at the edges and corners of the picture area. Although this prime system is to be used mostly with refractor telescopes, it can also be used with reflectors if the reflecting mirror can be moved upwards in the telescope tube to allow proper focusing.

Negative Lens Projection

While the previous method will undoubtedly produce the best photographs optically the disadvantages of vignetting and limited focal length are quite real. Perhaps the ideal compromise system is negative lens projection.

When professional astronomers wish to increase telescope power without losing definition they insert into the telescope a negative lens called a Barlow, after the inventor. Average Barlows will produce respectably sharp images. However, first class coated achromatic Barlows, usually available from telescope supply houses or manufacturers can yield pictures which are virtually as sharp as with the prime telescope lens alone. By changing the positioning of the Barlow lens in relation to the film plane you can vary the magnification of the Barlow negative lens and telescope combination. The Barlow lens simply slips into the telescope eyepiece tube between telescope and camera.

To find the approximate total focal length of Barlow lens and telescope:

1. Measure the light path from refractor lens or reflector mirror to the telescope end of the eyepiece holder. With a 4 in. refractor, this might be about 45 in.

2. Multiply the total telescope length in step 1 by the magnification of the Barlow or negative lens. With a 4× magnification, this would be $4 \times 45 = 180$ in. or 4500 mm.

To find the working aperture:

(a) Divide the total focal length in step 2 by the diameter of your telescope or mirror lens. This would be in our example $180 \div 4 = f45$.

There is yet a fourth method of taking pictures through a telescope—by using the eyepiece of the telescope as a projector lens and actually projecting the image into the lensless camera body. However, the necessary couplings are rather expensive to make and the results are not as satisfying as

those which can be obtained by the negative projection method already mentioned.

Avoiding Vibration

When taking pictures through telescopes, great care must be exercised. There are two prime factors involved, steadiness and focus.

One of the difficulties of using any telescope is one of steadiness. Telescopes, because of their very long shape tend to see-saw and vibrate. Before use, they must be allowed to come to a complete rest. With camera attached this is still very true. The gentle action of the shutter going off can actually cause vibration. You can minimize this by using the fastest ASA index film you can to maintain a high shutter speed. In addition, fasten both camera and telescope securely to a solid tripod. Although it certainly is clumsier, better results can be obtained by mounting camera and telescope on separate tripods and then bringing them together. To minimize and damp the shutter vibration, drape a blanket or similar heavy material over the telescope.

Precise focus is absolutely essential. There is virtually no depth of field when using such long focal lengths, even when shooting at fairly great distances.

When using telescopes for terrestial photography, don't attempt long distance shots because of atmospheric conditions which normally prevail (see page 216). Telescopes can be used for effective medium range photography such as sports or nature pictures.

In astronomical photography where you can actually shoot upwards through the atmospheric layers instead of across them, you can photograph distant objects. The moon is perhaps the best initial target for would-be-astronomical photographers. If you have an interest in this subject, there are several excellent books which can take you further along the line.

Using a Monocular

While telescopes will undoubtedly give you the most spectacular results, you can also adapt a pair of binoculars or a monocular (half a pair of binoculars) to photo use. Binoculars or monoculars, of course, do have the advantage of far more compact size than do the telescopes.

A binocular or monocular can be most expeditiously fitted to the 50–55 mm. Takumar lens by means of a Series VI filter adapter ring available from your photo dealer. Many binoculars and monoculars which are convertible to photo use have the proper threads on the eyepieces to allow direct fastening of the camera lens to the monocular.

If not, a camera repairman can easily fabricate such a connection which can be interchanged with the present eyepiece or your binocular or monocular.

To use the binocular or monocular on your camera, open the lens to its widest aperture and set it to infinity; the focal angle of the camera-ocular combination depends upon the focal length of the Takumar used and the magnification of the monocular or binocular. On each ocular such numbers as 6×30, 8×50, etc., appear. The first of these pairs of numbers indicates the magnification. To find the equivalent focal length of the camera-ocular combination, multiply the focal length of the camera lens by the magnification of the ocular. For instance, if you are using the 55 mm. SMC Takumar and a 6×30 binocular or monocular, the equivalent focal length would be $55 \times 6 = 330$ mm.

To find the working aperture of the combination, divide the second number of the combination into the total focal length. With our example we would divide 330 by $30 = f11$. However, in actual picture taking you may find that some light is lost due to flare in the system. Therefore it is advisable to allow between $\frac{1}{2}$ stop and 1 full stop additional exposure.

While the best pictures through binoculars and monoculars can certainly be had with the use of a tripod, the compact size and light weight of the camera-ocular combination makes hand-holding possible at reasonably fast shutter speeds of about 1/125 sec. and over. With today's fast black-and-white and colour films, such exposures should not be hard in reasonably bright outdoor illumination.

While most monoculars and binoculars have but one shooting aperture, some are supplied with extra aperture discs which can be slipped over the main ocular objective lens. These limit the aperture even further, but they help improve sharpness.

Close-up lenses can also be used in conjunction with binoculars and monoculars. These are slipped over or threaded into the ocular's main lens.

P.W.—M

Certainly the results obtained with even the finest monoculars or binoculars cannot begin to compare with the excellence of the pictures obtained with long Takumar lenses. However, for many snapshots, such oculars will prove adequate until you're ready for real long lenses.

HOW LENSES BEHAVE

Like any other science, optics has its immutable laws, but these laws largely depend on a lens behaving as a "perfect" lens. Unfortunately, the perfect lens has not yet been invented, so the laws of optics have to be bent a little to fit in with the performance to be expected from practical lenses in practical cameras.

That, along with a few popular misconceptions, leads to many arguments among photographers on such subjects as focal length, perspective, depth of field and so on. There are different views on how far the laws have to be bent.

As we've seen in preceding chapters, lenses of varying focal lengths have more use than merely to make images smaller or larger from the same camera-to-subject distance. Shorter focal length lenses can cause apparent distortion of perspective by appearing to enlarge close images out of proportion to the parts of the subject further away. Distances in depth appear greater with short focal length lenses. The shorter the lens, the more pronounced the effect.

Longer than normal focal length lenses can produce just the opposite effect if you use them to frame the same picture area. Instead of close objects appearing too large, the same objects appear smaller. Depths seem compressed.

Don't be Misled

Don't be fooled into the notion that it is the focal length of the lens which produces this apparent change in perspective. The focal length of the lens merely changes image size. It is the actual distance from camera lens to subject which creates the extension or compression.

You can prove this to yourself quite easily if you have a long lens and a shorter focal length lens.

First, from about 3 ft. shoot a picture with the short lens of a person holding his hand toward the camera. The hand will appear over large in the resulting picture.

Secondly, replace the short focal length lens with the longer lens and back away from the subject until the subject's body is the same size in the prism finder as it was in the first picture. Shoot a second picture. In this shot you'll see that the hand is much smaller in relation to the rest of the body.

Finally, replace the longer lens with the short lens again and shoot a picture from the same distance as in your second shot. Of course, the image will be much smaller in this third picture because you are using a shorter focal length lens. However, after producing the picture, if you enlarge the *image* to the same size as the *image* in the second picture you will see in your picture that you have exactly the same perspective in the relationship of the size of the hand to the size of the body as you obtained with the longer lens.

This proves that it is distance and not focal length which determines this apparent perspective distortion.

In practical terms this means you should back away from a subject and increase camera-to-subject distance to avoid close image enlargement. You can then vary focal length to increase image size.

Using Perspective Control

Once you have convinced yourself that camera-to-subject distance really controls apparent perspective, you can use this to excellent advantage in controlling your background—provided you have one or more additional focal length lenses.

Suppose you are photographing a person but notice that a large tree seems to be growing out of his head some distance behind him. You could of course use a large lens opening to throw the tree out of focus. However, if you do wish a sharp background you can exercise perspective control. Try a shorter focal length lens and approach closer to the person to maintain image size. The shorter lens will tend to increase the apparent depth. This will make the tree appear far smaller in relationship to the person.

If you think the picture can be enhanced more readily by making the tree appear larger, you can try the opposite approach. Use a longer focal length lens and back off to keep the main subject the same size as before. The tree will now appear larger than before.

Backgrounds can therefore be minimised or increased in

228

FOCAL LENGTH VS PERSPECTIVE

Changing focal length alters image size but not perspective as long as the camera-to-subject distance remains constant.

House and tree behind house are photographed by normal, wide angle and long lens from the same position.

Images produced by three lenses vary in magnification. Long lens creates biggest image, wide angle, smallest image.

If wide angle picture is enlarged and cropped to produce image size equal to either normal or long lens picture, perspective in enlarged wide angle picture will be exactly the same as in shot with longer lens.

importance by maintaining subject size but changing focal length and shooting distance.

Understanding Depth of Field

This brings us to a controversial subject—depth of field, which is so easy to define in theory but capable of being much misunderstood in practice. There are various schools of thought on this subject but practical experience leads me to the conclusions outlined below.

The "perfect" lens delivers its sharpest image at a single properly focused flat plane in space. Sharpness falls off in front of and behind that plane. By closing down the lens opening, the degree of sharpness fall-off can be lessened. More depth in the picture appears adequately sharp. However, in theory, still only one single plane in the picture is in sharpest focus.

How do we determine the outer limits of our depth of field? Without going into scientific details, we can explain as follows. If we could focus our "perfect" lens on a point source of light, the light would be reproduced on the film as a pinpoint. When this pinpoint of light is not sharply focused by the lens, it forms a disc on the film. The more it is out of focus, the larger the disc appears. This disc is called the circle of confusion and, in fact, with practical lenses, it always is a disc, even when in sharpest focus. However, by establishing a limit on the size of this circle of confusion we can lay down a criterion of sharpness and thus establish limits to depth of field. The smaller the limit we place on the maximum circle of confusion, the greater we can enlarge a picture and still find sharpness acceptable within the depth of field.

It follows of course, that depth of field is what we make it. We set our own limit on the size of the maximum circle of confusion according to the type of work we are doing. Where high degrees of enlargement are normal, as in 35 mm. work, the maximum circle of confusion must be kept relatively small. Then, at normal viewing distances, which are likely to be rather shorter than the theoretical "correct", everything within the depth of field should look equally sharp, because, at normal viewing distance, the eye is unable to tell the difference between a point and a disc of a certain size.

Nevertheless, the fall-off in definition is very gradual and, at reasonable shooting distances and apertures, even objects a

foot or so outside the theoretical limit may be sharp enough to be acceptable or annoying as the case may be. So, in practical terms, if you want to *use* your depth of field, you compute it from tables designed specifically for 35 mm. work, such as those in the back of the book. If you want to throw a relatively close background out of focus, you would be wiser to rely on your screen image with the depth-of-field preview lever in use—or open up the lens as fully as possible in the existing circumstances. Depth-of-field is, in practice, entirely subjective. It can only be calculated exactly if various ideals as to film size, enlargement, viewing distance, etc., are all observed.

Depth of Field and Focal Length

From any given distance and at any given aperture, a wide-angle lens gives greater depth of field than a longer focal length lens. This leads many photographers to rely on the wide-angle lens for increased depth sharpness in their pictures. They feel that accurate focus will be less critical and that they can use a larger aperture and still retain greater depth-of-field than they would with a longer lens.

This works out nicely in practical picture taking provided you use the same aperture and shooting distance for each picture. Then, the shot taken with the wide-angle lens always shows greater depth-of-field, even at greater degrees of enlargement.

But suppose you use the wide-angle lens to move in close and get the principal subject the same size on the film as you would with the longer lens and a more distant viewpoint. What happens to your depth-of-field then? Well, in this case, the wide-angle lens does not give greater depth-of-field. Even this does not always apply but you will find in most picture taking situations that when lenses of different focal lengths are used to produce the same size image *on the film*, the depth-of-field is the same when the same aperture is used, regardless of focal length.

All this may seem to be of purely theoretical interest, but it does have practical applications and can help you to avoid some pitfalls into which many a photographer has fallen. For instance if you purchase a wide-angle lens to achieve a greater viewing angle from any given distance, well and good. However if you purchase a wide angle lens with the idea that it will provide greater sharpness in depth than your

normal or tele lens, remember that this will not be true if you use the wide-angle lens to give the same size image on the film as the longer lens gives. Only by closing down the aperture of your lens, wide-angle, normal or tele, can you be sure of getting an actual gain in sharpness with images of the same size.

The impossibility of maintaining image size on the film while altering depth-of-field by changing focal length obviates some photographic old wives' tales. One tale suggests you use a wide angle lens for greater depth in closeups. This rarely works. If you photograph the same picture area with a long focal length lens, your actual depth of sharpness between objects in the picture is the same at the same aperture.

The conclusion that can be drawn is: choose your focal length lens primarily for image size needed and apparent perspective desired.

Focal Length and Movement

Another misconception which we must put to rest, we've discussed briefly before—the belief that shorter focal length lenses shake less and therefore cause less subject unsharpness than do longer lenses. If you shoot a subject from the same distance with both a short and long focal length lens, then enlarge the shorter lens shot so that the subject image is the same size as in the longer lens shot, you will have the same amount of unsharpness provided you were just as unsteady when holding one lens as the other. Of course, it may be true that the longer focal length lens is simply heavier or harder to hold than the shorter lens. But then the unsharpness is not an optical phenomenon caused by the focal length. It's a physical phenomenon caused by you.

Let's track down another widely-held belief—that a shorter focal length lens when photographing action will stop movement to a greater extent than will a long focal length lens. If you enlarge the subject made with the short lens, you will have just the same amount of unsharpness as you did before. There are only two sure ways of getting sharper action pictures, use a faster shutter speed or pan with action.

Close-range Distortion

There are two very real distortions which you may discover when using normal or shorter focal length lenses. In shooting

DISTANCE VS PERSPECTIVE

Changes in perspective can be made with different focal length lenses if you change camera-to-subject distance.

When shooting close portraits with 50 mm. lens, faces tend to elongate and become slim. By using longer lens, such as 135mm. you can shoot at a greater distance, maintain same size face in your finder, yet get much broader facial contours.

When shooting close-ups many photographers mistakenly believe they can get much more depth-of-field with a wide angle lens than with a longer lens at the same aperture and same image size. This is not so. If you vary camera-to-subject distance to maintain image size and you use same lens aperture, you can only vary perspective. With longer lens, depths are compressed, more distant leaves appear larger in relation to pistils. But depth is the same.

Real distortion occurs when a wide angle lens is used fairly close to a subject. Images close to picture edge, much as the end columns here tend to broaden out and look flatter.

close portraits with a normal or shorter focal length lens, you will find that full faces tend to elongate and become narrower. Ears disappear. The reason for this is rather simple. While the centre line of the face is being photographed straight on, the sides of the face towards the cheeks are being photographed at rather an oblique angle. You receive a false impression that the face is really narrower than it actually is. While this may be quite suitable in enhancing the slimness of a pudgy face, it is usually disturbing. Either get further away, photograph the face and then enlarge the facial area if necessary or back off and use longer lenses to increase image size.

With lenses of 28 mm. or shorter, beware of subject matter close to the edges of the picture at moderate distances. For instance if you photograph a group of people at about 10 ft. that extend from one edge of the picture to the other, you will find that the people towards the edges appear flat and stretched out horizontally, an effect somewhat similar to the very close focusing subject, but the oblique angle of the wide angle lens picks up extra surface instead of less. The solution is to keep subject matter away from the very edges or back up further and use a less wide angle lens.

ARTIFICIAL LIGHT

Photographic lighting is an extremely broad subject. There are many types of lighting—sunlight (and moonlight, too), flashbulbs, flashcubes, electronic flash, various floods, spots, fluorescents, and quartz-iodine lamps plus all the types of lighting you have around your house. There are seldom clear-cut rules which state when one type of lighting is better than another. Often it's a matter of personal taste, of convenience and quite frankly, of what lighting equipment you happen to own. Besides the type of lighting, you have two other factors to consider—the amount of light, the number of lighting units and the proper placement of them.

Since placement of the lights—and number of units used is much the same no matter the type of lighting used, let's first discuss the various types of lighting.

We will rule out sunlight outdoors. This is covered in chapters on exposure, films and shooting various types of pictures. Aside from changing your shooting angle or moving out of the light you have little control over daylight. You must adapt your picture-taking to it.

With all artificial illumination, you are the artist in control—except for artificial existing light shots where you are simply shooting in whatever lighting happens to be available.

Let's examine the assets and liabilities of the type of artificial lighting most familiar to amateur photographers—light from flashbulbs.

Flashbulb and Flashcube Pros and Cons
The advantages of flashbulbs are numerous. Today's flashbulb or cube is tiny—many can be carried in a pocket. The flashgun and reflector for these tiny bulbs are compact and often can also be carried in a pocket. They fit easily on the camera and do not get in the way of camera operation. Bulbs or cubes produce an amazing amount of light when compared

to their modest size. They allow you to shoot pictures in surprisingly large areas with the light of just one flash.

Now let's look at the disadvantages. Because flash is an instantaneous light, you have no sure way of determining just what effect it will have on the subject—where the highlights will be, how the shadows will appear. There is also an expense factor. You can only use a bulb once. Each bulb is fairly inexpensive—but if you shoot many pictures, expense begins to add up. Lastly you cannot measure proper exposure for flash accurately. You must use simple tables based on your shutter speed, your lens opening and the distance of your subject. No practical amateur meter has yet been devised to use on flash.

Nevertheless, the bulb or cube because of size and convenience factors remain extremely important light sources not only for amateurs but professionals who want the assurance that wherever they go they can always pull out a tiny flash reflector plus bulb, or just a cube, and be assured of pictures.

For amateurs who don't shoot too many artificial light pictures, flashbulbs or cubes are the ideal answer when they are needed.

What is a flashbulb? Basically it is a small glass envelope —much like a tiny electric light bulb. Inside is a highly inflammable wire which is connected to the negative and positive poles of the bulb. When a current passes through the bulb, the wire lights quickly and brilliantly—just long enough to illuminate the subject while the shutter is open. Often various gases are used alone or in combination with the wire to heighten the brilliance and hasten the burning.

Flash Synchronization

The electrical circuitry in a focal plane shutter single-lens reflex is cleverly designed to make the most of the bright light of a flashbulb. The camera must work in such a way that the flash circuit is closed before the shutter is released since it does take a fraction of a second, called the delay, for the bulb to reach near peak illumination. Because the focal plane shutter on Pentax cameras consists of a slit travelling over the film itself, the flashbulb must remain evenly lit during the entire travel of the slit. If it doesn't, part of the picture may be well lit while other parts may be much underexposed.

To simplify matching the flash to the right shutter speeds, we've included a flash synchronization table in the Facts and Figures Section in the back of the book to show which flash-bulbs should be used at what speeds. There are special focal plane bulbs which do allow flash synchronization at all shutter speeds. These would seem the best all around choice but they are rather more expensive than the ordinary AG1, PF1, M2, flashcube, etc., which can generally only be used at shutter speeds of 1/30 sec. or slower. This makes them a distinct liability in terms of obtaining sharp, motion-free photographs if there is an appreciable amount of other light in the scene.

You'll note from the synchronization table that your flash unit must be connected to either the X or FP terminals on the front of your camera (or directly to the hot sync shoe atop the prism of the Spotmatic II or Pentax ES). Check that you have the synchronization cord securely attached—also that you are using a recommended speed. It's best to use the fastest speed your bulbs (and exposure necessities) allow.

For black-and-white photography, you can use either clear white flashbulbs or blue tinted flashbulbs. For colour negative film manufacturers have hitherto advised the use of clear flashbulbs but there is now a tendency to recommend blue bulbs. Check the instructions supplied with the film. You can use either but following the manufacturer's instructions makes life easier for the printer. For daylight type transparency films, use blue bulbs only or your pictures will have a reddish-orange coloration.

Flash Exposures

Determining approximate flash exposure is usually easy. Examine the carton or sleeve of flashbulbs when you buy them. The correct flash guide number for your film is often printed on the back or side. Make sure you look for the instructions for focal-plane-shutter cameras. You'll see that the guide numbers are listed in terms of the film's speed. Find the right guide number of your film. Note the suggested shutter speeds. The rest is simple. Divide this guide number by the distance of your subject from the direct flash. The resulting figure is the right lens aperture. Shoot at this opening and the shutter speed allowed for that bulb. For instance, if the guide number of your flashbulb is 160 and

you plan on shooting a subject at 10 ft., you'd just divide the 160 by 10 and come up with an *f*16 shooting aperture.

Sometimes your division may come out with a number between actually marked lens apertures. Then use the in-between click aperture markings on your Takumar lens.

Note that we've stressed direct flash and flash-to-subject distance. If you point the flash anywhere but directly at the subject, your guide number calculations have to be modified.

Bounced Flash

Why point the flash away from the subject? Many advanced amateurs and professionals have found that they can get more pleasing flash results by pointing the flash at the ceiling or wall. The light reflected on to the subject is then more diffused, even and pleasant. Such light appears very natural and it is difficult to tell that flash was used at all. When flash is pointed at a ceiling half way between the camera and subject, the entire surrounding area is quite well lit by the reflected light. The picture no longer has the characteristic flash shadows directly behind the subject plus the marked light fall-off.

When bounce flash is used, however, exposure calculation becomes a very risky business indeed. The exactly correct exposure no longer depends on just direct distance. You must take into consideration the height of the ceiling plus its reflective ability. You can usually make a fairly good estimate of practical bounce exposure by calculating the distance from the flash to the reflecting surface plus the distance from the reflecting surface to the subject. Add these two distances together and use them as the flash-to-subject distance. Then allow one or perhaps two more *f*-numbers exposure to compensate for the light lost in actually reflecting from the surface of ceiling or wall. With very white surfaces, one *f*-number more exposure will be enough. However, with cream or other light coloured surfaces, allow two more *f*-numbers.

Bounce flash works best for black-and-white photography. With colour materials there is the danger of having off-white or coloured bounce surfaces add coloration to the colour picture. Use bounce flash with colour only if you have a very white surface or you are willing to tolerate off-colour pictures in return for more even illumination.

very low# LIGHTING

Direct flash or flood at camera is most convenient but often creates unpleasant results. Lighting on subject is harsh, two dimensional. Shadows appear right behind subjects.

By directing the light from camera position on to ceiling or wall, soft, even illumination can be produced. But exposure is often hard to determine and coloured bounce surfaces can alter colour picture results.

Best direct flash or flood can be obtained by using light some distance away from camera. Shadows now fail to one side.

Two very convenient types of indoor lighting units are the quartz iodide lamps (left) and the self-contained reflector floods (right).

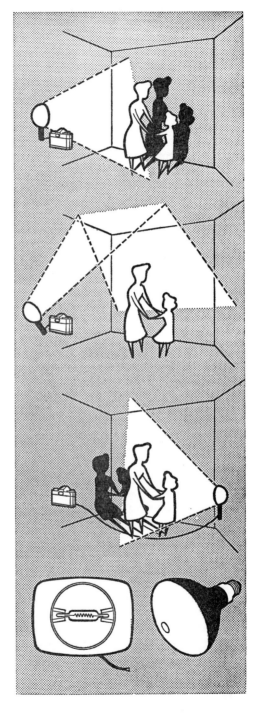

Off-the-camera Flash

Although most flashguns are designed to be used on the camera, this is a particularly bad place for them unless you're using bounce flash. Direct camera flash has very little to recommend it except expediency. Flash-on-camera tends to flatten out the subject. It creates very unflattering shadow areas behind the subject. When photographing people or animals head-on, you will get bright reflections of the flash in the pupils of their eyes.

While this is sometimes acceptable in black-and-white photography, it is most annoying in colour where these highlights in the pupils may show as two glowing red spots—interesting if you are photographing lions but not so desirable with other subjects. This is the so-called "red-eye effect" typical of on-camera flash technique.

How can you avoid these unfortunate on-camera flash results? By removing your flash from the camera. Although some flash units do have fairly long synchronization cords which would permit the removal rather easily, most modern flash units have very short ones. You can obtain an extension for this cord from your photo dealer.

When removing the flash from your camera for better results, you can either hold the flash yourself or attach it to a light stand, a tripod or other convenient unit. Since the entire purpose of using flashbulbs is one of convenience, you will probably wish to hold the flash yourself. Holding the camera in one hand while holding the flash in the other does take some agility. It's wise to practice a bit before attempting to use off-camera flash technique.

One of the best places to hold the flash is about two feet above the camera and slightly to the side. This will give you some three-dimensional modelling caused by off-camera shadows. It will also prevent the extreme shadows that flash far off to one side or another can cause.

If your flash gets fairly far from the camera, you will not be able to use camera-to-subject distance for calculating exposure. Remember that you must calculate flash-to-subject distance, not camera-to-subject distance.

You can judge the effect at different flash positions by holding a photoflood lamp in a reflector or even a table lamp in the same position you intend to use with the flashbulb or electronic flash. Note the effect on the subject. This is

approximately the same effect that you will get when you use the flash.

You can also use a single flood to give you an indication of just how much light you will lose if you use bounce flash instead of direct flash. Just point your flood directly at the subject and take an exposure meter reading. Now point your flood at the spot on wall or ceiling from which you intend to bounce the light. Take another reading from your subject. The amount of light loss in percentage is approximately the same amount of light loss you will get when you use bounce flash as opposed to direct flash. If the light loss is two *f*-numbers with flood, when using bounce flash try using two *f*-numbers more exposure than the guide number calls for.

Quite often in comparing the exposure directions that come with your flash unit against the recommendations on the flashbulb package you will note a discrepancy of one or perhaps even two *f*-numbers. Flashbulb makers give guide numbers for the average flash unit. Manufacturers of flash units, however, are in a far better position to give precise information on guide numbers for a specific flash unit. The manufacturer knows the reflector's contours, the surface and its reflecting ability plus the angle of coverage of the reflector. Some reflectors concentrate a very bright beam for normal focal length lenses such as the 55 or 58 mm. Takumars or longer. Other flash unit makers deliberately design shallower reflectors which spread the light further thus covering the angles of view for wide-angle lenses such as the 35 mm. Takumars. When wider angles of light are produced, the light spread is necessarily greater but the concentration of brightness is less and a lower guide number must be used. Always follow the suggestions of the flash unit maker first. Better, shoot a trial set of pictures first to make sure the guide numbers advocated are correct.

At one time it was quite fashionable to use multiple flashbulbs for special lighting effects. While it is possible to link up many flashguns with extension flash reflectors, it is seldom done today. Most photographers whose work requires such extensive flash use now have turned to electronic flash for multiple work. The cost of shooting two or more bulbs to get one picture quickly mounts up to the point where the initially higher cost of electronic flash quickly equals the cost of the flashbulbs.

Electronic Flash

Closely allied to the flashbulb is the electronic flash unit. The electronic flash unit uses a tube filled with gas. When a very high voltage electric current is passed through the tube the gas produces a brilliant but extremely brief light.

The great advantage of electronic flash over the flashbulb is the flashtube's ability to fire again and again—perhaps 25,000 to 50,000 times without wearing out. The flashbulb can only fire once.

Small electronic flash units have become quite common. To make the gas light up so brilliantly it's necessary to feed a very short burst of high-voltage electricity into the tube. The power can come from house current or from various types of accumulators or batteries—wet cells like those used in automobiles, dry cells which must be thrown away after some use or the rechargeable nickel cadmium batteries which can be charged from house current after their power has been exhausted. The power passes through a relatively complicated circuit of transformers and capacitors to build up the required high voltage. This takes a certain amount of time, known as the unit's recycling time. A small pilot light usually indicates when the unit is again fully charged and ready to fire. Flashguns which work off household current or have large power packs may recycle in less than 5 sec., while the recycling time of the smaller, more compact, battery-powered guns is likely to be in the region of 8–12 seconds. The recycling time increases rapidly as the battery nears exhaustion.

While the flashbulb holder used only a tiny battery to set off the flashbulb, the combination of circuitry needed plus the size of even the most compact electronic flash batteries makes the electronic unit of comparable power considerably larger than the modern bulb flashguns. Of course the initial cost of purchasing the electronic flash unit is greater.

There has been a decided trend to smaller and less expensive electronic flash units. Most can now slip right into the camera accessory shoe. However, if you compare the light output against the output of even the tiniest flashbulbs, you will see that the power of the flashbulb exceeds that of the small electronic flash units. The small electronic units produce a limited number of flashes. Batteries must be changed or recharged after 50 or so shots. Charging may take 24

hours. For more shots per charge, the units become larger and often require a flash head on the camera plus a heavy battery case carried by a strap over the shoulder. Such units are also more expensive, of course.

The small electronic flash unit is becoming more and more a very common accessory. No longer need bulbs be changed. A prospective purchaser can quickly calculate just how many flash pictures must be taken before the unit actually becomes less expensive to buy than the same number of flashbulbs.

Electronic Flash Practice

Unlike the flashbulbs, which must be dyed blue for use with daylight colour films, the flash emitted from electronic flash units has much the same qualities as daylight in terms of practical photography. If you own an electronic flash unit you can use daylight colour film exclusively with no need for any filters.

Since the duration of the electronic flash is quite short—usually $1/500$ to $1/1000$ sec.—the problems of synchronizing electronic flash to your camera are quite different from those of flashbulbs. There is no delay needed to allow the gas in the flashtube to reach maximum intensity. It flashes almost instantaneously. On the shutter speed dial of your Pentax there's a red X mark which indicates the proper shutter speed to use with electronic flash. At this speed, the entire shutter is fully open so that the whole film area can be exposed to this instantaneous flash of light. Do not use faster speeds or part of your picture will be unexposed.

Your electronic flash synchronization cord must be plugged into the X socket on the front of your camera. This socket provides virtually no delay between the time the shutter is open completely and flash goes off. On the Spotmatic II and ES, a cordless hot shoe flash unit can be slid directly into the prism accessory shoe.

While the very high speed of the electronic flash can be of great help in freezing all action and so insuring sharp pictures, this very quick flash does present a problem, too. The electronic flash must be used at fairly slow shutter speeds. On Pentax cameras the X settings usually represent either $1/45$ or $1/60$ sec. shutter speeds. If you are using your film in an area which has some reasonable amount of existing

light already, there is danger of producing a second or ghost exposure—primary exposure from the flash but a ghost from the light already in the room. To avoid such a ghost image keep the light level in the room well below the level of the flash illumination.

Calculation of correct electronic flash exposure is much the same as for flashbulbs. Practically every electronic flash manufacturer provides a calculator on the electronic flash unit which indicates the proper flash guide number to use with various films. Before actually shooting an important subject, however, try a practice roll using the guide number suggested by the unit's maker. Also shoot a few pictures using a guide number slightly greater and slightly less than the maker's suggested guide number. Quite often you will find that some slight alteration in guide number will produce better pictures. This is often true in colour photography.

The very popular fully automatic exposure electronic flash units simplify flash photography immensely. You simply use one specific lens aperture depending on film speed and distance range. An auto sensor on the front of the flash unit automatically adjusts light output to fit the subject distance.

Multiple Flash

Multiple lighting setups for photoflood lamps are discussed on page 247. The enterprising user of flash who is willing either to make the moderate purchase of additional flashbulbs or the less moderate purchase of extra electronic flash units can also achieve more flexibility in this way. Check carefully with your photo dealer to make certain that you have the right connections between units and your camera. It is possible to mismatch units and cause damage to your camera's flash contacts. To determine exposure, use the guide number of your main light source when the other units are used only as fill-in and background lights.

With flashbulb or electronic, it is no longer necessary to have sync cords attached to all your supplementary lighting units. Small cable-less slave units are available with photo cells which fire automatically when the main light goes off. These are much more convenient to use than the older, wired accessory flash units.

When shooting in your home, you can save valuable accumulator or battery life by operating from house current. If

you have a rechargeable battery electronic flash unit and want to get the most flashes from each charge, try this: whenever the unit has been stored for over a day, attach it to house current before you use it. Here's why. When the unit isn't in use, the current which has been stored up in the capacitors by the batteries drains away. By attaching the unit to house current briefly you refill the capacitors without draining the batteries.

Continuous Light Sources

While the two types of flash—electronic and flashbulb—have certainly gained great acceptance, continuous forms of lighting are still very important in photography. By continuous forms of lighting we mean the lighting most familiar—illumination which goes on at the touch of a switch and stays on with even brightness. Compared to flashbulb or electronic flash, continuous light is generally less expensive even if bright and unnatural. Of course, it does need to be connected to house lines. However, it has very important assets. You can see just what effect it has on your subject before you shoot. That's why skilled portraitists, still life photographers and other careful workers still use it in preference to flash.

Floods and spots for photography come in all forms, shapes and sizes from the simple housebulb-sized lamp to giant arc lights for professional use. We'll confine our discussion to the most practical types of lighting for general 35 mm. use.

Photoflood Lamps

The two most common types of small tungsten lights for photography are the photoflood lamps which must be used with separate reflectors, and the reflector floods and spots which have reflectors already built-in. If you plan on using them with colour films, consult the colour filter nomograph in the Facts and Figures section at the back of the book.

All special bulbs for photographic use have one feature in common—they are short-lived. In order to produce great quantities of light, the filaments must be so designed that they burn more brightly than standard filaments. Flood and spot bulbs often have their estimated life span printed on the container.

The plain No. 1 and No. 2 reflectorless floods are the least expensive types of illumination. However, you will need to

purchase metal reflectors plus a clamp-on socket or simple light stand to use them. The reflector floods are usually **more** efficient and compact but they do have their own reflectors which must, of course, be thrown away with the bulb when the bulb burns out. The reflector floods and spots are therefore higher in cost. There are several reflector flood types and sizes. Consult your photo dealer concerning the proper fittings and holders for them.

Quartz-iodine Lamps

Perhaps the most efficient continuous light is the quartz-iodine (or tungsten-iodine) lamp. Although originally designed primarily for motion picture work, quartz-iodine lamps were soon adapted to still photography.

What is a quartz-iodine lamp? It's a quartz glass sealed small tube a few inches long with a tungsten filament, an inert gas and iodine. When current is turned on, vaporized tungsten combines with the gaseous iodine in the lamp to form tungsten iodine. The tungsten iodine then recycles back to the filament and tungsten particles are returned to the hottest part of the filament in a continuous cycle. There are no black deposits on the glass envelope as there are with ordinary bulbs, so colour temperature remains constant no matter how many hours the bulbs are used. A 30-hour life—far greater than the life of floodlamps—is not unusual.

These small quartz-iodine tubes are generally used in very carefully designed reflectors. As a result of the extreme efficiency of the tube plus the efficiency of the reflector, such tubes can produce as much light as up to 4 regular reflector floods. They are primarily designed for use with Type A colour films, but many manufacturers are planning to filter them for use with daylight colour films.

These quartz-iodine lamps are so efficient and convenient that they may replace all standard floods in a few years. They are available in many different models to mount on your camera, on light stands or tripods. The lamps also come in several sizes and brightnesses. Since overloaded house current lines are always a problem when using more than one floodlamp, the quartz-iodine lamp lessens the danger of blown fuses. You get more light for less wattage. Consult your photo dealer for the latest quartz-iodine units available.

While one flashgun or electronic flash unit is usually used

by 35 mm. camera owners, the ease of checking results and making exposure readings allows continuous light enthusiasts to try multiple setups. Three lights—two floods and a spot—can make up an excellent at-home or small studio system capable of handling most requirements. While we will take up the lighting of various subjects when we discuss each subject, we feel that experimenting with various lighting setups using two and then three lights will probably teach you more about lighting than most lighting diagrams. However, it's advisable to use one flood fairly close to your subject as a main light, another flood at a distance to lighten the shadows somewhat of the first flood, and the spotlight to brighten the background or furnish a toplight. Exposure? Use your meter carefully.

If you do use quartz-iodine lamps, please remember that they tend to build up a great deal of heat. Not only the bulbs but the housings themselves can cause severe burns. It is not advisable to use them around children where there is any possibility that the child could possibly get close to them.

PICTURES OF PEOPLE

Pictures of people present an extremely wide range of possibilities for your camera. Subjects may vary from the simple (but satisfying) family snapshot to the posed formal portrait, to candids taken on the street or in theatres, to photojournalistic stories such as those which appear in leading news magazines. Your camera is more than capable of handling all of them. Without any accessories it can do a splendid job. With various aids such as interchangeable lenses it is capable of results that cannot be surpassed by other equipment, professional or amateur.

Since we will study candid pictures, and night photography in other chapters, here we'll concentrate on informal pictures of individuals and small groups. We'll start with the simplest and most common type of photography: the pictures of family or friends near home.

The Family Snapshot

No matter how poor a family snapshot is—blurry, badly exposed, awkward in pose—it will be treasured and loved by mothers, fathers, sisters and brothers. Such pictures are the most common products of cameras throughout the world today. And although you can shoot such pictures with virtually any camera, including the most inexpensive, it's surprising how many of these photographs are made with superlative equipment—like the Pentax.

With proper technique, your camera can produce far better photographs which can also be admired for their artistic ability as well as their family appeal. You can also put each subject's best foot forward, bringing out each person's good features while minimizing the less admirable.

In learning to photograph people, it's wise to start with readily available subjects who expect to be photographed and will be ready and willing to aid you. They will not expect miracles of photography immediately—even

if you do own fine equipment. Once you have mastered some of the basics with your home-grown subject material, you'll be ready to pass on to the more difficult subject.

The family portrait is probably the most important type of picture made. Most are dreadful. A very self conscious child standing too far away from the camera blinks bravely into a brilliant sun right behind the photographer. The subject's face is washed out by the sun while deep eye shadows are formed by the direct light. Quite often the low angle of the sun causes the photographer's shadow to become visible on the ground right in front of the subject. Let's see how we can improve this picture.

The average poor photograph of a person which we justify by terming a "snapshot" is a product of a self-conscious subject and an unschooled photographer. As awkward as the pose may look, it is a posed picture—except that the subject does not know how to pose and the photographer doesn't know how to pose the subject.

Professional photographers often have a great deal of difficulty eliciting the proper pose and expression even from professional models. Small wonder that an amateur, beginner or expert, may have difficulties with a subject who has no schooling in posing.

The best "snapshots" and often the best serious photographs are unposed. Luckily the Pentax, with its easy to focus lenses, fast shutter speeds and ease of operation is an ideal camera with which to capture unposed photographs.

Get Out of the Sun

Let's go back to that awkward-looking subject and try again. First we must find a better photo environment. Bright sunlight is hard to control. While the old rule of keeping the sun over your shoulder was adequate in the days of very slow film, the harsh nature of bright sunlight makes the rendition of pleasing facial tones quite difficult. What subject can face a sun and not squint? And why suffer the deep shadows under the eyes or increase the chance of highlighting wrinkles with direct sunlight?

Instead let's find a picture area in bright shade—perhaps underneath a large tree or within the shadow of a building. Suddenly the subject is no longer faced with the sun's glare. The harsh contrasty light is gone and is replaced with a more

even overall lighting. If there were wrinkles and furrows before, notice how the absence of pronounced sunlight minimizes them.

Improve the Pose

Your subject, however, is still just standing there, looking directly into the camera. This won't do at all. What we want is a natural expression, easily recognizable as being characteristic of the subject. First, how do we get the subject to relax? We must find a natural pose. Seating the subject on a rock or in a chair is commendable. Asking the subject to lean against a tree or a doorway is a useful alternative. The subject may also be asked to stand, sit or kneel in a natural position. Now move in with your camera. Don't keep waste space in that viewfinder. The bigger your subject appears in the finder, the larger the image will be on the negative and the sharper and crisper will be your final picture. Keep moving in until you have a very tight composition with just the minimum amount of surrounding scenery.

How is the background? If it's distant, you will have little trouble since it will probably be outside the depth of field when you focus on your main subject. If the background appears close and cluttered, plan on using a fairly large lens opening to throw the clutter out of focus when you shoot. Better still, move the subject or change your own shooting angle to improve the background.

Now we have a relaxed, more natural pose, a tight camera-to-subject distance, an appropriate background and have set the exposure properly for the camera.

Your subject is still looking stone faced, right at you. Start a conversation. If you know his or her interests, fine. If not, discuss what your subject is wearing, the weather—anything but the camera. The subject must really become interested. Continue the conversation but start looking through that viewfinder. See the expression you want? Release the shutter.

Still not quite certain of the pose? While talking to your subject, suggest a change. Want his or her hands folded in the lap? Suggest it. How about a man lighting a pipe? Need a profile? Ask your subject to look at a specific object in the direction you wish, but keep up the conversation.

Obviously this technique of conversation plus photography will require practice. All the technical aspects must be out of

PEOPLE OUTDOORS

Despite the old advice that it's best to photograph people with the sun over your shoulder, don't do it. Direct sunlight is harsh and subject will have to squint in order to open eyes at all.

Bright shade is excellent light, produces soft even illumination in which your subject will appear far more at ease. Bright overcast days are also good.

Watch those backgrounds. If they are confusing and distract from subject, use larger aperture and correspondingly greater shutter speed. Large aperture shortens depth of field, blurs background, thus making it less distracting.

Use camera angle to control background. At left, picture shot on level contains annoying tree. By increasing camera height and shooting downwards, you can eliminate tree and get small brook as background instead.

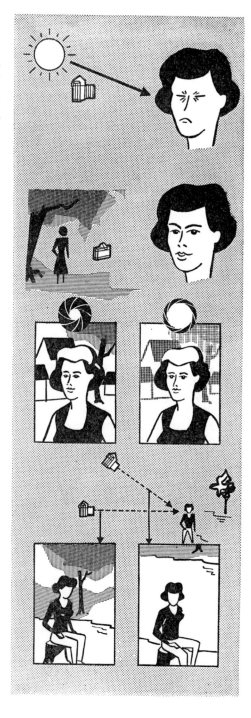

the way first—distance, choice of film, exposure settings, proper focus, background angle—so that you can concentrate on the subject only with occasional need to refocus.

The foregoing technique works with almost every adult subject, whether a friend, relative or absolute stranger. But it seldom works on children. With children you need some diversion—a book for them to read, a kite to fly, an ice cream cone to eat, a ball to play with. The list of diversions is endless. If you haven't had much practice in following an active child with a camera, find some stationary diversion to keep the child in one place.

Dealing with Groups

Photographing two people or a small group should hold no fears either. How much worse can a group picture be than the traditional album pictures you've seen of two or more people standing in line facing the camera? Instead, get them into a naturally arranged discussion group. Standing groups (unless you are taking formal pictures of a school graduation) should be avoided. Try seating your subjects if possible. However, a small group of people leaning on a bridge or stair railing, can make an interesting picture. You must use your ingenuity and imagination to make the most of natural props at hand.

With groups, you can often get conversation started among the individuals. Then let them carry on while you change angle and subject distance for different pictures. If you want all the subjects to look at you, just interrupt the conversation. But shoot just as soon as all heads turn in your direction or your subjects will lose their naturalness.

So far we have only attempted to improve the basic snapshot and make it into a more acceptable photograph. However, there are many more techniques you can use to improve picture taking of people further. With a single-lens reflex many of the most common mistakes made when photographing people can be easily avoided since you can actually see just what effect you are achieving by watching your viewing screen.

Choose the Right Angle

From what angle should you shoot subjects? This depends on the subject to some extent. However, it's more advisable to

shoot at a downward angle than from lower than a subject's eyes. If you do shoot from a low angle you will emphasize the size of the chin and the nostrils at the expense of the really essential features of the face such as the eyes. Usually you will achieve the best results by shooting at the same level as your subject's eyes. If your subject is seated, it may be advisable to seat yourself at the same level. You can often improve your background by shooting down from a higher level. If you do, make sure you have your subject look upwards so that you get the face fairly parallel to the camera film plane. Incidentally many a double chin will disappear as if by magic if you ask your subject to raise his or her head.

In shooting pictures of children, many photographers take the easy way and shoot downwards from adult height. This produces a dwarf affect—largish heads and tiny feet. Children are best photographed from their own level. To check this statement, try looking at a child from your height and then from the child's height. You can see the difference immediately on your finder screen.

Baby pictures suffer even more because of poor picture taking angles. Far too many are photographed from on high. Faces are lost and backs of head and bodies favoured. With a crawling or walking baby, you will often find the best shot can be made if you lie flat on the ground and aim right at the baby. Of course, excellent pictures of children are possible by having the parents or parent hold the child. If you take such a picture, don't allow the mother and child to stare at the camera. Ask the mother to attract the child's attention. A parent looking at the child and the child looking at the parent does offer a far warmer and more satisfying picture possibility. And remember to get as close to your subject as you can without actually cutting off valuable subject material around the main subject.

From what angle should you shoot pictures of people? Full face, head-on portraits are often the most flattering. Few people have sufficiently good profiles for profile pictures. Three-quarter pictures are difficult since a three-quarter photograph does show the cheekline and shape of the nose quite acutely. If these features are fine you will have few problems. If the nose is large and the cheek contour poor, full face photography is to be preferred.

What can you do with very round faces to minimize them? There are two possibilities. You can slim a full face by split lighting. If it's possible to create a slight highlighted area on one side of the face and slight shadow on the other, you will find that the face does appear narrower. However, this is difficult outdoors where the directional lighting for such a picture—the sun—is largely uncontrollable. Directional sunlight can also throw unfortunate shadows across the nose and mouth.

A second method of slimming the face when shooting pictures outdoors is to focus closely with a normal 50–55 mm. Takumar lens which, as we've seen, does have a tendency to elongate the face.

However, you will probably best ignore the problems of a round face and attempt to lead the viewer from the roundness by having the subject rest his or her head in his hand, by asking the subject to tilt his or her head or any other pose which breaks up the symmetrical roundness of the face.

Watch the Background

What is the ideal background? Either it should be as simple as possible to prevent it from detracting from the subject—a sky is usually fine, for instance—or it should be a background which has some personal connection with the subject—the subject in front of his or her house, for instance, would be a correct use of background. The subject standing in front of a brick wall or a timber yard would be incorrect use of background—unless the subject were a bricklayer or carpenter. When a background is unsuitable, first attempt to find a suitable one. If you can't find one you must use your technical ability to blur the background by placing it outside the depth of field as previously explained.

When on vacation or when travelling, a detailed background can become an essential part of any good snapshot. The background itself becomes a vacation or travel scene while the person within it establishes the fact that he or she was there.

Controlling the Light

So far we have restricted your picture taking to a bright but shaded area to simplify lighting and posing problems. Unfortunately, you will often be unable to find such ideal spots.

You may be forced to shoot with technically inconvenient lighting. However, even here good results can be obtained when care is exercised.

If the sun is still fairly high on a bright sunlit day, and you find your subjects squinting, and the shadows unflattering, try doing just the opposite to what most photographers advise. Instead of standing with the sun at your back, have the subjects stand (or sit) with the sun behind them. This, in effect, immediately removes the sun from their eyes and produces much the same lighting situation in terms of frontal rendition as you had with bright shade. Be sure, however, to make a fairly close exposure meter reading of the subject's face so that you will not be led astray by the brighter background.

Sometimes, however, you may have no choice concerning the direction of the lighting. You will be forced to take pictures with your subject looking into harsh bright sunlight.

It's often suggested that you use a large white cardboard or crinkled aluminum foil pasted to a large board as a reflector in which to catch the sunlight and reflect it back to the subject. This does lighten the shadows and works quite well in practice. The effect of it can readily be seen through the viewfinder.

However, few photographers keep such reflector material handy at all times when taking pictures.

It is possible to lighten shadows by using synchro-sunlight, either flash or electronic flash in combination with daylight. However, the difficulties of balancing the daylight with artificial light are rather great because of the mechanical complications of the single-lens reflex's focal plane shutter.

If your subject must face a bright sun, ask him to keep his eyes shut until the moment you are ready to shoot. When you are ready, ask the subject to open his eyes for just an instant. Shoot immediately.

Exposure for facial tones in extremely bright sunshine can be very tricky. As we've seen in the chapter on exposure, most black-and-white films have the ability to reproduce the brightness range of about 7 f-numbers, but printing papers cannot encompass such a range unless some amount of printing manipulation—burning-in heavily exposed areas and dodging lightly-exposed areas—is attempted. With colour films, the difficulty of reproducing colours accurately

when the brightness range is stretched makes compromise necessary. You must decide which colours are most important. A compromise exposure half way between the proper exposure for highlight and the proper exposure for shadow is often the best answer. But on a bright day, the brightness range almost invariably exceeds the limits of colour film. In such a case most photographers expose for the highlights and let the shadows go dark. The reason: deep undetailed shadows are acceptable in a picture, but bright washed-out highlights are not acceptable.

Shooting Indoors

Many photographers connect indoor picture taking automatically with some type of added artificial illumination. But some of the very best indoor photographs in both black-and-white and colour are actually made with daylight or room light.

Professional studio photographers today use more and more daylight. Many build giant skylights and huge windows into their studios to facilitate such photography. Some have even installed huge overhead banks of lights in an attempt to simulate daylight if and when there is no daylight available.

As an amateur photographer, you can choose your time and type of daylight for indoor photography. While you may not have the elaborate skylights and giant studio windows, you do have windows in your own home or apartment or flat which let in light. If they let in light, they will be usable for indoor picture taking.

Your Asahi Pentax is the ideal 35 mm. camera for shooting pictures indoors by windowlight. With its large maximum lens aperture it can make the most from even weak illumination. And, of course, you can see just what effect the daylight streaming in through the window will actually produce.

Advantages of Daylight

Why is daylight so ideal for indoor picture taking? First, because it's natural. It lights your house interior and the people therein as you see them each day.

Since the lighting is natural, subjects are apt to be at their ease and less self-conscious. You can photograph often then, at your and their leisure. A person is seldom as stiff and awkward in his own home as when facing a camera in a strange location.

USING WINDOWLIGHT

Effective indoor pictures can be made easily using only the light coming through the windows in your home. To get light on your entire subject, place camera close to window. To achieve a half lit subject with partial shadow area, place camera at right angle to window. For a silhouette or backlit picture, place subject between camera and window.

Some windows shed better light than others. North light which never has direct sunlight is fine all day and is preferred by professional photographers. South light is equally good. East and West windows can also be used but you must pay attention to the sun's position. Direct sunlight on an indoor subject should be avoided unless you deliberately wish harsh, contrasty results.

Daylight is also a vast economizer of equipment. You will be expending no bulbs, trying to connect no lights, waiting for no electronic flash unit to recycle. All you need is your camera, film and a subject.

Perhaps the most cogent reason to use daylight indoors is actually the very nature of daylight itself. It can produce all sorts of effects depending on how and where you use it.

With east and west oriented windows through which the sun actually streams into the house or interior during the day, you have very harsh dramatic lighting on sunny days. On north and south windows with no sun, or with any window on a bright overcast day, you have soft delicate light which best brings out pleasing facial contours.

By using today's rather fast black-and-white and colour films, you will not experience any difficulty in producing well-exposed indoor pictures using daylight.

The greatest amount of illumination, of course, is right at the window. Illumination falls off rapidly in brightness as you move away from the window. The interior of your room also affects the amount of light available. Dark-panelled, curtained rooms with rugs (which absorb light) certainly won't be as bright as when the same amount of sunlight enters a white-walled, light floored room (which reflects light).

If you want even illumination on your subject, you must stay between your subject and the window. From this camera position your entire frontal subject area will be lit by window-light. As soon as you let the subject get between you and the windowlight, you create shadows. These can be interesting if properly handled. For instance, if daylight is hitting the side of a face toward the window and the other side of the face is in shadow you can produce a dramatic picture.

To make silhouettes, just move to a point where you can face the window. Your subject should be between you and the window. If you expose for the daylight behind the subject you will have a silhouette.

Exposing indoors with daylight requires much the same technique as outdoors. For black-and-white try a compromise exposure between the highlight and the lowlight reading. With colour, expose for the highlights if the brightness range is over $1\frac{1}{2}$ or 2 stops.

Using Household Lamps

Available light picture taking not only means shooting indoors using daylight by day; it also indicates using only the household illumination to shoot indoors during the sunless hours.

If a house or interior is suitably lit for reading, it is also usually suitably lit for much black-and-white photography and some colour photography. As with daylight indoors, one of your biggest assets is the naturalness you can preserve.

Before attempting to shoot pictures in your own home by available house lamps and lights, run an exposure test. Pick the most likely spots where you'll want to take pictures—near a reading lamp, at the piano, around the coffee table. Take an exposure meter reading from the palm of your hand held in the light which would normally be illuminating a subject at one of these locations.

You will then learn where you do and where you don't have enough light for picture taking.

If you find that several key places have insufficient illumination, don't give up. Simply replace the bulb with a stronger one.

What about colour photography under existing house lamps? Since artificial-light colour transparency films are balanced for specific types of floodlamps you might be reluctant to expose them with ordinary houselamps. However, you will be surprised at the reasonable quality of the colour rendition you can achieve with houselamps and Type A or Type B colour films. Careful tests indicate that filtering is not absolutely necessary. You will be quite pleased with filterless results.

A word of warning, however. The colour of the lampshades can seriously affect the colour of your transparency. White or cream coloured shades are best. Avoid any tint or stronger colour. If you are photographing with the aid of a ceiling, wall fixture or any type of lighting which reflects light from the ceiling or walls, the wall or ceiling colour may affect your colour pictures. White or near-white ceilings and walls, of course, produce the best colour.

Since colour films do have such a very limited exposure latitude and ability to encompass a broad brightness range (as we've seen), it's essential that you keep your subjects quite close to the light source and that you expose carefully for

that part of the face or body close to the light. Shadow areas will simply go dark.

How should people be posed indoors? If possible, they should not be posed at all. Within the walls of their own house or a house familiar to them, they should be allowed to assume natural positions. They should read, write, listen to music, sew—do whatever they would normally. You should then try various camera angle and heights while cropping the picture carefully in the viewfinder until all extraneous picture material has been removed. When you're ready to shoot you can either photograph your subject concentrating on whatever he's doing or you can call him or her by name. As they look up, snap the picture.

The secret of photographing anyone, indoors or out, colour or black-and-white, daylight or tungsten is to maintain or re-establish naturalness. If you bend your best efforts towards removing the stone faces, the stares, the awkward, self-conscious poses of your subjects, you will be well on the way to successful photography of people.

Formal Portraits

In formal portraiture the prime aim is to idealize the subject. The tools to be used are: pose, camera and lighting.

Perhaps the most flexible tool is lighting. If you think of light areas of a print coming forward and dark areas receding, you can begin to see the possibilities in the alteration of light. There are five main areas which govern modelling: forehead, nose, chin and both cheeks. By changing the lighting on these five areas many different portrait effects can be achieved.

However, the problem of lighting for portraiture is often not only one of attempting to idealize the subject. It may be even more essential to hide actual facial defects—a jutting chin, a thin face, a long nose.

The Main Light

In formal portraiture—or any portraiture for that matter—one light source should predominate and all other illumination should be secondary. For this reason the placement and direction of the primary light source in formal portraiture is of prime importance. There are three main lighting placements based on achieving three different results:

FORMAL PORTRAITS

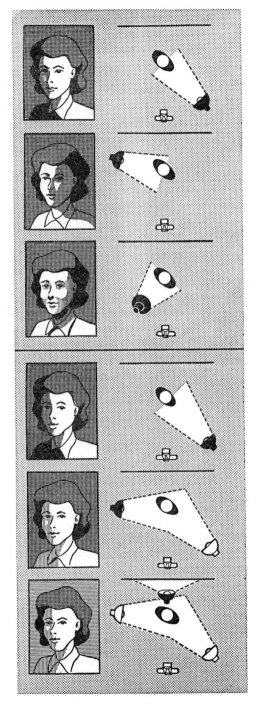

Broad lighting: The side of the face turned toward the camera is illuminated fully. Such a light is used primarily to help widen thin or narrow faces.

Short lighting: The side of the face turned away from the camera is now illuminated fully. This is a good light for the average face since it emphasizes facial contours well. However, it does tend to narrow plump faces and can thus be used correctively if needed.

Butterfly lighting: When the main light is placed directly in front of the subject, it casts a shadow underneath the nose. This is a good type of illumination for glamour pictures of attractive girls.

Try to build your lighting set up in three successive steps. First establish your main light.

Now add your secondary fill-in light and adjust distance to achieve proper balance with main light.

Lastly add third light illuminating background to the required degree.

1. *Broad lighting* places the main light so as to illuminate fully the side of the face nearest the camera. Such lighting tends to broaden faces which are too thin.

2. *Short lighting* places the main light so as to illuminate the side of the face furthest from the camera. Such lighting narrows oval or too broad faces. It is also useful as a strong or low key light for portraits of men.

3. *Butterfly lighting* places the main light in front of and slightly higher than the face, in line with the nose. Such lighting is excellent for normal faces. It tends to delineate good cheekbone lines, but it does light up prominent ears and is therefore seldom used on male subjects, whose ears are not usually hidden by hair.

Now for light placement. The main floodlamp should be placed slightly higher than the seated subject's head, about 45° to either side of the camera and about 3 ft. from the subject. This main light should cause a reflection in the pupils of the subjects' eyes. Don't move the main light too high or the shadow underneath the nose will begin to lengthen and become objectionable.

The best main light is a soft flood. A diffuser over the front often proves helpful. While the three types of lighting already mentioned will give you a general guide in fitting the lighting to the face, keep in mind that a narrow face should be lit as completely as possible while a broad face should be illuminated as little as possible with as many broken up areas of light as is feasible.

Background and Secondary Lighting

A background light should be positioned behind the subject, between the subject and background. Make sure that no part of the lamp or its cable can be seen in the viewfinder. The purposes of this light are many. It can serve to separate the subject from the background. It can provide an even lighting over the background for high-key shots. It can even put a pattern or subtle shading on the background if you put a suitable screen or other object in front of the light.

The secondary light is called the fill-in light. Generally a lesser-powered, rather diffused light is used from a position close to the camera or on the opposite side of the camera from the main light. If no lower powered illumination is available, use the same power illumination as the main light

but at a greater distance—perhaps six feet instead of three.

The fill-in light's purpose is to control the degree of difference between the highlight and the shadow areas of the portrait. However, there are some dangers in using a fill-in light. If the subject wears glasses, watch out for unwanted reflections. If you notice them from camera position, move the fill-in light until they no longer appear. Also watch out for a second set of light reflections in the eyes. If they appear, you will have to spot them out on the final print.

Often a third light, called a hairlight or top light, is used. This is usually located behind the subject at somewhat of a height but directed downward to illuminate the subject's hair.

Portraiture Problems

The problems besetting the formal portrait photographer and their solutions are many. Herewith a few difficulties which may arise and how to solve them.

Reflections from glasses: Tilt the lenses slightly downwards if possible without altering the characteristic appearance of the subject. Alternatively, alter the angle of the subject's gaze or the position of the offending light. Check the result in the viewfinder. The reflex viewing system is your insurance that if the reflections don't show in the viewfinder, they won't show in the picture.

Long Nose: Minimize it by taking a full face picture with the nose pointing right at the camera but don't shoot from too close in.

Prominent Ears: Use ¾ view with one ear hidden. Keep the other ear in shadow.

Baldness: Lower camera angle, blend top of head with background tone, avoid lighting on top of head.

Double chin: Tilt chin upwards or use a higher camera position.

Heavy subject: Use short, low key lighting. Have subject dressed in dark clothes.

Wrinkles in face: Use diffused lighting, ¾ pose.

These, of course, are but a few of the problems and solutions. As far as camera technique is concerned, make full use of the fixed subject position to employ a tripod and cable release for complete camera steadiness. Use a fairly small

aperture for maximum sharpness in depth. A fairly slow, fine grained colour or black-and-white film is preferable for quality and biggest enlargement with full detail. If you have one, use an 85 mm., 105 mm. or 135 mm. lens to minimize apparent perspective distortion of close facial or body features appearing too prominent in pictures.

When actually shooting, compose and focus carefully through the viewfinder. Then move away from the finder and take the picture with a cable release while directing your subject. While you are actually focusing through the finder you may find that your subject will appear most apprehensive and stiff in pose. By moving away from the camera, even if you still are holding a cable release, you can often get a subject to relax somewhat.

THE CANDID APPROACH

The words "candid photography" were once almost synonymous with 35 mm. The first 35 mm. cameras set the photographer free from long exposures and posed subjects. With a small camera and a fairly fast lens, a photographer was able to depict people and events as he saw them. He became the unobtrusive observer able to preserve a "slice of life" whenever and wherever he pleased—provided, of course, that there was sufficient light to expose his rather slow film.

Today, candid photography has become more or less the standard method of shooting with a 35 mm. camera. The term "candid" is generally used to distinguish the approach as opposed to "studied" or "posed". The candid photographer is always ready and capable of shooting pictures as they occur—at home, on vacation, in world events, in sports As you can readily see, candid photography is practised by the photojournalists who shoot pictures for magazines and newspapers as well as the amateur photographer who plans little else than good representative photographs of his friends and family.

Overcoming Timidity

Although the Pentax camera makes excellent candid photographs and is actually used for this purpose by many professional photographers, there are many owners of this superb instrument who have never made a really candid picture. The reason is generally one of timidity. The photographer is psychologically unprepared to point the camera in the direction of a subject who is not expecting to be photographed.

You can see such photographers near any vacation spot. They may even have their cameras out and ready. But whenever they wish to take a photograph, they purposely wait until everyone passes by and then take a picture of the scenery with no human subject matter visible. Quite often such photographers talk themselves into believing that such pictures *are*

really better with no human beings. However, this is simply not true. Every camera owner must overcome timidity, shyness or aversion to taking candids. The world is full of people and your pictures will be the better for the proper ones in the right position.

You can, of course, avoid the whole problem by photographing people only from the back, when they couldn't possibly see what you are doing. However, such pictures certainly do not have the interest of those made with peoples' faces showing.

Basically there are two candid approaches to photography. You can keep your Pentax out of sight until the subject appears and then quickly take a picture before the subject has a chance to react to the presence of the camera, or you can keep the camera in constant sight and take pictures with no regard as to whether the subject notices the camera or not. There are good reasons for both approaches. Which you use depends on your subject. But first, how do you overcome the timidity of photographing people you don't know?

There is but one way. Go ahead and shoot. It is akin to diving off a high board into a pool for the first time. The first time *is* the hardest. The more you think and agonize, the more difficult taking the picture becomes.

There is another interesting aspect of candid photography which is extremely important. If you take pictures with no hesitation, many subjects will find no reason to object. However if you appear unsure as to whether you dare take a photograph, your hesitation and lack of purpose is immediately transmitted to the subject. This gives him or her an opportunity to make objections even if no such objections were originally planned.

Surprisingly enough, people don't normally bite. If you are not invading their privacy, taking pictures of them in awkward positions or otherwise making fun of them, people are usually found cooperative subjects.

Prove this to yourself by going out on the street and taking pictures.

Approaching the Subject

Now back to the two methods of making candid pictures. The first is to hide the camera until you're ready to shoot. This technique is often necessary with children, who will start to

CARRYING YOUR CAMERA FOR CANDIDS

If you don't want your camera seen but wish to have it ready at all times, attach neckstrap to caseless camera, wrap strap around wrist to prevent accidental dropping, and keep camera hand behind your back.

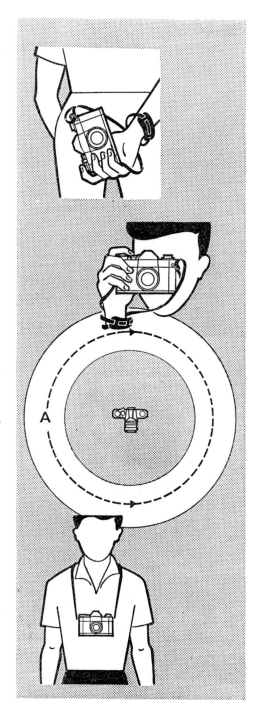

When you see subject, bring hand around, lift camera to your eye and shoot. Have shutter speed, aperture, focusing distance preset. Check depth-of-field scale to see actual possible zone of adequately sharp shooting. Think of this as a circular doughnut around you (A). Anywhere within, you can shoot and be sure of getting good results.

If carrying a camera in full view isn't a drawback to the taking of candids, hang bare Pentax (or Pentax in back half of carrying case only) around neck with short neck-strap so camera rests on chest. It takes only a split second to grab camera, raise it to your eye and shoot.

overact, to freeze, to "mug" for the camera. If you are around the children often enough and they can become used to your camera, it may not be necessary for you to hide the camera when shooting pictures. But if the children are new to your camera and you to them, they will probably be more natural if they do not realize you are trying to take pictures of them.

There are subjects who are camera shy—a wife who freezes whenever her husband shows up with a camera, for instance. There are others who really do not want their pictures taken if asked but who will not object if you do not ask. In some tourist vacation spots where tourists have been lavish with tipping money, any native seeing a camera will immediately demand a tip and then pose frozen faced because he thinks that this is what is expected of him. There are those who may be engaged in some interesting job until they see you and the camera. They will then stop and watch you.

You must decide upon the subject approach. But there is nothing to be ashamed of in hiding a camera before you are ready to use it. You are simply making certain that you will have natural unspoiled picture material.

When can you walk around with your camera in full view? Whenever your subjects are completely engrossed in some event and are taking no notice of you. Examples: spectators at a sports event, people watching a parade.

Quick-shooting Methods

If you intend to keep your camera out of sight, you will have to practice drawing and firing like learning to draw and shoot a pistol or revolver quickly. Where can you hide a camera as handy as the Pentax? First, remove the front of the case if you can. If you cannot, you will have to take the camera out of its case and carry it by the neckstrap attached to the camera by lugs.

Wrap the strap around your right wrist so that most of the strap "play" is removed. Then grasp the camera in your right hand with your right forefinger on the shutter release and your right thumb on the rapid wind lever.

You should be able to hold the camera securely in one hand whether at your side or behind your back. The strap is a safety device in case you lose your grip on the camera itself.

Practice bringing the camera quickly to your eye, focusing and firing. The more you can preset the Pentax, of course, the

easier it will be to shoot quickly. Whenever you arrive at the place where you intend to take pictures, make an exposure meter reading and set your camera accordingly. Keep in mind that you want a fairly good depth of field so that any mistakes in focus will not ruin your photo possibilities.

If you are to photograph in two lighting conditions calculate two exposures, one for each condition. Be prepared to shift your camera controls from one condition to the other quickly depending on where you find your subject.

Although it is sometimes possible to find the time to focus your camera accurately once you have the Pentax at your eye, it is still advisable to preset not only exposure but focus too. Try to predetermine just how far away your subject is likely to be or just how close you are likely to approach. Learn to estimate distances fairly accurately, but as explained, allow yourself some room for error by using an aperture producing a fairly extensive depth of field (zone of sharp focus). Allow your subject to reach this range before you shoot.

If you do keep your camera in full view, carry it around your neck, not over your shoulder. Although an over-the-shoulder carry is quite sufficient for carting a camera from one picture taking situation to another, a camera over the shoulder is not near shooting position. You would have to unsling the camera, then bring it up to eye level.

Most of the camera carrying straps, including the Pentax straps, are too long. You may have to put an additional hole in the strap to shorten it. A Pentax should be carried not at stomach level but at chest level.

Although you may be carrying the camera in clear sight you may still be able to achieve a good element of total surprise. People noting a camera around the neck do not immediately expect that you may raise it and shoot swiftly. You should be able to get the camera to eye level and shoot before the subject realizes what is happening. In addition, the slow methods by which less practised photographers take pictures are in your favour. Most people do take a long time, getting the camera ready, setting it, focusing it and finally taking the picture. Few of the subjects will believe the speed at which you can operate. You will have already perhaps taken three pictures before your subjects realize you are even ready to take the first one.

When to Shoot

In shooting candids you should develop a very definite approach as do professionals. When should you take the picture? As soon as you see it. Is it worthwhile waiting to see if the subject gets better or the composition improves? It seldom is. Instead shoot immediately to make sure you do not miss the picture. If you wish then to find a better position, background or change angle or height, do so.

Shoot a picture as soon as it intrigues you. Then move in toward your subject tightening the composition. As soon as you feel you have improved the picture, don't hesitate to see whether it will get or can be made even better. Shoot again. Then attempt further improvement. Each series of photographs should be a small picture story beginning when you first spot the subject and continuing until it becomes impossible for you to better the picture.

Of course, there are exceptions to this rule. There will be many once-in-a-lifetime subjects which will allow no possibility of a retake. Also, once the subject is aware of the camera, the whole appeal of the photograph may disappear.

Using Lenses

Since the Asahi Pentax accepts a large variety of interchangeable lenses, both wide angle as well as long lenses should be used where they can be of advantage.

In close quarters such as a marketplace, the wide angle lens, either the 35 mm. or 28 mm. Takumar, will be best. With these you can shoot general scenes and groups. You will have little focusing trouble since the over-all depth of field is considerable.

The longer lenses, particularly the 85 mm., 105 mm. and 135 mm. Takumars are excellent for candids. Since the lenses are quite small in physical size, many subjects don't realize that you are actually taking closeups. These longer lenses do allow you to remain further away from subjects.

For indoor work the fast speed of the 85 mm. $f1.9$ or $f1.8$ SMC Takumar is extremely helpful. Outdoors the 105 mm. $f2.8$, 120 mm. $f2.8$, 150 mm. $f4$ or 135 mm. SMC Takumars are good performers.

For candid work, you must have the most reliable and fast operating lenses. That's why the Super Takumars with their fully automatic diaphragms are recommended.

Film choice is important in candid photography. Use fairly fast films from Group 3 (see page 109). These will allow fairly fast shutter speeds and allow sufficient depth of field. For colour, try films with fairly high ASA indexes.

Candid photography requires all your abilities—physical coordination, will power, technique, quick thinking, ability to judge distance, ability to anticipate the moves of your subject. Aside from some memorable formally posed portraits of famous statesmen, practically all the best known and great pictures made in recent years by amateurs and professional alike were the results of candid photography.

OUT AND ABOUT

Your camera can travel with you to a variety of locations. Holiday and business trips are obvious occasions when interesting shots may present themselves. But even in your ordinary leisure time, at the theatre or circus, or even at home by the TV set, you can still find plenty of opportunities to add to your photographic record.

The Travelling Camera

It isn't our purpose here to examine where you might travel. That will be your own personal preference. We can, however, make some suggestions about equipment and approach to subjects. First the equipment.

If you take only colour or only black-and-white film you will have little trouble in deciding which film to carry, although the type and speed needed will make some choice necessary. If you like both colour and black-and-white pictures, you do have a problem if you have only one camera body. The ideal answer, of course, is to have two bodies—even if you have but one lens. You can swiftly shift from one camera to the other to cover subjects in both colour and black-and-white.

If you do not have two camera bodies, there are two possible alternatives. You can shoot some of the time in colour and some of the time in black-and-white. Of course, this does mean that if you are travelling in a hurry and cannot revisit a spot, you will not be able to duplicate all your subjects in both colour and black-and-white. Here's another possible solution, although it is not possible to make accurate colour pictures from black-and-white film, surprisingly good black-and-white enlargements can be made from colour transparency and negative originals. If you choose a fine-grained colour transparency film, you can use a slide copying device or have a photofinisher make a black-and-white negative of any transparency on fine grain black-and-white film. This

black-and-white negative can then be used to make black-and-white enlargements in the usual manner. It would be foolish to suggest that such black-and-white copies are always as good as those made from original black-and-white negatives, but they can approach quite close.

Films to Take with You

What film should you take and how much? Make a careful investigation of film purchases (and prices) where you are going. If you are certain of picking up good fresh film with which you are familiar at reasonable prices, there is little sense in lugging film with you. But it is poor economy if you must rely on a foreign brand of film with which you have had no previous experience. If you plan on being away for over a week, make provision for having your colour film processed. Once colour film has been removed from its hermetically sealed container, its worst enemy, humidity, gets at it. The sooner it is processed the less chance of any annoying shifts in colour. In selecting a lab., don't trust services that are untried. If the pictures are valuable make sure they are processed by people with whose work you are familiar.

Should you carry fast or slow black-and-white and colour film? The choice depends on the type of subject material with which you will contend. A landscape photographer who plans all shots from a tripod need not take anything but slow fine-grained materials. However, for nearly everyone else a fairly fast black-and-white emulsion with an ASA index between 200 and 400 should suffice for low light shots while a slow or medium slow emulsion from ASA 25 to 160 will take care of other exigencies.

In colour, two films, one fine grained with good colour at ASA 50 or less and another with a speed between 160 and 200 for emergencies, should be carried. If you plan on shooting indoor colour by low available light you might want to consider using only tungsten balanced film (with a proper correction filter outdoors). You will find this technique more convenient than that of using daylight-balanced film with a filter for indoor shots. This latter combination yields very low film speeds.

Filters? Close-up equipment? Only necessary if you really expect to use them. A tripod? Quite a bother but often a big help. Accessory lenses? If you have them, by all means

273

take them along. Besides making many an impossible picture possible, they will add variety to your composition. Now what do you put all this equipment in?

A carryall bag is a great aid but too large a bag is as bad as none at all. Don't get a bag which is so large that you must find things to put into it. If anything get a bag slightly too small which will make you selective in carrying equipment. And remember that bags become heavier and heavier the longer and farther they are carried.

Avoid the Picture Postcard

When travelling most people photograph scenes much like those in postcards. Make a simple rule. If there is a postcard scene which is identical to the picture that you intend to take, don't take the picture. In any scene try to inject individuality. If you are travelling with someone, have the person included in the scene—not staring into the camera, but examining a building's ornamentation, or waving while riding the tramcar. People must fit into the scene, not look as if they were stuck on like figures atop a wedding cake.

If you are travelling alone, quite often you will be able to get some photographer passing by to take a shot with you in the picture.

How do you take pictures of people that you don't know when travelling? The answers are as varying as people are. In some areas, people don't mind having their picture taken. In others, every snapshot is considered a distinct invasion of privacy. In some areas heavily travelled by tourists, the natives expect to be paid whenever you take their pictures.

For the best possible natural pictures, shoot quickly. Even if people are willing to pose later, the pictures look posed. You will probably find that your most effective pictures are made with unposed subjects.

The automatic diaphragm of the Takumar lenses will allow you to get pictures quickly and easily. Be sure that you keep your camera set with the proper exposure at all times. After you have seen a picture possibility, it is too late to start worrying about exposure. Exposure must be preset.

Lenses for Travel Shots

The 35 mm. $f2.8$ and $f2$ SMC Takumars are excellent travelling companions for general scenes. However, make sure that

you do not try to include so much distant detail in your picture or all the subject material will appear minute. Never use a wide angle lens on distant scenics. Invariably you will be disappointed in the diminutive size of the picture components.

Be selective. If you do have a choice of lenses, use the longest one possible and the tightest cropping you can. With no longer lens at your command, use your feet and approach each subject as closely as possible. Try to maintain some continuity to your pictures. Good magazine and newspaper photographers realize that every picture cannot be a masterpiece. Many pictures must be functionally descriptive bridging shots. If you try to make all your pictures individual works of art, you will have a rather disjointed series of photographs. Think of the pictures as you might show them later. Don't miss any important points even if, aesthetically speaking, they don't appeal to you at the time.

A small electronic flash unit makes an extremely valuable accessory—particularly for interiors. More and more places—even churches—allow electronic flash. The small modern units have rechargeable batteries and charging units which can recharge the cells on virtually any current on earth. There is really very little excuse today for the picture that got away indoors because there wasn't sufficient light.

Scenics

The Pentax camera is one of the best instruments for shooting scenics. Perhaps the scenic requires the most practised eye, the most ability to see individual elements of the picture. The life-size viewing and focusing image allows all elements to be analyzed and controlled.

What is a scenic? We'll define it as any photograph in which the setting dominates the picture. This might be a landscape, a seascape, a city scape. But we certainly don't wish to imply that these dominating picture areas must be peopleless. Far from it. The right human or animal subjects positioned in just the right place in the picture area can quite often add just the extra bit of seasoning that's needed to make a scenic come alive.

How should the picture be framed? Where should the people, if any, be placed? What should be in focus or out of focus?

Composing the Picture

Many rules have been made for scenic photography. By following these rules you are supposed to arrive at the proper composition for landscapes. While most rules were based on the general methods of composition used by academic painters, following them too stringently can cripple the creative ability of photographers. As many good scenics are shot by disregarding the rules as are made by sticking to the rules.

Every scenic must have a focal point of interest—that part of the picture to which your eye is drawn. It may be a distant mountain, the façade of a building, a boat on the sea. It may be quite small, but it must be there. Too often photographers shoot scenics in which there is no focal point. Often the mountains in the background are too small because a wide angle lens is used, or the sea trails off into nothing but water. Your eye seeking a centre of interest simply wanders away to infinity. The picture defeats itself in its inability to hold your interest.

Whatever the main subject, it should be of sufficient size to be readily recognizable. Of course, there are some exceptions to this. When you are attempting to reproduce the hugeness and grandeur of a scene, you will deliberately make your subject small in relationship to his or her surroundings. How can you control image size in a landscape? To some extent by moving back and forward yourself if the main subject is not too distant. If your main subject is a distant mountain, you will have a difficult and long walk to alter its size in your picture area. In this case, a change in focal length lens will produce the required image reduction or enlargement.

If your main subject area contains people, you can, of course, place them nearer or further away from the camera to achieve different size images.

Just how big should the central image be? To some extent this must be dictated by circumstance. An ocean liner cutting through the water toward you should be large and overpowering. Two seated figures in a vast woodland area can be quite small. An impressive mountain seen across a lake can be medium sized to allow you to frame it tastefully.

Placement is also important. Impressive dynamic objects can often be centrally located. Medium size landscape images should be placed off centre, but not at the very picture edge.

Can a landscape have more than one main subject? Yes

COMPOSITION OF SCENICS

While hard and fast compositional rules seldom work at all times in practice the following technique of improving a scenic may be helpful.

Scenic with distant houses and horses is pleasant but rather static. Can it be improved?

We've come in closer to make images larger, but, alas, we've chopped off part of tree without improving overall picture much.

Let's get even closer and eliminate the distracting tree at left. The images are large enough to be striking but we need some framing device.

By moving to the right and thus changing camera angle we can keep image size, pick up the tree at right for framing and also include the tree in the left distance to complete the compostion.

it can. You can have people in a scenic who are looking at a distant mountain. The viewer's eye should first pick up the small figures, then shift to the same subject that the small figures are viewing—the mountain.

Dynamic, large central subjects often don't require framing, but other landscape subjects usually do. Without some framing, the main subject at a distance appears lost on the enlarging paper or projection screen.

Foremost framing device is foliage, usually tree branches in both the top left and top right hand corners of the picture area. If these do not actually exist they can be printed in later on black-and-white prints. An arch or doorway also serves as a useful frame. The frame simply channels your viewing eye into the picture and towards your main subject.

It's quite important in scenic photography that you render both frame and subject in sharp focus. An out-of-focus frame can be extremely disturbing. You can generally rely on a quick check of your lens's depth of field scale. The depth of field can sometimes be shifted if necessary in case the depth of field does not appear to get both foreground and main subject in good sharpness (see pages 160–164).

The illusion of depth is most important in scenic photography. Certainly the framing accounts for at least one additional plane of depth. However, other planes should be recorded. With each subject or framing at a different plane of depth you can add to the picture's ability to hold the viewer.

Contrasting colour plays an extremely important part in scenic photography. A bright red, blue or yellow jacketed subject carefully placed within a landscape can spice a dullish scenic. Of course, persons with such bright colouring should be kept at an appropriate distance within the picture frame or they will take over and dominate the entire picture.

Using Filters

In black-and-white scenic work, the proper use of filters can help produce better scenics. Even if you do not use filters, some differential between clouds and sky will be recorded on film. However the clouds may not be visible in a standard print. The clouds and sky will need special, additional print manipulation. You can make the clouds easily printable by using a medium yellow filter for average cloud effects, or

dark red filter for very dramatic dark sky and white cloud effects.

A green filter helps scenics with foliage. The green filter lightens foliage and also provides some darkening of the sky to enhance clouds.

In taking scenics be careful to keep your camera as level as possible—don't point it up too far to include a tree or the entire façade of a building. If you do, you will create apparent perspective distortion. The trees and buildings will appear to be falling over backwards.

While this fault can be overcome to some extent by tilting the enlarging easel when making a black-and-white enlargement, there is little that can be done to aid a colour transparency. The closer your viewpoint the more apparent distortion you will create if you tilt the camera upwards or downwards.

Exposing the Scenic

Although we have examined exposure problems in a full chapter, the special difficulties of obtaining good exposure of a scenic requires additional mention.

A meter reading from camera position will usually produce a sufficiently accurate exposure. This is particularly true if the scene is fairly evenly lit and the highlight areas do not overpower the shadow areas. If there is a very great difference in size between highlight and shadow areas, you will have to read the light from the bright area and shadow area, average them and use the mid-way reading.

In many scenics it will not be possible for you to approach the various areas in the picture to take an accurate highlight and shadow area reading. In such cases you must make what is called a substitute reading. This means that you must find some subject material close at hand which appears to be in approximately the same light as your more distant subject. You must then take readings from these substitute subjects and calculate the exposure from them. If no actual subject is available, try holding the palm of your hand in the light and take readings from it.

When making overall readings of a scene with a great deal of sky area, always point the meter down slightly. This will prevent the bright sky from dominating the picture area and giving you an erroneous, underexposure calculation.

Scenics, like pictures of your family and friends can be simply dull snapshots or good photographs. Much depends on the time and effort that you put into it.

Architecture

When using the Pentax camera for architectural photography there are some cardinal rules which will aid you in obtaining more acceptably accurate pictures. Always keep your film plane parallel to the subject. If the plane of your subject is parallel to the film plane of your Pentax, there will be no linear distortion. In other words, if you are photographing a building, don't point your camera up or down. Point it straight ahead and all lines will be parallel, all right angles, true. If you cannot get all the required subject material within the finder, back off until you can. If you cannot increase camera-to-subject distance, you will have to use a wider angle lens. If you do not have one or still find that the subject is insufficiently covered, you will have to point your camera upwards or downwards and risk linear distortion. In black-and-white printing these lines can sometimes be restored to linearity by tilting the enlarger easel in the opposite direction from which the camera was tilted until the lines again appear parallel on the easel.

If possible, try to work with just the normal lens of your camera. It produces a pleasing perspective and, at most shooting distances, an acceptable illusion of three dimensional depth. When using wide-angle lenses be careful that you do not exaggerate distances of near and far objects—unless you want to. Certainly there is no better way to create the effect of spaciousness in a room that is less than really spacious than to use a wide-angle lens. On the other hand, the more distant viewpoint of a long lens produces foreshortening distortion. Distances in depth appear abbreviated. Here, too, the effect may be useful or it may damage the accuracy of your picture.

When photographing buildings be sure that you get good separation between the building and the sky area. If the building is fairly light in colour and you wish to have a sharp building line delineation, use a deep yellow or red filter to darken the sky, but remember the effect such filters have on other colours in the scene.

When an interior is inadequately lit, you do have a prob-

BUILDINGS AND INTERIORS

If you photograph a tall building you will get correct linear perspective only if you keep the camera's film plane parallel to building. To keep whole building in picture, however, you may tilt camera upwards—unless you can back away far enough or change to a sufficiently wide angle lens. If you do point the camera upwards your resulting picture will show the buildings converging and falling towards you. In printing, this can be corrected either by tilting the enlarger head, the baseboard or both.

Beware of buildings whose tone blends into sky. A filter, particularly a yellow or orange filter outdoors can separate building from sky.

When photographing interiors with a normal lens, you may not be able to cover the entire room. However, a 35 mm. or wider lens will allow you to take in a far greater angle from the same camera position. In addition, a wide angle lens tends to increase the apparent depth between objects, making the room appear bigger.

lem which is possibly insurmountable. In large interiors where you cannot use a tripod and must take the pictures while others are in the building there seems little that can be done. However, if you can put your camera on a tripod and use a floodlamp, you can try a technique which works for many photographers. Set your shutter to "B" and use the smallest lens opening possible. Now "paint" the interior of your picture area with light by travelling around with the lamp on an extension cord, lighting the shadow areas. Make sure you do not throw any light on yourself and that no part of you or the lighting equipment comes between the cast light and the camera lens. Otherwise blurred traces will appear in the picture.

Flashbulbs or electronic flash can be similarly used to lighten the shadows in interiors but you must take care not to overpower existing lighting. If room lights are on, they should appear natural. The exposure has to be carefully calculated so that the flash or flood exposures are weaker than the existing lighting, which will be receiving rather long exposure while the shutter is set on "B". If strong daylight is entering and will be included in the picture area this method is not suitable, for windows and daylight parts of the room will be far too heavily overexposed.

Shots in the Night

Your camera should not retire at nightfall merely because there is no more outdoor illumination or because flash, floods, or even natural room-light are no longer available. Excellent outdoor photographs are still possible with street lights, the illumination coming from houses, theatre marquees, moonlight, advertising signs, car headlamps—the list is virtually endless. Your camera need never go to sleep.

Obviously the amount of light available for such picture taking does vary. To be safe, choose fairly fast films—colour or black-and-white. Films with ASA indexes of 400 or over are preferable in black-and-white. In colour, films with indexes between 160 and 200 are obtainable. Strangely enough, many professional photographers prefer to use daylight-type colour films for outdoor night shots rather than the tungsten types which you might imagine would better match the artificial illumination prevalent at night. The warmish coloration of the daylight films when used with tungsten lighting is

often more pleasing for night shots than the rather coldish results obtainable with tungsten-balanced colour films.

Subject matter is wide indeed—particularly in a large city. Many buildings are well lit, fountains are meticulously illuminated. Lighting under movie theatres is quite good and well illuminates passersby. Store windows can be fascinating with the people passing in front of them in silhouette. Most cities have specific colourful areas which only come alive at night and make excellent hunting grounds for you and your camera.

After rain, streets shine and reflect the street and theatre lighting. Interesting reflection patterns can be photographed in both colour and black-and-white. The tracery of head-lamps and tail-lamps of cars also forms interesting patterns. Any busy street at night will give you a bewildering criss-cross of headlamps. A time exposure will record many of these and also allow the headlamps to light up considerable portions of the surrounding scenery.

Exposure in Low Light

Naturally exposure is somewhat of a problem with such diverse sources of illumination. Both the clip-on meter and the Spotmatic camera with meter behind the lens are sensitive enough to make readings of such scenes with good accuracy. The question, of course, is: what do you read and where do you read it from?

When photographing people under fairly bright light outdoors, take a reading as you normally would. Read for the highlight areas predominantly in colour photography and for the shadow areas in which you wish to hold detail if you are shooting in black-and-white.

Store windows can be read by your meter. Just point the meter inwards at the displays. If you wish to use the passers-by as silhouettes, stand some distance away from the window and let the people pass between you and the window. If you expose for the window only the people will be in silhouette.

Neon signs, street lights and automobile headlamps are perhaps the most confusing subjects to expose for properly. With any lights in which the light itself plays the most important part, you need do no more than approach fairly close to the illumination source, point your meter and take a read-

ing. You can then retrace your steps back to the more distant position from which you wished to take the picture and shoot according to the close-up reading.

Such an exposure, however, will only show off the signs or lights themselves. If you wish the lights to illuminate some of the surrounding area, you will have to give additional exposure. If there is some specific subject which is illuminated—a person under a street lamp for instance, make your reading from this subject rather than the lighting itself. When photographing lighting alone, it is often advisable to allow slightly more exposure than the meter calls for. While the meter reading will give you a perfectly exposed light, the light will not seem real. By overexposing the light will produce some natural appearing flare.

Moving Lights

Pictures made by the tracings of automobile headlamps and taillamps are really quite easy to take. If you point your camera up any street on which there is traffic, the oncoming cars will show bright white headlamps while only the red tail-lights will glow from the other lane of traffic—provided the street is a two way thoroughfare. For such pictures a tripod or other support is needed. The exposure can be as long or as short as you wish depending on the number of light tracings you wish and the brightness of the picture you intend to create. If the street is a busy one and you keep the camera shutter open on "B" for a minute or so, the whole picture area will be rather bright. For such pictures, a meter is of doubtful value. Only experimentation with various amounts of exposure time will yield answers as to what results you can expect. Don't forget about depth of field, however. Make sure your entire subject area lies within the zone of sharp focus. If your camera is on a tripod and you are taking a time exposure, there is no reason to use the widest lens opening. Use the proper lens opening for the subject material and then increase exposure time to compensate for it.

Exceedingly long time exposures at night on a busy thoroughfare can be quite interesting, because people and cars hurrying by will not be visible. Only subjects who remain in one place for any length of time will show up in the picture.

Night out of Town

City life is not the only type which offers possibilities of making night photographs. Moonlit shots in the country or at the seashore with the moon reflecting from the water can be very dramatic indeed. The moon, incidentally, is brighter than you might think. You can usually get a rather accurate reading of the moon itself using the Pentax ES, SP500 or the Spotmatic camera. You can also use a separate meter. If not, try exposures of 1/30 at f2.8 with fairly fast black-and-white film for the moon itself. To make sure of your picture, take a few additional frames at more and less exposure. An exposure of 1/30 sec. is usually sufficient to stop the movement of the moon itself relative to the earth.

For landscapes or seascapes lit by the moon, you will have to rely on judgment. If you have had no experience in guessing such exposures, take a number of photographs at varying time exposures up to a few minutes. Check the results and use the data when you're ready to try a moonscape again.

Fireworks

Fireworks can easily be captured in both black-and-white or colour. Certainly the most interesting results are those in colour. Firework pictures should be made with your camera on a tripod. Use a fairly large aperture and fast colour film with an ASA index of 50 or over. Before the individual display goes off, open your shutter by turning the shutter dial to "B" and maintaining pressure on a cable release. Keep the shutter open until the entire individual display is over—the complete flight and bursting of a skyrocket, for instance. Then close the shutter. You will have thus photographed the entire pattern and path of the skyrocket. For most spectacular effects, you can leave the shutter open to record a number of different displays on the same film frame.

At the Theatre

In many theatres you will not be allowed to photograph from your seat. In some countries the stagehands' or actors' unions have specific instructions against allowing such pictures to be taken. Still many people do take such photographs, rules or no rules.

Taking pictures of stage presentations, circuses, ice shows and similar entertainments isn't really difficult. Most such events are lit by powerful arc lamps allowing you to use daylight colour films which generally have higher ASA indexes than the slower tungsten types.

If you have a Spotmatic or ES Pentax, you can take accurate meter readings. A fairly long interchangeable lens helps, because you can use it to make a close-up reading of the subject from your seat. If your reading still takes in too much of the brighter stage area around your subject, allow between ½ and 1 stop extra exposure to compensate for the darker subject. However with no metered camera or Spot Meter you will not be able to make an accurate reading of the actual lighting available. In such cases some intelligent guessing will be necessary.

Serious stage plays are fairly easy to judge. The lighting is usually good and not coloured. With a moderately fast film having an index of between 160 and 200, exposures of 1/30 sec. at f2.8 or larger should produce good results. This is for average stage lighting. If a bright spotlight is used, of course, cut down exposure. Low-key dramatic scenes are generally impossible to photograph from audience position.

Musical shows and reviews are more difficult to photograph. The colour and brightness of the lighting is constantly changing. While 1/30 sec. at f2 or f1.8 is a good usual exposure, it is almost impossible to expect consistently good results unless you've had a good deal of practice in stage photography.

Amateur plays and shows do offer the average photographer a better chance to get good pictures. During dress rehearsal the photographer can get to the stage to make a correct reading right from the subjects.

Circus performances also offer a great challenge to serious photographers in terms of subject choice and timing. While you should use the fastest shutter speed possible to stop action, you can still get crisp photographs at 1/60 sec. if you can anticipate events and catch performers at the peak of the action when there is the least motion. Generally, however, large apertures, accurate focus and fast shutter speeds produce the best circus results. If you are sitting fairly close to the arena or rings, you can make good meter readings from the performing area itself.

At the Cinema

Pictures from motion picture screens tend to be very disappointing in terms of quality. The movie when watched seems quite sharp, yet the individual still pictures shot from the screen lack this very sharpness. Actually the motion picture itself is seldom as sharp as it looks during a showing. The movie is made up of 16 or 24 individual frames per second projected in rapid sequence. Frames showing motion are often blurred. You do not notice this any more than you notice the momentary blanks between the individual pictures. But when you photograph the screen with a still camera you remove the action and expose the blur. Nevertheless taking a still picture from a movie screen does represent a rather simple method of obtaining an adequate still snapshot from a movie without going through the elaborate techniques of direct printing from the film itself.

You can make quite respectable still snapshots with high-speed black-and-white film using a shutter speed no faster than 1/30 sec. Actually 1/15 sec. is better to avoid the possibility of catching the film during one of its intermittent periods of darkness between frames. Most movie projectors running at 16 or 24 frames per second have shutters working at about 1/30 to 1/50 sec. The Pentax shutter speed therefore should be slower. A good exposure on a fairly bright screen would be 1/15 or 1/30 sec, at f2. Naturally exposure will depend greatly on the brilliance of the projected image. To get the sharpest picture possible wait until action ceases on the screen. Then shoot. The finer the screen surface, the better the still picture possible. Take a number of exposures of each scene as insurance.

Television Stills

Quite akin to taking pictures from a motion picture screen is photographing from your own TV set. Here the production of the image is somewhat different from that of movie screen. In movies complete pictures are intermittently flashed on the screen. The TV picture is composed by a single spot travelling back and forth across the tube at phenomenal speed. Owing to a certain amount of afterglow existing on the tube face and the natural phenomenon known as persistence of vision it appears to form a complete picture made up of horizontal lines.

These lines are formed interlace fashion, the spot covering the whole picture area in 1/50 second but forming only half the lines. It then shoots back to the start position to fill in the gaps between the lines. Thus the complete picture is formed in 1/25 second. These figures apply to the British 405-line systems. The times are slightly less for the American 525-line system and European systems using a greater number of lines.

Thus, for any television screen, 1/30 sec. or thereabouts is the minimum shutter speed. With the British system the shutter speed must be no faster than 1/25 sec.

The aperture required will naturally vary with the brightness of the picture but a few experiments with a reliable exposure·meter, taking readings directly from a mid-tone on the screen, will soon provide the answer. That is likely to be somewhere around $f4$ with a 200 to 400 ASA film. There is no point in using fine-grain material. Even with the smallest screens, the lines making up the picture are far more destructive of definition than the grain of the film.

Line your camera up squarely with the tube face and focus on the lines of the picture. Take care that there are no reflections on the protective screen from windows or room lights. If you turn up the brightness control a little, you will increase the illumination and cut down the contrast.

SPORTS AND PASTIMES

Twenty or so years ago, the 35 mm. single-lens reflex would have been the last camera any serious photographer would have suggested for taking sports or action pictures. The camera was just too slow in operation. By the time you focused your subject, made the decision to take a picture and then closed down your lens aperture manually to the proper opening, the decisive, climactic instant of the action was over. Should you somehow capture the picture, the view-finder went black the moment after the picture was taken because the interior mirror flipped up out of the way of the light path—and stayed up.

Today the 35 mm. single-lens reflex has moved to the very forefront of those cameras judged ideal for sports and action photography. The automatic diaphragm of the Takumar lenses solves the problem of closing the lens down after you decide to take the picture. You need only press the shutter release and the lens closes to any preselected opening and re-opens to full aperture automatically. The introduction of the rapid return mirror eliminates the problem of continuous viewing and focusing. It is no longer necessary to lose sight of the action after the shutter is released. A photographer can shoot, wind, refocus if necessary and shoot again without removing the camera from his eye.

However, the Pentax camera offers further assets to the photographer wishing to photograph action. The rapid wind lever makes it possible to take pictures in almost split-second sequence, a built-in meter system on the Spotmatic or the even more advanced electronically controlled exposure of the Pentax ES provides constant check on exposure. And a wide series of lenses allows the photographer to pick the exact picture area he wishes to cover for any photograph. The Takumar zoom lens introduces even greater flexibility. Suddenly the photographer has an infinite choice of focal lengths. The action can be followed and the picture area varied constantly as the photographer wishes.

P.W.—Q

From an outcast in the field of sports photography, the 35 mm. single-lens reflex has grown to become the leading camera type used today.

Balancing the Variables

Whether you are a professional photographer assigned to cover games or events, or an amateur sitting in a fixed position in the stands, you must tackle three important variables in sports photography; lighting, distance and focal length of the lens. These three factors plus all the other usual variables of camera operation govern your success or failure technically in action photography.

Lighting is of extreme importance. When you expect to halt action, more lighting is called for than if you are taking quiet pictures around your home. Seldom will you have the advantages of creating your own lighting as you would at home, particularly if you are an amateur. Professionals, of course, can and do use flash, both bulb and electronic, when they are sufficiently close to the action. At outdoor events, there is generally enough lighting for either colour or black-and-white—particularly with today's modern faster film emulsions. Indoors, however, lighting is usually just barely adequate.

Distance is a factor in sports photography because most games require the photographer—amateur or professional—to remain on the sidelines, off the playing field. The spectator has an even greater distance problem since there is an additional distance from sideline to seat. In local or amateur events, the amateur photographer has a far better chance of operating right at the sidelines close to the field.

Choice of lens focal length is the opposite side of the coin from distance. If you cannot get sufficiently close to the action, the only possible alternative is to make the action come to you by drawing it in with a longer than normal focal length lens. But while many sports pictures are made with long lenses, a normal or even wide angle lens is needed to record large areas close to the camera. The amateur, often further away, must make use of even longer lenses to achieve the same subject area size on his negatives or transparencies.

The battle over focal length has been in progress for some time—ever since modern optical science made the long lens a rather small, fairly easy-to-hand-hold instrument. Photo-

WHAT SPEED FOR ACTION?

Is there one speed which will assure complete sharpness when shooting a moving subject? Usually not. Subjects in motion generally have different parts travelling at different speeds. Obviously the runner's hands and legs are moving faster and require a higher speed than his body. Solution: Use the fastest shutter speed possible.

When using speeds of 1/125 sec. or slower, most subjects in action will appear blurred if you hold camera steady.

If you pan with the action and move your camera in the same direction as the subject you can get a sharper picture of the moving subject, but your background will now be blurred.

When action is coming towards you, movement is not as noticeable as when action is moving at right angles. Here a slower shutter speed can be used.

graphers too often find it more convenient to remain aloof from the sports or action and to draw it close with a long lens. Other photographers feel that the long lens produces a sense of remoteness from the subject. They explain that proximity is most important to "feel" the action. Simplifying the problem a bit, this is the difference between a photographer close to a pole vaulter, pointing his short focal length lens upwards from the ground at the vaulter high in the air, as opposed to the photographer at a great distance photographing the same jump but with his long lens more or less level with the subject. It's evident that the most dramatic and compelling picture will be made by the photographer close to the action. Generally, you will get better pictures if you get closer than if you rely on the long lens to bring the action closer.

There are as many different techniques in photographing sports and action as there are different types of games and sports. Photographing any of them, of course, is an excellent test of your reflexes, judgment and quick thinking. There is no time to rethink a problem either technically or in terms of subject composition. Every action from setting the exposure to determining the proper moment to press the shutter release must be almost automatic. Balancing what you see in your viewfinder against your technical limitations—top shutter speed available because of lighting conditions and maximum depth available for this particular exposure—is all part of the challenge of sports photography.

Catching the Action

One of the keys to any sports picture is mastering the moment of peak action. If you analyze any athletic motion, you will see that there are certain climaxes when the action reaches a dramatic point and is actually moving at a much slower pace than usual. For instance, a hurdler going over a hurdle seems to float without moving a muscle for a brief instant as he clears the hurdle. A pole vaulter seems to remain virtually suspended in air at the moment he clears the bar. These moments not only are the most dramatic but are the best photographically since they epitomize the action and allow you to capture the instant with the slowest possible shutter speed.

Panning with the motion, one of the most effective ways to

portray action, can be used with some types of action and sports events, yet oddly enough does not seem to work well with others. At track meets or other events where the action's direction and general speed can be predetermined to some extent, panning is certainly the best method of obtaining a sharp image against a blurred background. The background blur heightens the feeling of motion in the picture.

Panning is really quite a simple technique. With your feet apart to give you good balance and your Pentax held firmly, simply twist the upper half of your body slowly and evenly while following the action in your viewfinder. At the best picture-taking-instant, as determined through the finder, take the picture while still twisting. Then continue panning in a follow-through motion. A good panning technique can help you take a number of photographs in one pan provided you can advance film quickly and continue to pan after your first shot.

Team games and team events are more difficult to photograph with pan action since much of the action usually involves broken field running and attempts to elude pursuers. In such instances, you can follow the action in the finder, shifting focus quickly as the action shifts, shooting at whatever moments you can. If you learn to move your camera smoothly by rotating at all times from your waist you may sometimes be able to take advantage of brief pans.

What speed should you use to photograph action? If you can pan, you can often cut down the shutter speed considerably. Runners, hurdlers, even sports cars can be stopped at an amazingly slow 1/125 sec. However, other actions which must be spot shot will require 1/500 sec. The safest general rule is to use the fastest shutter speed available that will still give a reasonable shooting aperture. For action, $f4$ is about the largest aperture you should consider. While it is possible to get a sharp figure in motion at $f2.8$ or even larger apertures, the extremely shallow depth-of-field at these apertures plus the moving subject makes the possibility of focusing errors too dangerous.

Electronic flash is an ideal subject-stopping light source. Most units work at 1/500 sec. or even faster quite independent of the shutter speed set. There is, however, owing to the slow shutter speed necessary, a distinct danger of secondary or ghost images from any existing daylight or

strong artificial light. The lighter the subject the greater the danger of such secondary images.

Choosing the Viewpoint

Proper picture taking angle is an essential part of sports and action photography. Quite often the angle will be dictated by your position or the type of action. However, when you can pick and choose your vantage point, height and angle, do so. The most striking position for nearly every action is right in front of it. This is not usually possible. Sometimes it is possible but unwise—as in sports car racing. However, the next best angle would be as close to directly in front as possible. In the sports car field it would be right at the edge of the track or road where the cars could be pictured at less than a 45-degree angle.

Camera height has a great deal to do with dramatic impact of action pictures. Usually a low angle will emphasize speed and power. Care must be taken, however, not to distort the subject inadvertently. If your viewpoint is too close, parts of the subject close to the camera will appear larger than those further away. In some instances, however, this increase in close mass plus subject elongation adds to the effect of action. In recent years, many photographers have actually turned to such wide angle lenses as the 20 mm. *f*4.5 SMC Takumar and 17 mm. *f*4 SMC Takumar to achieve this deliberate distortion.

Photography Under Water

With the advent of skin diving as a hobby within recent years, the possibilities of underwater photography as a companion hobby have become quite evident. Here is a beautiful world of different landscapes, colours and creatures. They can be photographed by a swimmer with but a simple face mask and camera protector or by a practised diver using underwater breathing equipment and the most expensive of underwater cameras and housings.

We cannot take the time and space to examine underwater diving itself but we can discuss the practicalities of using the Pentax for underwater photography.

Taking pictures under water represents quite a challenge, since the problems to be encountered are like nothing on earth. But before we discuss the technique of taking

pictures we had better find a safe, watertight case for the Pentax.

Surprisingly, one of the easiest, most convenient and practical housings is also the least expensive. This is the simple rubber or plastic bag with glass face plate through which you take the picture. You take off the face plate, insert the camera loaded with film, refasten face plate, and you're ready to go. Almost all the camera controls can be operated right through the soft rubber housing. You can check changes in shutter speed, aperture and focus by looking at the camera controls through the face plate. Unfortunately there is no way to use the prism reflex system either for viewing or focusing underwater. You just point the camera in the direction of the subject.

The soft rubber housing and face plate work remarkably well in shallow water to 10 ft. or so of depth. Below this, the camera controls and housing become increasingly difficult to use. There is also some danger of the housing leaking. For deeper and/or more serious work, a solid underwater case is needed. While Asahi does not make its own case, many underwater camera housing manufacturers produce cases which can be suitably adapted. Housings are of either plastic or metal. The plastic housings are usually less expensive and allow you to see the camera clearly through the plastic so you can check control settings. Clear plastic or brass gear rings are fastened to the camera controls and these, in turn, are controlled by knobs or levers which extend through the housing. Generally, the more controls you require, the more expensive is the housing. Many underwater photographers find that film transport, shutter release, focusing and shutter speed controls suffice. They preset the aperture and control exposure with shutter speed alone.

The housing is usually kept watertight with rubber "O" rings which resemble giant rubber bands. These fit into grooves around the lid of the housing. As water pressure increases the housing lid presses further against the "O" ring and housing back, thus keeping water out.

Before using any underwater housing, test it carefully for leaks. A Pentax is an expensive camera to ruin by inadvertent submersion inside a leaky case. To test, take your empty camera case underwater as far down as you will probably photograph. Look for tell-tale air bubbles escaping. If there

are bubbles, you have a leak. Luckily, plastic housings can be repaired easily with special cements available from any of the stores selling the housings.

While plastic housings are practical and less expensive, they are brittle and subject to damage. All-metal housings are far more expensive and do not let you see the settings of the camera itself. However, they are more durable than plastic. Both the metal and plastic housings can easily be equipped with a large open sight which frames your picture area.

Housings should have a strap which you can hang around your neck (made of plastic or nylon cord). When in the water a housing should have slight negative bouyancy—that is, the housing plus camera should neither bounce to the surface nor sink quickly. When left alone in the water, it should almost stay put or sink very slowly. If the housing sinks rapidly, weight must be pared from it or small air containers must be fitted to it. If the housing bounces to the surface there is too great an air space within. Either it must be pared down or lead weights added inside or outside the housing.

To prevent fogging of the front glass plate through which the pictures are to be taken (and even plastic housings use glass here), small containers of a dried dessicant such as silica gel should be included within the case. These will not absorb water if the case leaks, but they will prevent moisture from fogging the glass when underwater.

Camera Controls Under Water

Unfortunately, the metering system of the Spotmatic or ES cannot be used underwater. The system works well but you can't get your eye close enough to the finder to see the needle. With other models the clip-on meter provides an ideal exposure check. You can leave it right on the camera and adjust exposure as you normally would above water.

As you probably already know, the refraction of light rays in water causes all objects under water to appear $\frac{1}{3}$ closer to you than they actually are. This is the enlarging effect of water which also increases the effective focal length of your lens by a third. That's why wide angle lenses of 35 mm. or 28 mm. are preferred by underwater photographers.

There is another reason why long lenses are not used under-

water. Water is about one thousand times less transparent than air even at its clearest. The further away you are from an underwater subject the more danger of losing both sharpness and picture contrast. Therefore a wide angle lens used as close as possible will yield the best results. A 35 mm. Takumar lens becomes a 47 mm. lens underwater, while the 28 mm. Takumar elongates to about 37 mm. Luckily there is no alteration in aperture.

Focusing Problems

The problem of setting correct footage is not as great as it would seem. If you simply set your lens for the *apparent* distance underwater instead of the *actual* measured distance, the subject will be correctly focused. Of course, you can no longer use the depth of field scale on your lens, since the lens, for practical purposes is $\frac{1}{3}$ longer in focal length. However, you can adapt the scale safely if you allow about two stops error. In other words instead of trying to read the footage scale between $f8$ markings, read the scale between the two $f4$ markings.

For exposure, you can make your readings as you would normally, getting as close to the subject as you can. However, light does fall off the deeper you dive. Unless the water is spectacularly clear, and the sun bright, photographs should be taken within 15 ft. of the surface.

As very few caves allow a clear sight of the meter needle, Pentax owners will probably want to use an accessory meter for underwater photographs. Almost any good hand-held meter whose circuit can be switched on and remain on can be used. Just seal it tightly into a glass pickle jar or the like with sufficient cotton or cloth wadding to prevent the meter from moving inside the jar. Wedge the meter carefully so that the cell can be pointed out of the closed jar and so that you can see the scale.

Underwater Flash

While many good underwater pictures are made by sunlight, the most brilliant are made with flash, either electronic or bulb. Many different flash housings are available, usually made by the same companies producing the underwater camera housings. The use of flashbulbs or cubes underwater presents no problems, provided the flashgun itself is completely waterproof and safe against shocks.

You can carry a load of bulbs in a mesh bag. While bulbs may not explode underwater, implosions, or the crushing of bulbs by water pressure after exposure, has been known to occur at depths.

Because of the tiny dust and dirt particles in all water, it is essential that the flash be placed as far from the camera as possible. If direct on-camera flash is used, the tiny particles act as direct reflectors and bounce the light right back at the lens causing loss of contrast, increased flare and reduction of sharpness. Most flash units have rigid and long extension arm brackets which allow the flash to be used some distance from the camera and at an angle.

Electronic flash units must be encased in watertight housings similar to the camera housings. They, too, must be removed from the line of direct flash.

Flash can give the skin diver the advantage of a consistent light suitable for colour work. As soon as you can work out your own flash number for your gun and flashbulbs underwater you will be able to set exposure exactly. You may want to use clear flashbulbs rather than blue ones with colour films to counteract the bluish tint of the water. Similarly you might need to use a filter with electronic flash.

Electronic flash has the additional advantage of a very short-duration light which freezes all motion. When photographing rapidly moving fish or in turbid water where it is difficult for the photographer to remain in the same position, electronic flash is most convenient.

It isn't possible to offer additional information on flash exposure since much depends on the clarity of the water. Medium fast and fast black-and-white and colour films seem to work best underwater.

NATURE AND WILDLIFE

The single-lens reflex camera design and the necessities of flower photography seem virtually wedded together. In no photographic field is the advantage of through-the-lens focusing and viewing better adapted to the subject material.

Actually flower photography can cover a vast number of different approaches—from the photography of entire fields of blossom to photomicroscopy of tiny segments. However, here we'll take up the more common types: general photography for horticultural use and the photography of flowers for artistic purposes.

Equipment for Flower Photography

The Pentax is particularly suitable for flower photography. In its basic form with normal lens, it can focus to less than two feet making it possible to shoot many flower pictures with no more equipment than the camera plus normal lens. Quite often you will not be able to get close enough with just the normal lens. The Close-Up Lens can then be threaded in front of the normal lens. However, a close-up lens, in effect, shortens the focal length of your normal lens slightly. This means that you must get closer to your subjects. Since apparent perspective distortion (the enlargement of closer objects in relationship to more distant ones) increases with closeness to the subject, close-up lenses are not the best solution.

Perhaps the handiest equipment is the extension tube set which allows you to focus for greater than life-size reproduction. When out shooting you can easily pocket the extension tubes and then thread those needed to the camera lens when you're ready to shoot. The bellows units allow continuous focusing to a 2.7× magnification, but they are rather more cumbersome when out shooting in the field.

Both extension tubes and bellows unit allow you to maintain a greater camera-to-subject distance than the close-up

lens, thus avoiding apparent perspective distortion to a greater extent.

For best flower photography results close-up, the 105 mm. Super Takumar or Super-Multi-Coated Takumar seem to furnish a close-to-ideal perspective at a good shooting distance. The 105 mm. ƒ2.8 Super or SMC Takumar with the extension tube set will handle just about any flower situation you may encounter.

Surprisingly there is a great disparity in requirements for flower pictures for horticultural purposes and flower photos for artistic use. Horticulturists are mostly interested in the clearest, sharpest delineations of flowers. They require the petals, pistils, stamens, stems, buds and leaves all to be crystal clear. Slight backlight is generally needed to provide petal translucency. Most flower photographs which satisfy the needs of the flower expert will not impress you as beautiful photographs.

Choosing the Flowers

For best possible non-artistic but technically satisfying flower pictures, you must pick your flowers with care.

What type of flowers do you intend to photograph? Probably the most universal type are those which are domesticated and grown in a garden. These pictures then become a documentary of each flower type or arrangement. Entire gardens, of course, can also be photographed and provide enjoyment for gardeners during the winter months when the flowers themselves are not available.

The author, however, prefers to photograph wildflowers. Hiking in the fields and woods while keeping a sharp eye peeled for the smallest new blossoms presents a real challenge. A large collection of wildflower photos taken over a year's span offers beauty, colour and variety.

Wild flowers seem to offer the greatest possibility for artistically satisfying pictures.

If you do intend to photograph wildflowers and know little of them, a good wildflower field guide is a must. Make sure that the guide covers the flowers in your region. Wildflowers change from country to country, area to area. Names also change; characteristics change. Make sure that the illustrations—usually drawings in colour—are clear and explicit. If you are not yourself an enthusiast, ask someone

who is to recommend the best pocket guide on the subject. In searching out wildflowers begin in early spring. Wild flowers blossom then. Unfortunately, many wildflowers have only a brief blossoming period so check your field or woods often.

It's almost impossible to suggest any specific areas in which to look for wildflowers. There are different types in fields, in the woods, in marshes, near streams. Some are large and easily spotted. Others are amazingly tiny. And remember, practically every plant—even grass—has blossoms which can be photographed.

The flowers should be physically perfect with no blemishes. At least one leaf should be showing in the photograph. If possible a yet unopened bud should also be included. When sharpness and complete delineation of the entire flower is necessary, an extremely small aperture should be used, coupled with, of course, a slower shutter speed. A small table top tripod with a fairly large universal head is an almost necessary acquisition. Some large tripods have reversible centre-posts which allow the heads to be reversed for close ground work.

When using a slow shutter speed, even the slightest breeze can cause unsharpness. To overcome it, use a cardboard sheet upwind of the flower to protect the flower from wind movement. Some photographers prefer to build a small cylinder of cardboard and drop it over the flower. They can then photograph from above and use the cardboard itself as a separating background. When using a small aperture, the background plays a very important part in the picture. If you photograph the flower against the background as you find it, you may have a dreadfully complicated tangle of leaves, grass blades and flower. If you do not use the protective cylinder already described, a coloured cardboard can be tried behind the flower. A light blue or brown cardboard generally will produce sufficient separation.

Exposure and Lighting

For most accurate exposure meter readings, make the reading from a standard grey card held just before the subject. This provides quite accurate exposure for most flowers except those which are white or very pale or those which are extremely dark. For very light flowers one half stop less ex-

posure is preferable. For dark flowers a half stop additional exposure should take care of the problem.

Remember to allow the additional exposure required by the bellows or extension tubes as well. Of course, if you have the Pentax Spotmatic camera with its behind-the-lens meter, you can simply take a reading right through bellows or tube without any additional exposure increase calculations. But, as already discussed, use a grey card and adjust exposure depending on the deepness of the flower colour.

Quite often the lighting of the flower will not be all that it might be. In such cases you can aid it by using a white cardboard reflector or a cardboard on which you've pasted crumpled aluminum foil. Many photographers find that a small shaving mirror makes an excellent reflector to redirect light to small flowers.

Usually, lighting to the side and slightly behind the flower shows the flower to best advantage. Such illumination has the advantages of cross lighting to delineate detail and also provides you with sufficient trans-illumination through the petals. However, with judicious use of reflectors, such light can often be simulated if it isn't actually available.

Artistry with Flowers

The most enjoyable wildflower photography forsakes the quest for overall sharpness and instead seeks to produce a photographic work of art. The delicacy and beauty of a wildflower isn't necessarily contained in sharpness. It is rather in the overall visual illusion created. Within recent years, there has been a serious re-examination of nature and flower photography. Many important new books of wildflower photographs have appeared with pictures which would have shocked photographers of a generation ago. In these books, wildflowers are shown in which only a small portion of the flower—usually the pistils and stamens is sharp. The background is a blur of green and the stem and petals swiftly fade into unsharpness. Yet many flower experts admit they do get more of the feeling of the wildflower from these softer delineations than from the more accurate, technically correct, supersharp photos of the same flowers.

I have personally found that if I used the entire Pentax extension tube set with a 105 mm. Takumar lens, *f*5.6 was about as small an aperture as I wished for best results with

the "new" flower photography. Quite often even larger apertures of ƒ4 were better.

Of course, the large lens openings do allow a much faster shutter speed. Consequently I now find that it is relatively unnecessary to take a tripod along on my woodland trips. A speed of 1/125 sec. or faster can usually stop any camera or flower movement. Most of my flower pictures are made flat on my stomach with both elbows resting on the earth. Even when there is a slight breeze, I can often pick the instant when the breeze lets up and the flower remains still. I shoot most easily without a cable release. Somehow a cable release slows up my ability to release the shutter at the precise instant that I wish.

With a large lens opening it isn't necessary to use background material. The large lens opening throws all the confusing natural background into a pleasing out of focus green blur which is, of course, really more natural than an artificial background.

Preparing a wildflower for its portrait can take patience. When you have what you feel is the best angle, don't automatically take an exposure meter reading and shoot. Look around the picture area through the finder. Often there will be distracting grass blades or weeds near or even in front of the flower. Remove all annoying additional vegetation, but don't disturb the plant you are photographing.

For very small flowers even the 105 mm. lens and bellows or extension tubes may offer insufficient magnification. In such cases the normal 50 mm. or 55 mm. lens can be used. Since the flower itself is so small the depth of the flower will be less and the danger of apparent perspective distortion from the shorter focal length lens will not be so acute.

While the entire concept of taking flower pictures at a large aperture when working so close may seem rather odd to you at first, do make some comparison shots. Shoot the same flowers at a large aperture and then repeat the same photographs of the same flowers from the same angle but at a small aperture. When the pictures have been processed, compare the results. I think you'll like the larger aperture pictures better.

A word about choice of colour films. Pick a film which offers the softest colours and best reproduction of subtle changes of hues. In flower photography you will really be

able to tell differences between colour film capabilities! Try to avoid those colour films which produce bluish greens, orangy yellows and reds. Purple is often a most difficult colour for a film to render properly. You may need to do some experimenting with films before you find the proper one for flower photography—and it may not be the film that you generally prefer for ordinary photographic work.

Bringing Birds to the Camera

Bird photography is probably one of the most rewarding areas of picture taking. It represents a challenge—the hand must be quicker than the bird. It also can furnish valuable orthinological data and will, of course, give you a record of all the species in your own neighbourhood. In addition, you will also acquire excellent photographs.

Most people think of photographing birds as roaming the fields with a giant telephoto lens. This is seldom practical. You can either approach a known bird nest carefully or make the bird come to you.

Oddly enough, making the bird come towards the camera is the easiest technique. All that is required is a bird feeder fastened to a window and some bird seed. If you then open your window, place your Pentax on a tripod and wait, inevitably you will have your chance at a bird or birds. Even the normal 50 or 55 mm. lens can be used. Since it's necessary to approach closer than 3 feet to the bird for a good sized image on the film, focus your camera at some specific area of the bird feeder. Sit further away yourself and trip the shutter with a long cable release.

The normal lens of the camera does have a disadvantage, of course. To advance film, you must get to the camera. This can scare away the birds. However, if you leave your window open constantly and the birds see that they aren't being harmed, they will become bolder and ignore your actions. Quite soon you will find that the various bird species have personalities. Some are bold and will allow you to approach quite closely. Others will only be lured to the feeder after many weeks. And any movement inside the house will scare them off again.

A 135 mm. lens will certainly prove far more convenient for photography than a 50 mm. or 55 mm. lens—not to get closer to the birds, but to allow the camera to be further

from the window. With small birds a short extension tube may be needed to produce a sufficiently large sized image. However, with a long lens you can keep the camera in your own hands, releasing and advancing film whenever you wish.

For a beginning, use daylight and a rapid colour film—it would seem such a shame to shoot birds in black-and-white. Be careful of the lighting. If the light is coming towards the camera you will have near silhouettes. Top or sidelight is best. Wait until the bird has actually landed or you will find a natural blur on your film. Since most bird feeders are not too photogenic, you may wish to adapt your bird feeder to photography. Small branches and twigs can make excellent perches for the birds between actual feedings. You can then shoot them right on the branch or twig perches and crop out the feeder itself in the viewfinder. The pictures will show the birds perching on a tree branch. Make up a number of different branches so that it won't appear that all your bird pictures were made on the same branch.

The advantage of the perched-on-branch bird is the ease with which you can get sharp pictures at fairly slow shutter speeds. With regular daylight you will often have to shoot at 1/30 or 1/60 sec. which is far too slow to capture any bird in motion.

While these basics will do nicely if you don't intend to get thoroughly enmeshed in bird photography, you can increase the variety of birds and therefore the variety of pictures. Where should the feeder be put? If you are in the country, place it on a windowsill next to some outside shrubbery or a tree. The shrubbery or tree affords the birds some protection in case of danger. Use a good birdseed mixture. Some of the most interesting bird pictures are made in the winter with the snow on the ground. Colourful birds contrast beautifully with the snow. If you start feeding birds towards the autumn every day, many will stay around all winter giving you good photographic companionship. However, since they will depend on you for a food supply, don't stop feeding them. Within one day, they can starve to death. If you plan on being away from your home for any length of time, make certain that you make proper arrangements for someone to come in and feed your birds.

Not all birds, of course, will eat from a feeder. As food is dropped by the birds at the feeder, others will sit patiently

on the ground below and pick over the leavings. During the winter you can scatter birdseed in the snow and catch these ground feeders against a tastefully plain background.

Birds in Flight

Inevitably the possibilities of photographing still birds will begin to bore you. Actually you can photograph birds in flight with much the same set-up plus a small electronic flash unit.

Set up a small flash unit with the light directed on to the added branch of the feeder. Connect the flash to the camera with a long lead. You're now set up for taking frozen-action (or at least near frozen) pictures of the birds. You may find that the flash scares some birds at first, but they soon get used to it.

When do you actually snap the shutter? Where do you point the camera? Keep your camera trained on the same branch. Try to prejudge the birds' action. You will see that birds generally repeat their flight habits. They may travel from a nearby bush or tree to the branch, back to the feeder, back to the branch and then return to the distant tree. I found that I could just about catch a bird landing with wings outstretched if I pressed the shutter release as the bird left a nearby branch to attempt a landing on my pre-rigged branch.

When using flash with a focal plane shutter camera care must be taken to avoid the formation of a secondary or ghost image by the available light. To minimize the possibility try shooting against a dark background. This tends to absorb the secondary image, which is usually underexposed and dark-toned, even if the subject is light-coloured.

Mobile Bird-watching

While taking bird pictures through your own window is certainly the easiest way, only certain birds will approach a feeder. Many larger birds must be sought out. This can be a time and energy consuming proposition.

Without getting involved in the many complicated techniques such as the hides used by professional bird photographers—there are some hints that might help you in the field. A longer lens is essential—the longest lens you can safely hand-hold at speeds of 1/125 sec. or faster.

You may get good results actually stalking through the fields, but an automobile makes good mobile camouflage. It's also not too difficult to adapt a simple camera support which fastens to the car's window channel. You can then cruise up and down slowly looking for birds and often shoot them from the car.

Wild Animals, Too

Photographing domesticated animals—cats, dogs etc. presents no more difficulties than photographing the more human members of a family. They, too, are best caught unaware.

Photographing animals in the wild is entirely another matter. Serious animal photographers have gone to extraordinary lengths to bring down the quarries, building elaborate and time-consuming hides. Generally speaking whatever can be shot with a rifle can be photographed—and a good picture of deer or other game animal is often a more difficult but more lasting prize to bring home than the dead animal is to the hunter.

The problems of nocturnal animals, which require the uses of special tripping devices and remote flash units, is too specialized a subject for this book. But stalking wild animals in daylight merely requires the presence of the animals, the right equipment, technique and patience.

Like any good hunter, the photographer must attempt to get downwind of the animal where the human smell and the noise of the photographer's movements are not as likely to be communicated to the animal. Clothing which blends into the foliage is helpful. When animals are present, move only when absolutely necessary. Many animals have poor eyesight but they can detect movement. It is advisable to use a fairly long lens which is easily hand-holdable: the 200 mm., 300 mm. and 400 mm. Takumars are superb for animal photography. Medium fast film will allow you a fairly rapid shutter speed of 1/125 sec. or better at maximum apertures.

Most animals in the wild must be photographed before they are alarmed and take flight, so movement of the subject is seldom the problem. The shallow depth-of-field at maximum aperture also aids the separation of the animal from the background. Focus on the animals' eyes when possible. If the animal is facing away, you may have to chance

it and make a slight noise to attract its attention in your direction for that instant before it takes flight. Be prepared to shoot quickly. You will often not get a chance at a second shot. Even the shutter noise may cause animals to bolt.

CAMERA MAINTENANCE

Camera equipment only works properly if it is treated well. What constitutes good treatment and what constitutes bad, however, is not often as clear as one might like.

Camera Cases

The safest place for any camera is in its case—the sturdier and more cushioned the better. However, the sturdier the case, the more difficult it often becomes to use the camera. For instance, the hard everready case undoubtedly offers the greatest camera protection, but it is bulky and does take time to open and shut. Photographers instead often prefer the soft leather case, which is more supple and easier to open but does not offer the same amount of protection.

There are also many photographers who feel that any case whatsoever is a restriction which takes up room and causes the loss of valuable time in opening and closing These photographers often use no case at all but merely fasten the camera to a neck strap by the eyelet lugs at the camera ends.

Maintenance in terms of carrying the camera safely to protect it against bumps, abrasions or even dropping it is a matter of personal preference. Most amateurs do keep their cameras in cases at all times when the cameras are not in actual use.

Lens Protection

There are three important protective items for camera lenses. When lenses are not in use both ends should be covered by lens covers, front and rear. When the lens is on the camera, the front cap alone, of course, is sufficient. The rear cap should only be removed at the time you intend to place the lens on the camera. The front cap should remain on except when actually taking pictures. If the camera body is to be left for any time at all with no lens, a camera

body cap should be threaded into place to prevent dust, dirt or other foreign matter from entering the mirror box.

When taking pictures, your lens should have one of two protections or perhaps both. A Pentax lens hood is designed specifically for each focal length lens to prevent extraneous light from hitting the lens and causing flare. However, the lens hood also furnishes excellent physical protection against fingermarks on the lens or the accidental contact of the front lens surface with other objects. The hood further protects against flying sand or moisture at the beach or against raindrops in stormy weather and snow during the winter. Therefore, even if there is no sun and no optical reason for a lens hood, use it for lens protection.

The front lens element is quite delicate. There will be much less cause to clean it if you keep a skylight filter permanently threaded into the front of the lens mount. The skylight filter eliminates some types of haze and also gives a warmer (tendency towards red) rendering at most colour pictures. However, it will also serve as further lens protection. Dust, dirt, moisture and fingerprints can be cleaned from a filter far more conveniently than from the camera's own lens. Since the skylight filter requires no additional exposure and can never harm a photograph, there is no reason why the skylight filter can't be used over your Takumar lens at all times.

Cleaning Lenses

Inevitably lens surfaces do get dirty. Even if you avoid touching them, some amount of dust will be attracted by the glass surface and adhere to it. If the lens surface exhibits dust only, don't feel that you have to clean the glass thoroughly. Instead, concentrate on removing the dust. This can be done in two ways—by using a small brush to flick it off or by blowing the dirt off with a stream of air.

To remove the dust with a brush, either buy a small pocket brush specially made for photo use or purchase a good sable brush. Avoid inexpensive paint brushes. These often contain some oil to help hold the shape of the brush. While this oil is relatively harmless to paintings, it can come off on the front element of your lens. An inexpensive brush is apt to cause more trouble than it solves.

When using the brush, hold your camera upside down with

PROTECTION
AND CLEANING

When carrying a lens on camera or in gadget bag, reverse lens hood, place lens cap over it. When ready to shoot, take off lens cap, place in pocket or gadget bag, reverse lens hood.

To clean lens properly with lens tissue, fold as shown, tear folded tissue in half, place torn halves together, use torn edges to clean lens surface. Work from outer edges in towards centre.

Small specks of dust can be flicked off lens with clean brush.

Cotton swab on toothpick cleans finder window nicely.

To clean dust from mirror, remove lens, hold camera upside down so dust won't resettle as you flick it off with tip of brush.

the lens pointing to the floor. If the lens faces upwards, you simply do what many a maid does with a feather duster—stir up the dust, which then settles again right back where it came from. By holding the camera with the lens pointing downwards, the dust or dirt will quit the glass when dislodged by the brush and continue its progress downwards out of harm's way.

Start cleaning with a circular stroke from the outside of the lens. If you start from the inside and attempt to clean outwards, much of the dust and dirt dislodged at the centre might be massaged into the edges underneath the manufacturer's identification rims. If you start at the lens circumference, you can work the dirt inwards. When you get it in the middle, you can remove it with one final swipe.

Most dust and dirt on lenses should be readily removable with a small brush. However, to avoid touching the soft glass surface too often, you should try a small air blower such as an ear syringe. With it you may be able to blow much of the dust and dirt from lenses without actually touching them.

When even a gentle touch with a brush is insufficient to dislodge a particular speck or spot you must resort to lens tissue.

Most photographers do not know how to use lens tissue properly. You are not supposed to take a sheet and massage the front of the lens with the flat of it. This can grind the impurity into the front element and cause damage. Instead try following this technique.

Take one sheet of lens tissue. Roll it up like a cigarette. Now tear the "cigarette" in two. Holding one of the outside edges of the paper, use the rough edge on the glass as you would a brush. Massage in the same outside-to-inside circular motion. Do not apply any more pressure against the lens than you can exert from the end of the rolled up lens tissue.

Under no circumstances use ordinary eye glass tissue on a camera lens. Such tissues usually are treated with silicone materials, an abrasive composition which not only scratches the front of lens elements but also reacts chemically with the anti-reflection coating of the lens. This chemical reaction can build up a heavy deposit which causes loss of definition and colour balance.

Fingerprints are a primary and constant source of trouble.

No matter how hard you try, sooner or later you will inadvertently place a finger on the lens leaving a small grease spot. These grease spots are by no means easy to remove. Here's one possible way, however.

Roll a lens tissue and tear in two as indicated above. Now breathe heavily on the front element surface. Before the moisture has a chance to evaporate, begin to clean the front element with the torn lens tissue as already explained. If some grease streaks still remain, repeat the cleaning operation.

There will be times when your very best efforts at lens cleaning will not avail with grease spots. Purchase a reliable fluid lens cleaner from your camera dealer and follow directions carefully. Don't use too much lens cleaner. Often the cement between lens elements is soluble in liquids quite similar to those used for lens cleaner. The amount of lens cleaner therefore should be minimal.

The rear viewfinder window can be cleaned in a similar manner to the front and rear of the lens. However, it is often difficult to clean the outer edges of the finder window. For edge cleaning try some cotton swabs on a toothpick (called a Q-Tip in the U.S.).

Cleaning the Camera Body

The rest of the outer camera body should also be attended to regularly. A small brush can be used to clean the dust and dirt from nooks and crannies, particularly on or around the setting controls. The outer leather-like material needs no attention, but a very slightly damp cloth can help maintain the lustre of the chrome.

A great deal of dust does settle within the camera body and can deposit itself on your film causing small unexposed spots. To prevent this, establish a regular series of maintenance operations perhaps twice a month. Open the back of the camera and examine thoroughly. Sometimes, small bits of film leader snap off. These bits can easily get into the shutter speed mechanism and cause trouble. Clean them out. Then go after the dust. Hold the camera open with the lens facing upwards and flick out all dust with a small brush. Gravity will make sure it doesn't resettle in the same place. Avoid touching the shutter blinds. A small low-powered vacuum cleaner makes an excellent camera interior cleaning tool. Do not use a high powered cleaner! ·

After cleaning the lens and the camera back thoroughly, remove the camera lens and clean the interior of the mirror box with a brush. Again hold the camera face downwards so that dislodged dust can exit through the lens mount. Pay particular attention to the underside of the focusing screen. Quite often small particles of dust will become stuck there. These particles can usually be seen in the finder. While holding the camera to your eye, insert the brush carefully and locate the spot on the focusing screen. Then flick it off.

For this cleaning, use nothing but a good quality long handle painter's brush. Most photo brushes are too stubby and round. Such brushes could conceivably damage the mirror when you are attempting to reach the underside of the focusing screen.

The mirror is another major settling area for dust and dirt. While the dust and dirt there do not affect camera sharpness, a large amount can cause deterioration of the focusing image. In addition, it is quite easy for this dust on the mirror to redeposit itself on the underside of the focusing screen when the mirror flips upwards out of the way during exposure.

The mirror, however, is probably the most delicate exposed mechanism in a single-lens reflex. Unlike the mirrors you have at home in which the silver reflecting surface is underneath glass and is therefore protected, the silver surface of the rapid return mirror in the Pentax and similar single-lens reflexes is on the top. Top surface mirrors prevent double images which are difficult or impossible to focus accurately.

When cleaning the mirror use only the lightest strokes from a brush or from your rolled up lens tissue. Don't attempt to dislodge grease or fingermarks. There should, of course, be no finger marks or other smudges on the mirror. If there are, leave them there until you can send the camera to an authorized Pentax repairman for mirror replacement. The replacement cannot be done by the camera owner.

Lubrication

Your camera is carefully lubricated when it leaves the Asahi factory in Japan and should require no further treatment or lubrication for many years. Various parts use different lubricants which are designed to allow the camera to operate even

in extreme temperatures. However, if you are visiting locations where temperatures of far below zero are commonly encountered, consult your importer or distributor on the advisability of having your camera winterized. Such winterization usually requires that the ordinary lubricants be removed and special high viscosity lubricants substituted in some places and all lubricants removed from others. The camera should only be operated in this condition when absolutely necessary. As soon as it is returned from cold temperatures, the original lubricants should be replaced.

Under no circumstances attempt to use any oil or grease on the camera or equipment yourself. And do not take the camera to any but an authorized repair firm for service and lubrication. While other technicians can probably "lubricate" the camera, they may not have exactly the right lubricants. You may then find that the camera tends to become sluggish when the weather gets cold or run too swiftly if the weather is hot.

When the camera is not going to be used for some time, it's advisable to untension the shutter. Make it a practice to keep the Pentax shutter unwound whenever you are not using the camera. Only wind to the next exposure, thus also winding the shutter, when you are reasonably sure you will be taking additional pictures. Keeping shutter tensioned for a time will not harm it, but constant tension over a long period of time may cause a loss of shutter curtain travel speed.

Exercising the Camera

If you are not using your camera regularly, take it out once every week or so and operate the shutter at all speeds. Also operate the self-timing mechanism and the lens diaphragm at all apertures to keep them from getting sluggish.

If your camera is still loaded with film and you don't want to waste the remainder of the frames during this procedure, try this: Make a careful note as to which frame number you are on. Now rewind the film carefully. Watch the small red dot on the bottom of the rewind button. When the red dot ceases to turn, the film has left the take-up spool. Stop rewinding immediately. You can then remove the film cassette from the camera with a length of film leader protruding. If you continue to rewind after the red dot has ceased to turn, the film will be wound completely into the cassette.

With the cassette removed, exercise the camera as already explained. Afterwards, replace the cassette in the camera, re-thread the film and with the lens cap in place so you do not fog the film, advance the film by alternately pressing the shutter release and winding the film until you again reach the same frame number. As insurance, you might advance the film one additional frame. You will have then lost one frame only.

Camera maintenance depends greatly on your own thoughtfulness and attention. Many early model Pentaxes are still around in perfect condition optically, mechanically and visually, because the owners were careful. Others, used hard and not so carefully looked after, show the effects of hard wear and neglect much earlier. Pride of ownership should be important to the careful owner. It's always a pleasure to own and use a Pentax in perfect condition. And your pictures will show the difference too.

PRACTICAL HINTS

Reading aboutt he basic principles of equipment and its use represents just the beginning of learning to enjoy the possession of your Pentax camera and accessories. The rest will come in applying the knowledge and reaping the reward of the pictures themselves. Certainly much will be learned by trial and error as it always is with every photographer and his equipment. However, after spending many a year with single lens reflexes of many makes—with special emphasis on the Pentax—I would like to pass on some of the hints and tips that I have found of help in taking pictures.

Bags and Cases

First let's discuss the carrying of equipment. Ever-ready cases that chew up time between the instant you see the subject and the instant you are ready to photograph it, annoy me, but most people still keep the cameras in their cases. If you must, at least keep the case open or, if the front snaps off, keep the camera at the ready without the front.

Suppose you have accessories, what then? For a few accessories—even an additional lens and some film, an expensive gadget bag may look imposing but it isn't necessary. A soft leather pouch with top zipper and over-the-shoulder carrying strap will do just as nicely and will be less conspicuous.

I do not recommend keeping lenses or any accessories in the nicely made individual leather cases in which they inevitably come. These cases are bulky and take time to open. Instead remove the lenses and accessories and place them in small plastic bags similar to those used for keeping food in refrigerators. The lens or accessory drops down into the bag nicely and the bag can then be rolled up like a cocoon. It can be opened just as quickly. Because it's transparent, you can always see what's inside. Keep lens caps on both front and rear of all lenses not in actual use.

When you begin to accumulate enough accessories to make a small leather pouch rather a jumble in which you cannot put your hands instantly on what you want, it's time to investigate the possibilities of a real camera gadget bag. Personally, I don't like huge heavy leather ones with all sorts of odd outside pockets. Equipment is heavy enough to carry without adding the weight of a heavy case. Avoid cases with oval zippered tops. The zippers can stick either open, shut or half way. Things are forever getting caught in them. Instead search for a bag with a single snap lock and hard top. With a flip of the lock and top you can open the case, extract or replace what you wish and close the case again—all in seconds. At the beach or in bad weather you'll appreciate that fast operating snap top.

To prevent individual items of your equipment from banging together, some sort of compartmentation is quite essential. Those cases which offer the most flexibility in changing the shape and size of each compartment are probably the most useful. You can alter compartments as your equipment changes. Each compartment should be sufficiently large to allow you to drop the camera, lens or other accessory in with no trouble. If it is the slightest bit difficult to fit a piece of equipment in, think of how frustrating the case may become when you are taking pictures and you're in a hurry to change equipment!

Try not to buy a case larger than you really need. The smaller the case, the easier it is to carry. And there's little sense in buying a large impressive case which you then feel obligated to fill.

It is not necessary to get a case which can hold two camera bodies if you have two. You can always carry one camera at the ready outside the case. Make sure there is sufficient room for film. The amount of room needed depends on your own shooting tastes. You will obviously need more room if you are a prolific shooter than if you are a slow, careful shooter.

Handling Film

In placing film in a carrying bag, there is no real purpose in keeping it in the individual cardboard box. The box must be thrown away anyhow. When you're shooting pictures you can lose valuable time opening film boxes. Keep the

film in the metal or plastic foil sealed containers, however, since these have been sealed against moisture and humidity. After exposure replace the film in the container. If you are taking pictures in a hot and humid climate place the film containers in a plastic refrigerator bag along with some oven dried bags of silica gel. After shooting the film, get it into the containers and into the bag as quickly as possible. The silica gel will absorb the moisture (which actually is a far greater enemy of film than heat).

Having loaded Pentax cameras more times than I can remember, I have finally decided that it is not safe simply to thread the film leader only into the take-up spool. Quite often the film simply will not advance. You will find that you have no trouble if you keep the camera back open and advance film until the full width of the film winds on to the take-up spool and both sets of sprocket teeth on the sprocket wheel are engaging the sprocket holes of the film. Then you can close the camera with assurance that the film will advance properly.

In rewinding film, don't attempt to see how fast it can be done. Exceedingly fast rewinding with any camera can, under certain conditions, cause static electricity marks to form on the film. Take a little longer to rewind film and avoid the marks.

Viewing and Focusing

In using the central microprism grid for focusing, you will find that it snaps images in and out of focus with medium focal length lenses more efficiently than with either wide-angle or extremely long lenses. Of course, maximum focusing aperture also has much to do with it. However, you will find it more difficult to focus long lenses on a tripod than hand-held long lenses. The tiny prisms which make up the microgrid, cause shattering and shimmering of the subject when out of focus to a greater degree if the subject or camera moves slightly. Therefore, if you do have some trouble with exact focus when using a long lens on a tripod, remove the lens and focus hand-held. Then you can put the lens back on the tripod for greater rigidity.

Contrary to what you may have read or been told the Pentax viewfinder does not show exactly what the lens records on the film. In fact, it shows about 10 per cent. less. In addi-

tion, wide angle lenses actually produce a slightly larger picture area on the film than larger lenses because the edge rays from a wide angle lens "creep" under the focal plane picture frame at an acute angle. This means that you actually have available a larger picture area than you thought you had when you pressed the shutter release. In practical picture taking terms, this 10 per cent or so additional area is essential. Most cardboard mounts for 35 mm. transparencies use up about 10 per cent. of the total picture area in fastening the transparency edges to the mount. Many glassless negative carriers do the same with black-and-white negatives. However, you can use the extra area to reposition the negative or transparency slightly if a tiny bit of the picture appears nipped off when mounted or enlarged.

In actual shooting, make your entire picture frame work for you. Before you take a picture, look around all four sides carefully. Is there any part of the picture area that isn't essential? If so, you haven't framed your picture tightly enough. Move in until the subject material fills the frame so perfectly that there isn't any space that could be sliced off.

Always crop in your viewfinder. In colour you won't have another equally good chance unless you copy and enlarge the slide. In black-and-white you can, of course, exert considerable control during printing. But the less cropping you do, the less magnification you need and the better quality will be your enlargement.

Not coming close enough to the subject is one of the most frequent mistakes of all photographers. Except for vast sweeping landscapes, most subject material benefits from a close approach. A large dominating image has more detail, is easier to see and provides more impact. It's surprising how many camera users will photograph vertical subjects while holding the camera horizontally. They seldom think about taking a vertical-format picture which would allow them to get closer to the subject and provide a bigger image on the film.

The key to good cropping is to carry a built-in viewfinder within your head. You should learn to view a scene and know with fair exactness just how much will be recorded with each different focal length lens you own.

Every mechanical operation concerning the camera and accessories must become practically automatic requiring you

to give little thought to it. Finding picture material and re-cording it should occupy most of your time. The less time spent worrying about the operation of the equipment, the better will be your final pictures.

Essential Equipment

What equipment is essential and what equipment is not? Naturally it would be delightful to own every single piece of equipment and then to pick and choose just those items needed for specific purposes. However, we are limited by what we can afford and what we can carry. Probably the essential outfit would include a normal lens, 35 mm. lens and 105 or 135 mm. lens. If you shoot both black-and-white and colour transparency films, you will probably eventually need two camera bodies. A UV filter, medium yellow filter and perhaps a green filter would be a good small collection. A small electronic flash which can fit into your gadget bag will be handy. The clip-on meter (or the Spot Meter II for the more serious photographer) is almost essential—that is unless you already have a Pentax ES, SP500 or Spotmatic camera.

Lens hoods are often considered a must. I have found modern lens coatings such as used on the SMC Takumars to be so effective that I've yet to find an instance where a lens hood would produce a better picture optically than without one. Lens hoods, however, do keep dust, dirt and fingers away from the lens. In poor weather they keep out rain and snow. If for nothing else but protection, you should have them.

The extension tube set or close-up lens would round out the equipment we would suggest for an initial kit of equipment.

There are some odds and ends which you will find useful to have in your gadget bag. A small jeweller's screwdriver will keep all tiny equipment screws tight. Don't use a larger-bladed screwdriver than necessary or you can ruin the tiny screw heads.

A roll of adhesive tape and knife or scissors will serve as a labelling kit. You can stick tape labels on a camera and on it write the name of the film contained or note how many exposures are left in half-used film cassettes. A ball pen usually writes nicely on adhesive tape. Some photographers

321

prefer a roll of paint masking tape since it peels off more neatly than the ordinary adhesive tape.

A word about tripods. A compact folding job that just about fits into your hip pocket can actually be worse than no tripod at all. A tripod, to be any use, must hold the camera rigidly during exposure. Many light tripods actually vibrate when the shutter is released. Hand-held pictures, in which the camera action is cushioned by your body can provide sharper pictures than such a tripod.

If you need a tripod, get the traditional good sturdy one. Testing a tripod is quite easy. Load the camera with a fairly fast film and place it on the tripod. Photograph a pinpoint source of light such as a torch bulb shining through a tiny pinhole in a piece of metal foil. Use shutter speeds from 1/30 sec. downwards to the slowest speeds you have. If the tripod is steady each negative should show a light pinpoint. If you have a streak instead, the tripod's not good enough. Oddly enough, short focal length lenses often need a sturdier tripod than heavier, longer ones. The weight of the longer lenses often acts as an extra damping factor on shutter vibrations. In addition, long lenses add more weight to the tripod camera combination.

Storing Negatives

What do you do with your negatives after they have been developed? Is it necessary to have every one enlarged to see what they're about? How do you store these long rolls? These same questions have been asked about film ever since the advent of 35 mm. photography. Fortunately there are some practical answers to the questions.

It isn't necessary or even advisable to have every black-and-white picture you take enlarged. If you must watch expenses, you will only be able to afford the poorest quality photofinishing if you insist on a print from each negative. If you do your own work, so much printing will easily wear you out and turn the fun of photography into a dreadful drudge.

Once you have the negatives they should be cut up into strips of 5 or 6 frames and filed either in a single business envelope or better still in glassine sleeves that are available from photo dealers in nearly every country on earth. While many people once did keep their film in one long roll and

HANDLING NEGATIVES

Don't store negatives in long, curled-up strips within a film can. The emulsion may become scratched and the film itself curly and hard to handle. Instead, buy glassine negative folders from your photo store. Cut your long negative strips into smaller strips of 5 or 6 pictures and insert them into folders as shown. You can examine negatives through semi-transparant glassine material.

To check negatives for proper exposure, look through negative at white surface with backlight reflecting from surface as illustrated.

Have made (or make yourself) a same size identification contact sheet from each roll of negatives. You can use a low powered magnifier to check sharpness. With a grease pencil, mark any necessary cropping or printing instructions for yourself or a commercial processor.

stored in the metal can, the film grating against itself often scratched. A tiny grain of dust or dirt could cause some very unpleasant gouges.

To check your negatives' sharpness you will need a 10× magnifying glass. In an emergency you can use the normal Takumar lens as a magnifier. Just unscrew it from the camera. Place a sheet of white paper on a table. Shine a bright light on the white paper and view your negatives against this white paper. With such a technique you will be able to see whether your negatives are sharp and whether you have captured all the subject material that you wished. Unless you have had many years of experience, however, you will not be able to interpret the negatives and tell whether or not they are good photographs. You must make them into print positives first.

The simplest and least expensive way to make prints is to have a contact strip or sheet made from the negatives or make one yourself. Take an 8 × 10 piece of plate glass. Place an 8 × 10 sheet of contact printing paper on it, face up. Arrange the strips of negatives across the enlarging paper so that they do not overlap. Sandwich negatives and paper with another glass sheet. Expose a print by holding the strips to light as in ordinary contact printing. You can, of course, use the enlarger baseboard instead of the bottom sheet of plate glass and use the enlarger lamp as illuminant. Then it is relatively easy to standardise on the exposure required.

After development you will have a complete record of your entire roll of pictures. You can examine the individual picture frames with a magnifier and pick out the compositions and expressions which please you. Since the negative numbers of the film frames also print through, it will be easy to identify each frame. Mark the frame with a red grease pencil. Try cropping the frame with edges of white paper to enhance the picture composition. Outline the area to be enlarged with a red grease pencil. This will serve as a guide when you are doing the enlarging or giving the printer instructions to do it for you.

In filing your negatives, you can place each set of strips with the matching contact sheet, or keep the contact sheets in a separate file to avoid too much handling of the negatives. If you give a number to each set of negatives and the same

number to each contact sheet there will be less danger of losing track of either. Whenever you want additional prints, leaf through the contact sheet and select the necessary matching negative.

Storing Colour

If you shoot colour negative pictures, you can use the same black-and-white contact sheet technique for picking pictures and for filing instead of going to the expensive waste of having colour prints made of everything immediately.

The problem of storing colour transparencies is more complicated. If you have a projector—and it makes little sense shooting colour transparencies unless you do, or have one available to you—examine the slides by projection as soon as they are returned from the processor. Throw away the bad duplicates and failures immediately. Store the shots you intend to keep in whatever type of slide magazine your projector uses. If your projector does not have a magazine use the container in which the processor returned the slides to you, or buy a slide storage box.

Mark the transparency mounts so that you can easily project them correctly. To do this, hold the slide up to the light so that as you look through it, the picture is right-way-up and right way round. Then place a prominent dot or sticker on the bottom left-hand corner of the mount. As the slide goes into the projector, this dot should then be in the top right-hand corner facing you as you stand behind the projector.

THE PENTAX MOTOR DRIVE SYSTEM

While the standard models of the Pentax cameras are certainly sufficient to fill the needs of the average serious amateur and professional photographer, Pentax engineers have realized since the early 1960's that a fully motorized Pentax camera was an essential instrument for those photographers needing even more complete automation: sequence photography, time lapse studies, remote control work, or multiple exposure work exceeding the normal 36 exposures available in the standard 35 mm. cartridge. In addition many photographers seeking the utmost speed and flexibility in shooting frame after frame quickly, with the most convenience, wished a more advantageous advance system than the manual rapid wind lever.

For all these people and purposes plus many other scientific applications, Asahi has now introduced the Pentax Motor Drive System. The camera itself (described by Asahi as the Asahi Pentax Spotmatic Motor Drive) is in features and operation the same as the Pentax Spotmatic II and therefore all directions in this manual as to the Pentax Spotmatic II operation also apply to the motor drive camera. Previous to the introduction of the Spotmatic II Motor Drive System, the original Spotmatic camera with 50 mm. $f1.4$ Super Takumar lens was used. However all aspects of the motor drive and its operation are precisely the same with either camera.

The Motor Drive System is available in two different sets: The Set 36 comprises an Asahi (Honeywell) Spotmatic Motor Drive Camera with 50 mm. $f1.4$ SMC Takumar lens; a Motor Drive Unit, a Cordless Battery Grip, Battery Loader, Battery Checker and a soft leather case.

The Set 250 has, in addition to the items already named, a Bulk Film Magazine with two film cartridges, a Film Winder and an attaché carrying case.

A Charge Pack, Relay Pack, Power Pack and Timer are available as additional accessories.

MOTOR DRIVE SYSTEM FEATURES

Here are the major operating parts and accessories for the Pentax Motor Drive System

1. Back cover lock of bulk film magazine.
2. Film cartridge locking knob.
3. Set button.
4. Set lever.
5. Camera body retainer plate.
6. Film cartridge locking knob.
7. Bulk film magazine.
8. Motor drive unit.
9. Cordless battery grip.
10. Trigger button.
11. Back cover of film magazine.
12. Connector plug for film magazine exposure counter.

13. Bulb switch dial.
14. Battery grip attaching knob.
15. C/S (consecutive/single) switch dial.
16. Connector cord for film magazine exposure counter.
17. Film magazine exposure counter.
18. Connector plug for film magazine exposure counter.
19. Motor drive unit exposure counter.
20. Film rewind release button of motor drive unit.

Soft leather case

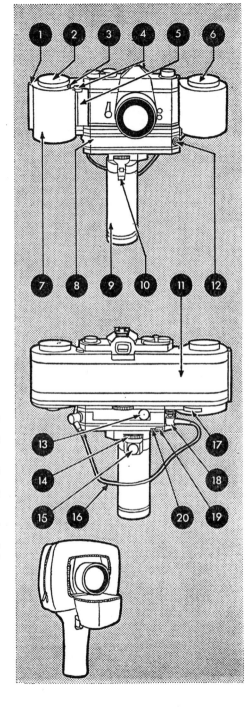

Setting Up

To attach the motor drive unit, simply unthread the slotted cover on the end of the camera's bottom plate by turning it clockwise, attach the unit to the bottom of the camera and lock the two together using the knurled knob of the motor drive unit. To make sure that the drive and camera are correctly locked together and that the film wind mechanism meshes properly with the motor, slowly cock the rapid wind lever of the camera and depress the shutter button.

To attach the battery grip, turn the C/S wheel on the grip to the green dot and thread the grip to the base of the motor drive unit using the knurled knob of the grip. Make sure that the electrical contacts of the grip fit properly into the holes of the motor drive unit. The grip can be loaded either with eight penlight size cells in a battery holder which will yield about 1500 exposures, or a rechargeable nickel cadmium battery—YUASA 10/500FZ (Japan), EVEREADY 10/BH500 (U.S.A.) or DEAC 10/500DKZ (Europe)—which offers about 2000 exposures per charge. We'll discuss NiCad batteries a little later (page 330).

Loading and Shooting

Load your camera as you would an ordinary Spotmatic II and make two blank exposures to bring the camera's frame counter to 1. Make sure that the rewind knob turns when you throw the rapid wind lever, indicating that the film is running through the camera properly. Now turn the disc in the base of the motor drive unit and set the drive's own exposure counter to the number of frames you wish to expose. The counter is of the subtracting type. When it reaches zero, the unit will switch off automatically.

Next, turn the switch on the battery grip to S for single shots or C for consecutive sequence photography. With the switch at S the camera exposes one frame when you press the grip's trigger button and winds automatically to the next frame when you release pressure. At C setting, the camera continues to fire frame after frame, up to 3 frames per second at 1/1000 sec., as long as you maintain pressure on the trigger button. After the last exposure, depress the film rewind release button of the motor drive unit and rewind the film with the folded rewind crank of the camera. You don't have to keep

HOW TO ASSEMBLE SET 36 MOTOR DRIVE UNIT

Remove threaded bottom cover by turning it clockwise using a thin coin edge in the cover slot.

Attach the top of the motor drive unit to the base of the camera by turning fastening knob to the right. Secure tightly.

Slowly cock camera's rapid wind lever and depress shutter release button to assure correct coupling of film winding mechanism.

With C/S switch at green dot, attach battery grip top to base of motor drive unit with protruding thread. Turn knob to right to secure.

HOW TO ASSEMBLE SET 250 MOTOR DRIVE UNIT

With camera back fully open, insert screwdriver (supplied) between back cover hinge and light seal. Push screwdriver toward's camera's base plate to disengage front shaft of hinge. Detach bottom portion in same manner. (Reverse procedure to reinstall back.)

Camera back may now be removed.

To attach bulk film magazine, depress set button near fully opened film cartridge knob. Push set lever and erect camera body retainer plate.

Align film takeup side of camera with film takeup side of magazine. Magazine's light seal edges must be properly set in camera body grooves.

Push film rewind side of camera body to other side of magazine. Magazine will lock to camera body with snap. Return locking knob to close position.

To use motor drive camera and film magazine without motor drive unit, attach coupler to base of camera body.

your finger on the rewind release button after you press it in once.

Use speeds 1/60 to 1/1000 sec. for consecutive sequence firing. For slower speeds, set the motor drive to S for single exposure. For either Bulb or Time exposures, set the control wheel on the back of the motor drive to B and the C/S switch on the grip to S. For time exposures, turn the C/S switch to "off" while pressing the trigger button. This keeps the shutter open. To close it, simply turn the C/S switch back again to S.

When the batteries are weak or near discharge, the exposure rate slows down slightly.

Cold Weather Operation

If you intend to operate the motor drive in cold weather, detach the battery grip when not in actual use and keep it warm in your pocket. It might be advisable in continuous cold weather to keep the battery grip in a warm place and connect it to the motor drive with various lengths of connecting cords which are available. In this manner the camera can be operated by remote control up to about 33 ft. distance. However, because of the increased resistance in the connecting cord, a separate relay pack or power pack is needed for greater distances.

When using the Pentax motor drive unit in cold weather be careful of sudden temperature changes. Wipe all parts to avoid condensation and wipe the nickel cadmium battery if one is used, before insertion in the battery grip.

Battery Checking and Charging

To check the amount of charge remaining in the nickel cadmium battery, insert the plug of the battery checker into the side socket of the battery grip with the grip's C/S dial set to C. The battery can still be operated if the checker's dial reads between 10 and 12. If below that, replace the battery or recharge. Don't use the battery checker for longer periods than 10 seconds or it will overheat.

To recharge the NiCad battery, set the C/S dial of the battery grip to the green dot, screw the fastening knob of the battery grip into the threaded hole of the charge pack, check to see that the contact of the battery grip makes contact with that of the charge pack and plug the charge pack cord into an AC outlet. Charging time is 14 hours but the unit can be

FEATURES AND ACCESSORIES

For exposures other than B or T, set bulb switch at CS (1) and C/S switch (3) at S. For B (bulb) exposure, set bulb switch at B (2) and C/S switch (3) at S. For T (time) exposure, set bulb switch at B (2) and C/S switch (3) at S.

Battery loader accepts 8 penlight cells readily available in many countries. Approximately 1500 exposures can be made on one set.

To check battery, plug checker (1) into side socket of battery grip. Set C/S dial (3) to C (which also means "check"). Good battery should read 10-12 in black area. When recharging nicad battery, set C/S switch (3) to green dot.

To set film magazine exposure counter, make 5 blank exposures manually, cock rapid wind lever for 6th shot, pull release knob downwards, turn exposure counter knob clockwise until index points to number of exposures you wish to make.

Film roller in magazine near takeup cartridge automatically switches off motor drive unit after film has run over roller.

To remove film cartridge turn locking knobs to open position, pull out edge lock with fingernail and pull back cover away using nipple.

Keep a good grip on back cover which is now completely separated.

Pull out release knobs and remove film cartridges from film chambers.

To insert film cartridges, drop them into the film chambers with the protruding outer lip down.

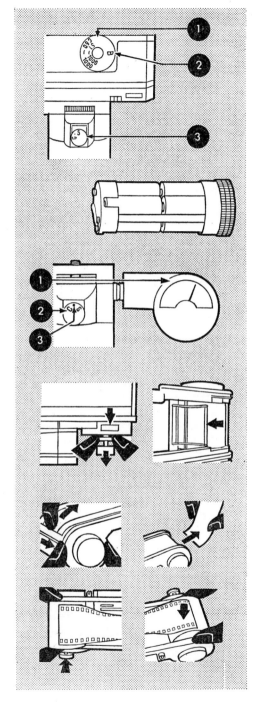

left charging up to 24 hours without harm. The average NiCad battery will last for a minimum of 100 recharging cycles. For best results, recharge the battery at temperatures above freezing but below 40°C. (104°F.).

Attaching the Bulk Film Magazine

All operating instructions for the Set 36 apply also to the Set 250. However, to use the 250 bulk film back you must first remove the camera's hinged back. Open the camera and swing out the back. Insert the small screwdriver supplied between the back cover hinge and the light seal from the inside of the back. Push the screwdriver towards the camera's base plate to unfasten the front shaft of the hinge. Now detach the top portion of the back. Detach the bottom portion by sliding in towards the camera's base plate. (When you want to replace the camera's regular back, just reverse these directions.)

To attach the bulk film magazine, turn the magazine's cartridge locking knob completely to the "open" position. Depress the set button and at the same time push the set lever with the white plastic roller to erect the camera's body retainer plate. Attach the camera body to the magazine by pressing the body and magazine together making sure that the camera's film takeup chamber matches the film takeup chamber of the magazine. Check that all light seal edges of the magazine are properly set in the grooves of the camera body. Be careful during the entire procedure not to touch the thin film guide plate located over the film roller.

To lock camera and magazine, press the film rewind side of the camera body to the other side of the magazine. The camera and magazine will lock with a snap. Now return the locking knob to the "close" position to lock magazine and body completely.

To remove the magazine, open the film cartridge locking knobs, push the set lever while depressing the set button to erect the camera's body retainer plate and lift the film rewind knob of the camera body. Disengage the film rewind side of the camera body from the magazine.

Using the Magazine Without Motor Drive

You can use the bulk film magazine and Spotmatic motor drive camera without the motor drive if you wish by attaching

the special coupler to the base of the camera body. Insert the threaded portion of the coupler into the receptacle on the base of the camera itself making sure that the coupler's gears mesh properly with the gear of the magazine. Fasten the coupler by turning its knurled knob counter clockwise. Now cock the camera using the rapid wind lever.

Attaching Motor Drive and Battery Grip

Attach the motor drive unit to the camera body and the battery grip to the motor drive unit as with Set 36. To activate the exposure counter of the bulk magazine, however, you must connect the outlet on the left rear of the motor drive unit with that on the bottom of the takeup side of the magazine using the exposure counter cord.

Loading Bulk Film Cartridge

To open the magazine and remove the bulk film cartridge for loading, first turn the locking knobs of the magazine to the "open" position. With your fingernail, pull out the magazine lock back. Pull away the back cover using the nipple, being careful not to drop the magazine back cover which is now completely detached. You can now remove the film cartridges from the film chambers by pulling out the release knobs.

The cartridges can be disassembled by pressing the round release button and turning the inner tube until the cut edge comes under the protrusion. You will now have three parts: film takeup spool, inner tube and outer tube.

Although you may wish to load the bulk film cartridge in another way, you'll find the furnished film winder most convenient. With it you can use a standard 100 ft. bulk film spool and at one time load up to 33 ft. for 250 exposures.

To operate the loader, first pull out the winder handle and turn it so you can set the exposure counter dial to the number of frames you wish to load into the cartridge. The loader will automatically stop winding after this set amount has been loaded. The counter is conveniently marked in luminous paint for ease of operation in the dark.

In the dark, remove the bulk film from its can and place the bulk film spool on the rear wheel of the loader. To detach one of the rims of the reel, turn it counter-clockwise while holding the other rim. Place this reel on the shaft of the

P.W.,—U

winder and place the takeup spool of the cartridge on the other shaft. Erect the film holder and let it fall to the other side. Now pull the film over the sprocket gears and insert the leader end into the slit of the takeup spool. Cut the leader end to allow easy insertion into the slit.

Don't attach the film leader end to the takeup spool with tape because the film is not rewound after all exposures have been made. It is completely taken up on to the takeup spool of the bulk film back.

Push the film holder down so that the film perforations engage with the sprocket gears. A magnetic button keeps the film holder down in its working position.

Using the winding handle, wind the film until it stops automatically. After cutting the film, put the remainder of the bulk film back into its can. Remove the loaded takeup spool and reassemble the cartridge.

Insert the takeup spool into the inner tube and place in the outer tube. Turn the inner tube in either direction until it locks with the outer tube.

Loading Cartridges into Magazine

To load the bulk film magazine with the empty cartridges, drop the cartridges into the film chambers with the outer protrusion of the cartridges downwards. Turn the cartridges so that the two end protrusions drop properly into place. Push back the release knobs and reinstall the magazine back by reversing the procedure for removal. Turn the locking knobs to the "close" position.

To insert a loaded cartridge, place it in the film chamber and push back the release knob. Pull out about 10 inches of the film leader and insert the end into the slit of the other cartridge's takeup spool. Roll the film around the takeup spool about three times, emulsion side in, and check to make sure the film end is now secure on the takeup spool. Assemble the cartridge and insert it into the other chamber making sure that the sprocket gears of the camera body properly engage with the film perforations. Push back the release knob and place the magazine back on the camera as already explained.

Setting Exposure Counter

To set the film magazine exposure counter, make five blank exposures manually using the camera's rapid wind lever to

advance film. Wind the lever again for the sixth exposure. Pull out the release knob and turn the exposure counter knob clockwise until the index points to the number of frames you wish to shoot. If there are fewer than 36 exposures remaining, you can set the counter to o.

Checking Film Transport

The film is moving correctly if both release knobs of the film magazine turn clockwise when you wind film manually, using the rapid wind lever, or if you use the motor drive unit. If both knobs are not moving the film leader is probably not secure on the takeup spool and you should rethread it.

Partial Unloading

You can remove just those frames you have already shot whenever you wish by first making five or more blank exposures to protect those frames already exposed. You can then open the magazine, cut the film and remove the cartridge with the exposed film. In rethreading the remaining film, you must reshape the leader edge and reload as if you were again placing fresh film in the magazine.

Automatic Switch-off

There is an automatic switch off mechanism near the takeup cartridge within the magazine which will turn off the motor drive unit when all film has passed through or when the counter is at o. Therefore the motor drive unit cannot be operated with the bulk film magazine unless there is film passing through the magazine.

Relay Pack Connections

The accessory relay pack allows the Pentax motor drive unit to be operated at distances greater than 33 ft. (the limit for simple cord connection), to be powered by a 12 volt DC source such as a car battery, and to trip the shutter release in a number of ways for trick photography, surveillance work or nature photography.

When using the loaded battery grip with the relay pack, connect the "Batt" socket with the remote control socket of the battery grip using an extension cord. Now connect the "Motor" socket with the remote control socket of the motor drive unit. To activate the camera and motor drive unit, you

can either press the trigger button of the relay pack or use the battery grip button.

By attaching extension cords to the two remote control terminals of the relay pack and touching them together, the camera can also be made to fire and advance film. By using these two extension cords as the connection for various tripping devices, the relay pack can be used to set off the camera in all sorts of novel ways—when an animal enters a trap, when a door or window opens, etc.

On the back of the relay pack is a C/S switch. Operate it and the trigger button in the same way you operate these controls on the battery grip.

Power Pack Operation

The accessory power pack performs all the functions of the relay pack and will in addition run the motor drive from a 50-60 cycle AC line of 110, 120, 200, 220 or 240 volts and act as a battery charger. When ordering the unit specify the voltage of the AC line on which it will be operated.

When using the power pack's DC input terminals to connect it to a 12 volt DC source, be sure that the AC input and "Batt" sockets are plugged off. When attaching the loaded battery grip to the power pack, keep the power pack switch "off". When using the power pack with other 12 volt DC sources, you can keep its switch either "on" or "off". The pilot lamp won't light in either case.

To use the power pack as a relay pack, follow all directions given previously for the relay pack. To use it as an AC pack, connect the AC input socket to an AC outlet. Connect the "Motor" socket with the remote control socket of the motor drive unit. When the power pack switch is turned on, the pilot lamp will light indicating that the power pack is in operation. Now operate as you would the relay pack.

To use the power pack to recharge your NiCad battery in the battery grip, connect the NiCad battery-loaded grip with the "Batt" socket of the power pack. Connect the AC input socket with an AC line outlet and turn on the switch. The pilot light will go on and charging will begin. Charge for the same time as indicated with the regular battery charger already described. However you can still run your motor drive unit from the power pack while charging the battery.

While operating the power pack, if the pilot lamp does not

go on, the fuse may have burned out. You can check the conditions of the fuse easily by removing the fuse cover.

Remote Control Operation

Either the relay pack or the power pack must be used if you wish to control the motor drive unit at a distance of more than 33 ft. First connect the motor drive unit with the relay or power pack using the extension cord. Then connect the pack being used with the battery grip, the 12 volt DC power source or the AC outlet using the power pack. Connect the remote control terminals of the relay pack with the extension cord. By using a small switch at the end of the extension giving intervals between 5 and 60 seconds, 2 and 60 minutes cord or shortcircuiting the cord by bringing its two wires together, you can cause the motor drive unit to operate.

The length of the extension cord from the motor drive unit to the relay or power pack must not exceed about 33 ft., but the extension from either pack to the switch can be up to 20,000 ft. depending on the amount of resistance within the cord. The maximum permissible resistance of the extension from pack to switch is 365 ohms.

A radio control unit is planned for remote control of the motor drive system. Its receiver will connect with the radio control terminals of the power pack. The transmitter will send signals from about 1500 ft. (outdoors on flat ground) to operate the motor drive unit, change the C/S switch of the power pack and check whether the camera shutter is operating correctly.

Timers for Time-lapse Sequences

Three different AC powered timers are available to activate the motor drive unit through the relay or power pack at any preset time interval. There are second, minute and hour timers and 1 and 24 hours respectively. When ordering, specify the intervals required and the working AC voltage. All timers can be used either for 50 or 60 cycle operation. Each timer has an AC outlet at the rear to connect flood or other light sources for photographic illumination up to a maximum of 600W.

By turning the rotary switch at the bottom left of the timer to Position 1, only the rear AC outlet is switched on. At Position 2 the timer is also switched on. After you have set

the needle of the timer dial, the remote control terminals at the back of the unit automatically activate the motor drive unit when the dial reaches zero after each elapse of the set time.

At Position 3, the timer is switched on and the AC outlet cuts in two seconds before shutter release so that your subject is lit automatically. The lights are switched off again after each exposure.

At the bottom right of each timer is a reset button which allows you to reset the timer to the preset time before the timer reaches the zero mark.

There are two pilot lamps on the front of the timer. The left hand lamp lights when the AC outlet is switched on. The right hand lamp is illuminated when the timer is switched on.

FACTS AND FIGURES

Film	Speed ASA	DIN	Grain	Colour Sensitivity
Fast and Ultra-Fast Films				
Adox KB27	1300	33	m	Pan
Agfapan 1000	1000	31	m	Red pan
Agfa Isopan Ultra ...	400	27	m	Pan
Ansco Super Hypan ...	500	28	m	Pan
Fuji Neopan FSS	200	24	m	Pan
Ilford H.P.4	400	27	mf	Red pan
Kodak Tri X	400	27	m	Pan
Perutz 27	400	27	m	Red pan
Medium Speed Films				
Adox KB21	100	21	m	Pan
Agfa Isopan ISS	100	21	m	Red pan
Ilford F.P.4	125	22	f	Pan
Kodak Plus X	125	22	mf	Pan
Perutz 21	100	21	mf	Pan
Fine Grain Films				
Adox KB17	40	17	f	Pan
Agfa Isopan IF	40	17	f	Pan
Ferrania P.30	80	20	f	Pan
Perutz 17	40	17	f	Red pan
Extra Fine Grain Films				
Adox KB14	20	14	ef	Pan
Agfapan 25	25	15	ef	Pan
Fuji Neopan F	32	16	ef	Pan
Ilford Pan F	50	18	ef	Pan
Kodak Panatomic X ...	40	17	ef	Pan
Reversal Films				
Adox UBK 17	40	17	f	Pan
Gevaert Dia Direct ...	32	16	f	Pan
Kodak Direct Pos. Pan ...	80	20	mf	Pan
Infra-red Film				
Eastman Infra-red ...	†40	17	—	Infra-red
Negative Colour Films				
Agfacolor CN17	40	17	—	Universal
Agfacolor CNS	80	20	—	Universal
Ferraniacolor N27 ...	40	17	—	Universal
Fujicolor N100	100	21	—	Universal
Kodacolor X	80	20	—	Universal
Sakuracolor R100 ...	100	21	—	Universal
Reversal Colour Films				
Agfacolor CT18	50	18	—	Daylight
Agfachrome	50	18	—	Daylight
Agfacolor CK 20	80	20	—	Tungsten
GAF 64 Daylight ...	64	19	—	Daylight
GAF 100 Tungsten ...	100	21	—	Photoflood
GAF 200	200	24	—	Daylight
GAF 500	500	28	—	Daylight
Ektachrome X ...	64	19	—	Daylight
Ferraniacolor CR50 ...	50	18	—	Daylight
H.S. Ektachrome ...	160	23	—	Daylight
H.S. Ektachrome B ...	125	22	—	Tungsten
Kodachrome II Daylight	25	15	—	Daylight
Kodachrome II A ...	40	17	—	Photoflood
Kodachrome X	64	19	—	Daylight
Perutz Color C18 ...	50	18	—	Daylight

The main 35 mm. films for the Pentax are listed according to types in black-and-white and colour. The speed is the daylight speed in the case of black-and-white films or with colour films the speed to the light for which the film is balanced.

The degrees of graininess are medium (m), medium fine (mf), fine (f) and extra fine (ef).

†With deep red filter.

ASA	Din	Relative Exposure Needed
800	30	1
640	29	1.3
500	28	1.6
400	27	2
320	26	2.5
250	25	3.2
200	24	4
160	23	5
125	22	6.3
100	21	8
80	20	10
64	19	13
50	18	16
40	17	20
32	16	25
25	15	32
20	14	40
16	13	50
12	12	63
10	11	80
8	10	100
6	9	125
5	8	160
4	7	200
3	6	250
2.5	5	320
2	4	400

Exact ASA-DIN conversion is not possible but these figures are accurate for all practical purposes and are those used by most film manufacturers.

Feet/inches to metric units		Metric units to feet/inches	
$\frac{1}{8}$ in.	0.32 cm.	0.5 cm.	$\frac{3}{16}$ in.
$\frac{1}{4}$ in.	0.64 cm.	1 cm.	$\frac{3}{8}$ in.
$\frac{1}{2}$ in.	1.27 cm.	2 cm.	$\frac{13}{16}$ in.
1 in.	2.54 cm.	3 cm.	$1\frac{3}{16}$ in.
2 in.	5.08 cm.	4 cm.	$1\frac{9}{16}$ in.
3 in.	7.62 cm.	5 cm.	$1\frac{15}{16}$ in.
4 in.	10.2 cm.	6 cm.	$2\frac{3}{8}$ in.
5 in.	12.7 cm.	7 cm.	$2\frac{3}{4}$ in.
6 in.	15.2 cm.	8 cm.	$3\frac{1}{8}$ in.
7 in.	17.8 cm.	9 cm.	$3\frac{1}{2}$ in.
8 in.	20.3 cm.	10 cm.	$3\frac{15}{16}$ in.
9 in.	22.9 cm.	12 cm.	$4\frac{3}{4}$ in.
10 in.	25.4 cm.	15 cm.	$5\frac{7}{8}$ in.
11 in.	27.9 cm.	20 cm.	$7\frac{7}{8}$ in.
1 ft.	30.5 cm.	25 cm.	$9\frac{13}{16}$ in.
2 ft.	61.0 cm.	30 cm.	$11\frac{3}{4}$ in.
3 ft.	91.4 cm.	40 cm.	$15\frac{3}{4}$ in.
4 ft.	1.22 m.	50 cm.	$19\frac{3}{4}$ in.
5 ft.	1.52 m.	60 cm.	$23\frac{5}{8}$ in.
6 ft.	1.83 m.	80 cm.	$31\frac{1}{4}$ in.
7 ft.	2.13 m.	100 cm.	$39\frac{1}{2}$ in.
8 ft.	2.44 m.	1.5 m.	4 ft. 11 in.
9 ft.	2.74 m.	2 m.	6 ft. 7 in.
10 ft.	3.05 m.	2.5 m.	8 ft. 3 in.
15 ft.	4.57 m.	3 m.	9 ft. 10 in.
20 ft.	6.10 m.	4 m.	13 ft. 2 in.
30 ft.	9.14 m.	5 m.	16 ft. 5 in.
40 ft.	12.20 m.	10 m.	33 ft. 0 in.
50 ft.	15.24 m.	15 m.	49 ft. 2 in.
100 ft.	30.48 m.	20 m.	66 ft. 0 in.

One metre is actually a little over 3 ft. $3\frac{1}{4}$ in. This table is calculated on 3 ft. $3\frac{1}{2}$ in. and the error is of little consequence in practical photography.

These tables, like all depth of field tables, are intended for guidance. They are mathematically computed and therefore assume various ideal conditions as regards focal length of lens, degree of enlargement of the final print, viewing distance and so on. These ideals are seldom met in practice. For each focused distance and aperture in use, the nearest and farthest planes of acceptably sharp focus are quoted in feet and inches. Thus, with the Super-Takumar 28 mm. set to 2 ft. 6 in. and at aperture *f* 16, depth of field theoretically stretches from 1 ft. 9.1 in. to 4 ft. 6.5 in.

Focused Distance (Feet)	Depth of Field (Feet and Inches) for Macro-Takumar 50 mm. at Aperture					
	f 4	*f* 5.6	*f* 8	*f* 11	*f* 16	22
	0–11.9 1–0.1	0–11.9 1–0.1	0–11.8 1–0.2	0–11.8 1–0.2	0–11.6 1–0.4	0–11.5 1–0.5
1.2	1–2.3 1–2.5	1–2.2 1–2.6	1–2 1–2.8	1–2 1–2.9	1–1.8 1–3.1	1–1.6 1–3.4
1.5	1–5.8 1–6.2	1–5.6 1–6.4	1–5.4 1–6.6	1–5.3 1–6.8	1–4.9 1–7.2	1–4.6 1–7.7
2	1–11.4 2–0.6	1–11.3 2–0.8	1–10.9 2–1.2	1–10.6 2–1.7	1–10 2–2.5	1–9.2 2–3.7
3.5	3–4.1 3–8.2	3–3.4 3–9	3–2.4 3–10.4	3–1.2 4–0.5	2–11.3 4–4.1	2–9.4 4–9.4
7	6–4.1 7–9.8	6–1.3 8–2.4	5–9.6 8–10	5–5.4 9–10	4–11.5 12–1	4–5.8 16–8
∞	62–6 ∞	44–8 ∞	31–4 ∞	22–10 ∞	15–9 ∞	11–6 ∞

Forward Distance (Feet)	Depth of Field (Feet and Inches) for Super-Takumar 28 mm. at Aperture						
	f 3.5	*f* 4	*f* 5.6	*f* 8	*f* 11	*f* 16	*f* 22
1.3	1–3 1–4.2	1–2.9 1–4.3	1–2.6 1–4.7	1–2.3 1–5.2	1–1.9 1–5.9	1–1.2 1–7.2	1–0.1 1–9.2
1.4	1–4.1 1–5.6	1–4 1–5.8	1–3.7 1–6.1	1–3.2 1–6	1–2.8 1–7.7	1–2 1–9.4	1–1.2 1–11.8
1.5	1–5.2 1–7	1–5 1–7.1	1–4.7 1–7.6	1–4.2 1–8.3	1–3.6 1–9.4	1–2.8 1–11	1–1.9 2–2.6
1.75	1–7.8 1–10	1–7.7 1–11	1–7.2 1–11	1–6.5 2–5	1–5.6 2–2	1–4.6 2–5.4	1–3.4 2–10.9
2	1–10 2–1.9	1–10 2–2	1–9.6 2–3.1	1–8 2–4	1–7.7 2–7.2	1–6.2 3–0.5	1–4.7 3–9.7
2.5	2–3.4 2–9.1	2–3.1 2–9.7	2–2 2–11	2–0.1 3–2.5	1–11 3–7.2	1–9.1 4–6.5	1–7.1 6–8.4
3	2–8.3 3–4.8	2–7.8 3–5.6	2–6.4 3–8.5	2–4.4 4–1.6	2–2.4 4–10	1–11.6 6–9.6	1–9.2 13–6.5
4	3–5.3 4–9.5	3–4.4 4–11	3–2.2 5–5.4	2–11 6–5.6	2–7.9 8–5.6	2–3.8 17–10	2–0 ∞
5	4–1.7 6–4.1	4–4.8 6–7.2	3–9 7–7.7	3–4.8 9–9	3–0 15–5	2–7.2 ∞	2–2.5 ∞
6.5	5–1.1 9–4.8	4–11 9–7	4–6.1 11–10	4 18–6	3–6 64–1	2–10.9 ∞	2–5.2 ∞
10	6–11 17–11	6–8 20–3	5–11 34–10	5–0 ∞	4–3.1 ∞	3–4.8 ∞	2–9 ∞
20	10–6 216	9–11 ∞	8–3 ∞	6–7 ∞	5–3 ∞	4–0 ∞	3–1 ∞
∞	21–10 ∞	19–1 ∞	13–8 ∞	9–7 ∞	7–0 ∞	4–10 ∞	3–6 ∞

DEPTH OF FIELD

Focused Distance (Feet)	Depth of Field (Feet and Inches) for Super Takumar 35 mm. f 3.5 at Aperture						
	f 3.5	f 4	f 5.6	f 8	f 11	f 16	f 22
1.5	1–5.4 1–6.6	1–5.3 1–6.7	1–5 1–7.1	1–4.7 1–7.6	1–4.3 1–8.2	1–3.6 1–9.4	1–2.9 1–11
1.75	1–7.7 1–9.2	1–7.6 1–9.4	1–7.2 1–9.8	1–6.7 1–10.4	1–6.1 1–11.4	1–5.3 2–1.1	1–4.4 2–3.5
2	1–10.9 2–1.2	1–10.7 2–1.4	1–10.3 2–2	1–9.6 2–3	1–8.9 2–4.4	1–7.7 2–7.1	1–6.5 2–11
2.5	2–4.2 2–8	2–4 2–8.4	2–3.2 2–9.5	2–2.2 2–11.2	2–1.1 3–1.7	1–11.3 3–6.8	1–9.5 4–3.1
3	2–9.4 3–3.1	2–9 3–3.6	2–7.9 3–5.2	2–6.5 3–8	2–4.9 4–0.1	2–2.5 4–9.1	2–0.2 6–1.8
4	3–7.3 4–6	3–6.7 4–7	3–4.9 4–10.3	3–2.4 5–4.3	2–11.8 6–1.8	2–8.2 8–2.4	2–4.7 13–9
5	4–4.7 5–9.8	4–3.7 5–11.5	4–1.1 6–5.5	3–9.5 7–4.8	3–5.8 9–0	3–0.8 14–5	2–8.3 53–7
7	5–10 8–9	5–8.4 9–1	5–3.6 10–4	4–9.7 13–1	4–3.7 19–6	3–8.2 115–2	3–1.6 ∞
10	7–8.9 14–2	7–6 15–0	6–9.8 18–11	6–0.1 30–10	5–2.9 150–4	4–3.8 ∞	3–7 ∞
15	10–4.7 27–1	9–11.5 30–8	8–9.4 53	7–5.6 ∞	6–3.6 ∞	5 ∞	4–0.4 ∞
30	15–9 324	14–9 ∞	12–3 ∞	9–10.2 ∞	7–10.7 ∞	5–11.3 ∞	4–7.2 ∞
∞	32–11 ∞	28–9 ∞	20–7 ∞	14–5 ∞	10–6 ∞	7–3 ∞	5–4 ∞

Focused Distance (Feet)	Depth of Field (Feet and Inches) for Super-Takumar 35 mm. f 2 at Aperture							
	2	f 2.8	f 4	f 5.6	f 8	11	f 16	f 22
1.5	1–5.6 1–6.4	1–5.5 1–6.5	1–5.4 1–6.7	1–5.2 1–7	1–4.8 1–7.4	1–4.4 1–7.9	1–3.8 1–9	1–3.1 1–10.4
1.75	1–8 1–8.9	1–7.8 1–9	1–7.6 1–9.2	1–7.3 1–9.7	1–6.8 1–10.3	1–6.4 1–11.4	1–5.5 2–0.6	1–4.7 2–2.8
	1–11.4 2–0.1	1–11.2 2–0.9	1–10.8 2–1.3	1–10.4 2–1.9	1–9.7 2–2.9	1–9 2–4.1	1–7.9 2–6.5	1–7.1 2–10.1
2.5	2–5 2–7.1	2–4.7 2–7.6	2–4.1 2–8.3	2–3.4 2–9.2	2–2.4 2–10.9	2–1.3 3–1.2	1–11.6 3–5.8	1–10 4–1.3
3	2–10.6 3–1.6	2–10 3–2.3	2–9.1 3–3.4	2–8.2 3–4.9	2–6.7 3–7.6	2–5.2 3–11.4	2–3 4–7.6	2–0.7 5–10.2
4	3–9.2 4–3.1	3–8.3 4–4.4	3–6.8 4–6.6	3–5.2 4–9.7	3–2.8 5–3.4	3–0.2 6–0.1	2–8.6 7–10.1	2–5.3 12–6
5	4–7.7 5–5	4–6.2 5–7.2	4–4.1 5–10.9	4–1.4 6–4.6	3–10.1 7–3	3–6.4 8–9.1	3–1.4 13–5	2–9 39–2
7	6–3.6 7–10.4	6–0.7 8–3.5	5–8.9 9	5–4.2 10–2.2	4–10.4 12–8.2	4–4.6 18–4	3–9 75	3–2.5 ∞
10	8–7.3 11–11	8–1.9 12–11	7–6.8 14–9	6–10.8 18–4	6–1.2 28–10	5–4.1 103	4–5 ∞	3–8.2 ∞
15	12 19–11	11–2 22–11	10 49	8–10.9 49	7–7.2 ∞	6–5.2 ∞	5–1.6 ∞	4–1.7 ∞
20	15 29–11	13–8 37–4	12 59	10–5 306	8–7.9 ∞	7–2 ∞	5–7 ∞	4–5 ∞
∞	60–4.1 ∞	42–3.7 ∞	29–7.8 ∞	21–2.5 ∞	14–10.6 ∞	10–10.3 ∞	7–6 ∞	5–5.9 ∞

Depth of Field (Feet and Inches) for Super-Takumar 50 mm. at Aperture

Focused Distance (Feet)	f1.4	f2	f2.8	f4	f5.6	f8	f11	f16	f22
1.5	1–6.1 1–6.1	1–5.9 1–6.1	1–5.8 1–6.2	1–5.6 1–6.4	1–5.5 1–6.5	1–5.4 1–6.6	1–5.2 1–7	1–4.8 1–7.3	1–4.4 1–7.9
1.75	1–8.9 1–9.1	1–8.8 1–9.2	1–8.6 1–9.4	1–8.5 1–9.5	1–8.4 1–9.7	1–8.2 1–10	1–7.8 1–10.3	1–7.3 1–11	1–6.7 1–11.9
2	1–11.8 2–0.2	1–11.6 2–0.4	1–11.5 2–0.5	1–11.4 2–0.6	1–11.2 2–1	1–10.8 2–1.3	1–10.4 2–1.9	1–9.7 2–2.9	1–9 2–4.1
2.3	2–2.8 2–3.2	2–2.6 2–3.4	2–2.4 2–3.6	2–2.2 2–3.8	2–1.9 2–4.2	2–1.4 2–4.8	2–1 2–5.5	2–0.1 2–6.7	1–11.2 2–8.5
2.5	2–5.6 2–6.4	2–5.5 2–6.5	2–5.3 2–6.7	2–5 2–7.1	2–4.7 2–7.6	2–4.1 2–8.3	2–3.4 2–9.1	2–2.4 2–10.8	2–1.3 3–1.2
3	2–11.5 3–0.6	2–11.3 3–0.8	2–10.9 3–1.1	2–10.6 3–1.7	2–10 3–2.3	2–9.1 3–3.4	2–8.2 3–4.8	2–6.7 3–7.6	2–5.2 3–11.3
3.5	3–5.3 3–6.7	3–4.9 3–7.1	3–4.6 3–7.6	3–4 3–8.3	3–3.2 3–9.2	3–1.3 3–10.8	3–0.8 4–1	2–10.9 4–5	2–8.9 4–10.9
4	3–11 4–1.1	3–10.6 4–1.4	3–10.1 4–2.2	3–9.2 4–3.1	3–8.3 4–4.4	3–6.8 4–6.6	3–5.3 4–9.5	3–2.8 5–3.2	3–0.2 6
5	4–10.4 5–1.7	4–9.8 5–2.4	4–9 5–3.4	4–7.7 5–5	4–6.2 5–7.2	4–4.1 5–10.9	4–1.6 6–4.2	3–10 7–3	3–6.4 8–8.9
7	6–8.9 7–3.4	6–7.6 7–4.9	6–6 7–7.1	6–3.6 7–10.4	6–0.7 8–3.5	5–8.9 9	5–4.6 10–1	4–10.4 12–7.7	4–4.4 18–2
10	9–5.6 10–7.2	9–3.1 10–10.6	8–11.9 11–3.2	8–7.4 11–11.2	8–1.9 12–11.2	7–6.8 14–9	6–11.3 18	6–1.2 28–7	5–4 97
15	13–9 16–4	13–4 17–1	12–9 18–1	12 19–11	11–2 22–10	10–1 29–7	8–11.8 46	7–7.2 ∞	6–5.2 ∞
30	25–6 36–4	24 39–11	22–3 46	20 59	17–8 100	15 ∞	12–8 ∞	10–1 ∞	8–1.1 ∞
∞	169 ∞	118 ∞	84 ∞	59 ∞	42–6 ∞	29–10 ∞	21–9 ∞	15 ∞	10–11 ∞

Depth of Field (Feet and Inches) for Super Takumar 55 mm. at Aperture

Focused Distance (Feet)	f1.8	f2	f2.8	f4	f5.6	f8	f11	f16	f22
1.5	1–5.9 1–6.1	1–5.9 1–6.1	1–5.9 1–6.1	1–5.8 1–6.2	1–5.6 1–6.4	1–5.5 1–6.5	1–5.4 1–6.7	1–5.2 1–7	1–4.8 1–7.4
1.75	1–8.9 1–9.1	1–8.9 1–9.1	1–8.8 1–9.2	1–8.6 1–9.4	1–8.5 1–9.5	1–8.4 1–9.7	1–8.2 1–10	1–7.7 1–10.4	1–7.3 1–11
2	1–11.8 2–0.2	1–11.8 2–0.2	1–11.6 2–0.4	1–11.5 2–0.5	1–11 2	1–11 2–1	1–10.8 2–1.3	1–10.3 2–2	1–9.7 2–2.9
2.3	2–2.8 2–3.2	2–2.6 2–3.4	2–2.5 2–3.5	2–2.4 2–3.6	2–2.2 2–3.8	2–1.8 2–4.3	2–1.4 2–4.8	2–0.7 2–5.8	2 2–7
2.5	2–5.6 2–6.4	2–5.6 2–6.4	2–5.4 2–6.6	2–5.3 2–6.8	2–4.9 2–7.2	2–4.6 2–7.7	2–4 2–8.4	2–3.1 2–9.6	2–2.3 2–11.2
3	2–11.5 3–0.6	2–11.4 3–0.6	2–11.2 3–0.8	2–10.8 3–1.2	2–10.4 3–1.8	2–9.8 3–2.5	2–9 3–3.6	2–7.8 3–5.5	2–6.5 3–8
3.5	3–5.3 3–6.7	3–5.2 3–6.8	3–4.9 3–7.2	3–4.4 3–7.7	3–3.8 3–8.5	3–2.9 3–9.6	3–1.9 3–11.2	3–0.4 4–1.9	2–10.6 4–5.9
4	3–11 4–1	3–10.9 4–1.1	3–10.6 4–1.6	3–9.8 4–2.3	3–9.1 4–3.4	3–7.9 4–4.9	3–6.6 4–7	3–4.6 4–10.9	3–2.4 5–4.6
5	4–10.4 5–1.7	4–10.3 5–1.8	4–9.6 5–2.6	4–8.6 5–3.8	4–7.4 5–5.4	4–5.6 5–8.2	4–3.6 5–11.8	4–0.6 6–6.8	3–9.4 7–5.5
7	6–8.9 7–3.4	6–8.5 7–3.7	6–7.2 7–5.4	6–5.4 7–7.9	6–3 7–11.5	5–11.8 8–5.5	5–8 9–2.2	5–2.6 10–8	4–9.2 13–4
10	9–5.6 10–7	9–4.9 10	9–2.3 10–11	8–10.7 11–5	8–6.1 12–1	8 13–4	7–5.4 15–3	6–8.2 20–3	5–11.3 33–1
15	13–9 16–5	13–8 16–7	13–2 17–4	12–7 18–6	11–10 20–6	10–10 24–4	9–10 31–10	8–6.2 66	7–4.2 ∞
30	25–6 36–4	25–1 37–3	23–7 41	21–7 49	19–5 66	16–10 138	14–6 ∞	11–9 ∞	9–7.4 ∞
∞	168 ∞	151 ∞	108 ∞	75 ∞	54 ∞	38 ∞	27–8 ∞	19–1 ∞	13–11 ∞

Depth of Field (Feet and Inches) for Super Takumar 85 mm. at Aperture

Focused Distance (Feet)	f 1.9	f 2	f 2.8	f 4	f 5.6	f 8	f 11	f 16	f 22
2.75	2–8.9 / 2–9.2	2–8.8 / 2–9.2	2–8.8 / 2–9.4	2–8.6 / 2–9.4	2–8.5 / 2–9.6	2–8.3 / 2–9.7	2–8 / 2–10.1	2–7.6 / 2–10.6	2–7.1 / 2–11.3
3	2–11.8 / 3–0.2	2–11.8 / 3–0.2	2–11.6 / 3–0.4	2–11.5 / 3–0.5	2–11.4 / 3–0.7	2–11 / 3–1	2–10.8 / 3–1.3	2–10.2 / 3–2	2–9.6 / 3–2.8
3.5	3–5.6 / 3–6.4	3–5.6 / 3–6.4	3–5.5 / 3–6.5	3–5.4 / 3–6.7	3–5 / 3–7	3–4.7 / 3–7.4	3–4.2 / 3–7.9	3–3.5 / 3–8.9	3–2.6 / 3–10.1
4	3–11.5 / 4–0.5	3–11.5 / 4–0.5	3–11.4 / 4–0.6	3–11.2 / 4–1	3–10.8 / 4–1.3	3–10.2 / 4–1.9	3–9.6 / 4–2.6	3–8.6 / 4–4	3–7.6 / 4–5.6
5	4–11.3 / 5–0.7	4–11.3 / 5–0.7	4–10.9 / 5–1.1	4–10.6 / 5–1.6	4–10 / 5–2.2	4–9.1 / 5–3.1	4–8.2 / 5–4.4	4–6.6 / 5–6.7	4–4.8 / 5–9.6
6	5–10.9 / 6–1.1	5–10.9 / 6–1.1	5–10.4 / 6–1.6	5–9.8 / 6–2.3	5–9 / 6–3.2	5–7.8 / 6–4.8	5–6.4 / 6–6.7	5–4.2 / 6–10.2	5–1.7 / 7–2.9
7	6–10.6 / 7–1.4	6–10.4 / 7–1.6	6–9.8 / 7–2.2	6–9 / 7–3.2	6–7.9 / 7–4.6	6–6.2 / 7–6.7	6–4.3 / 7–9.5	6–1.3 / 8–2.5	5–10 / 8–9.5
8	7–10.1 / 8–2	7–10 / 8–2	7–9.2 / 8–3	7–8 / 8–4.3	7–6.6 / 8–6.1	7–4.4 / 8–9	7–1.9 / 9–0.8	6–10.1 / 9–7.9	6–5.9 / 10–5.8
10	9–9 / 10–3	9–8.8 / 10–3	9–7.6 / 10–4	9–5.8 / 10–7	9–3.5 / 10–10	9–0.2 / 11–2	8–8.4 / 11–9	8–2.6 / 12–9	7–8.5 / 14–4
12	11–7 / 12–4	11–7 / 12–4	11–5 / 12–7	11–3 / 12–10	10–11 / 13–2	10–7 / 13–10	10–1 / 14–8	9–5 / 16–4	8–9 / 19
15	14–5 / 15–7	14–4 / 15–7	14–2 / 15–11	13–10 / 16–4	13–5 / 17	12–10 / 18	12–2 / 19–6	11–2 / 22–8	10–3 / 28–1
20	18–11 / 21–1	18–11 / 21–2	18–6 / 21–8	17–11 / 22–6	17–3 / 23–9	16–3 / 25–11	15–3 / 29–2	13–9 / 36–11	12–4 / 54
30	27–8 / 32–8	27–7 / 32–10	26–9 / 34–1	25–7 / 36–3	24–1 / 39–7	22–3 / 46	20–4 / 57	17–9 / 99	15–5 / 765
50	44 / 58	43 / 58	41 / 62	38–8 / 70	35–6 / 84	31–7 / 120	27–9 / 257	23–1 / ∞	19–3 / ∞
∞	355 / ∞	337 / ∞	241 / ∞	169 / ∞	120 / ∞	84 / ∞	61 / ∞	42 / ∞	30–11 / ∞

Depth of Field (Feet and Inches) for Super-Takumar 105 mm. at Aperture

Focused Distance (Feet)	f 2.8	f 4	f 5.6	f 8	f 11	f 16	f 22
4	3–11.6 / 4–0.4	3–11.5 / 4–0.6	3–11.3 / 4–0.7	3–10.9 / 4–1.1	3–10.6 / 4–1.6	3–10 / 4–2.2	3–9.2 / 4–3.2
4.5	4–5.5 / 4–6.5	4–5.3 / 4–6.7	4–5 / 4–7	4–4.6 / 4–7.4	4–4.1 / 4–8	4–3.4 / 4–9	4–2.4 / 4–10.2
5	4–11.4 / 5–0.6	4–11.2 / 5–1	4–10.8 / 5–1.3	4–10.2 / 5–1.9	4–9.6 / 5–2.6	4–8.6 / 5–3.8	4–10.2 / 5–5.5
6	5–11 / 6–1	5–10.7 / 6–1.4	5–10.1 / 6–1.9	5–9.4 / 6–2.9	5–8.4 / 6–4	5–7 / 6–6	5–5.3 / 5–8.5
8	7–10.2 / 8–1.8	7–9.5 / 8–2.6	7–8.5 / 8–3.7	7–7.1 / 8–5.4	7–5.4 / 8–7.7	7–2.8 / 8–11.5	6–11.8 / 9–4.7
10	9–9.1 / 10–3	9–8 / 10–4	9–6.5 / 10–6	9–4.3 / 10–8	9–1.7 / 11–0	8–9.5 / 11–7	8–5 / 12–4
15	14–5 / 15–7	14–2 / 15–10	13–11 / 16–2	13–6 / 16–4	13 / 17–7	12–4 / 19–1	11–7 / 21–1
20	19 / 21–1	18–7 / 21–7	18–1 / 22–3	17–5 / 23–5	16–7 / 25	15–5 / 28–4	14–3 / 33–8
30	27–10 / 32–6	26–11 / 33–9	25–11 / 35–7	24–6 / 38–8	22–11 / 43	20–9 / 54	18–7 / 79
50	44 / 57	42 / 61	39 / 68	36–3 / 80	32–10 / 104	28–6 / 210	24–7 / ∞
100	78 / 136	72 / 162	65 / 216	56 / 432	48 / ∞	39 / ∞	32–4 / ∞
∞	369 / ∞	258 / ∞	184 / ∞	129 / ∞	94 / ∞	64 / ∞	47 / ∞

Focused Distance (Feet)	Depth of Field (Feet and Inches) for Super-Takumar 135 mm. at Aperture						
	f 3.5	f 4	f 5.6	f 8	f 11	f 16	f 22
5	4–11.5	4–11.5	4–11.3	4–11	4–10.7	4–10.1	4–9.4
	5–0.5	5–0.5	5–0.7	5–1.1	5–1.4	5–2.2	5–3
6	5–11.3	5–11.3	5–10.9	5–10.4	5–10	5–9	5–8
	6–0.7	6–0.8	6–1.1	6–1.6	6–2.2	6–3.2	6–4.6
7	6–11	6–10.9	6–10.4	6–9.8	6–9.1	6–7.8	6–6.4
	7–1	7–1.1	7–1.6	7–2.3	7–3.1	7–4.7	7–6.6
8	7–10.7	7–10.6	7–10	7–9.1	7–8	7–6.5	7–4.6
	8–1.3	8–1.6	8–2.2	8–3.1	8–4.3	8–6.4	8–9
10	9–10	9–9.6	9–8.8	9–7.3	9–5.8	9–3.1	9–0.1
	10–2	10–2	10–3	10–5	10–7	10–10	11–3
12	11–8	11–8	11–7	11–5	11–2	10–11	10–6
	12–3	12–3	12–5	12–7	12–10	13–4	13–10
15	14–7	14–6	14–4	14–1	13–9	13–3	12–9
	15–5	15–5	15–8	16–0	16–5	17–2	18–2
20	19–3	19–2	18–10	18–4	17–10	17	16–1
	20–9	20–10	21–3	21–11	22–8	24–3	26–4
30	28–4	28–1	27–5	26–5	25–4	23–8	21–11
	31–10	32–1	33–1	34–7	36–9	41	47
50	45	44	43	40	38	34	30–9
	55	56	59	64	72	92	135
100	83	81	75	68	61	52	44
	125	130	147	186	276	∞	∞
∞	488	427	305	213	155	107	78
	∞	∞	∞	∞	∞	∞	∞

Focused Distance (Feet)	Depth of Field (Feet and Inches) for Takumar 200 mm. at Aperture						
	f 3.5	f 4	f 5.6	f 8	11	f 16	f 22
9	8–11.4	8–11.3	8–10.9	8–10.6	8–10	8–9.1	8–8
	9–0.7	9–0.7	9–1.1	9–1.6	9–2.2	9–3.1	9–4.3
10	9–11.2	9–11	9–10.7	9–10.1	9–9.4	9–8.3	9–7
	10	10–1	10–1	10–1	10–2	10–4	10–5
12	11–10	11–10	11–10	11–9	11–8	11–6	11–4
	12–1	12–1	12–2	12–3	12–4	12–6	12–8
15	14–10	14–10	14–8	14–7	14–5	14–2	13–11
	15–2	15–2	15–3	15–4	15–7	15–10	16–2
20	19–8	19–7	19–5	19–3	19	18–7	18–1
	20–4	20–4	20–6	20–9	21–1	21–7	22–3
25	24–6	24–4	24–2	23–10	23–5	22–9	22–1
	25–6	25–7	25–10	26–3	26–9	27–8	28–10
30	29–3	29–1	28–9	28–4	27–9	26–10	25–10
	30–9	30–10	31–3	31–10	32–7	34	35–9
50	47–10	47–7	46–8	45–4	43–10	41–7	39–1
	52–4	52–8	53 10	55	58	62	69
100	91	90	87	82	77	70	63
	110	111	117	126	140	171	235
200	168	165	154	140	126	108	92
	245	253	284	346	478	1310	∞
∞	1071–11	938	670–2	469–4	341–6	235	171–1
	∞	∞	∞	∞	∞	∞	∞

Depth of Field (Feet and inches)
for Takumar 300 mm. at Aperture

Focused Distance (Feet)	f 4	f 5.6	f 6.3	f 8	f 11	f 16	f 22
18	17–10 / 18–1	17–10 / 18–2	17–9.7 / 18–2.3	17–9 / 18–3	17–8 / 18–4	17–6 / 18–6	17–4 / 18–8
20	19–10 / 20–1	19–9 / 20–2	19–9 / 20–2	19–8 / 20–3	19–7 / 20–5	19–4 / 20–7	19–2 / 20–10
25	24–9 / 25–3	24–7 / 25–4	24–7.3 / 25–4.8	24–6 / 25–6	24–3 / 25–8	24 / 26	23–8 / 26–5
30	29–7 / 30–4	29–5 / 30–6	29–5.2 / 30–7.2	29–3 / 30–9	29 / 31	28–7 / 31–7	28–1 / 32–2
35	34–5 / 35–6	34–3 / 35–8	34–2.5 / 35–10	33–11 / 36	33–7 / 36–5	33 / 37–2	32–4 / 38–1
40	39–3 / 40–8	39 / 40–11	38–11.4 / 41–1.3	38–8 / 41–5	38–2 / 41–11	37–5 / 42–11	36–6 / 44–2
50	48–11 / 51	48–6 / 51	48–4.1 / 51	47–10 / 52	47–1 / 53	45–11 / 54	44–7 / 56
70	67 / 72	67 / 73	66 / 73	65 / 74	64 / 76	62 / 80	59 / 84
100	95 / 104	93 / 106	93 / 107	91 / 110	88 / 114	84 / 122	79 / 133
150	140 / 161	136 / 166	135 / 168	131 / 174	125 / 185	117 / 207	108 / 243
200	182 / 220	176 / 230		168 / 245	159 / 269	145 / 319	132 / 411
300			245 / 385	234 / 417	216 / 489	192 / 686	163 / ∞
500	404 / 654	376 / 746		339 / 946	303 / 1425	257 / 9098	218 / ∞
∞	2110 / ∞	1507 / ∞	1342 / ∞	1055 / ∞	767 / ∞	528 / ∞	384 / ∞

Depth of Field (Feet and Inches)
for Tele-Takumar 400 mm. at Aperture

Focused Distance (Feet)	f 5.6	f 8	f 11	f 16	f 22
27	26–9 / 27–2	26–8 / 27–4	26–6 / 27–5	26–4 / 27–8	26–1 / 27–11
30	29–8 / 30–3	29–7 / 30–5	29–5 / 30–7	29–2 / 30–10	28–10 / 31–2
35	34–7 / 35–4	34–5 / 35–7	34–2 / 35–9	33–10 / 36–2	33–5 / 36–8
40	39–5 / 40–6	39–3 / 40–9	38–11 / 41–1	38–6 / 41–7	37–11 / 42–2
50	49 / 50	48 / 51	48 / 51	47 / 52	46 / 53
70	68 / 71	67 / 72	66 / 73	65 / 75	63 / 77
100	96 / 103	95 / 105	93 / 107	90 / 111	87 / 116
150	142 / 158	139 / 162	135 / 168	129 / 178	123 / 191
300	269 / 337	258 / 356	246 / 384	227 / 440	208 / 535
∞	2654 / ∞	1858 / ∞	1351 / ∞	929 / ∞	676 / ∞

Focused Distance (Feet)	Depth of Field (Feet and Inches) for Takumar 500 mm. at Aperture					
	f4.5/f 5	f 5.6	f 8	f 11	f 16	f 22
35	34–9 35–2	34–9 35–3	34–7 35–4	34–6 35–6	34–3 35–8	34 36
40	39–8 40–3	39–8 40–4	39–6 40–5	39–4 40–8	39 40–11	38–8 41–4
50	49–7 50–5	49–5 50–6	49–2 50–9	48–11 51–1	48–6 51–7	47–11 52–2
70	69 71	69 71	68 71	68 72	67 73	65 74
100	98 101	97 102	96 103	95 104	93 106	91 109
150	145 154	144 155	142 157	140 160	136 166	132 173
520	238 262	236 265	230 272	224 282	214 300	203 324
500	456 552	447 567	427 601	405 651	373 756	341 936
∞	5209 ∞	4186 ∞	2930 ∞	2132 ∞	1466 ∞	1066 ∞

Focused Distance (Feet)	Depth of Field (Feet and Inches) for Takumar 1,000 mm. at Aperture			
	f 8	f 11	f 16	f 22
100	99–2 100–9	98–11 101–1	98–5 101–7	97–10 102–2
110	109 110–11	108–8 111–4	108–1 111–11	107–4 112–9
125	123 126	123 126	122 127	121 128
150	148 151	147 152	146 153	145 155
200	196 203	195 204	193 207	191 209
250	244 255	242 257	239 261	236 265
350	339 360	335 365	329 372	323 381
600	569 633	559 646	542 670	524 701
1500	1323 1730	1267 1837	1184 2046	1097 2370
∞	11183 ∞	8108 ∞	5593 ∞	4068 ∞

349

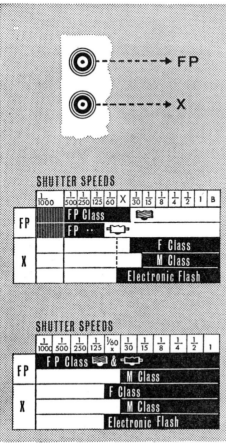

SHUTTER SPEEDS

	$\frac{1}{1000}$	$\frac{1}{500}$	$\frac{1}{250}$	$\frac{1}{125}$	$\frac{1}{60}$	X	$\frac{1}{30}$	$\frac{1}{15}$	$\frac{1}{8}$	$\frac{1}{4}$	$\frac{1}{2}$	1	B
FP		FP Class											
		FP ··											
X							F Class						
							M Class						
							Electronic Flash						

SHUTTER SPEEDS

	$\frac{1}{1000}$	$\frac{1}{500}$	$\frac{1}{250}$	$\frac{1}{125}$	$\frac{1}{60}$x	$\frac{1}{30}$	$\frac{1}{15}$	$\frac{1}{8}$	$\frac{1}{4}$	$\frac{1}{2}$	1
FP	FP Class &										
				M Class							
X		F Class									
				M Class							
				Electronic Flash							

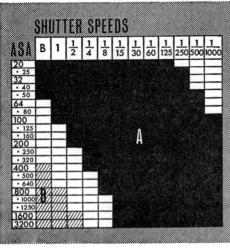

SHUTTER SPEEDS

ASA	B	1	$\frac{1}{2}$	$\frac{1}{4}$	$\frac{1}{8}$	$\frac{1}{15}$	$\frac{1}{30}$	$\frac{1}{60}$	$\frac{1}{125}$	$\frac{1}{250}$	$\frac{1}{500}$	$\frac{1}{1000}$
20												
· 25												
32												
· 40												
· 50												
64												
· 80												
100												
· 125												
· 160												
200									A			
· 250												
· 320												
400												
· 500												
· 640												
800	B											
· 1000												
· 1250												
1600												
3200												

PENTAX FLASH SYNC

Every Pentax has two push-on PC flash terminals on the front of the camera body. (The Spotmatic II in addition has a hot sync shoe atop the prism finder which accepts cordless flash units. An FP and X switch for the shoe is located beneath the rewind knob. The Pentax ES also has a hot shoe but it can be used for X sync only.

Your flash sync cord will fit either terminal. The top terminal labled FP should be used for special focal plane shutter flashbulbs only and possibly for M bulbs if proper tests are made (see below).

For most Pentaxes when using screw base FP bulbs employ speeds from X upwards. With bayonet FP bulbs, use speeds from 1/125 sec. upwards. Use 1/1000 speed with Pentax SV or H3v cameras only. With F bulbs, use speeds to 1/30; with M bulbs, to 1/15; with electronic flash to X setting.

For Spotmatic I, II, SP500 and ES cameras, use all FP bulbs at any speed. Sometimes M bulbs will also work on FP sync to 1/30 sec. Try it out first. On X sync, use F bulbs to 1/60 sec., M bulbs to 1/30 sec. and electronic flash to 1/60 sec.

SPOTMATIC METER RANGE

Black area A indicates operating range of Spotmatic. Shaded B area indicates range where needle will move and speed index window is black but meter will not operate properly. The meter range on early models was slightly more restricted. ASA range of Spotmatic extends to 1600, ASA range of Spotmatic II extends to 3200.

QUICK READING
CLOSE-UP SCALE

Here's a quick way of adjusting your exposure properly to compensate for extension tube or bellows extension when shooting closeups if you do not have a Pentax with through-lens meter.

1. Focus on your subject at close range. Turn this book on its side and use scale at subject distance across the horizontal length of picture area. Align zero mark with left hand edge of picture as seen through viewfinder.

2. Read required exposure increase at right edge of picture area in finder. Either use multiplying figure to adjust exposure or increase exposure by indicated number of stops.

Extension tube combination	Subject size	Film-to-subject distance	Magnification	Exposure factor

Super and Auto Takumar 35 mm.
Distance scale set 1 ft. 6 in. (.45m.)

Not used	10¼ × 1–7½ (26 × 49 cm.)	1–6 (45 cm.)	0.1	1.2
1	2½ × 4 (6.6 × 10 cm.)	7 (18 cm.)	0.4	1.9
2	1½ × 2¼ (3.8 × 5.7 cm.)	6 (15 cm.)	0.6	2.7
3	1 × 1½ (2.6 × 4 cm.)	5½ (14 cm.)	1.0	4.0
1+	¾ × 1¼ (2 × 3 cm.)	5½ (14 cm.)	1.2	4.7

Super and Auto Takumar 55 mm.
Distance scale set 1 ft. 6 in. (.45 m.

Not used	5½ × 8¼ (13.9 × 20.8 cm.)	1–6 (45 cm.)	0.2	1.4
1	2¾ × 4 (6.9 × 10.4 cm.)	11½ (29 cm.)	0.3	1.8
2	1¾ × 2¾ (4.6 × 6.9 cm.)	9½ (24 cm.)	0.5	2.3
3	1½ × 2 (3.5 × 5.2 cm.)	9 (22.8 cm.)	0.7	2.9
1+3	1½ × 1¾ 	8¾ (22.1 cm.)	0.9	3.5
2+3	1 × 1½ 	8¾ (22.1 cm.)	1.0	4.0

Super and Auto Takumar 85 mm.
Distance scale set 2 ft. 9 in. (.85 cm.)

Not used	7½ × 11¼ (18.9 × 28.4 cm.)	2–9 (85 cm.)	0.1	1.3
1	4 × 6 (10.1 × 15.1 cm.)	1–9¾ (55 cm.)	0.2	1.5
2	2¾ × 4 (6.9 × 10.3 cm.)	1–5½ (44 cm.)	0.3	1.8
3	2 × 3 (5.2 × 7.8 cm.)	1–3½ (39 cm.)	0.5	2.1
1+3	1¾ × 2½ (4.2 × 6.3 cm.)	1–2½ (37 cm.)	0.6	2.5
2+3	1½ × 2 (3.5 × 5.3 cm.)	1–2	0.7	2.8
1+2+3	1¼ × 1¾ (3 × 4.5 cm.)	1–1½ (34.4 cm.)	0.8	3.2

These tables are mathematically calculated and are intended for guidance only. Each individual lens may give fractionally different results when working at such close range. In many cases the figures have been rounded off. The metric figures are the more accurate. In practical work, further rounding off is possible, especially when the exposure factors are applied to black-and-white work. In such circumstances, there is no practical difference for example, between 1.8 and 2.0. Measurements are given in feet and inches with metric figures in brackets, i.e. 1–6 denotes 1 ft. 6 in.

EXTENSION TUBE DATA
for S-3 type extension
tubes.

Extension tube combination	Subject size	Film-to-subject distance	Magnification	Exposure factor
Super and Auto Takumar and Takumar 105 mm.		Distance scale set 4 ft. (1.2 m.		
Not used	8¾ × 1–1¼ (22.4 × 33.6 cm.)	4–0 (120 cm.)	0.1	1.2
1	4¾ × 7¼ (12.1 × 18.2 cm.)	2–6 (76 cm.)	0.2	1.4
2	3¼ × 5 (8.3 × 12.5 cm.)	2–0 (60 cm.)	0.3	1.7
3	2½ × 3¾ (6.3 × 9.5 cm.)	1–9 (53 cm.)	0.4	1.9
1+3	2 × 3 (5.1 × 7.7 cm.)	1–7 (48 cm.)	0.5	2.2
2+3	1¾ × 2½ (4.3 × 6.4 cm.)	1–6 (46 cm.)	0.6	2.4
1+2+3	1½ × 2¼ (3.7 × 5.5 cm.)	1–5¼ (44 cm.)	0.7	2.7
Super Takumar and Takumar 135 mm.		Distance scale set 6 ft. 6 in. (2 m.)		
Not used	1–0 × 1–6 (30.6 × 45.9 cm.)	6–6 (200 cm.)	0.1	1.2
	6¼ × 9½ (16.1 × 24.2 cm.)	4–0 (120 cm.)	0.15	1.3
2	4¼ × 6¼ (11 × 16.5 cm.)	3–0 (92 cm.)	0.2	1.5
3	3¼ × 5 (8.3 × 12.5 cm.)	2–6 (78 cm.)	0.3	1.7
1+3	2½ × 4 (6.7 × 10 cm.)	2–3 (69 cm.)	0.35	1.8
2+3	2¼ × 3¼ (5.6 × 8.4 cm.)	2–1 (64 cm.)	0.4	2.0
1+2+3	2 × 2¾ (4.8 × 7.2 cm.)	2–0 (61 cm.)	0.5	2.3
Takumar 200 mm.		Distance scale set 8 ft. (2.5 m.)		
Not used	9¾ × 1–2¾ (25 × 37.5 cm.)	8–0 (245 cm.)	0.1	1.2
1	6½ × 10 (16.7 × 25.3 cm.)	6–0 (182 cm.)	0.15	1.3
	5 × 7½ (12.6 × 18.9 cm.)	4–10 (149 cm.)	0.2	1.4
3	4 × 6 (10 × 15 cm.)	4–3 (129 cm.)	0.25	1.5
1+3	3¼ × 5 (8.4 × 12.6 cm.)	3–10 (116 cm.)	0.3	1.7
2+3	2¾ × 4¼ (7.2 × 10.8 cm.)	3–6 (107 cm.)	0.35	1.8
1+2+3	2½ × 3¾ (6.3 × 9.5 cm.)	3–3 (100 cm.)	0.4	1.9

These figures are approximate. See note on p. 352.

Extension tube combination	Subject size	Film-to-subject distance	Magnification	Exposure factor
Takumar 300 mm.		Distance scale set 18 ft. (5.5 m.)		
Not used	1–3 × 1–11 (39 × 59 cm.)	18–0 (550 cm.)	0.05	1.1
1	10½ × 15½ (26 × 39 cm.)	12–6 (380 cm.)	0.1	1.2
2	7½ × 11½ (19 × 29 cm.)	9–10 (300 cm.)	0.1	1.3
1+2	6 × 9 (15 × 23 cm.)	8–6 (260 cm.)	0.15	1.3
1+3	5 × 7½ (13 × 19 cm.)	7–6 (230 cm.)	0.2	1.4
2+3	4¼ × 6¼ (200 cm.)	6–6	0.2	1.5

Extension tube combination	Subject size	Film-to-subject distance	Magnification	Exposure factor
Super and Auto Takumar 35 mm.		Distance scale set 1 ft. 6 in. (.45 m.)		
Not used	10½ × 1–3¾ (27 × 40 cm.)	1–6 (45 cm.)	0.1	1.2
1	3 × 4½ (7.7 × 11.6 cm.)	7¾ (19.5 cm.)	0.3	1.7
2	1¾ × 2¾ (4.6 × 6.9 cm.)	6 (15.5 cm.)	0.5	2.3
1+2	1¼ × 2 (3.2 × 4.9 cm.)	5½ (14.3 cm.)	0.7	3.0
3	1 × 1½ (2.5 × 3.8 cm.)	5½ (14 cm.)	1.0	4.0
1+3	¾ × 1¼ (2.1 × 3.2 cm.)	5½ (14.1 cm.)	1.2	4.7

Extension tube combination	Subject size	Film-to-subject distance	Magnification	Exposure factor
Super and Auto Takumar 55 mm.		Distance scale set 1 ft. 9 in. (.55 m.)		
Not used	7½ × 11 (18.5 × 27.7 cm.)	1–9 (55 cm.)	0.1	1.3
1	3½ × 5½ (9.2 × 13.8 cm.)	1–1 (33.3 cm.)	0.3	1.6
2	2½ × 3½ (6 × 9 cm.)	10½ (27 cm.)	0.4	2.0
1+2	1¾ × 2½ (4.4 × 6.6 cm.)	9½ (24.2 cm.)	0.5	2.4
3	1½ × 2 (3.6 × 5.4 cm.)	9 (22.9 cm.)	0.7	2.8
1+3	1¼ × 1¾ (3 × 4.5 cm.)	8¾ (22.2 cm.)	0.8	3.
2+3	1 × 1½ (2.5 × 3.8 cm.)	8½ (22 cm.)	1.0	4.0
1+2+3	¾ × 1¼ (2.2 × 3.3 cm.)	8½ (22 cm.)	1.1	4.3

These figures are approximate. See note on p. 352.

Extension tube combination	Subject size	Film-to-subject distance	Magnification	Exposure factor

Super and Auto Takumar 85 mm.
Distance scale set 2 ft. 9 in. (.85 m.)

Extension tube combination	Subject size	Film-to-subject distance	Magnification	Exposure factor
Not used	7½ × 11 (18.5 × 27.7 cm.)	2–9 (85 cm.)	0.1	1.3
1	4½ × 6½ (10.9 × 16.4 cm.)	1–11 (58.3 cm.)	0.2	1.5
2	3 × 4¾ (8 × 12 cm.)	1–6¾ (47.6 cm.)	0.3	1.7
1+2	2½ × 3½ (6.2 × 9.2 cm.)	1–4½ (42 cm.)	0.4	1.9
3	2 × 3 (5 × 7.5 cm.)	1–3¼ (38.8 cm.)	0.5	2.2
1+3	1¾ × 2½ (4.2 × 6.3 cm.)	1–2½ (36.8 cm.)	0.6	2.5
2+3	1½ × 2¼ (3.6 × 5.5 cm.)	1–2 (35.5 cm.)	0.7	2.7
1+2+3	1¼ × 2 (3.2 × 4.9 cm.)	1–1¾ (34.7 cm.)	0.75	3.0

Super and Auto Takumar and Takumar 105 mm.
Distance scale set 4 ft. (1.2 m.)

Extension tube combination	Subject size	Film-to-subject distance	Magnification	Exposure factor
Not used	8½ × 1–1 (21.8 × 32.7 cm.)	4–0 (120 cm.)	0.1	1.2
1	5¼ × 8 (13.3 × 20 cm.)	2–8 (81.6 cm.)	0.2	1.4
2	3¾ × 5¾ (9.6 × 14.4 cm.)	2–2 (65.6 cm.)	0.25	1.6
1+2	3 × 4½ (7.5 × 11.3 cm.)	1–10½ (57 cm.)	0.3	1.7
3	2½ × 3½ (6.2 × 9.2 cm.)	1–8½ (51.8 cm.)	0.4	1.9
1+3	2 × 3 (5.2 × 7.8 cm.)	1–7 (48.5 cm.)	0.45	2.1
2+3	1¾ × 2½ (4.4 × 6.7 cm.)	1–6¼ (46.2 cm.)	0.5	2.4
1+2+3	1½ × 2¼ (3.9 × 5.9 cm.)	1–5½ (44.7 cm.)	0.6	2.6

Super Takumar and Takumar 135 mm.
Distance scale set 5 ft. (1.8 m.)

Extension tube combination	Subject size	Film-to-subject distance	Magnification	Exposure factor
Not used	10½ × 1–4 (27 × 40.5 cm.)	5–0 (180 cm.)	0.1	1.2
1	6¾ × 9¾ (17 × 25 cm.)	4–0 (120 cm.)	0.15	1.3
2	4¾ × 7 (12 × 18 cm.)	3–1 (94 cm.)	0.2	1.4
1+2	3¾ × 5½ (9.5 × 14 cm.)	2–9 (81 cm.)	0.25	1.6
3	3 × 4½ (7.7 × 11.5 cm.)	2–4 (57 cm.)	0.3	1.7

These figures are approximate. See note on p. 352.

355

Extension tube combination	Subject size	Film-to-subject distance	Magnification	Exposure factor

Super Takumar and Takumar 135 mm.—contd.

Distance scale set 5ft. (1.8 m.)

1+3	2½×3¾ (6.5×9.8 cm.)	2–2 (51 cm.)	0.35	1.9
2+3	2¼×3½ (5.7×8.5 cm.)	1–11 (46 cm.)	0.4	2.0
1+2+3	2×3 (5×7.5 cm.	1–10 (42 cm.)	0.5	2.2

Takumar 200 mm.

Distance scale set 8 ft. (2.5 m.

Not used	9¾×1–2½ (25×37 cm.)	8–0 (250 cm.)	0.1	1.2
1	7 ×10¼ (18×27 cm.)	6–6 (192 cm.)	0.13	1.3
2	5½×8¼ (14×21 cm.)	5–3 (160 cm.)	0.17	1.4
1+2	4¾×6¾ (12×17 cm.)	4–8 (140 cm.)	0.2	1.5
3	4×6 (10×15 cm.)	4–2 (126 cm.)	0.25	1.6
1+3	3×5 (8×13 cm.)	3–10 (116 cm.)	0.28	1.6
2+3	2¾×4¼ (7×11 cm.)	3–7 (109 cm.)	0.32	1.7
1+2+3	2½×4 (6.7×10 cm.)	3–6 (103 cm.)	0.36	1.8

Takumar 300 mm.

Distance scale set 18 ft. (5.5 m.

Not used	1–3½×1–11 (39×59 cm.)	18–0 (550 cm.)	0.06	1.1
1	11×1–4½ (28×42 cm.)	13–7 (410 cm.)	0.09	1.2
2	8¾×1–0½ (22×32 cm.)	10–10 (330 cm.)	0.1	1.2
1+2	7×10¼ (18×23 cm.)	9–2 (280 cm.)	0.14	1.3
3	6×8¾ (15×22 cm.)	8–2 (250 cm.)	0.16	1.35
1+3	5×7½ (13×19 cm.)	7–6 (230 cm.)	0.2	1.4
2+3	4½×6¾ (11×17 cm.)	6–11 (210 cm.)	0.2	1.45
1+2+3	4×6 (10×15 cm.)	6–2 (190 cm.)	0.25	1.5

These figures are approximate. See note on p. 352.

Bellows extension	Subject size	Film-to-subject distance	Magnification	Exposure factor
Super and Auto Takumar 35 mm.				
Minimum	1 × 1½ (2.4 × 3.6 cm.)	5¾ (14.9 cm.)	1.0	4.0
Maximum	⅜ × ¼ (.7 × .5 cm.)	10½ (26.6 cm.)	5.2	38.0
Super and Auto Takumar 55 mm.				
Minimum	1½ × 2¼ (3.7 × 5.5 cm.)	9 (22.9 cm.)	0.7	2.7
Maximum	⅜ × ½ (.8 × 1.1 cm.)	12 (30.4 cm.)	3.2	17.5
Super and Auto Takumar 85 mm.				
Minimum	2¼ × 3¼ (5.5 × 8.2 cm.)	15½ (39.6 cm.)	0.4	2.0
Maximum	½ × ½ (1.6 × 1.1 cm.)	15	2.1	10.0
Super and Auto Takumar 105 mm.				
Minimum	2¾ × 4 (6.8 × 10.1 cm.)	21¾ (55.3 cm.)	0.4	2.0
Maximum	⅞ × ¾ (2.1 × 1.3 cm.)	18 (46.2 cm.)	1.7	7.5
Super Takumar 135 mm.				
Minimum	3½ × 5½ (8.7 × 13.7 cm.)	32 (80.7 cm.)	0.3	1.5
Maximum	¾ × 1 (1.8 × 2.7 cm.)	22 (56.2 cm.)	1.3	5.5
Takumar 100 mm.				
Minimum		∞		1.0
Maximum	¾ × 1 (1.7 × 2.5 cm.)	16¼ (41.4 cm.)	1.4	6.0

As with the extension tube data, these figures are rounded off expressions of mathematically calculated data. Exact figures cannot be given to cover every individual lens, owing to the normal slight variations in actual focal length as compared with the nominal or marked focal length. Data are given here only for the minimum (1½ in.) and maximum (7 in.) extensions of the bellows. There is, of course, a wide range of settings between these limits. Measurements are given in inches with metric figures in brackets.

FILTER EQUIVALENTS

Accura Enteco Kodak Tiffen Walz	Ednalite	Harrison and Harrison	Enteco Hasselblad Lifa Rollei Tiffen	Gevaert
85B	Chrome B	C-5	R13	
85	Chrome A	C-4	R11	CTO8
85C	Chrome F	C-2	R8	
81EF	CTY6	C-1	R5	CTO4
81D	CTY5	C-½	R4	
81C	CTY4	C-½	R3.5	
81B	CTY3	C-¼	R3	CTO2
81A	CTY2	C-¼	R2	
81	CTY1	C-⅛	R1	CTO1
Skylight	Chrome Haze	U.V.-Haze	R1 or 1.5	
82	CTB1	B-⅛	B1	CTB1
82A	CTB2	B-¼	B2	CTB2
82B	CTB3	B-¼	B3	
82C	CTB4	B-½	B4.5	CTB4
80C	80C	B-2	B8	
80B	80B	B-4	B11	CTB8

Various manufacturers label filters differently. Those in the left column above are used in the Nomograph on page 358; the others listed are *approximate* equivalents.

FILTER NOMOGRAPH

This helps you find the proper correction filter for any given light source and type of colour film. To use the nomograph, find the film type or balance of film to be used in the right-hand column. Locate type of lighting in left-hand column. Lay a straight-edge so that it cuts these two points. Where the straight-edge cuts centre column, read filter as correction in decamireds needed.

Notes: a—The colour temperature of these lamps decreases gradually throughout their life. *b*—These values are approximate. Exact colour temperatures cannot be assigned to this type of lamp.

FILM

Type B
Type A

Daylight Type

BALANCE IN DECAMIREDS

40
36
32
28
24
20
16
12
8
4

CORRECTION IN DECAMIREDS

20
16
12
8
4
0
-4
-8
-12
-16
-20

FILTER

Yellowish

85B+81C
85B+81 · 85B+81A
·85+81 · 85B
85+81 · 85C+81·81A
85C
81EF+81B · 81EF+81C
81EF+81 · 81EF+81A
81EF
81C · 81D
81A · 81
0 · 82
82A
82B
82C · 82A
82C+82 · 82C+82A
82C+82B · 82C+82A
80C+82
80C+82 · 80C
80C+82A · 80B
80B+82 · 80A
80B+82B · 80B+82A
80B+82C · 80B+82C
80B+82C+82A

Bluish

CORRELATED COLOUR TEMPERATURE °K

25,000
13,000
9,000
7,500
6,500
6,000
5,500
5,000
4,800
4,500
3,800
3,500
3,400
3,200
3,000
2,950
2,860
2,790
2,760

LIGHT SOURCE

Clear Blue Sky

Hazy Blue Sky

Lightly Overcast Sky
"Daylight"Fluorescent Lamp[b]
Heavily Overcast Sky
Midday Sun & Skylight
Electronic Flash
Blue Flashlamps(NotM2B)[b]
M2B Flashlamp
Average Noon Sunlight
Blue Photoflood(115-120v)[a]
"Cool White"Fluorescent Lamp[b]
Clear Flashlamp
"WarmWhite"Fluorescent Lamp[b]
Photofloods[a]
Studio Lamps[a]
Tungsten Lamp 1000watt
500
100
60
40

358

Filter	Wratten No.	Application	Exposure Factor

For Monochrome Films

Filter	Wratten No.	Application	Exposure Factor
U.V., Haze	1A	Many filters are sold under these and similar description. Their main function is to absorb ultra-violet radiation that is invisible to the human eye. They reduce distant haze.	1
Light Yellow		Absorbs excess blue and emphasises difference between blue sky and white clouds.	1.5
Medium Yellow		Stronger effect than light yellow.	2
Yellow-green		Similar effect to medium yellow but some photographers prefer it for out-door portraits with sky background.	2
Orange		Stronger absorption of blue to give dramatic skies. Useful for marine scenes, aerial photography, some architecture and copying.	3
Red		Very strong absorption of blue for maximum sky/cloud contrast and simi-lated night scenes by underexposure. Strong haze cutter. Excellent for copy-ing blueprints.	6

For Daylight Type Colour Reversal Films

Filter	Wratten No.	Application	Exposure Factor
U.V., Haze, Skylight	1A	See above. Particularly suitable with colour film to remove blue cast in mountain views, scenes over water, sunlight snow scenes, pictures in open shade, etc.	1
Cloud	81A	Stronger effect than haze or U.V. type. Suitable for use on cloudy days to "warm up" colours that might look too blue.	1.5
Morning and Evening	82A	Within two hours of sunset and sunrise, the light tends to contain a higher proportion of red. This filter prevents too much red light getting through to the film.	1.5
Flood	80B	In emergencies, you can use this filter to bring photoflood lighting into balance with daylight film. It is not recom-mended for general use, both on account of the compromise colour rendering and the loss of film speed.	3

These are the principal uses of filters with mono-chrome and colour film. It must be remembered, however, that few natural colours are pure. A col-oured filter may have some effect on all the colours in a scene.

*The exposure factors given here are approximate. Experiments must be made to find the correct factor of any particular filter.

INDEX